In Our Time

WILLIAM MANCHESTER

In Our Time
The World
as Seen
by Magnum
Photographers

ESSAYS BY
JEAN LACOUTURE AND
FRED RITCHIN

THE AMERICAN FEDERATION OF ARTS IN ASSOCIATION WITH
W·W·NORTON & COMPANY, NEW YORK·LONDON

This book is dedicated to the friends of Magnum and, most especially, to those friends who have worked on the Magnum staff.
The survival of this fragile idea of a creator's cooperative has been in their hands and we are grateful to them—every one of them.

Manufacturing by Balding and Mansell, Ltd.

An exhibition organized in conjunction with this volume has been
sponsored by

EASTMAN KODAK COMPANY.

The exhibition was organized by the American Federation of Arts
with the cooperation of the Minneapolis Institute of Arts.
The project was developed by Lisa Cremin and Associates, and
supported by a planning grant from Cray Research, Inc., Beverly J.
Rollwagen, and John A. Rollwagen.

First Edition

In our time: the world as seen by Magnum photographers /
William Manchester: with essays by Jean Lacouture and Fred Ritchin.
—1st ed.
p. cm.
Bibliography: p.
History, Modern—1945- —Pictorial works. I. Lacouture, Jean.
II. Ritchin, Fred. III. Title.
D840.M23 1989
908.82—dc20 89-32440

ISBN 0-393-02767-8

W. W. Norton & Company, Inc., 500 Fifth Avenue, New York, N.Y. 10110
W. W. Norton & Company Ltd., 37 Great Russell Street, London WC1B 3NU
1 2 3 4 5 6 7 8 9 0

CONTENTS

For a photojournalist,
the 1930s were the worst of times and the best of times.
War raged in Europe and the Far East. And America moved
inexorably toward its rendezvous with destiny.

Against this somber backdrop, documentary
photography entered its golden age.
There were new picture magazines. New 35mm cameras.
New Kodak films. And a new attitude in photojournalism.

The idea of the concerned photographer
took root in Magnum Photos, where it has flourished
for more than four decades.

The Professional Photography Division
of Eastman Kodak Company is proud to have helped generations
of Magnum photographers create a tapestry
of our times—a rich photographic record of momentous
events and intimate moments.

Sponsoring this book and
the companion exhibition is our way of expressing
our gratitude to the photographers of Magnum for sharing
their extraordinary visions with the world.

Raymond H. DeMoulin
General Manager, Professional Photography Division
Vice-President, Eastman Kodak Company

In Our Time marks the first comprehensive survey of the work of Magnum Photos, Inc., a cooperative agency founded in 1947 by Henri Cartier-Bresson, Robert Capa, Maria Eisner, David Seymour (Chim), George Rodger, and William and Rita Vandivert, and today considered the world's most renowned collective of photographers. This is a landmark exhibition, as is the accompanying publication; the American Federation of Arts is very proud to be presenting this extraordinary body of work to audiences throughout the world.

First and foremost, the exhibition has come about as the result of the vision of the Magnum photographers. Those who have been particularly instrumental in guiding the project include Magnum's former presidents, Philip Jones Griffiths and Gilles Peress, and current president, Burt Glinn. An exhibition committee comprised of Magnum members—Burt Glinn, Philip Jones Griffiths, and Alex Webb in New York; Eve Arnold in London; and Bruno Barbey, René Burri, and Martine Franck in Europe—steered the project on Magnum's behalf.

The Minneapolis Institute of Arts undertook the initial planning of the exhibition with the organizational direction of Lisa Cremin and Associates and the financial support of Cray Research, Inc. and John Rollwagen and Beverly Baronowski. In 1986, following the institute's proposal that the American Federation of Arts take on the project, the AFA became the fortunate recipient of an extremely generous grant from Eastman Kodak Company; it is this grant that ultimately made possible the realization of the project. At Kodak, thanks are particularly due Raymond H. DeMoulin, vice-president and general manager of the Professional Photography Division, whose belief in the project enabled its many goals to be realized. We also wish to acknowledge Marianne Samenko, director of marketing communications and support services, and Ann R. Moscicki, communications planning specialist, for their assistance.

The curatorial responsibility for the exhibition and publication has been in the hands of Robert Delpire, director of the Centre National de la Photographie, Paris; Fred Ritchin, writer, curator, and picture editor; and Carroll T. Hartwell, curator of photography at the Minneapolis Institute of Arts. Mr. Delpire selected and developed sequences for the photographs in the exhibition and publication; Mr. Ritchin acted as a consultant in the selection of photographs in the exhibition, and played an active role in defining the conceptual direction for the project; and Mr. Hartwell, the originating curator for the project, conducted preliminary research and made an initial selection of photographs. Throughout the organization of this project the following individuals have also provided invaluable curatorial assistance: Stuart Alexander, who compiled the bibliographies and biographies for the publication; Belinda Rathbone, who researched the founders and early Magnum photographers and selected photographs to accompany the Lacouture and Manchester essays; and Esther Samra, who conducted interviews with the individual photographers and helped coordinate the overall research effort.

Three distinguished authors were invited to contribute essays to the publication. To historians William Manchester and Jean Lacouture and photohistorian Fred Ritchin, we owe a special debt of gratitude.

From the inception of the project, the AFA has had the invaluable assistance of the Centre National de la Photographie (CNP) in Paris. Annik Duvillaret at the CNP arranged the European tour, supervised the management of the exhibition in Europe, and kept the AFA informed of developments across the Atlantic. The cooperation of the staff at Magnum's three offices—New York, Paris, and

London—was critical to the success of the exhibition. We wish to single out the contribution of Catherine Chermayeff, director of special projects in New York, who negotiated the publishing arrangement on Magnum's behalf and was in daily communication with the exhibition committee and the AFA regarding a myriad of important details. Her counterparts in Paris and London, François Hebel and Neil Burgess, respectively, were frequently called upon for their assistance. Robert Dannon, editorial director and Elizabeth Gallin, former director of the library in New York, Jimmy Fox, syndicate editor, and Agnes Sire, director of commercial photography projects in Paris, provided direction and insight into Magnum's vast archive and complex history. Without the assistance of Ernie Lofblad, director of technical services, and Allen Brown, director of transportation, the extensive task of assembling prints and negatives from the Magnum archives would have been impossible. The following former Magnum staff members were also consulted in the course of research: Inge Bonde; Maria Eisner, founding secretary/treasurer; Lee Jones, former New York bureau chief; and John Morris, former international executive editor. We also wish to acknowledge the insight gained through conversations with friends of Magnum: Romeo Martinez, former editor of *Camera* magazine; Carole Naggar, photohistorian and author, Jinx Rodger; Warren Trebant, former editor of *Heute* magazine; Mrs. Irwin Shaw; and Howard Squadron, Magnum's legal counsel for many years.

We are also indebted to the many individuals who have helped us gain access to information on and work by deceased Magnum photographers: Cornell Capa of the International Center of Photography, who is responsible for the Robert Capa and David Seymour estates in New York; Alexander and Victoria Haas, Nancy D'Antonio and Marilyn Schroeder for the Ernst Haas estate in New York; Kevin Eugene Smith, representative for the W. Eugene Smith archive in Tucson; Marc Bischof, for the Werner Bischof estate in Zurich; and Brian Carey at the National Archive of Canada in Ottawa, for assistance in researching and obtaining the work of Kryn Taconis. We also wish to express our gratitude to the former Magnum photographers who cooperated in lending their original negatives to the exhibition.

For the publication, we are especially indebted to W. W. Norton vice-president and senior editor, Jim Mairs, for his patience and dedication, to project editor Patty Peltekos for her skillful editing, and to Eve Picower for her editorial assistance. We are also grateful to Balding and Mansell in England for the exceptional quality of the printing.

For the printing of the photographs, we would like to acknowledge the outstanding work by Pictorial Services, Gossens, Imaginoir, Publimod, Jean-Yves Brégand, and Yvan le Marlec in Paris and Gary Schneider of Schneider/Erdmann and Igor Bakht in New York. The dye transfers were made by Guy Stricherz, Karen Balogh, Irene Malli, and Curt Rowell of CVI Lab in New York. The tremendous effort of coordinating the printing and researching and compiling caption information was undertaken by Sara Pozefsky and Cecile Kambouchner in New York and Paris respectively. Sara Pozefsky was also responsible for researching visual material for the publication.

The AFA also wishes to thank the directors and curators at the American and European museums participating in the international tours. For the exhibition's opening in the United States at the International Center of Photography (ICP) in New York, we are especially grateful to Cornell Capa, executive director, for his encouragement, for making possible the exhibition's presentation at the new ICP midtown galleries, and for electing to host the exhibition on the occasion of ICP's fifteenth anniversary. For the opening at the Palais de Tokyo in Paris, it is again Robert Delpire and Annik Duvillaret whom we wish to thank. At the Minneapolis Institute of Arts, we want to express special thanks to the following individuals: former director Alan Shestack and current director Evan Maurer; Michael Conforti, chief curator; and Timothy Fiske, associate director.

Finally, I want to thank all of the AFA staff members who have contributed so much to the realization of this project over the last three years. In particular, I wish to acknowledge Jeanne Hedstrom, exhibition coordinator, for so capably taking responsibility for virtually every aspect of the project's organization; Michaelyn Mitchell, publications coordinator, who negotiated the publishing arrangement on the AFA's behalf and assisted on other aspects of the publication; Sandra Gilbert, former public relations director, and Tom Connors, publicity coordinator, for coordinating the publicity effort; and Mary Ellen Goeke, registrar, for handling the registrarial details.

Myrna Smoot
Director, The American Federation of Arts

In Our Time

Images:
A Wide Angle

WILLIAM MANCHESTER

As a young *Baltimore Sun* reporter in the years immediately following World War II, I fell easily into the traditional, symbiotic relationship between newspapermen and news photographers. Knowing something of their trade, and eager to know more, I began feeling cameramen out on matters then being discussed in the journals of photography. Their replies were exasperatingly vague. Slowly it dawned on me that either they didn't understand my questions or didn't know the answers.

It had been naive of me to expect more. Just as journalists and public school teachers comprise America's intellectual proletariat, so do newspaper cameramen occupy the lower rungs of their craft. There are exceptions, but in the main they lack imagination, a sense of composition, and an awareness of what Henri Cartier-Bresson calls the "decisive moment"—an intuitive gift for knowing precisely when to push the button. That instinct is essential to great photography. You cannot learn it. You cannot fake it. You have to have been born with it, and most of the men lugging *Sun* Speed-Graphics around didn't even know it existed.

My curiosity was not idle. To be sure, on one level it was that of the informed amateur—photography is America's most popular hobby—but on a higher level it was professional. Although teachers and newspaper photographers are usually blocked from advancement, clever and talented reporters are entitled to cherish higher hopes. If a writer rises, the importance of his assignments, and the eminence of photographers sent to cover his stories, also rise. Should you be covering an event of national, or even international, significance, you are likely to be joined by top-drawer photojournalists. You come to know them, to drink with them, and once they discover that your interest is genuine, they let you watch as they work.

It was my great good fortune that the *Sun*, then at the height of its glory, employed a dozen men in its Washington bureau and stationed correspondents in key capitals around the world. Every reporter in the city room aspired to this elite. In late 1952 I was chosen and so, at the same time, was Russell Baker, later to become a gleaming ornament of the *New York Times*. We were both still in our twenties, junior to almost everyone else on the staff; nevertheless the magi who ruled the *Sun* in late 1952 smiled on us. Russ was

11

annointed as the *Sun*'s Fleet Street correspondent. I was given a roving commission, free to wander through the Middle East, India, and Southeast Asia, writing about whatever I fancied.

Baker and I were friends, and our dispatches would appear in the same paper. Nevertheless, we were fiercely competitive, which was one reason we had been picked. Even before we sailed, each was trying to outperform the other. Russ, eager to start, boarded the new *United States*, which crossed the Atlantic in four days. I booked first-class passage on the more leisurely *Queen Mary* because I knew something he didn't. Winston Churchill and his entourage were to be among my fellow passengers. Unknown to Russ, I had contrived—never mind how—to occupy stateroom M101, adjacent to the prime minister's suite.

I was devious. I was also lucky. On the trip over, the prime minister's personal private secretary had read, and enjoyed, a copy of my first book's British edition. He introduced me to the P.M. Aware that Churchill had been a young foreign correspondent in the 1890s, I casually mentioned that I was headed for the lands he had known in his youth. It was bait and he took it. I was invited to join his party for dinner in the ship's Verandah Grill and seated beside him. The upshot was a series of exclusive Churchill interviews—a real coup. Afterward I was told that when Baker learned of it, he threw himself on the floor of the *Sun*'s Fleet Street office and drummed his heels on the carpet. I dismissed the story as malicious gossip. I knew the office had no carpet.

It is humbling to report that the rest of my career as an overseas correspondent was less lustrous. I lacked the temperament for the job: the detachment of, say, Homer Bigart of the *New York Herald Tribune*, then the doyen of our profession. When generals and governments debated new policies, and the lives of thousands hung in balance, it was impossible for me to remain aloof. My convictions colored my dispatches, a cardinal sin. The last straw, for me, was the struggle in what was then called Indochina—the federated states of Vietnam, Laos, and Cambodia. Before the war they had been French colonies. Now they demanded independence. The fight was in its eighth year, but neither side, it seemed, could win.

Americans, though few of them knew it, were paying for the French struggle to keep its Asian colonies. Appropriations for their effort came before the U.S. Congress from time to time, and whenever that happened Agence France Presse, the government-owned wire service, chattered out lurid details of the Communist menace and the gallant French soldiers who were sacrificing their lives to assure that the United States would remain safe from Red tyranny. The war itself was poorly reported in America; including correspondents from all countries, there were never more than a half-dozen of us in the Hotel du Jockey Club Hanoi. The United Press International (UPI) was unrepresented in Indochina and would get its news from Agence France Presse. In effect UPI bought propaganda. During one military aid debate in Congress, the Agence actually invented a Communist invasion of Laos. The story was front-page news of every newspaper subscribing to UPI, and all of us received rockets from home, demanding to know how we could have permitted ourselves to be scooped.

To envisage the strategic situation in early 1953, one must keep in mind three cities: Saigon in the south; the northern port of Haiphong; and, near the Red River delta to the west of Haiphong, the ancient Indochinese capital of Hanoi. Travelers, including correspondents, arrived in Saigon, were flown to Haiphong in military transports, and then carried to Hanoi by jeeps in heavily armed convoys. Concertinas of barbed wire and beau geste forts lined both sides of the road. By day the French ruled here. When dusk approached, they and their guests, including correspondents, withdrew into the forts, drank appalling wine, and sang rousing choruses of "*Contre les Viets*" ("Against the Viets"). Meanwhile, outside the forts, the Viets sited their guns, developed fields of fire, and planted land mines.

To Saigon, Haiphong, and Hanoi a fourth geographic name was about to be added: Dien Bien Phu. If I had any illusions about the war, they were about to be lost; the Battle of Dien Bien Phu, soon to be fought, would be the focus of the world's attention, and was for me the last straw. No trap is so deadly as the one you set for yourself. The French had picked the spot to take a stand, where French valor would prevail over Viet cowardice. Dien Bien Phu lay two hundred miles west of Hanoi, astride lines of communications linking China, Laos, and northern Vietnam. Over fifteen thousand French paratroopers had been dropped there to develop an airstrip for transport planes, carrying other troops. Their plans had been approved in a morning meeting and classified Most Secret. By noon we had copies, complete with maps, and all of us with military experience agreed, unanimously, that the French decision was indefensible.

Dien Bien Phu and the surrounding terrain resemble a saucer. The French, led by Colonel Christian de Castries, built their strongpoints among the little hummocks at the bottom of it, ignoring the ridge, or rim, encircling them. To win, the Vietminh—fathers and grandfathers of the later Vietcong—need only wheel 155-mm Long Toms into place along the rim. They could interdict aircraft supplying the French and dig snakelike, zigzag trenches toward the fortress. Once they were close enough, they could rise up out of the ground and overwhelm the defenders.

We were flown there to inspect the place where French military honor, stained in 1940, would be redeemed, and were shepherded about by de Castries' executive officer, who, after a thorough inspection, asked for our opinion of the French strategy. We told him. He was incredulous. How, he asked us, would the Viets get Long Toms on the ridge? By manhandling them up the jungle trails, we replied. He flipped his hands to his hips, arched his back, and laughed heartily. The natives, he said, were incapable of that. I had a lot more confidence in *les Viets* than he did, and I was aboard the next plane to Hanoi, leaving the lethal quadrille to be played out exactly as we had predicted.

Back in Saigon, while waiting in line for airline reservations which would return me to my base in Delhi, I met another traveler who shared my dim view of the war. He was an American; we could speak our own language. I remarked that in my opinion, the last competent French general lay in Napolean's tomb. He vehemently agreed. It turned out that he was a *Life* photographer on his way home. He bore an uncanny resemblance to Gary Cooper and introduced himself as David Douglas Duncan.

I was impressed. I knew the name. I had seen his striking pictures of combat in Korea and had bought *This Is War!*, a collection of his best. His genre was conveying the slogging life of the infantryman. Now, after six months here, he had decided to fly straight back to New York. He

wanted *Life* to devote an entire issue to his Indochina photographs. Even though they were undeveloped, he knew they were among his best work, and when we were told that reservations would be impossible for twenty-four hours, he staged a tantrum.

His rudeness was embarrassing. Later, on the plane, I was to be further mortified when he treated me to an encore at the expense of a soft-spoken American diplomat in front of us. The diplomat's offense had been to tilt his seat back, to the inconvenience of Duncan and his long legs.

Later I learned that photographers with Dave's gifts are not celebrated for their elegant manners. Sometimes rudeness seems a tool of their trade, and so, sometimes, it is. Most people, when photographed, are self-conscious. Their shyness is a challenge to the man with the camera. In the early years of this century, Paul Strand, an innovative photographer, solved this by fitting a 45-degree prism over his lens, so that people would not know he was focusing on them. Purists scorn such artifice. They prefer to startle a subject, or even insult him, to jolt him out of his anxiety for a fraction of a second—long enough to trigger the shutter.

One of photography's most famous portraits is Yousuf Karsh's Winston Churchill taken in 1941. The prime minister's defiant expression seems to reflect England's resolution as she stood alone, facing the prospect of defeat at the hands of a merciless Hitler. What had actually happened in the studio was very different. Just before he tripped his shutter, Karsh had reached out and yanked the cigar from the prime minister's teeth. The grim expression is there, but it is less heroic than it seems, being, in fact, closer to that of a small child deprived of its pacifier.

Dave and I agreed to team up for our last evening in Saigon, and it was then that I discovered that he would do anything for a picture—*anything*. Gambling halls were illegal in the city. *Défense jouer de l'argent* signs were posted everywhere, and it was typical of that time and place that every *Maison de jeu* was flourishing quietly. Quietly was the operative word. The syndicate didn't advertise because it wasn't necessary, and openly flouting the law was unwise. To expose this hypocrisy would be to invite reprisal from both the syndicate and *les flics*. It was probably the most dangerous venture in the city, far more hazardous than staging a Vietminh demonstration in front of the Hotel Continental. As insurance, every gambling den required patrons to check cameras at the door. Dave, with sublime indifference to all this, had decided to photograph the plushest den in Saigon.

Rummaging around in his equipment before setting out, he came up with the tiniest camera I had ever seen. Minoxes are no rarity now; even so, I have never seen another this size. It was smaller than a pack of cigarettes, so he concealed it in an empty Chesterfield pack. The casino was rigorously policed by armed guards on catwalks overlooking the betting floor. Passing himself off as a homosexual, Duncan draped one of his long ropy arms over my shoulder and cupped his bogus cigarette pack in the palm of his hand, giggling and simpering to me as he took pictures, relying on his long experience to set *f*-stops and exposures blindly. When he needed to change film we went to *les toilettes*. I wondered, fleetingly, whether or not I would have been wiser to have stuck it out at Dien Bien Phu. The odds here were that we would wind up on the bottom of the Mekong, and in fact the guards had started to move in on us when we slipped out.

The only time I saw Duncan nervous was at the airport. He was carrying a huge conical peasant's hat. He and his wife lived in Italy, he explained; she was sensitive to the sun, and this would shade her. The customs men bought it. I didn't. I thought that its real purpose was to divert attention from a peculiar piece in his luggage, a cylindrical-shaped carpetbag, and I was right.

A fellow photographer, he whispered to me, had spent four weeks in one of what we now call the emerging nations. Then, at the airport, before he could get to a darkroom, an electric beam had exposed all his film. His carpetbag, Duncan told me, held four *months* of film. He was tense, terrified, as anyone in his situation would have been, dreading the possibility that such a beam might be his undoing.

It didn't, and once aloft he was Daring David again. As I recall, we were flying an old Gloucester westward to Rangoon, with one stop at Phnom Penh. The British pilot made a graceful landing at Phnom Penh, and we were no sooner on the tarmac than my audacious fellow traveler accosted him, all but calling him a coward for not circling over Phnom Penh's celebrated ruins. You don't treat pilots that way, especially former Battle of Britain RAF aces, one of whom, I learned from the crew, this one was. Once we had our petrol and were airborne again, the ace said tightly, we would take another look at those ruins. David urged everyone to be doubly sure his seat belt was fastened. As it turned out, it was absolutely necessary. In the cockpit our survivor of England's Few performed acrobatic turns over the ruins—actually flying *sideways*. All around us, passengers were praying. Three were sick. Duncan chuckled and cranked out two rolls of film.

In New York the editors of *Life*, examining his prints, agreed that they were extraordinary, and although they didn't devote an entire issue to his work, they gave him most of one. Its impact on the American public was enormous. It was also brief, and soon forgotten. Young newspapermen and photojournalists frequently exaggerate the power of the press, particularly among the forgers of U.S. foreign policy. Later, when American draftees were dying in Vietnam, the situation was different. In my time the sword was mightier than the pen. Our dispatches swayed few. Military observers from other NATO capitals completely misread the Indochinese situation. They blamed the French temperament. The armies of France, they pointedly noted, had been routed in 1870, 1914, and 1940, and after each defeat they had wallowed in self-pity, complaining *"Nous sommes trahis!"*—they had been betrayed. Before leaving Hanoi I had lunched with an American major general who was sending his analyses back to the Pentagon. He shook his head sadly. "Isn't this fuck-up of the French typical?" he had asked me. "Americans would never do it."

The principle of photography was understood before 1066, when William the Conqueror achieved the Norman Conquest. The device itself was anticipated by the camera obscura, a dark room with a hole through which objects outside could be projected. Six centuries later, sketches of a camera were found in the papers of Leonardo da Vinci. Later in the sixteenth century a fellow countryman, Giambattista della Porta, perfected a camera obscura with a lens. In the sixth century, the blackening of silver salts was discovered, but it was not until the eighteenth century that

inventors found that the blackening was made, not by heat, but by light. The first photograph was taken by Joseph Nicéphore Niepce, a French lithographer, in 1826, but the world did not become aware of cameras until thirteen years later, when the French painter Louis Jacques Mandé Daguerre opened the doors of his studio to show Parisians his first daguerreotypes.

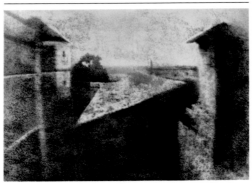

Joseph Nicéphore Niepce

View from Window at Gras, France, 1826. (Gernsheim Collection, Harry Ransom Humanities Research Center, University of Texas at Austin)

The exhibit was a sensation. Aesthetically, the critics wrote, photography was marked by the medium's authenticity and immediacy. Viewing the prints, it was said, was like examining nature through a telescope. William Henry Fox Talbot, Daguerre's British rival, noted:

It frequently happens . . . that the operator himself discovers on examination, perhaps long afterwards, that he had depicted many things he had no notion of at the time. Sometimes inscriptions and dates are found upon the buildings, or printed placards most irrelevant, are discovered upon their walls; sometimes a distant dial-plate is seen and upon it—unconsciously recorded—the hour of the day at which the view was taken.

Writing of the daguerreotype in his *Journals*, Ralph Waldo Emerson claimed photography as "the true Republican style of painting. The artist stands aside, and lets you paint yourself." Photography, he went on, "is distinguished by its immediacy, its authenticity, and the remarkable fact that its eye sees more than the human eye. The camera shows everything." A cliché was born: "The camera does not lie."

After Daguerre's exhibit, enthusiasm for this new phenomenon was unbounded, and innovations proliferated. At the Crystal Palace Exhibition of 1851, Queen Victoria was delighted by the stereograph, a photograph taken with a twin-lens camera that when viewed through a stereoscope, provided an illusion of three dimensions. The stereograph vogue did not last, but nothing could stem the growing popularity of photography. Within two years (1841–43) Daguerre published two volumes of his work under the title *Excursions daguerriennes*. By 1850 every community of any size or claim to distinction had its "daguerrean artist," and New York City had seventy-seven. Being photographed then was only marginally preferable to a session in the dentist's chair. The subject had to pose, absolutely immobile, outdoors, often beneath a cruel sun or in a wintery gale, his face caked with flour. However, by April 12, 1861, when

General P.G.T. Beauregard opened fire on Fort Sumter, the time had been cut to less than a minute.

One of New York's daguerrean galleries was owned and operated by Mathew B. Brady. Until the South fired on the Stars and Stripes, his chief interest had been collecting photographs of celebrities. By late 1861 twelve of his best prints had been published in a lithographic folio volume. Soon after, Brady, who had kept abreast of the latest photographic techniques, particularly development from negatives, built a mobile darkroom and headed for Virginia, where the dying had begun.

Six years earlier, in the Crimea, Roger Fenton had become photography's first combat photographer. But his subjects had posed in mock heroic attitudes, and the battle scenes had been staged. Brady, more talented, ambitious, and sensitive to the brutality of war, had a different vision. He conceived *Incidents of War*, a photographic history of the conflict. The *New York Times* of July 21, 1862, called him "the first to make photography the Clio of the war," adding that his *Incidents* were "nearly as interesting as the war itself; for they constitute the history of it, and appeal directly to the great throbbing hearts of the north." Brady's photographs of the devastation following the Battle of Antietam on September 17, 1862, tempered the zeal of war fever. On October 20, 1862, the *Times* reported: "Brady has done something to bring home to us the terrible reality and earnestness of war."

Suddenly, the image of war was no longer confined to the stories of veterans and the patriotic appeals of army recruiters. Brady's somber photographs of battlefields dealt not with the glorious Union army, but rather with the dead and wounded soldiers strewn upon fields or lying in ditches. This was the real beginning of photojournalism. Its impact on the public perception of war was seismic. Writing in the

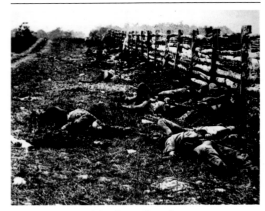

Mathew Brady

Confederate Dead, Antietam, Maryland, 1862. (Permission granted by Josephine Berti.)

Atlantic Monthly, Oliver Wendell Holmes (Sr.) observed that "the very things that an artist would leave out, or render imperfectly, the photograph takes infinite care with, and so renders its illusions perfect. What is the picture of a drum without the marks on its head where the beating of the sticks has darkened its parchment?"

Brady's work also raised America's awareness of photography. He had been the first, the most famous, and the most gifted of the war's photographers, and his prints are now treasured, not only as historical documents, but also for their aesthetic merits.

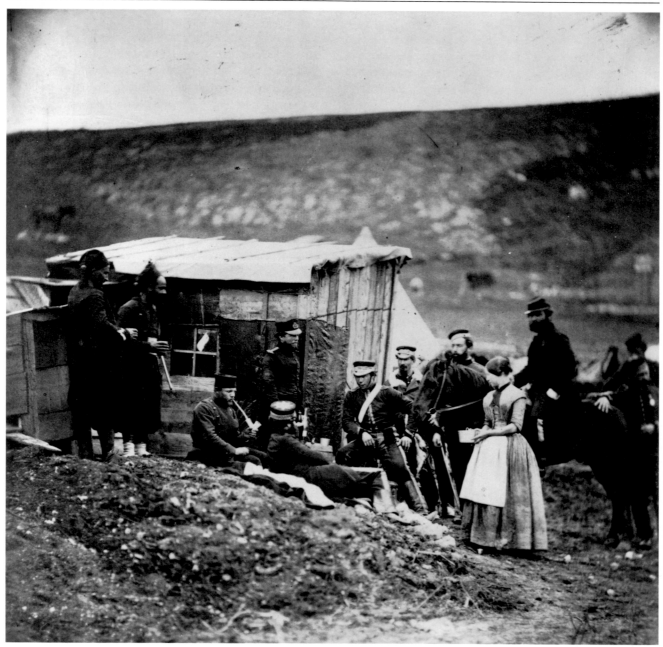

Nevertheless, he had not been alone. Alexander Gardner was also a combat photographer; his "Home of a rebel sharpshooter" has that sense of immediacy one finds in a Henri Cartier-Bresson print. The dead rifleman, his rumpled butternut uniform, and the glistening barrel of his weapon strike you with an almost physical impact. You do not pause and reflect, as with a painting. There is no interval, no time for thought. You are instantly aware of him and his potential menace. He is an agent of death, and you will remember him.

In the years following the war, skilled photographers were not unemployed long. Railroads, now spanning the new nation, demanded prints of the bridges they were building, the track they were laying, and the stunning scenery they now traversed. Official Washington wanted pictures for government surveys. Photographs which would seem prosaic today—e.g., street scenes in London, Paris, Berlin, and Rome—were fascinating then. Americans had long read of these fabled cities. Now they could actually be seen. That vague, frightening, romantic adventure known simply as "The West" cried for documentation, and it was supplied

most memorably by William Henry Jackson and Timothy H. O'Sullivan. Jackson's prints of Yellowstone persuaded Con-

15

gress to make it a national park. His pictures of the Union Pacific Railroad were in constant demand. Earlier generations had scarcely credited travelers' tales of icebergs, Eskimo life, the Sphinx and the Pyramids, bathing in the Ganges, the Wonders of the World. With photographs the world became immeasurably smaller.

ing the threads, the shutter of each camera would be broken. Inviting members of the popular and scientific press to join him at the Scientific Arts Association, Muybridge threw the pictures, one after another, on a slide projector he had designed for the purpose. The result was a forerunner of the world's first movie. Later, at the University of Penn-

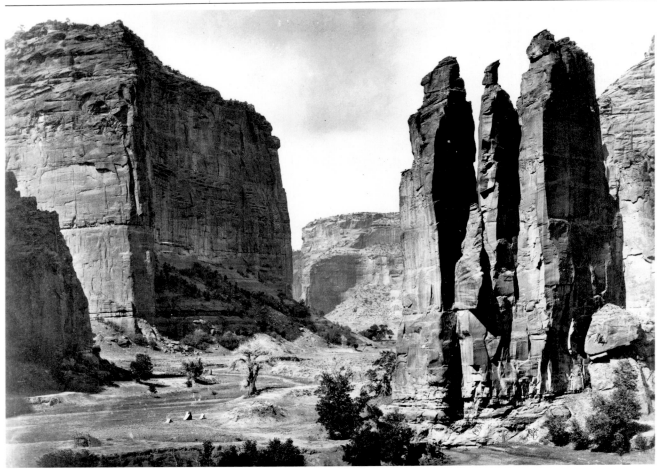

Timothy O'Sullivan

Cañon de Chelle, Arizona, 1873. (Library of Congress)

There were other surprises. Some photographic developments so strained credulity that nothing short of demonstrations would bring doubters around. In the mid-1880s Eadweard Muybridge announced that he had taken a series of photographs which gave the illusion of movement. His subjects were horses. Muybridge had set up a series of cameras side-by-side opposite a reflecting screen. The shutters were attached to threads; as a horse dashed by, break-

sylvania, he presented 781 sequences, including men and women, dressed and nude, doing this and that. The audience was riveted.

In the ante- and post-bellum years, a series of developments had led to an unprecedented rise in mass-circulation newspapers, magazines, and books—"literature for the millions," as it was called by Archibald Constable, the Scottish publisher, bookseller, and, for a decade, proprietor of the

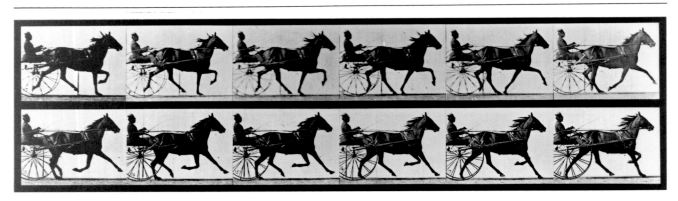

Eadweard Muybridge

Trotting Horse with Sulky, plate 609 from Animal Locomotion. *(Collection, The Museum of Modern Art, New York. Gift of the Philadelphia Commercial Museum.)*

16

At the beginning of the century paper had been handmade, from linen; new books were leather bound; printers toiled over slow, wooden flat-bed presses. All this changed when the Germans discovered that paper could be made from wood pulp, and in England the Hoe family revealed that their steam-powered web presses could print—on both sides of a sheet—18,000 newspapers an hour. Stereotyping, iron presses, and mechanical typesetting cut costs, at the same time increasing production. In England alone the number of new books published each year rose from 100 to 6,000. And England's population was merely doubling. In the United States it was multiplying fifteen-fold. Moreover, on both sides of the Atlantic governments had passed legislation making attendance at free schools compulsory. For the first time in history huge populations of people were learning to read. And the presses offered more than prose. There were also pictures. It seemed that each edition brought an improvement in the quality of reproduction. These developments marked the beginnings of a revolution.

To the men working in newspaper composing rooms, the very notion of mass-produced photographs had seemed ludicrous. How could pictures be reproduced on wood-pulp paper, cascading from steam-powered presses at three hundred copies a minute? The answer was provided by Ben Day, a New York newspaper engraver whose name, for this achievement alone, may be found in *Webster's Dictionary.* Day used a series of celluloid screens bearing raised dot and line patterns. The screen surface was covered with a waxy ink, which was transferred by pressure and rolling to a metal plate. The ink was reinforced with powdered resins and the plate etched, resulting in a halftone image.

Though fascinated by photography and its images, the average man could not duplicate them. The prices of cameras were beyond his means. Furthermore, he lacked the education and skills to produce a finished print. Pursuit of the new medium was reserved for professionals or wealthy men and women who were handy and possessed a workable knowledge of chemistry. Wet-plate photography entailed heavy, awkwardly shaped cameras; a stout tripod; a portable darkroom with tanks; brittle glass plates as large as twenty by twenty-four inches; a plate holder; a supply of water; and, in the field, a vehicle, usually towed by a mule, to carry all this around. But in the 1870s technicians developed a dry plate coated with silver salts in a gelatin base. Instead of sensitizing their plates, photographers could buy them; they could, moreover, be developed long afterward. This was a long step in the right direction. Nevertheless, cameras were still cumbersome and expensive, and the photographer still had to develop his own prints.

Enter the amateur photographer, shepherded by George Eastman, a Rochester, New York, bank clerk with an eye for the main chance. In the summer of 1888 Eastman introduced a small box camera, which he christened the "Kodak." The letter "K," he explained, was a "strong, incisive sort of letter," and the short distinctive name would be "easy to remember." His Kodak was priced at $25; the camera came with enough film for one hundred round exposures. The film was wound on a roll, thus disposing of the large, fragile plates. So inconspicuous were the box cameras that they were called "detective cameras." The film was so fast that movement could be recorded and tripods became unnecessary; what had been a profession could now be, for tens of millions, a hobby.

The photographer's role had been greatly simplified. He pulled the string to cock the shutter, pushed a button to take a picture, and turned a key to advance the film. Eastman's slogan said it all: "You press the button—we do the rest." After pressing the button one-hundred times, the photographer mailed the camera to Rochester, where Eastman photofinishers developed the roll, producing 2½-inch prints. They then reloaded the camera and mailed everything back. The service charge, including the developing and the new film, was ten dollars.

But ten dollars was the weekly wage of factory hands. Although Eastman was prospering, the mass market continued to elude him. Throughout the 1890s he produced cameras for serious amateurs and professionals. In 1895 a pocket Kodak was marketed at five dollars. Then, in 1900, Eastman hit the jackpot. His Kodak Brownie was priced at one dollar; a six-exposure roll of film was fifteen cents. The Brownie was designed for children. Advertisements de-

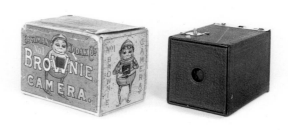

Eastman Kodak Company's No. 1 Brownie camera. (International Museum of Photography at George Eastman House)

clared that it could be "operated by any school boy or girl," and the ads featured elfin figures from a well-liked children's book.

The elves were soon dropped, however, because the Brownie, which was popular enough with children, was even more so with their parents. It was moving across counters six times as fast as the original Kodak. In less than a year 100,000 Brownies were sold. Today many American grandparents have Brownie snapshots of themselves taken when they were children. The box camera held an almost absolute monopoly among amateurs until the "candid camera" fad, which emerged between the two wars, a consequence, once more, of technological advances. Small cameras with fast lenses, notably the Ermanox and Leica, were now available. It was these cameras which became the reporting tools of photojournalists.

Among those examining these early photographs in detail was the insatiably curious Oliver Wendell Holmes. A devoted physician, he was in the habit of studying the human gait. Peering at photographs of European street scenes, he was struck by the distinction between man's visual impression of the way arms and legs move and those caught by the unimpeachable camera eye. "No artist," he wrote in 1853, "would have dared to draw a walking figure in attitudes like some of these."

Artists were harder to persuade. Among them, George Eastman's gadgets were amusing, but no more. Photography's popularity as a hobby did not recommend it to its professional critics, who refused to consider it a new artistic genre. To them, it wasn't even art. Among the most skeptical were those painters who uneasily perceived the photograph's ability to compute likenesses as a potential trespass upon their domain. James McNeill Whistler, a titan of the Victorian arts, met the threat with scorn. In *The Gentle Art of Making Enemies*, he wrote scathingly:

The imitator is a poor sort of creature. If the man who paints only the tree, or flower, or other surface he sees before him were an artist, the king of artists would be the photographer. It is for the artist to do something beyond this: in portrait painting to put on canvas something more than the face the model wears for that one day: to paint the man, in short, as well as his features.

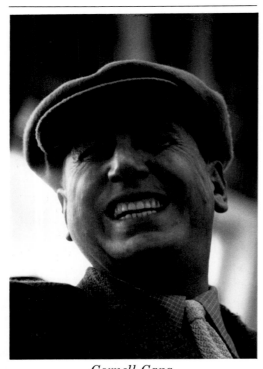

Cornell Capa

Juan Perón, Buenos Aires, Argentina, 1955.

One wishes that Whistler had lived to see Cornell Capa's 1955 photograph of Juan Perón for a *Life* story, "Argentina Under Perón." The essence of the man is caught in this portrait. His overstated features mark him as a fraud. He is trying to be what he is not, and the distortion in his features exposes him as a devious master of self-promotion and propaganda. Cornell Capa cracked Perón's facade; the duplicity in the face is almost embarrassing.

This stirring volume of extraordinary photographs, presenting our times in all their elegance, squalor, courage, hope, betrayal, agony, sacrifice, heroism, and majesty is as unsparing of its audience as it was unsparing of its photographers—brave, talented men and women, all of them Magnum members. A single essay cannot do justice to them; if one tried, the result would be as soporific as Seconal, or worse—a sly deceiver, imitating Perón. In this essay the approach is, therefore, largely personal.

The essayist can at most provide context and suggest implications. But these pictures demand involvement. This

is a moral imperative, and you have no choice, unless you offer the "good German" excuse—the alibi that yes, you lived near Dachau, but no, you didn't know what was going on, and besides, you were only obeying orders. Dien Bien Phu was a battle, and battles are exciting, at least when seen at a safe distance. But the event itself is meaningless unless you reflect upon the blunders of French colonial policy; of politics in Paris, Saigon, and Hanoi; and of why the military strategy of Saint-Cyr-l'École was doomed from the outset, because the Viets' passion for independence, which the French officer had found laughable, gave them the strength to move huge cannons through the jungle.

The photographs here have been chosen because they reflect the mood of our eclectic times, or are heavy with significance, or are simply moving. But the reader whose eye drifts idly through this book and then sets it aside on a coffee table has not only cheated himself, he has also diminished himself. In the 1960s demonstrators protested war, racism, and wickedness. They were asked to justify their actions and they did. It has always been so. When Thoreau was jailed for civil disobedience, Emerson visited him and asked: "Henry David, why are you here?" Thoreau replied: "Ralph Waldo, why are you *not* here?"

The photographers whose triumphs are represented on these pages need no advocates, no champions, not even an introduction. Their work stands proudly alone. Created in fractions of a second, it stands here, enshrined in time. Nevertheless, readers living in a society harried by the hawkers of dubious products and unimaginative pictures may be unaware of Magnum and its high seriousness.

Who were—who are—the Magnum photographers? Until forty years ago, a magnum had but one definition; it was a very large wine bottle holding 1.5 liters, nearly a quart and a half. In April 1947, however, the word acquired a second meaning. Robert Capa, David Seymour (Chim), Henri Cartier-Bresson, George Rodger, and William and Rita Vandivert met in the penthouse restaurant of New York's Museum of Modern Art. They were resolved to form a consortium which would protect their ownership of photo negatives (then a startling idea) and provide them with control over the editorial use of their photographs, including

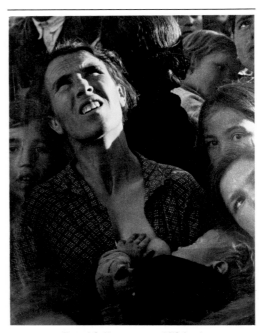

David Seymour (Chim)

Spanish Civil War, Barcelona, c. 1936.

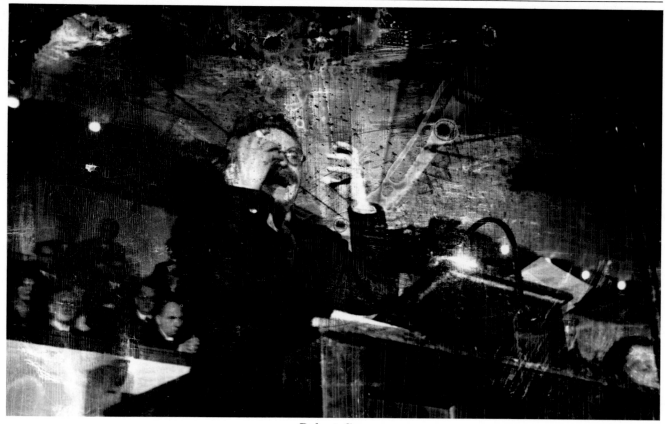

Robert Capa

Trotsky giving a speech, Copenhagen, 1932.

sales to other countries, to magazines like *Berliner Il-lustrirte Zeitung*, *Paris Match*, and *L'Epoca*. They decided to invite other distinguished photographers to join them, and on May 22 they filed a certificate of incorporation. On a whim, perhaps thinking of the flow of champagne which rewards victories, they called their corporation "Magnum Photos, Inc." Today there are over one hundred Magnum members, associate members, and staff, with offices in New York, Paris, and London. Their work has appeared in virtually all magazines publishing fine photographs in the United States, the United Kingdom, the Continent, Japan, and South Africa.

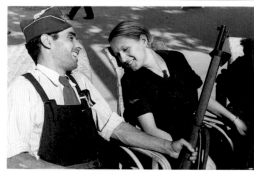

Robert Capa

Republican volunteers, Spanish Civil War, Barcelona, 1936.

In Our Time is a tribute to their genius, their versatility, and their devotion to their profession. If seen chronologically, it reaches back over a half-century, to 1932, when Robert Capa's portrait of Trotsky giving a speech in exile in Copenhagen became Capa's first published picture. Despite the cracks and water damage on this surviving print,

Trotsky's ferocity and evangelism are almost an assault on the senses. Capa had been called in at the last moment and didn't even know who Trotsky was, or why he should be photographed. In the same decade, sitdown strikes were photographed on both sides of the Atlantic, Cartier-Bresson faithfully recorded the coronation of England's King George VI, and Robert Capa, at great peril, covered the Spanish Civil War.

The war in Spain has been called a rehearsal for World War II. It was certainly that for those who chronicled it on film. The leaders of news photography did not always remain at the front. Robert Capa's photograph of a mother and child watching German Luftwaffe bombers eagling overhead introduced both a new form of warfare and a new generation of combat photographers. Death from the skies, particularly the Guernica holocaust, told the world that that safety far beyond the lines no longer existed. Chim's photographs of Barcelona under heavy bombing won him global recognition. Its lesson was clear: the battlefield was now everywhere.

It would be hard to exaggerate the impact of the photography in Spain upon both the public and the photographers themselves. After the "phony war" had turned into an ugly war, when England stood alone, photographs became weapons. The British photographer George Rodger was profoundly affected by the plight of his countrymen. His photographs expressed his alarm; they may have helped undermine American isolationism. It was Rodger's achievement that, for the first time, readers in faraway countries could feel the martyrdom of fellow civilians who had become victims.

Some of the photographs here depict memorable funerals of the postwar world's leaders: France's de Gaulle and Egypt's Nasser. Among those present, but not necessarily

mourning, were Magnum's Gilles Peress and Bruno Barbey. The world had seen these powerful men, now consigned to the grave, at the height of their fame. Readers felt that they knew them, in contrast to leaders in the past. Photojournalism had produced a new, deeper understanding of the

Photography has produced a massive literature. Celebrated cameramen and their admirers have filled shelves with books on lenses, filters, light meters, depth of field, infrared, portraiture, photomontage, collage, miniature cameras, strobes, Polaroids, and electronic "point and push"

Bruno Barbey

Nasser's funeral, Egypt, 1970.

times. Ironically, in the early 1970s, we witnessed the failure of *Life*. The magazine that had been a showcase for Magnum photographers was eclipsed by television. Tele-

Gilles Peress

Paris, 1978.

vision brought Vietnam into our living room, as Magnum photographs had done with earlier wars and catastrophes. If Henry Luce had been right in calling the twentieth century the American Century, this volume may, among its other virtues, become a vital reference book and guide for future photographers.

cameras. The versatility of this profession/art/hobby/obsession has enriched our lives, exploited them, and become an intricate source of, and part of, our history for 150 years.

In serious photography, beauty does not lie in the eye of the photographer. The explanation lies in the nature of human vision, which, at any given moment, can focus on a narrow angle of view and is never static. In that sense we are all shifty-eyed. Our eyes are constantly viewing the scene before us, turning to the left or right, observing objects in the distance or a printed page a foot away. Each time a man glances this way or that, the brain, monitoring vision, automatically adjusts to the new scene.

Camera lenses work differently. When Christopher Isherwood wrote, "I am a camera. . . . Some day all this will have to be carefully developed [and] printed," he was exercising poetic license. The vision of a lens, unlike that of a human eye, is fixed. A wide-angle lens broadens the field being photographed—to 180 degrees, for example—while paying a price in distortion. Telephoto or zoom lenses, at the other extreme, bring the field very close while sacrificing breadth, frequently reducing it to a few degrees.

Among the cameraman's other decisions, if he or she is a professional, is the choice of camera. He may prefer a twin-lens reflex (e.g., Rolleiflex), a 35-mm rangefinder (such as a Leica), or, if cheap cameras are ignored—Instamatics,

Henri Cartier-Bresson

At the coronation parade of King George VI, London, 1937.

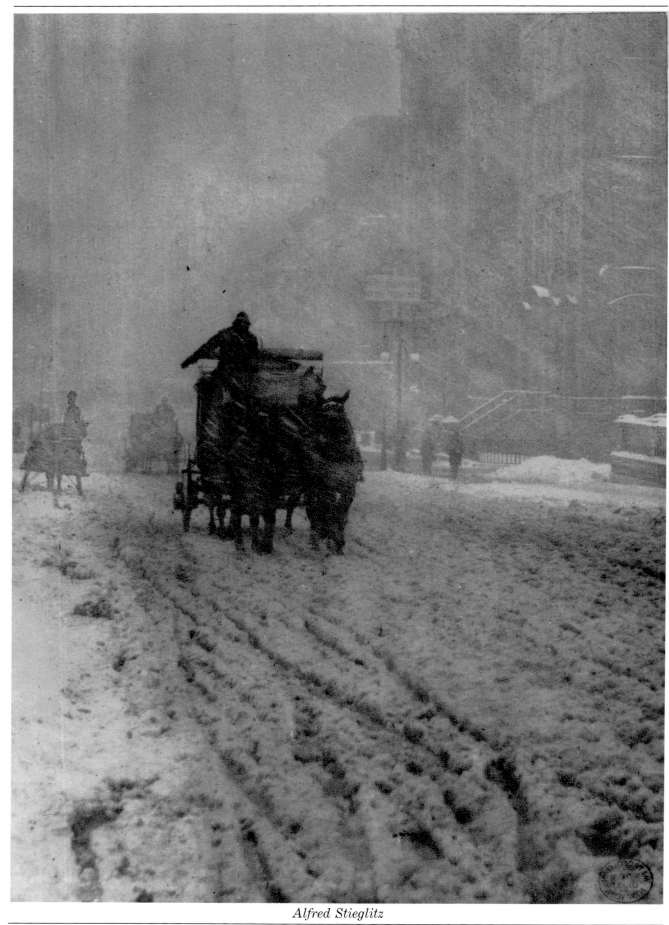

Alfred Stieglitz

Winter Fifth Avenue, 1892. (The Metropolitan Museum of Art, Gift of J.B. Newman, 1958)

for example, or "point and push" contrivances—the popular and versatile single-lens reflexes (SLRs—Pentax, Nikon, Canon, Minolta, etc.), the thinking man's cameras. Film comes next. "Fast" film may be used indoors without a flash, using only available light, or when photographing action, such as a horse race. Contrast, grain, and light sensitivity will also be determined by the film. If you pick infrared, which is sensitive to radiation, you may penetrate atmospheric haze and produce startling effects: skies of impenetrable black, say, or stark white shrubbery. Next, the

photographer selects the camera aperture—the size of the hole through which light will reach the film. Then, with the help of a light meter, he determines exposure time, which may range from ⅟₃₂₀₀ of a second to several hours. If the exposure is to be longer than ⅟₁₂₅ or ⅟₆₀ of a second, the inevitable tremors of a hand-held camera make it impractical. It must be mounted on a tripod. Finally, development can produce flat prints, shades of gray, or dazzling prints of black and white.

The evolution of photography as an art can be traced to 1888, when Eastman introduced his Kodak. The previous year the *Amateur Photographer* awarded a prize to Alfred Stieglitz. Stieglitz never had any doubts about the aesthetic and creative potential of what he was doing. In 1890 he was editing the Camera Club's magazine, *Camera Notes and Proceedings*, in which he demonstrated the possibilities of cameras in all weather. He counseled patience. For his "Winter Fifth Avenue," he stood for three hours in a fierce snow storm to await "the proper moment."

In 1902, frustrated by the lack of standards in American photographic exhibitions, Stieglitz joined a younger man, Edward Steichen. Together they formed a society, the "Photo-Secession." Steichen's approach to photography—

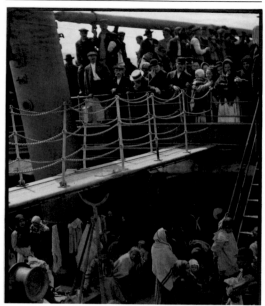

Alfred Stieglitz

The Steerage, 1907. (International Museum of Photography at George Eastman House)

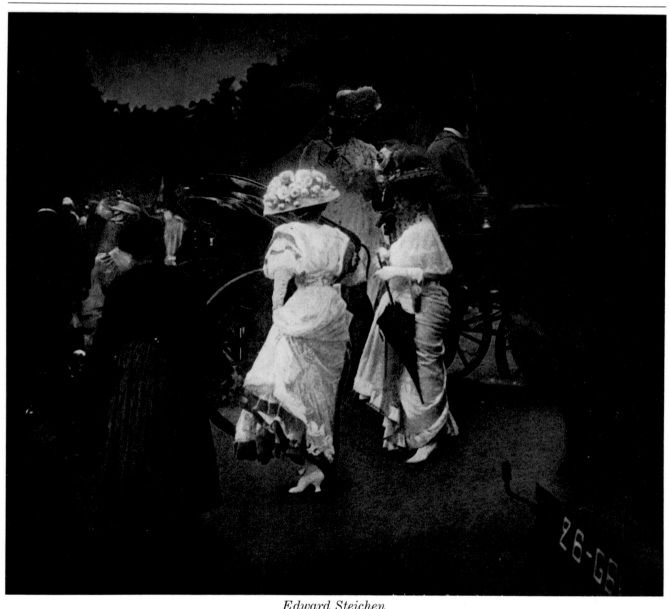

Edward Steichen

Steeplechase Day, Paris: After the Races, 1905. Duogravure from Camera Work *42/43, April–July 1913. (Collection, The Museum of Modern Art, New York. Gift of William A. Grigsby.)*

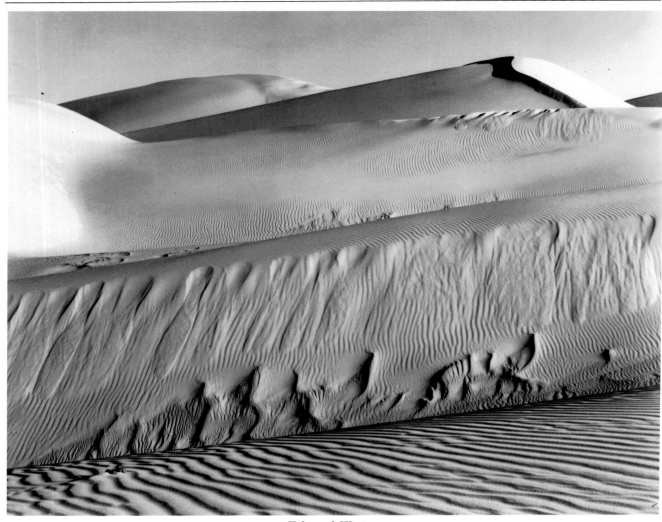

Edward Weston

Oceano, 1936. (Courtesy of the Center for Creative Photography, University of Arizona)

Paul Strand

Portrait, New York, 1915. (International Museum of Photography at George Eastman House)

very controversial at the time—was evocative of Whistler. In a 1902 London exhibition, the "New American School," his bold cutting and flat tones, with soft-focus portraits and landscapes, had established him as a bold innovator. In 1905 he and Stieglitz set up a gallery at 291 Fifth Avenue, soon known to all serious artists simply as "291." There they displayed not only photographs, but also sculpture by Matisse, drawings by Picasso, and lithographs by Cézanne. It was in a 1915 issue of their magazine *Camera Work* that Stieglitz first published an eleven by fourteen-inch reproduction of "The Steerage." The alliance of "291" with some of the most brilliant members of painting's avant-garde clearly established these young photographers as artists themselves—artists moreover, in the front lines of modernism.

Experimental art photography now entered its most exciting period. In *Camera Work*, Paul Strand introduced subscribers to powerful views of New York's Lower East Side. Then his studies of driftwood, vegetation, and people in the Southwest provided a feeling of peace unmatched by any of his peers, and Ansel Adams, examining Strand's negatives in 1930, decided to devote his life to photography. Two years later he and Willard Van Dyke founded Group *f*.64, taking its name from the aperture setting which gives a camera its greatest depth of field.

Alvin Coburn created "New York from its Pinnacles"— shots taken looking down from Manhattan's tallest buildings. The boldest photographers, however, were moving toward abstraction; Coburn's "Vortographs" of 1917 were devoid of all recognizable images. Steichen also experimented with a broad, quasi-impressionistic style, but after commanding the AEF aerial photography group in France, he turned to sharply focused portraits of celebrities under

24

stage lighting. The results, published in *Vanity Fair* and *Vogue*, were enormously popular. In the far West, Edward Weston had won his following with his soft, flat, frequently sentimental landscapes. Though he turned to a direct, abstract use of his lens, he never permitted it to divert attention from his subjects. In 1924 he wrote: "The camera should be used for rendering the very substance and quintessence of the *thing itself*, whether it be polished steel or palpitating flesh."

In Europe photography was more stark. To be sure, Albert Renger-Patzsch, living in the Ruhr, found beauty in the ordinary and presented it to the world in *Die Welt ist Schön*—"The World is Beautiful"—but there was nothing lovely in the brutal photomontage of Germany's George Grosz and Raoul Hausman, expressing outrage over a lost war and its aftermath, and nothing even recognizable in the dadaist movement, particularly the photographic techniques introduced by Christian Schad of Zurich and later

Alvin Langdon Coburn

House of a Thousand Windows, New York, 1912. (International Museum of Photography at George Eastman House)

25

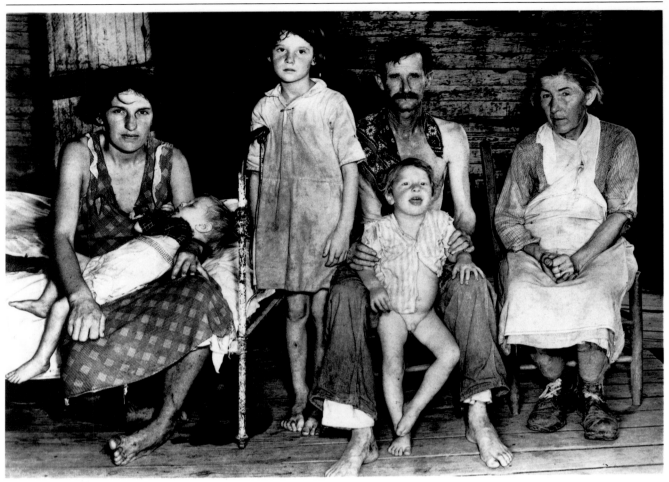

Walker Evans

(Courtesy of Farm Security Administration, United States Department of Agriculture.)

adopted by more celebrated photographers. Surrealism and symbolism were more marked in Europe and throughout the 1920s American painters, composers, and writers were drawn to Paris, often experimenting with radically different styles and aesthetics.

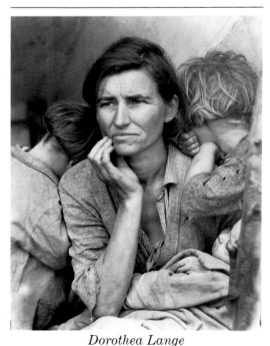

Dorothea Lange

Migrant Mother, 1936. (Library of Congress)

After the stock market crash of '29, debates over whether photography could be art were temporarily forgotten. Individual professionals quietly pursued their artistic vision, but for the most part experimentation was set aside throughout the 1930s. The worldwide financial collapse and the rise of European dictators subsumed preoccupation with technique. In the United States, the photographic momentum during the decade could be summed up in a word: documentary. Lacking television, Americans untouched by the Depression were unaware of its victims' suffering. The Roosevelt administration intended to inform them. In Washington Roy E. Stryker, an economics professor on leave from Columbia, had been appointed to the Farm Security Administration. He hired professional photographers and sent them out to document the desperate plight of those farmers migrating westward, driven from their homes in the dust bowl, hoping to find better homes in the overadvertised state of California.

At the same time the lens of Walker Evans and the typewriter of James Agee combined to produce *Let Us Now Praise Famous Men*. Margaret Bourke-White, already familiar to the subscribers of *Fortune*, and Erskine Caldwell, her husband, published *You Have Seen Their Faces*. In the slums and on the blighted farms of Depression America, professionals like Dorothea Lange were recording the desolation of main streets, emaciated farmers, and tattered billboards. Like Mathew Brady, these photographers brought the country's hardship into sharp focus, indicting a system which seemed to be spinning dangerously out of control.

The Associated Press introduced its Wirephoto service in 1935. A year later it was followed by the first issue of *Life*, and a year after that, by *Look*. Distracted by the crisis at home, Americans were slow to waken to the approach of war in Europe. England, still traumatized by the horrors of 1914–18, and now uncertain of its empire, was also inclined to turn away from what was happening on the Continent. Alarmed by American isolationism and British passivity, photographers forced the world to raise its eyes. Documentary photographers brought fascism and Hitler into their homes.

Robert Capa's "Death of a Loyalist Soldier" first appeared in France's picture magazine, *Vu*, and was picked up by *Life* and England's *Picture Post*. It was part of the 1930s overture which led to World War II. After the fall of France in 1940, all pretense of objectivity was abandoned. Nazi Germany must be crushed. George Rodger's photographs continued to be particularly effective; his photographs of the British home front stirred the sympathies of *Life*'s American readers. "I felt I really could contribute to the war effort," he said later, "by bringing to the millions of *Life* readers an understanding of Britain under the threat of a Nazi invasion. Desperately we needed American aid—war materials, fuel, food, and money. I could show not only how much we needed it but also what we did with it when we got it."

The Third Reich's picture magazines were also effective, showing the German public the power of the Wehrmacht in the *Berliner Illustrirte Zeitung* and the *Münchner Illustrierte Presse*.

By the outbreak of World War II in September 1939, technology had provided professional cameramen with everything they needed, and the circulations of the popular magazines in which their work appeared skyrocketed. Be-

tween 1942 and 1944 the advertising income for these periodicals increased by $100 million. Among the most tireless and imaginative war photographers were Robert Capa, Cartier-Bresson, Chim, Rodger, and Wayne Miller. During the London blitz, the Luftwaffe's mass bombing, Magnum photographers shared London bomb shelters with air wardens and the ladies of Lambeth, and at Dover they photographed English children watching dogfights overhead. In the Middle East they snapped unconcerned Saudis playing chess. In Vichy France Cartier-Bresson found an equally unper-

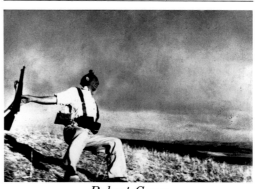

Robert Capa

Death of a Loyalist soldier, Spain, 1936.

turbed Matisse, surrounded by doves. Then came the Normandy invasion and the Liberation of Paris. Parisians were overjoyed. Robert Capa's photographs capture that jubilation. After four years of Nazi rule, their city was once more theirs.

This was one war in which, after the Nazi surrender, the victors became as bitter as the defeated. Allied soldiers were shocked and outraged by the German death camps and

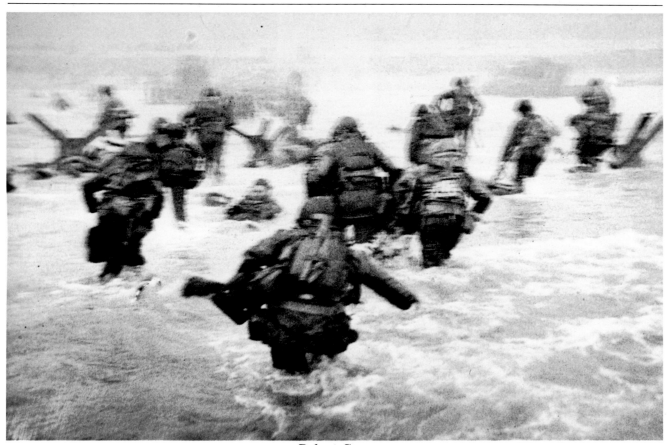

Robert Capa

D-day landing, Normandy, June 6, 1944.

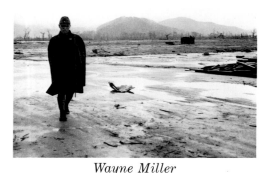

Wayne Miller

Hiroshima after the dropping of the atomic bomb, August 1945.

what was left of the Warsaw ghetto, photographed by Robert Capa. On the other side of the globe, U.S. soldiers and Marines saw the very dead end to which military technology inevitably led—"perverted science," as Churchill called it—and Wayne Miller photographed the white hot saucer which had once been Hiroshima. During the conflict the distinction between good and evil had been precise. In the aftermath it was often blurred. Sometimes the questions raised were unanswerable. Robert Capa created a tableau: a young French woman, her head shorn, clutches a swaddled infant. A scornful crowd witnesses her humiliation as she is paraded through the streets of Chartres. Was she actually a collaborator? Or had it been her misfortune to fall in love with a German soldier? Capa didn't know; neither do we.

Magnum photographers knew they were living through dark pages of history, and they wanted to get it right. George Rodger photographed the horror of Bergen-Belsen; Chim snapped a lusty Essen whore. Russian prisoners of

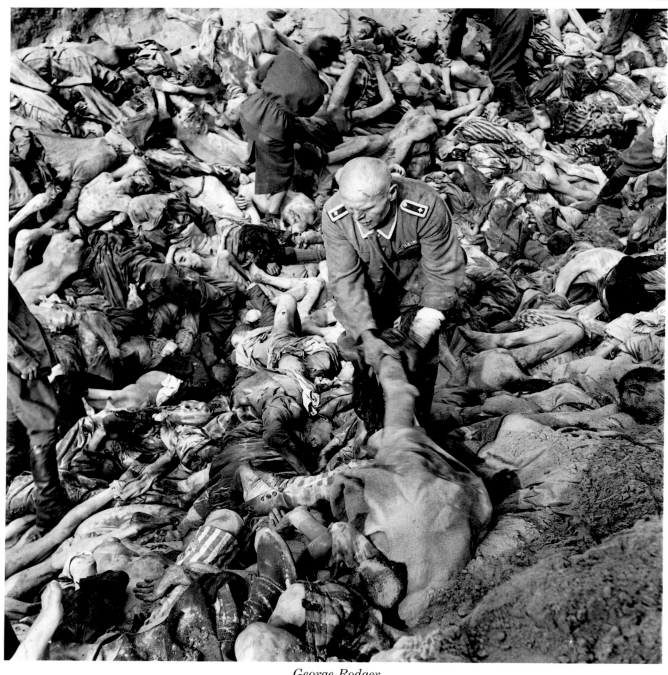

George Rodger

Bergen-Belsen concentration camp, Bergen-Belsen, Germany, 1945.

war left Germany for home, but for many Jews leaving the displaced persons' camps, the ghettos which had been their prewar homes no longer existed. Thousands who had survived the Holocaust sailed for Palestine. Robert Capa's photograph of immigrant Jews arriving at the port of Haifa reveals their hopes, their expectations, their determination to forge a new nation where Jews were strong and free.

problems; the Vietminh triumph encouraged nationalist leaders in other French possessions, notably Algeria. The generals who had lost Indochina were now told to quell the growing colonial revolt in North Africa. Algeria had been part of the French Empire for nearly a century. Though the French were outnumbered by the natives ten to one, they controlled Algeria's economic and political power. When

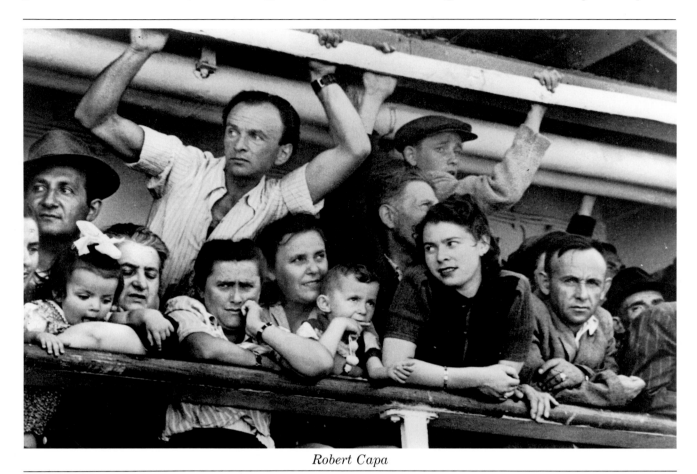

Robert Capa

The arrival of immigrants from Central and Eastern Europe, Haifa, Israel, 1948.

The global war was followed by smaller wars—in Korea, where Werner Bischof photographed prisoners of war and a mocking Statue of Liberty armed with a club; strife in the French colonies of Indochina and Algeria, photographed at its height by Kryn Taconis of Magnum. In virtually every colony natives became more militant.

France was among the nations hit hardest by the war and its aftermath. Political stability would have been impossible without massive transfusions of Marshall Plan money from the United States. During the war the ties between France and her empire were permanently fractured under the strains of the Occupation—some colonial governments had chosen Vichy, some chose de Gaulle and the Resistance, and in the Far East others fell under Japanese rule. In Indochina soldiers were in a state of almost permanent disaffection, aggravated by *fièvre jaune*. The *Marseillaise* sounded very faintly to the ears of the professional French soldiers who had been fighting in Indochina for years, not to mention the Foreign Legion, in which a majority of the enlisted men were veterans of the German Wehrmacht. By the spring of 1954 and the Dien Bien Phu debacle, 92,000 French soldiers had fallen—all for nothing. (The French, however, did not send draftees to Vietnam. That blunder was left to the United States.)

France's Dien Bien Phu defeat did not end her colonial

native demands for equal status were rejected by the French in 1954, the nationalists acquired weapons and rebelled.

It was a replay of the Indochinese struggle. The conflict lasted several years (until 1962) and led to deep strife in France itself. There Communist leaders—and Sorbonne

David Seymour (Chim)

Whore, Essen, Germany, 1947.

students—protested the war. The French public was indifferent. In Algiers settlers hated the Parisian government and feared a sellout. Their anxiety was justified. De Gaulle came to power, and after an army mutiny led by four French generals who were threatening to invade France, *le grand Charles* presided over the grant of Algerian independence. As a soldier remarked of the Indochina and Algerian wars, "Fifteen years of hope became fifteen years of defeat."

Erich Lessing

De Gaulle after speaking in Bône, Algeria, 1958.

The fact is that the age of imperialism was ending. Britain, once the proud possessor of an empire, was now a welfare state. India and Pakistan were free nations. In the ensuing conflict between Hindus and Moslems, the great Gandhi was assassinated. Magnum's Cartier-Bresson was there when Gandhi's sandlewood pyre blazed on the bank of the Yamuna River. Its flames died after fourteen hours, but the passions Gandhi aroused burned far longer. In a Raghu Rai photograph of Indira Gandhi, one is struck by the size of

her security accompaniment. Even so, it was inadequate. In 1984, she too would be dead of an assassin's bullet.

The collapse of Hitler's Reich and Japanese imperialism in 1945—and the fact that no nation would win a nuclear war—has brought the Great Powers an era of peace which, at this writing, had endured for nearly a half-century. Nevertheless, there has not been a day in that time which has not seen men killing one another in the name of this or that cause. Several have been mentioned here. Among other more memorable conflicts have been those between Israel and her Arab neighbors, photographed by Magnum's Burt Glinn; the Hungarian revolt against Soviet rule in 1956, and, that same year, the attempt of Britain and France, with Israeli support, to expel the Egyptians from the Suez Canal Zone, events photographed by Erich Lessing of Magnum.

The Cold War was at its most arctic in the early 1950s, when Julius and Ethel Rosenberg were executed for passing nuclear-weapon secrets to the Soviets. Nineteen-fifty-four saw the beginning of the end for Joe McCarthy, the Senate's most irresponsible Red-baiter. In the beginning of that year, pollsters found that fewer than three Americans out of ten disapproved of McCarthy, a demagogue who waved a list of what he called "card-carrying Communists" in the American State Department. In Eve Arnold's photograph, McCarthy is flanked by his brilliant but warped chief counsel, Roy M. Cohn, and Cohn's dainty companion, G. David Schine. Cohn was determined to exempt Schine from the draft. It was this arrogant, cynical abuse of power by Cohn, supported by McCarthy, that led to their downfall. Later, the Senator died of cirrhosis of the liver; his chief counsel, of AIDS.

The hope of a thaw between Washington and Moscow arose in 1959. Vice-President Richard Nixon, himself a reformed Red-baiter—Adlai Stevenson had called him a

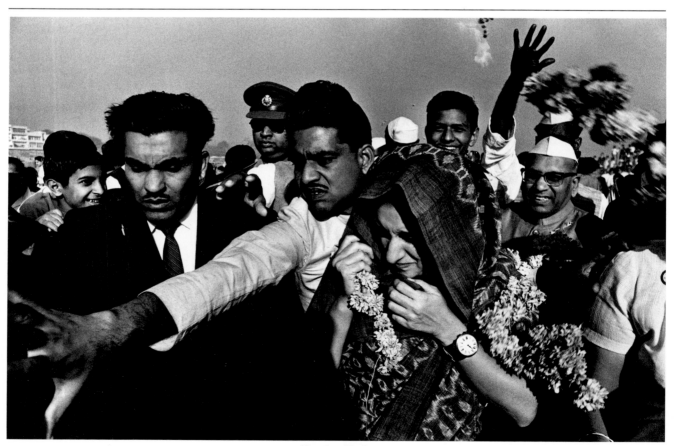

Raghu Rai

Indira Gandhi escorted by her Sikh security guards, Delhi airport, 1977.

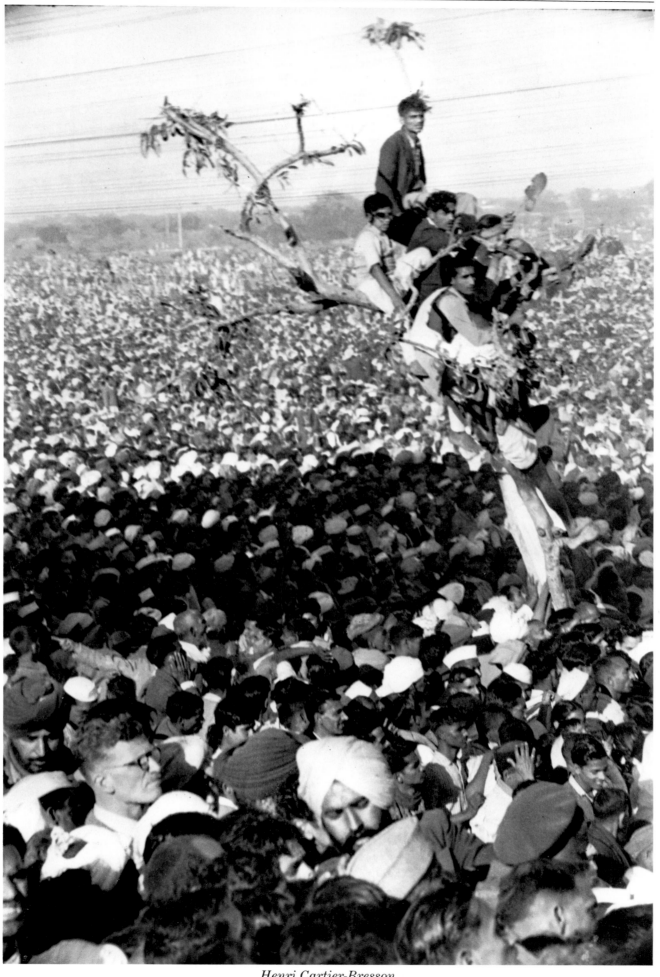

Henri Cartier-Bresson

Gandhi's funeral on the Yamuna River, India, 1948.

"white-collar McCarthy"—flew to Moscow. Nixon's ostensible purpose was to open an American National Exhibition. In reality, he wanted to sound out the Soviets on the possibility of détente. One of the exhibition's most interesting displays was a six-room, model U.S. ranch house with a central viewing corridor which permitted visitors to see all the furnishings.

to choose, the fact that we have a thousand different builders, that's the spice of life. We don't want to have a decision made at the top by one government official saying that we will have one type of house. That's the difference." In Elliott Erwitt's photograph, Nixon is poking the stubborn premier in much the same manner as he would poke John F. Kennedy the following year, when the two men were run-

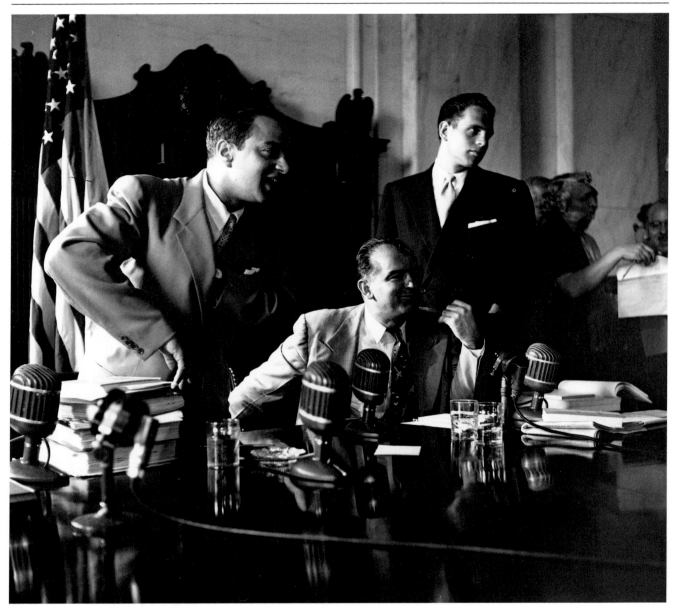

Eve Arnold.

Senator Joseph McCarthy with aides Roy Cohn and G. David Schine, Washington, D.C., 1954.

The opening ceremony was televised, which allowed both American and Soviet viewers to witness a confrontation between Soviet Premier Nikita Khrushchev and Nixon. Later the spectacle became known as the "kitchen debate." The opening salvos were fired as they paused in front of the model home's shining, convenient kitchen. Nixon said that this was a typical U.S. home, which almost any U.S. workman could afford. Khrushchev bridled. In his reply he said, "You think Russians will be dumbfounded by this exhibit. But the fact is that all newly built Russian homes will have this equipment . . . If an American does not have dollars he has the right to . . . sleep on the pavement."

Nixon's reply was reasonable, if glib. "We don't think this fair will astound the Russian people, but it will interest them just as yours interested us. To us diversity, the right

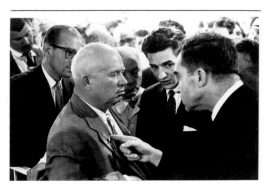

Elliott Erwitt

The "kitchen debate," Moscow, 1959.

ning for president. Khrushchev was annoyed. So was Kennedy. But Kennedy, unlike the Soviet leader, had mastered television, and he won the election.

In 1959 rebels led by Fidel Castro and Che Guevara had overthrown Cuba's corrupt Batista regime; Burt Glinn covered Castro's rise to power in *Life* magazine. Castro was appealing, articulate, and determined. Most Americans approved of his campaign for power. But despite his protests that he was not Communist-inspired, the Eisenhower administration remained skeptical. Some young Americans arrived in Havana to help the Cubans harvest sugar cane. Their enthusiasm waned, however, when they learned that Eisenhower had been right. Castro was indeed a committed Communist. Che's mystique continues to attract youth, however, in part because his execution in the Bolivian jungles martyred him, and because youth is quick to acclaim an idealist.

Returning home in 1976 after sixteen years abroad, Magnum's Eve Arnold was stunned by the changes in the country since she had left in the 1950s. She listed the catchwords for that decade. They included falsies, bobby-sox, blacklist, cold war, iron curtain, loyalty oath, rock 'n' roll, Malcolm X, civil rights, Little Rock, duck's ass. In Arnold's 1955 photograph of Marilyn Monroe arranging her hair, two Illinois State police, assigned as the actress's guard, stare as if mesmerized. Burt Glinn, by contrast, caught the dignity and respect Americans showed young Queen Elizabeth during her 1957 New York visit. The United States of the 1950s would be remembered for, among other things, James Dean, the decline and fall of Judy Garland, the first Boeing 707, the arrival of Hugh Hefner's *Playboy*, Joan Crawford joining Pepsi-Cola's board of directors (as the defeated Nixon

became Pepsi's lawyer). The first man-made satellite, Russia's *Sputnik I*, went into orbit, humiliating the United States and sobering Americans who had assumed that their country would always lead the world in technology. After the sputnik's return to Earth, it was displayed in Moscow. Cartier-Bresson photographed Russians admiring it, and

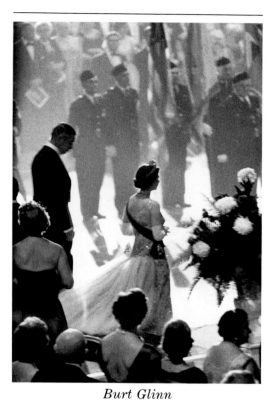

Burt Glinn

Queen Elizabeth II, New York City, 1957.

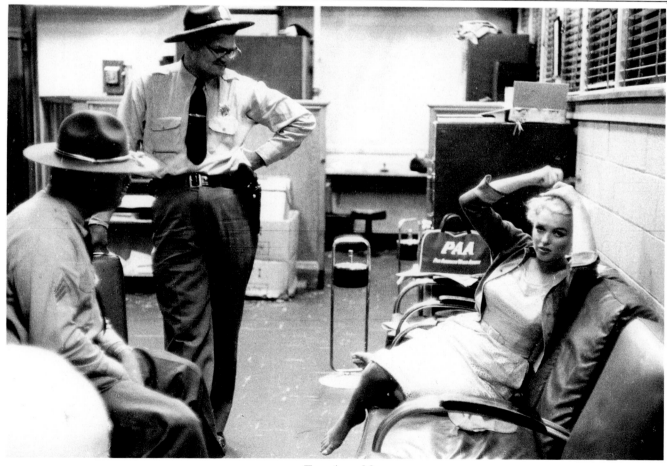

Eve Arnold

Marilyn accompanied by Illinois State Police, sent as her honor guard on behalf of the governor, Illinois, 1955.

John F. Kennedy quietly vowed to put an American on the moon.

But it had become clear that other challenges would also await Eisenhower's successor. In North Carolina Elliott Erwitt photographed separate drinking fountains for "white" and "colored." Bystanders looked on curiously, wondering why the photographer found the distinction interesting. They learned in the early 1960s. Kennedy was president now; his brother Robert was attorney general, and they

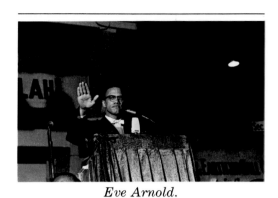

Eve Arnold.

Malcolm X, Chicago, 1961.

were coping with freedom riders, the right of blacks to enroll in southern universities, KKK bombings of churches, the killing of black children, and Black Power.

Then the president was slain in Dallas. In the nation beyond Love Field—where, aboard *Air Force One*, presidential photographer Cecil Stoughton was photographing Lyndon Johnson's swearing-in ceremony with a jammed Hasselblad—the nation grieved. Within a half-hour of President Kennedy's death, 68 percent of all adults in the United States—over 100 million people—knew of it. The nation was

subdued, even stunned by the rituals of mourning, the endless, uninterrupted telecasts, and Mrs. Kennedy's wan but graceful dignity, so poignant in Elliott Erwitt's photograph of her at JFK's funeral in Arlington National Cemetery.

It was difficult to stop mourning, to recover from the shock. And once the country had shrugged to its feet, it became obvious that America had changed. Lyndon Johnson, now president, escalated the Vietnam War Kennedy had begun to wind down. Martin Luther King, Jr., Malcolm X, and the Black Panthers found their way into Magnum files. An Alabama campaign for voter registration began with a march from Selma to Montgomery led by Martin Luther King, and turned violent when white policemen on horseback attacked it, swinging billy clubs and wet bullwhips. In Mississippi the murders of three white men from the North—they had come south to support blacks—outraged Congress and the nation. The Voting Rights Act, perhaps King's greatest achievement, was too little and too late for other black activists. Disillusioned with his strategy of nonviolence, their mood was defiant, as seen in Bruce Davidson's photograph of a young black marcher in whiteface. The seed had been sown in the 1950s; now the country was reaping the whirlwind.

And not just America. Throughout 1968 revolt was in the air, with varying degrees of solemnity, depending on where you were. Hippies became an American phenomenon, but, as Magnum's Chris Steele-Perkins discovered, they had their counterparts in England, youths who described themselves as "Teds," "Mods," or "Rockers." Mobs, mostly young, were rioting in the streets of Prague, Paris, and New Delhi.

In Czechoslovakia the demonstrations were sparked by the arrival of Soviet tanks crossing the country's borders to crush the reforms of Prime Minister Dubček and his dedication to "socialism with a human face"—which, a generation

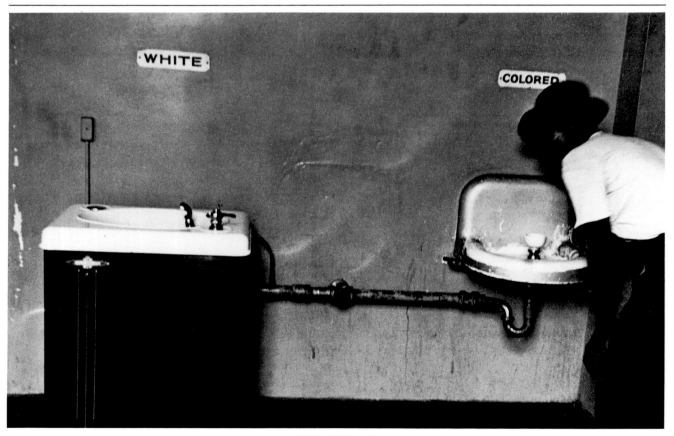

Elliott Erwitt

North Carolina, 1950.

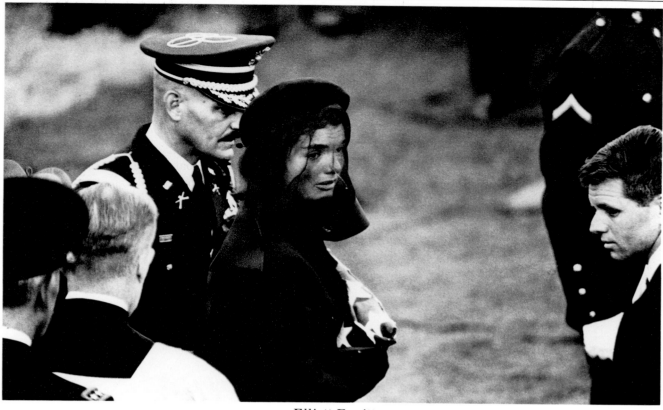

Elliott Erwitt

Arlington, Virginia, 1963.

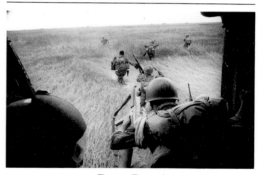

René Burri

Vietnamese troops land near Tan Hung, 1963.

later, would have been described as *glasnost*. In Josef Koudelka's photographs the spirit of Prague's youth is almost festive. Believing that the Red Army tanks were there as the result of a misunderstanding, they greeted them with pamphlets and impassioned arguments. The less naive raced to cross the Czech-Austrian border before the Red Army closed that gate. By the end of winter, the Prague Spring, as the reform had been christened, was a lost cause.

Paris was different, as Paris tends to be. The Communist-led student unions of the Sorbonne and Nanterre staged marches and demonstrations that led to riots, the building of barricades, the burning of cars; bruises, bloodshed—and arrests. But here the motives of those who disturbed the peace were obscure. Several months earlier Nanterre students had launched a sex-education campaign, calling for, among other things, the abolition of rules governing male visits to female dormitories. Abroad, Peking hailed the Nanterre riots as "heroic battles," but *Pravda* condemned their "irrational acts" and the French Commu-

nist paper *l'Humanité* held that the leftist students were serving the interests of de Gaulle and capitalism—even as the students were calling for de Gaulle's ouster.

Their occupation of the Sorbonne was followed by sitdown strikes throughout France. In the Renault factory at Ballancourt workers hoisted a red flag. Simultaneously, their union leaders denounced the student protests as adventurism. To defend the stability of his government against present and future riots, de Gaulle secretly flew to Germany, where French troops were stationed at NATO posts, and confirmed his support among French army commanders there, before dissolving the National Assembly and calling for elections. In Paris students responded with a march from the Montparnasse to the Austerlitz station chanting, "Elections betray the revolution!"

All over Western Europe, youths joined American students in protesting the escalation of the U.S. military effort in North Vietnam. During the forty-five months from February 1965 to November 1, 1968, North Vietnam suffered the heaviest and most sustained bombing in the history of air warfare, carried out by American planes based on carriers in the Gulf of Tonkin and airfields in central Vietnam and Thailand. American air force general Curtis LeMay threatened to bomb the Vietcong "back to the Stone Age."

Roads, bridges, railways, and harbors were the first targets of the American bombers. Then "installations of military importance" were leveled, including some hospitals and schools. Next the population of North Vietnam—peasants working in paddy fields and Hanoi suburbs—was destroyed. By November 1968, when the storm from the sky ended, both Hanoi and Haiphong were pulverized. Thousands had been killed or mutilated by high explosives and fragmentation bombs. "Strategic bombing" as it was called, had accomplished nothing. The flow of war supplies from

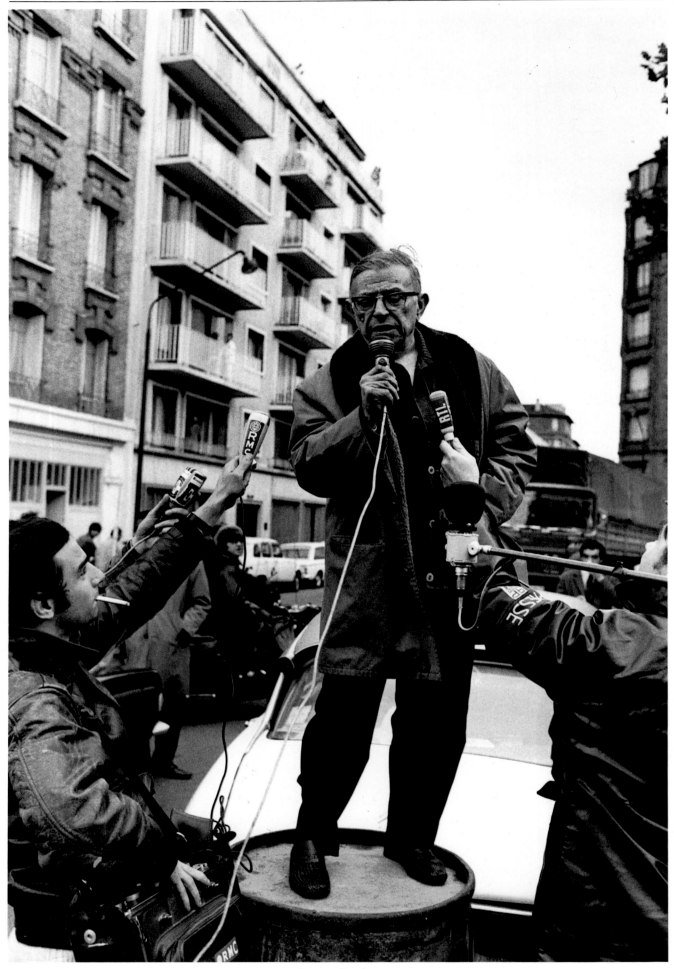

Bruno Barbey
Jean-Paul Sartre at the Renault factory, Ballancourt, France, 1968.

China continued. Indeed, the raids had hardened the resolve of the North Vietnamese, who condemned "the invaders from the sky" even as their own troops invaded South Vietnam.

When Washington ended the bombing, the Johnson administration and the Hanoi government issued a joint statement. Peace negotiations, they announced, would soon begin. Five days later Marc Riboud, who had covered Vietnam for *Life* and *Look* magazine throughout the conflict, photographed Ho Chi Minh and his foreign minister chatting outside what had once been the French governor general's palace. Four years later President Nixon's national security advisor, Henry Kissinger, would announce that "Peace is at hand"—just in time to boost Nixon's re-election campaign.

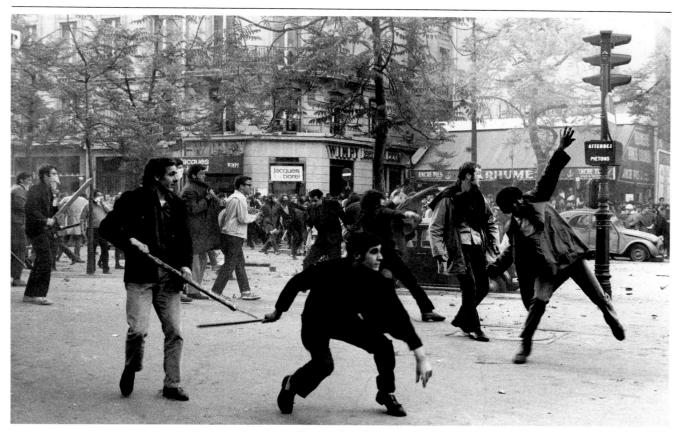

Bruno Barbey

Student riots, Paris, 1968.

Marc Riboud

Ho Chi Minh chats with his prime minister, Pham Van Dong, Hanoi, North Vietnam, 1968.

But peace wasn't. After twenty-seven years of fighting, the conflict did not end until the following year, when the formal accords were signed in Paris. Echoing Chamberlain's words after Munich, Nixon declared that he had achieved "Peace with honor." Kissinger, more humble, declared that "by now it should be clear that no one in the war has had a monopoly of anguish and that no one has had a monopoly of insight." At that time Americans believed that the struggle was a standoff, like Korea. It wasn't. For the first time in its history, the United States had lost a war.

It was also about to lose another president. The Watergate scandal was moving closer and closer to President Nixon's oval office, particularly when routine questioning revealed that he had taped his conversations there. In October 1973 Nixon outraged the country by firing Archibald Cox, who had been appointed to investigate charges of misconduct and criminal acts in Nixon's administration. But another, equally vigorous special prosecutor was swiftly appointed. Among those who went to jail was John Dean III, counsel to the president. The following August Nixon resigned, and his hand-picked successor, Gerald Ford, pardoned him. Public opinion was outraged. In the next presidential election Ford was defeated by Jimmy Carter.

America had entered the Age of Permissiveness. The mood of the country seemed to be "anything goes," and everything went, until November 1979, when the U.S. embassy in Tehran was seized by Iranians. The Americans inside became hostages; Iranians there used the American flag to cart out garbage. The ruler of Iran, Ayatollah Khomeini, congratulated those responsible for the seizure, and his son, Ahmed, climbed over the embassy wall—losing his turban

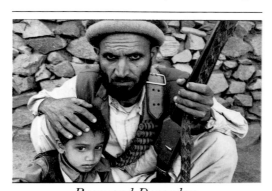

Raymond Depardon
Mujahedin, Afghanistan, 1978.

in his excitement—to join them. All this was a reprisal for U.S. support for the shah of Iran, exiled and dying of cancer.

Khomeini had begun the transformation of Iran into a fundamentalist Muslim society—and a terrorist state—in a world which, until the mid 1970s, had regarded the shah as its strongest, richest, and most deeply entrenched head of state. Not since the collapse of South Vietnam had America been so shaken. The hostage crisis would last 444 days and

cripple the Carter presidency. Iran, as Gilles Peress photographed the running story, replaced Libya as America's least favored nation in the Middle East. Americans would have preferred to ignore it. Unfortunately, that was impossible. A stable Iran was essential to the stability of the region.

During the hostage crisis, the Soviet Union invaded Afghanistan. This was an old story to the Afghans. Their country had long been called "the highway of conquest" for aggressors bent on invading India. The leaders of these aggressors included Alexander the Great and Genghis Khan. In the twentieth century nations were expected to be more civilized, however, and when two Soviet airborne battalions secured the airport in Kabul, Afghanistan's capital— permitting a massive airlift of Russian soldiers—the American response was outrage. Here, as in Iran, the United States was caught off guard, having failed to adopt a clear policy for shielding U.S. interests in the region.

President Carter called the Soviet invasion "the greatest threat to peace since World War II." Yet the Soviet aggression may have been defensive. Khomeini's Islamic fundamentalism was a menace to the USSR. The border between Russia and Iran was weak, and the Communist regime in Kabul was very shaky.

The motives of great powers are often plural. The Soviets were known to covet the Persian Gulf and the oil-rich Straits of Hormuz. Carter therefore launched a major rearmament campaign, announced trade embargoes, withdrew from the SALT II treaty, boycotted the 1980 Olympics in Moscow, sent the Afghan resistance arms—through Pakistan—and invited China to join in condemning the Soviets. In the end it all proved unnecessary. The Afghans themselves solved the problem. Their fierce mujahedin frus-

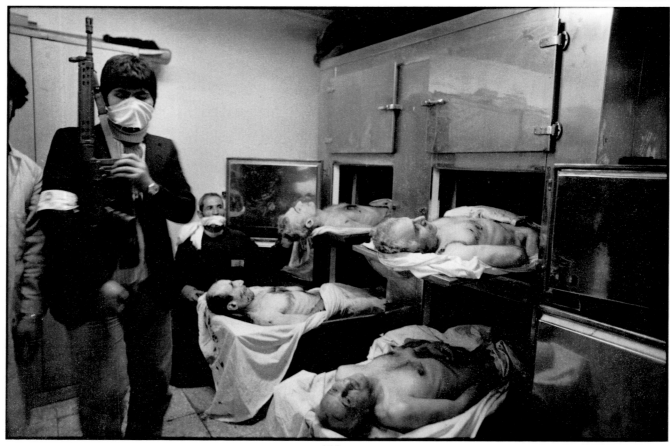

Abbas
The corpses of the first four generals who were executed by an Islamic court, Tehran, February 1979.

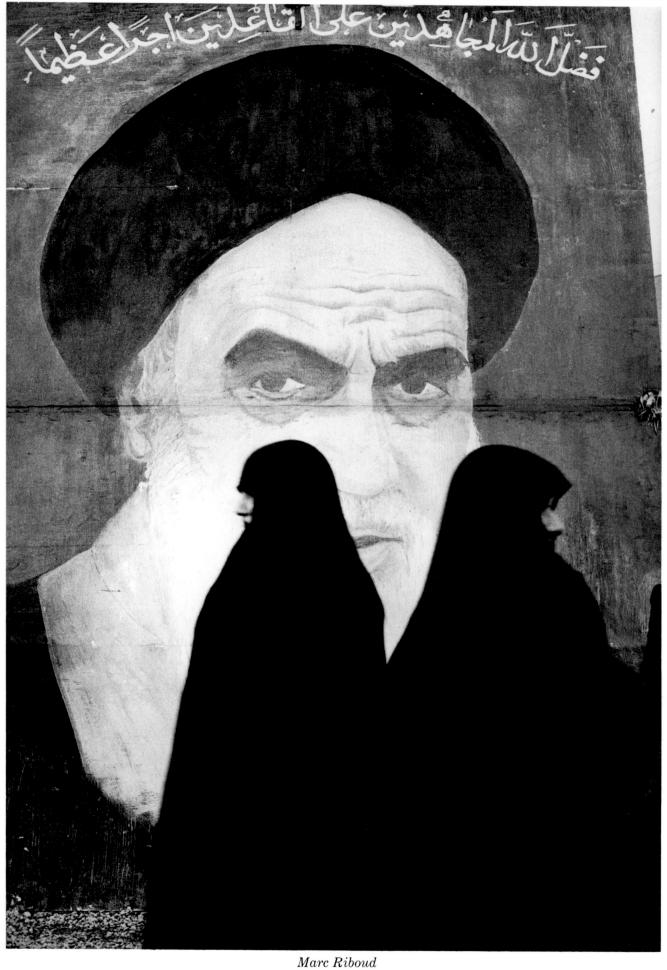

Marc Riboud

Women supporters of Ayatollah Khomeini, Tehran, 1979.

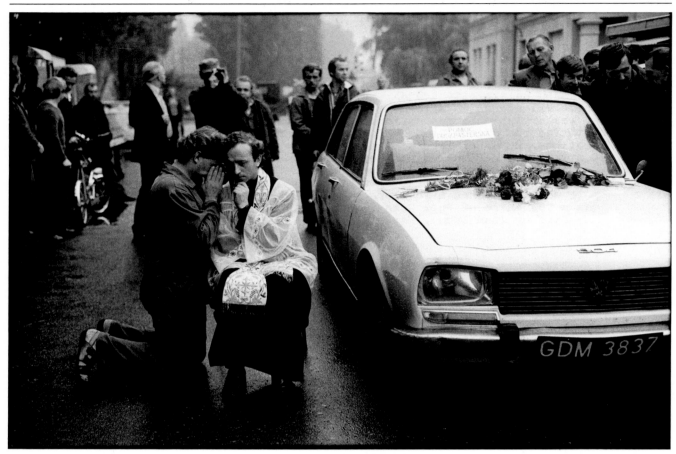

Jean Gaumy

Lech Wałęsa receiving benediction from a Roman Catholic priest, Gdansk, Poland, August 31, 1980.

trated the Red Army. After nearly ten years and close to 50,000 Soviet casualties, Moscow decided to withdraw, leaving behind chaos. Now the Soviet Union, like the United States, had lost a war.

Meanwhile, in Washington, the Reagan era had arrived. It was a curious administration. The president's popularity was enormous. So, in the beginning, were his major domestic goals. Yet few of them found support in Congress. Reagan's foreign policy was thwarted by a series of scandals and disasters. He himself remained aloof. The country disapproved of his programs, but the popularity of the "Teflon president," as college students called him, was unaffected. Polls reported that had he been eligible to run for a third term, he probably would have won.

England has had its own version of Reagan's conservatism. Prime Minister Margaret Thatcher might have been the president's feminine clone. Like him, she was an unlikely conservative, the daughter of a grocer from a Lincolnshire town. In May 1979 she moved into No. 10 Downing Street as Britain's first woman prime minister. Like Reagan, Mrs. Thatcher represents the values of an earlier age, and like him, she has been lucky. Argentina unwittingly gave her a great boost by seizing the Falkland Islands, a British possession in the south Atlantic. The prime minister sent a task force there, and in the Gilbert-and-Sullivan struggle that followed, British forces were triumphant. Englishmen were delighted. Her popularity was phenomenal. As prime minister she could call for a general election whenever she liked; she chose to call one in June 1983, and was triumphant. Moreover, she was as effective in Parliament as Reagan, in Congress, was not. In Parliament she persuaded the House of Commons to adopt an austere economic program, earning her the opprobrium of large blocs in the mid-

dle and lower classes. She knew she couldn't please everyone and didn't try. In 1982, when unemployment topped 2,500,000 for the first time since the 1930s, her only response was "the lady's not for turning."

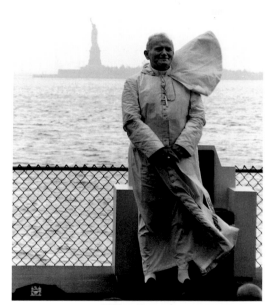

Gilles Peress

Pope John Paul II at Battery Park, New York City, 1979.

Magnum's photographs are often provocative because these have been years of provocation. In the last weeks of 1981, General Wojciech Jaruzelski imposed martial law on Poland. The country's Solidarity movement called for a liberal government. The general intended to crush it. Expecting violent resistance from blue-collar Poles, he put doctors on round-the-clock duty to handle the expected casualties. But nonviolence was an abiding principle of Solidarity's fifteen-month-old, ten-million-strong union. Indeed, its real threat to the government lay therein. Underground newspapers, having developed communication networks and contacts with Solidarity, played a key role in staging protests and boycotts. During propaganda telecasts by the government, an entire Polish town adopted the custom of taking walks; an author who had chosen to support the Jaruzelski government found a pile of his books on his doorstep, returned by his readers. For the first time since the outbreak

American politician, with the Statue of Liberty in the background, for Magnum's Gilles Peress. Harry Gruyaert of Magnum found photo opportunities in Las Vegas, where it always seemed to be night, and took spectacular pictures of Americans who appeared to be having a marvelous time while losing their shirts. Eugene Richards, in the documentary tradition of Walker Evans and Dorothea Lange, found a very different ambience in a neighborhood where youths addicted to the cocaine derivative, crack, were spending their time losing their lives.

In *The Republic* Plato sets forth an elaborate metaphor in which figures, similes, conceits, and analogies are so skillfully structured that the dialogue can be studied repeatedly, always with profit. Plato asks his readers to imagine men dwelling in a cavern, leading a wretched existence. Since

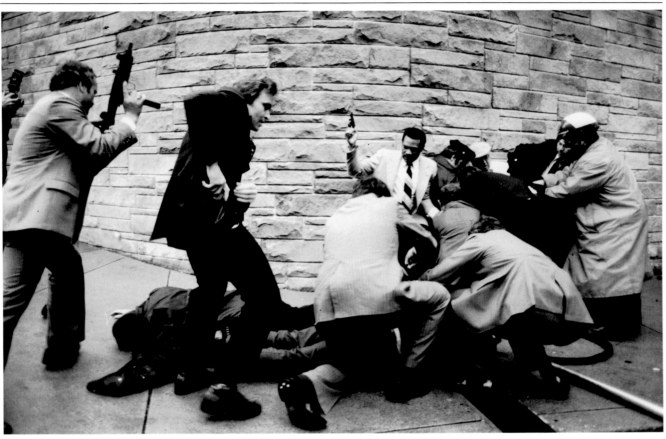

Sebastião Salgado

Would-be assassin of President Reagan after failed assassination attempt, Washington, D.C., 1981.

of World War II, Poland seemed to be moving toward autonomy and independence. Magnum's Bruno Barbey, Peter Marlow, and Jean Gaumy were witnesses to these events, which testified to the political skills of Solidarity's leader, Lech Wałęsa, who was awarded the Nobel Peace Prize. Polish intellectuals cast a wider net. Without Wałęsa, they declared, there would have been no Gorbachev and, without Solidarity, there would have been no *perestroika*.

So skillful had photographers become that they were a political and social force in themselves. When Reagan was fit and in high good spirits, news cameramen were encouraged to take advantage of "photo opportunities." But photographers chose their own opportunities. In 1981 Americans were stunned by an attempt on Reagan's life; Magnum's Sebastião Salgado was there to put it on film. The pope visited the United States and posed, smiling like an

childhood their legs and necks have been shackled. They cannot move—their fetters prevent them from turning their heads—so none knows the faces of the others. Although their cave is subterranean, it is not entirely dark; some illumination comes from an entrance, and further light is provided "from a fire burning higher up and a distance behind them."

Between the prisoners and the fire lies a low wall and a road. Animals and men pass along the road, carrying implements of stone and wood. Some of the passing men speak. The captives hear that. Speech is familiar to them; they can talk to one another. Yet fettered as they are, they cannot see the men on the road. Their only vision of the passersby "is the shadows cast from the fire on the wall of the cave that fronted them." They do not know what human beings look like. They only understand shadows—"in every way such

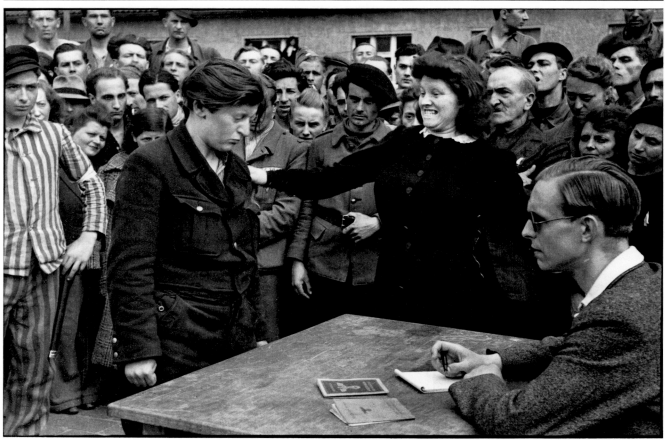

Henri Cartier-Bresson

A Gestapo informer impersonating a refugee in a displaced persons' camp is exposed, Dessau, Germany, 1945.

prisoners would deem reality to be nothing else."

Then—Plato does not explain how—one of the men is freed from his bonds "and compelled to stand up suddenly and turn his head around and walk and to lift up his eyes to the light." It is not a pleasant experience. The dazzle and glitter of the light hurts his eyes; once outside, he cannot

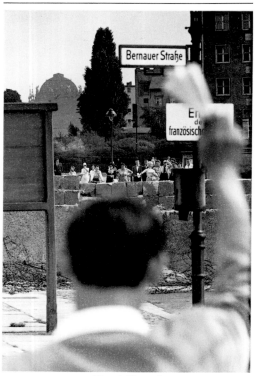

René Burri

Stranded East Berliners, August 1961.

see well enough to discern the resemblance between the men and animals there and their shadows, which had been familiar to him. If he were told that everything he had seen before was "a cheat and an illusion," and that what he now saw was reality, "he would be at a loss and . . . would regard what he formerly saw as more real than the things now pointed out to him." Plato continues, "If someone should drag him" to the crest of a rough, steep height and force him to look at the sun, "his eyes would be filled with its beams so that he would not be able to see even one of the things which we call real."

In time, however, he adjusts, learning to understand the role of shadows first, then the reflections of men on water, and finally the men themselves. At night he contemplates the heavens, the light of the stars, and the moon. Eventually he grasps the true nature of the sun, how it provides the seasons and presides over everything he sees. Happy now, pitying his fellow prisoners in the cavern, he resolves to visit their cave and emancipate them. It is a calamitous decision. His problem with vision, which had made his departure from the cave so disagreeable, is now reversed. His eyes have become unaccustomed to the dark, his sight dim; he stumbles about, and his old, fettered companions laugh at him. They conclude, Plato writes, that "he had returned from his journey aloft with his eyes ruined." To them, his insistence that a better world awaits them outside their cavern is subversive. If it were possible for them to "lay hands on" the comrade who left them and now wanted them to follow his example, the dialogue concludes, they would "certainly kill him."

Plato was, of course, talking about reality and illusion. This volume of photographs is a study of both. The purveyors of illusion, exploiting disillusion, delusion, and confu-

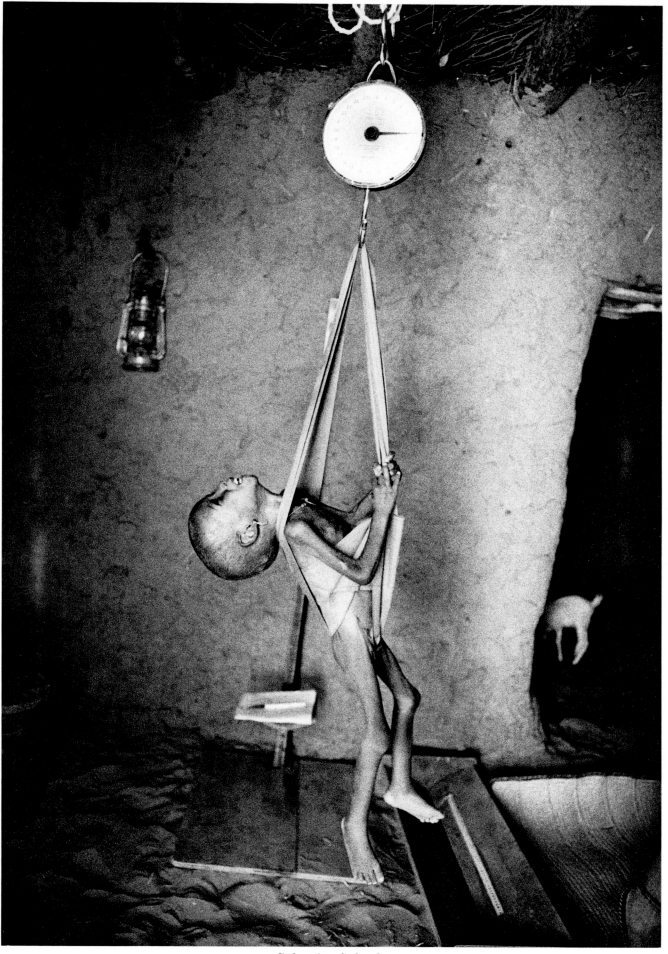

Sabastião Salgado

A child being weighed as part of a supplementary food relief program, Gourma Rarhous, Mali, June 1985.

sion—Juan Perón, Trotsky, Castro, John Mitchell, the Essen whore, McCarthy and Cohn, Nixon and Khrushchev, the Ayatollah playing Son of Rasputin—provide a gaudy thread throughout. Pandering to the same trade, even as they themselves are exploited by it, is Marilyn Monroe exhibiting her wares; the winner of a $65,000 question; Norman Mailer hawking his favorite product, Norman Mailer;

Reality is also the vengeful Frenchwomen in the DP camp, surrounding a fellow countrywoman who has just been exposed as a Gestapo informer. It is the ship crowded with Jewish refugees who want to settle in what will become Israel but are still barred by the British ships policing the shores. Among the faces of reality are those of ten-year-old Iranian boys in tears, waiting for transportation to the

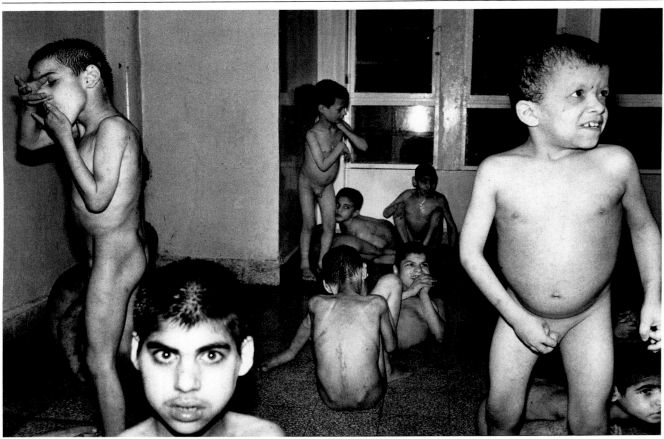

Chris Steele-Perkins

Traumatized children in a mental hospital shelled by Israelis, Beirut, 1982.

Joan Crawford selling soft drinks; and the great marketplace of dreams, Las Vegas, where secretaries after fifty-one weeks of thrift, spend their vacations standing in front of one-armed bandits like assembly-line workers, plugging in quarters, winning an occasional jackpot before flying home broke.

Among the photographs here is one of mothers crowding around a Naples schoolhouse, mourning their dead sons, who lie inside. For two weeks their children had fought the Germans with stolen guns and ammunition, waiting for the American army to break through. Robert Capa arrived with the army. As he entered the schoolhouse, he later recalled, there were twenty primitive coffins, too small to hide the dirty feet of children—children old enough to fight the Germans and be killed, but too tall to fit in children's coffins. "These children's feet," Capa wrote, "were my real welcome to Europe, I who had been born there. More real by far than the welcome of the hysterically cheering crowds I had met along the road, many of them the same that had yelled 'Duce!' in an earlier year." Capa's was the voice of a man who has left the cave and returned to tell us what he has seen. Often it is not easy to describe. Reality is the pain and the protest Capa saw in the faces of these women of Naples. It is the cheers that are an illusion.

front for suicidal charges against the Iraqis, and Chris Steele-Perkins' photographs of young children traumatized by the bombing in Beirut and Sabastião Salgado's vision of famine in the unbelievably thin body of a child in the Sahel. Where are these people now? What has become of the Indiana teenagers, dancing as though they expected life to be one long bunny hop, when in fact the boys would reach draft age at the height of the Vietnam War? One wonders where the weeping Berliner went, he who watched the Wall rise in the summer of 1961, and where the crying Palestinian child, orphaned minutes earlier by a bomb, and where the pregnant teenagers asking when they will be eligible for welfare, and where the striking steelworkers of Gdansk, and the twelve-year-old girls arriving in Manhattan on buses from the Minnesota heartland, ready to be adopted by pimps, to join their older sisters in crack comas, sprawled between garbage cans, waiting for the last John, Mr. Death.

Yet every negative has its print. The horror of Hiroshima meant nearly a half-century of peace between the superpowers. Former colonies and protectorates of the European empires have struggled to form societies in which they can live in pride and independence. Some visitors leave Las Vegas with fat wallets. Some of the bunny hoppers never will be disabused of the idea that life is a romp, per-

haps because they drew high draft numbers or could join the Indiana National Guard. The causes of Martin Luther King and Robert Kennedy survive their martyrdom. Archbishop Tutu may yet triumph. These men offer a greater vision than one-armed bandits, briefly distracting our attention from the shadows playing on the cave wall. And though the postwar world has also brought bitterness and vengeance, the antidotes to revenge are compassion and tolerance.

Can they absolve the great crime in this century of guilt? Or will fading recollections blur the jagged contours of the past? This book should sharpen the memories of those in my generation who fought, shed blood, and bore witness to the unspeakable. But the photographs should also elicit questions from the rising generation, unborn then but now old enough to understand the forces of anger, pride, joy, hate, and sacrifice. Surely reminders of the past are visible enough. The Vietnam War memorial is one. Another is the Berlin Wall. After twenty-eight years Berliners have come to terms with it. One feels that Berliners can survive anything. So, with courage, and its handmaid, love, may we.

People love snapshots. In the United States alone, we take seven billion a year. It is a striking fact that in most of them people are photographing each other. We would recoil, should anyone suggest it, that we submit to anonymity, like the builders of Notre Dame or the Cologne Dom, that most Prussian of German cathedrals. Twelve generations toiled to build each of such glories, but the identities of the craftsmen—even the names of the architects—are lost. It occurred to none of them that they should be remembered. In that age of faith, God was everything, man a cipher. Most people had no surnames; those who did were indifferent to how they were spelled.

In the twentieth century the exact opposite is true. We are possessed by an overweening sense of self. The rituals of self-reference have begun before American children have learned to crawl. Every stage in their development is photographed and pasted in albums. Their first words are taped, their first teeth saved, and if they are boys, the locks left

Leonard Freed

Martin Luther King in Baltimore, 1963.

after their first haircuts are lovingly preserved. Weddings are choreographed and videotaped for future generations, even though the chances that a given marriage will survive shrink each year. The right to privacy is vanishing. Hardly anyone hangs up on pollsters anymore, even when they ask the most personal questions. It is the paradox of our time that even as we buy vanity plates for our automobiles and fill out endless questionnaires, trying to establish our singularity, individualism becomes increasingly rare. And the more this riddle baffles us, the greater the likelihood that we, like the doomed men in Plato's cave, shall be shackled by

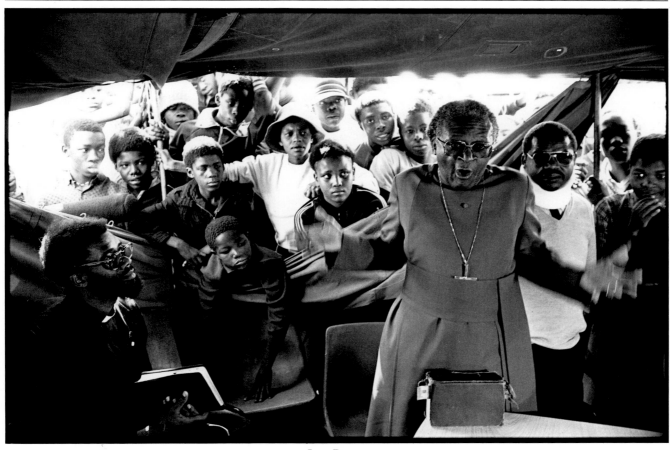

Ian Berry

Archbishop Desmond Tutu, South Africa, 1985.

our ignorance.

The distinction between a picnic snapshot and a great photograph is not subtle. You can glance at the first and remain passive. Art, however, is never mere spectacle. It engages you. You are forced, by your own best instincts, to participate. The skepticism and irony of the photographers may be harsh—they often deal with harsh, ironical material. Nevertheless, we are enriched by their vision, by the strength of the bonds binding our weltanschauung to the world which they stalked, searching for decisive moments.

Their commitment is absolute; many are brave, even heroic. Three Magnum photographers have been killed in action. In November 1956, Chim, covering the Suez fighting, was slain by an Egyptian machine-gunner. Robert Capa died on May 26, 1954, at the peak of his remarkable powers, the victim of a land mine in Indochina. Less than two weeks earlier, Werner Bischof's Land-Rover overturned on a high road in the Peruvian Andes, killing him instantly. Their loss, over thirty years later, remains tragic. But if, after you have finished this book, it seems that their deaths lack the finality of other deaths, that is because they live on in our imagination, our gratitude, our awe.

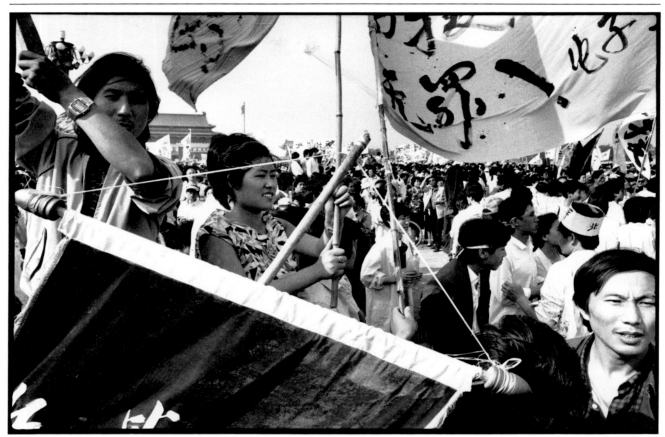

Patrick Zachmann

Student protestors in Tiananmen Square, Beijing, May 1989.

46

The Founders

JEAN LACOUTURE

A story never has just one beginning, a story starts over and over. The story of Magnum began one day in January 1934 (maybe a bit earlier, maybe later) on a Paris city bus running between Montmartre and Montparnasse. We will focus on two of its passengers. One is a tall, lean young man with a fair complexion, a high forehead, fiery eyes filled with passion, smartly dressed in a beige tweed jacket. He's fiddling with a Leica that he had just fitted with a new lens.

Across from him sits another man, slightly bent; shorter, even leaner and younger than the first, he is sickly, poorly clad. His eyes concealed behind thick glasses, he studies the other man in fascination. He eventually breaks down and asks the man across from him, "What kind of camera is that?"

Their eyes meet above the Leica. A strong friendship is born at this "decisive moment" that no photographer ever captured: Henri Cartier-Bresson and David Szymin, known to some as Chim, to others as David Seymour, form a lifelong bond, to last twenty-two years.

At the Dôme café a few weeks later, while Hemingway is describing the Pamplona *ferià* and Anaïs Nin is making eyes at Henry Miller, and Aragon is flirting with Nancy Cunard and not far from there throngs are besieging the Chambre des Députés, Chim has Henri shake hands with a tall, burly fellow. He has the eyes of a Latin lover and a hearty laugh. His name is André Friedmann, but he will soon be known as Robert Capa. André is a handsome man and Henri appreciates such

beauty. He is full of life, and Henri loves life. Chim has just brought together the two most antithetical image-trappers whom a novelist could ever dream up, who contrast on so many levels: structure and movement, culture and nature, water and fire. HCB and Capa strike the magic balance of a waterfall and the rocks.

That is precisely where the story of Magnum and its founders begins. Yet it could easily have stopped there. The basic concept took shape four years later in China, where Bob Capa had just been sent by clients as varied as *Life*, the French pro-Communist daily *Ce Soir*, and the Pix agency. The whole project was mastered by Simon Guttmann, Capa's editor in Berlin in 1932. In a letter to a friend, Capa admitted,

47

"His idea is that my atelier, my future and my China trip all belonged to him." A few days later, Capa told his old friend Ladislas Glück that he had started an association of young photographers and that he planned to set up

and the agreement was reached in the penthouse restaurant at the Museum of Modern Art in New York in April 1947—after a number of starts and stops. The founding members were Robert Capa, Henri Cartier-Bresson,

Photos, Inc., was officially registered with the County of New York.

Why this noble and dignified Roman name? To assert its independence and its will to resist the pressures of the major commercial media agencies, the cooperative had to affirm the scope of its ambition and the already renowned talent of its members. Choosing a name with an "antique" touch was a way of ennobling a field still searching for recognition and striving for dignity. Moreover, Latin was the natural lingua franca of a group associating a Hungarian, a Pole, a Frenchman, an Englishman, two Americans, and a German. Finally, Capa associated the word "magnum" with champagne, and legend has it that he dreamed of giving his camera this same glittering aspect. In any case, at least until Capa's death, the agency celebrated each of its numerous triumphs by uncorking one of these voluptuously shaped bottles.

Ever since the idea had occurred to Capa in 1938, as yet unknown, and throughout the war, these men had individually asserted their talent. After the war each of them could meet the demands of major editors. Why, then, did these news photographers—individualists and loners as they often are—choose to form a cooperative that would entail pooling their efforts and administering their collective works? Why would the hedonist Bob Capa decide to hook up with HCB, a puritan pacifist? Or the wandering Jew Chim with the very British George Rodger?

Romeo Martinez, an expert on the development of still photography of the first half of the twentieth century and who followed the creation and development of Magnum with utmost sympathy, gives this answer: "Capa was driven by a single notion, which proved to be the healthiest idea in the history of photography: a reporter is nobody if he doesn't own his own negatives. The cooperative was the best form of organization to preserve his rights and to insure the news reporters' freedom of action. In other words, Capa and his friends invented the photographer's copyright. Had they accomplished nothing else, they had at least set their trade free and transformed simple employees into artists who ruled their own lives."

Flexible in nature with a light office structure, the cooperative would allow each photographer to choose his own subjects: no longer would a photoreporter be sent to Egypt against his

Henri Cartier-Bresson

Robert Capa at Longchamps racetrack, Paris, c. 1952.

an organization in Europe, together with Cartier-Bresson and Chim, adding that "in no case would [he] want it to be a regular agency." As Richard Whelan, one of Capa's biographers, puts it, "this letter contains the germ of Magnum."

The spark was struck at Montparnasse, the idea took shape in Han-Ku,

and David Seymour (Chim), as well as George Rodger (who did not attend the meeting at MOMA), and William and Rita Vandivert. Rita was appointed president. Maria Eisner was made secretary and treasurer of the organization, which was conceived as a cooperative. No name was given for it at the time, but on May 22, 1947, Magnum

Three friends, Robert Capa, Henri Cartier-Bresson, and Chim, were accidentally reunited while celebrating the Liberation of Paris. John G. Morris is in the background. Paris, August 27, 1944.

will when he'd rather be covering the Salzburg Festival, or to Vietnam when he'd planned to depict new sexual trends in Holland. In freeing its members from the tyranny of big magazine or agency editors, who until then could use the reporters' time as well as their negatives as they pleased, Magnum had invented a new form of image-hunting.

Perhaps a new style as well. According to Ernst Haas, a close friend of the founders and a Magnum member from 1948 to 1966, "There are two kinds of photographers: those who compose pictures and those who take them. The former work in studios. For the latter, their studio is the world. The constant flux of life exerts a power of fascination over them. They are alert to it at all times. For them, the ordinary doesn't exist: everything in life is a source of nourishment. By creating Magnum, Capa, Chim and HCB intended to put it on film."

This deep conceptual harmony did not necessarily imply creating a single style. At the outset there were two styles. Capa worked essentially on instinct. Cartier-Bresson's images were more structured and composed. Capa's style was extroverted; Cartier-Bresson's was introverted. It may have been this unlikely combination of two temperaments, two visions, two ways of thinking and acting that became the

Magnum style, later characterized by Bischof and Morath, Arnold, Erwitt, Riboud, Davidson, Griffith, or Salgado.

Photography, as a mechanical means

Chim, Robert Capa, and Werner Bischof, Paris Magnum, c. 1947.

David E. Sherman

Robert Capa before the D-day crossing, Portsmouth, England, June 4, 1944.

by which to seize a spatial and temporal instant in life in order to reproduce it (for commercial purposes or not), dates from a century before the creation of Magnum. Nadar's portraits, William Henry Jackson's documents, Demachy's compositions are not simply artifacts, they are already models. But if it was possible to conceive of a company such as the one founded in April 1947, it was because since the 1920s a handful of men had paved the way, preventing photography from being torn between beauty and truth, art and fact, news reporting and "creative" photography.

According to Romeo Martinez, two men in particular, Edward Steichen of Luxembourg and Longanesi of Italy, gave photography a chance and laid down its laws. They understood that it was not a question of choosing between art and information, but a matter of what use would be made of the pictures. But others played a major role in developing the language of images in the first part of this century. Simon Guttmann, for instance, from Hungary, having experimented, like many others, with cubism, surrealism, the dadaists, and the Spartakus movement, founded the Dephot agency (*Deutsches Photodienst*) in Berlin at the end of the twenties. This organization sent some of the best contemporary roving reporters throughout the world: Umbo, Felix Man, Walter

Bosshardt, and a certain André Friedmann, who was to become Robert Capa. And let's not forget the role played by Romeo Martinez as editor of *Camera*; Lucien Vogel, founder of *Vu*, which prefigured *Life*, and Leon Daniel, who created the Pix Agency; or Teriade, the famous editor of *Verve*.

These men and a few others structured the world of photography in which the founders of Magnum began to work. During the same period, the political and social context fostered the growing importance of photography as a historical, documentary, and informative medium. During the mid-thirties the rise of fascism and institutionalized militarization, from Rome to Berlin and from Tokyo to Burgos, turned the world into a stage for tragedy. This enormous "studio" offered a wealth of subjects: the Ethiopian conflict, the savage theater of Nürnberg, the war of Manchukuo, the festive uprising of the French Popular Front, the Spanish Civil War, the Long March in China. . . . War makes as much work for photographers as it does for surgeons. Not that war is any more "photogenic" than a leisurely family stroll

along the Thames, but it creates a formidable appetite for images, a strong demand on the media and, as for reporters, an ambiguous but creative sense of competition.

The ten years spanning the Japanese invasion of Beijing and the meeting of the Russian and American troops at the Elbe River may not have changed photography, but they did change the status of photographers, from solitary adventurers into witnesses of reality and "freedom fighters."

In post-Liberation Paris, as in Tunis or Naples a little earlier, people such as Capa, Chim, and Rodger were hailed as heroes, as were Hemingway, Spender, and Malraux. From that time, the power and prestige professional photographers earned helped to make Robert Capa's dream, conceived seven years earlier in China, come true.

The insight of the great photographers and major editors of the thirties is not enough to account for the creation of Magnum, nor is it explained by the tremendous boost in news reporting and the proliferation of documents due to ten years of world war. The agency could never have seen the light

Robert Capa and George Rodger, Naples, 1943.

of day if the three figureheads of the cooperative—one returning from Italy, another from the French Underground, and the third from the United States—had not met up after the armistice. It is perhaps unfair to overlook the creative role of the Vandiverts (who left the company because of their commitment with *Fortune*, which could not be cancelled) and especially the role of George Rodger. Rodger remained in the wings of the organization, as a participant more than an active member. He refused all responsibility but offered the group support with his prestige, charm, and elegant integrity, characteristic of this very British professional. Nevertheless, we will focus on the original trio, in whom the spirit, if not the history, of Magnum is expressed.

Robert Capa had the idea. He brought it to life and was the herald as well as the driving force of the agency. If photography is life, Capa was a photographer's photographer. But photography is more than that, and that is why Capa needed Chim's perceptiveness and Cartier-Bresson's sense of composition. Capa's role—energy and imagination—is nevertheless pivotal: he can be compared to George Washington, while Chim had the thoughtfulness of a Jefferson, and Cartier-Bresson the talent of a Madison. Had it not been for fascism and the war, André ("Bandi") Friedmann may well have become a brilliant businessman in Pest, or started a shipping company on the Danube, or else directed an orchestra or a theater in Buda. In any case, he

Robert Capa, Pierre Gassmann, and Ernst Haas at Gassmann's lab, Paris, c. 1950.

would have radically altered the world around him. But the Hungarian regime in the early thirties had no patience with the antics of a young, hotheaded Jew connected with Lajos Kassák's revolutionary gang. In 1931, when he was seventeen years old, Capa was forced into exile in Berlin, where he soon met Simon Guttmann. Had he met Piscator, he may have become a great actor; Kurt Weill would have made of him another Stokowski. But he met Guttmann, worked with Dephot: his first big scoop was the report on

Trotsky in Denmark in 1932. Two years later the Nazis were on his tail; he escaped to Paris.

He remained a nomad his whole life, with no permanent address (except a studio on rue Froidevaux in Montparnasse for three years), not even a favorite hotel, not in New York or Rome or London. But he kept coming back to Paris. Was it because of the beautiful women? But there are beautiful women in Manhattan, Venice, and Vienna. Because the champagne is served on ice? Certainly not. It must have been because he spent the happiest years of his life there, from 1933 to 1938: with his greatest love, Gerda Taro, his dearest friend, David Szymin, and the man who had the greatest intellectual influence on him, Henri Cartier-Bresson.

For him, as for "Papa" Hemingway, Paris was at that time a feast, and he took it all in before setting out, camera in hand, for China or Spain, or before plunging back into the throngs of the Popular Front, capturing Léon Blum, head of the socialist government, speaking from the stand, or the communist leader Maurice Thorez. Meanwhile, Chim would be scanning the victorious demonstrators through his viewfinder, whereas Cartier-Bresson might be taking shots of old couples enjoying their first paid vacation along the banks of the Seine River. In 1935 André took the name of Robert Capa, the "great American photographer,"

Henri Cartier-Bresson
Chim and Robert Capa.

leaving André Friedmann as his Paris correspondent, while overseas Bob would incessantly sing Friedmann's praises! Why Capa? In Hungarian the word means sword—nice name for a war correspondent. In Spain, where Capa often worked, the name refers to a cover, or disguise.

The Spanish Civil War brought Capa fame due to the astonishing photograph of the Republican soldier falling under gunfire, tossing his rifle in the air. But the war took away Gerda, run over by a Republican tank near Brunete in 1938. After, he turned his attention toward China and the USSR, where he accompanied John Steinbeck on an investigation. He became a star reporter for *Life* and *Picture Post*. Yet he wrote in his memoirs that while in New York in 1942, out of work, deeply in debt, and threatened with expulsion as a persona non grata (Hungary was at war with the Allies at the time), he received a

telegram one morning from *Collier's* hiring him to cover the war in Europe.

Two years later, this remarkable gypsy who William Saroyan described as a "poker player who was a photographer on the side," had become the greatest war photographer in the world. In Africa, in Italy, in the Ardennes forest of France and Belgium at the Battle of the Bulge his camera captured more instants of life and death than that of any other man of his time.

But he loved at least as many women and lost as much money as his competitors. He was as intrepid, proud, insolent, and lived life as much to the hilt as anyone else. He seduced Ingrid Bergman—among others—and had a slew of friends: John Huston, George Stevens, Saroyan, Irwin Shaw, Hemingway. He even published a few books with striking titles: *Death in the Making, Slightly Out of Focus. . . .*

The creation of Magnum in 1947 had

Ernst Haas
Werner Bischof, Paris, c. 1950.

no effect on his lifestyle or his professional occupation. Of course he was company president, devoted his utmost energies to the organization, threw out ten ideas an hour, nagged his associates, multiplied challenges, bluffed, inspired, annoyed, endangered the agency's budget with his gambling debts and astronomical expenses, but always put it back on its feet with some new scheme. He seemed more eager each day to outshine his own reputation as the greatest image-maker, risk-taker, and lady-killer. "A card shark, a gambler? Maybe, but no way a cheater!" Marc Riboud said of him. He was in Israel with Irwin Shaw; in Poland, in Morocco, and then did portraits of Picasso and the Aga Khan. In the spring of 1954 he was in Indochina, then in Laos. Thai Binh, North Vietnam, was where the land mine exploded, ending this epic life.

His death could well have been the end of Magnum, which he had brought to life and nurtured. But Chim and Cartier-Bresson remained. The short man with thick glasses took on the heaviest duties in accepting the presidency. The cooperative was decidedly to have the most peculiar leaders; after the stormy Capa came the most unobtrusive man, apparently the least capable of taking the helm of this adventurous but vulnerable association of reporters bound for glory.

David Szymin was born in 1911 in Warsaw into a family of pious Jewish publishers of Yiddish books. At the age of twenty, he arrived in Paris to study photographic reproduction techniques, among other subjects. He met André Friedmann towards the end of 1933— either in Montparnasse or through the Jewish refugee circles which sprang up

Henri Cartier-Bresson in Beijing, China, c. 1948.

in Paris during the months after Adolf Hitler was elected Chancellor of Germany, while in France the police were unfriendly to stateless people.

In Budapest and Berlin Capa had previously mixed with various Communist groups without ever becoming a member of the party which had mistreated his friend Kassák. Chim was to become a regular contributor to *Regards*, a magazine controlled by the Communists, but he never joined the organization. When Chim, and later Capa, befriended Cartier-Bresson, the three joined the *Association des Ecrivains et Artistes Révolutionnaires* (*A.E.A.R.*) headed by André Gide and André Malraux. The *A.E.A.R.* was a non-Communist organization manipulated by Willi Münzenberg, the mastermind of many schemes employed by the Third International in Paris under the banner of anti-Fascism but used by Münzenberg to his own purpose.

None of the three could be considered as fitted for Communist militancy. Cartier-Bresson was a libertarian pacifist, Capa a sarcastic, rebellious hedonist. Chim was a soft-spoken fellow, a perceptive expert on the Book of Judges who, through the thick lens of his glasses, gazed with irony at the world, its cruelty and joys, its mixture of love and ferocity. Chim was not meant to change the world but to understand it and, if possible, to love it. He was as shy as Capa was bold. He smiled when his friend burst into laughter. Their relationship could have been compared to the one between Groucho and Harpo, provided Harpo could appear as an authority on the Talmud and Groucho as a satirist capable of laughing at himself, not at others. The best portrait that we have of David Seymour was done by Cartier-Bresson. "Chim, like Capa, belonged to Montparnasse. Clever as a chess player who looked a math teacher, he applied his wide curiosity and his vast culture

Robert Penn

Eve Arnold on the film set of Becket, *starring Richard Burton, England, c. 1964.*

to numerous topics. When he took out his camera, he was like a doctor pulling his stethoscope from his bag to examine the condition of a heart. His was vulnerable."

He was very conscious of being Jewish, as could be expected of the son of pious intellectuals born in a country haunted by anti-Semitism, who at the time of the big Nazi scare, fled to France, a country not unshaken by Fascist fever. Even so, David Szymin chose to live his Judaism in a manner closer to Woody Allen's than Elie Wiesel's. His affinity for the customs, the splendor, and the rituals of the Vatican and his fascination for the world of the monsignori could be considered as a superior form of his humor. At the end of his life, he admitted to Henri Cartier-Bresson that he wished to become a permanent correspondent in Rome so as to enjoy the pontifical atmosphere.

Two years after Capa's death (and following the accidental death of Werner Bischof in the Andes), Magnum's "studio"—the world—had taken away from the agency this vulnerable, righteous man who had managed to articulate Capa's ambitious voracity and Cartier-Bresson's Jansenist discipline. "Gentle president Chim" did not die in Italy but in Egypt, at the Suez Canal, on November 10, 1956, four days after Washington and Moscow imposed a cease-fire on the British, French, and Israeli forces. He was shot down by an Arab soldier, another casualty of the most stupid and unforgivable of wars.

Henri Cartier-Bresson was born on August 22, 1908, in Chanteloup, near Paris. Three words can sum up his personality: life, revolt, and geometry. His

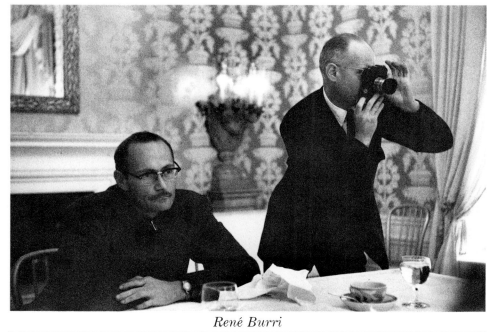

René Burri

W. Eugene Smith and Henri Cartier-Bresson, New York, 1959.

Magnum members, in New York for the annual meeting, are hosted by Arlene Francis on the Today Show. *Erich Hartmann, Inge Morath, Elliott Erwitt, Dennis Stock, Burt Glinn, Eve Arnold, and Henri Cartier-Bresson (on swing), New York City, 1955.*

Riboud maintains that the key to HCB lies in this very attitude. "I love taking pictures," Riboud says, "but I can also relax. Henri never does. Before he went back to drawing, he used to live with his Leica in hand, constantly hunting for images, on the lookout day and night."

Cartier-Bresson's relationship with photography is complex. An art? He shrugs. A profession? A friend once gave him a definition of his activity that he found particularly appropriate: "In short you don't work, you're having a hard pleasure!" There's no doubt about it being hard. Henri does not like photography. He likes to take pictures, to shoot, to shoot in the "hunting" sense of the term. But few hunters clean their own game. According to HCB, what comes out of his "black box" is of little interest. He knows that they have been composed. His Leica produces perfectly geometrical shapes as magically as Mansart's workshop seemed to when designing Versailles.

His most famous piece of writing is *The Decisive Moment* (*L'instant decisif*). It can be considered his artistic and professional manifesto. What is important to him is more a relation to space than to time. His photographic style is based on composition and structure. It is architectural, like De Chirico's. Geometric, like Leonardo da Vinci's. But with him, working with a camera instead of a brush, everything is summed up in this supreme moment

René Burri in Bangkok, Thailand, 1961.

strong sense of life is what once gave him the obsessive urge to capture the instant, to hold it back, to catch it in the act. But it is his sense of revolt that made him flee his bourgeois milieu, his native country, the dominating West and even, fifteen years ago, turn his back on his own reputation and fame as the greatest of all photographers. Instead, he turned his energies to revolutions, surrealism, the woes and uprisings of the Third World. HCB's detachment is so deep that against the splendid landscape in front of his house in Provence, he says: "I'm not from here, maybe from Asia. I am an unresigned Buddhist raging against the state of the world. But basically nonviolent."

A disciple of André Breton, the great surrealist prophet and poet, and a friend of André Lhote, a cubist theorist and painter, Cartier-Bresson started as a talented painter. Why, then, did he choose to devote himself to photography for almost half a century? For the spirit of adventure, maybe. But surrealism was an adventure in itself. Cartier-Bresson remained faithful to it, adopting Breton's motto: "Life first!", which he changed slightly to: "above all, pay attention to life!" To pay attention is a weak expression. Life fascinates him, he is wild about it. Marc

Ernst Haas and Inge Morath in Capri, while working on their first story for Magnum, 1949.

photographic style "decadent," and HCB didn't admire too much of Capa's photography, "but he adored the man, just as he loved Chim's remarkable wisdom. He needed both of them. Once he had asked for their advice, he generally decided against them both." In any case, HCB does recall: "Chim, Bob and I never spoke about photography, about technique or about good and bad shots. We used to talk about life, about the world, which is far more interesting."

Robert Capa gave the boost and energy, David Seymour the spirit and the sensitivity, Henri Cartier-Bresson gave Magnum his style—a strange mixture of beauty and truth. He derived much from this crew and this company, not only in terms of friendship ("I had friends there and I still do") but also through sharing risks, learning teamwork, and working against a deadline, always in the heat of the action. Was he in danger of becoming artificial, as Bob Capa had hinted? News reporting helped him avoid this trap without ruining his talent for composition. There was ample excitement without aesthetic damage.

In order to create Magnum, more was necessary than the advent of Nazism spewing westward, an exceptional group of young Jewish artists or democrats deprived of their homeland to benefit the world of free expression. More was needed than the unlikely meeting at Montparnasse of two refugees and a rebel and their altogether improbable 1945 reunion back in Paris

when form briefly takes on its essential meaning. He is said to be a classical photographer and that is how Ernst Haas defines him in an issue of the *Cahiers de la Photographie*. The surrealist in him does not deny that, but would rather put it this way: "I acknowledge that a plastic order exists which is capable of preventing us from disintegrating because of banality, chaos, and oblivion."

When asked to talk about his work, his first reaction is a dry and wild laugh: "My work!" Then he thanks you for showing interest in this long masturbating finger, then he may talk about his passion for drawing, the way he started painting with André Lhote, and if you ask him what his favorite subject is, he will answer: "Ask my nostrils." (Indeed, he is a genuine gourmet. Some think of him as a monk, but he knows the best restaurants in Hong Kong, Djakarta, and Paris.)

His life as a photographer can be divided into two periods: before and after Magnum. Before is the great "posthumous" exhibit in 1947 at MOMA organized by Beaumont Newman. After the exhibit, Robert Capa told him: "Beware of labels. They can give you a feeling of security, but one is going to stick on you—the surrealist label. Your manner will become pompous and affected. You should stick with news reporting and keep the rest in your little heart." That "little heart" was never forgotten, and as for news

reporting, HCB thought his friend's advice worthwhile. He followed it with all his characteristic love and passion. He published *Images à la sauvette*, with—it is worth noting—a Matisse on the cover, his major article *The Decisive Moment* as a preface, and Teriade as publisher. His following book, *Flagrants Délits*, was published by Robert Delpire.

Concerning his relationship with Capa and Chim, Ernst Haas—who became HCB's best friend after the deaths of these two founders, said that Capa used to call Cartier-Bresson's

Marc Riboud on the train between Canton and Beijing, China, 1965.

Elliott Erwitt

On the set of The Misfits, *Nevada, 1960.*

Illustrated in North America, enabling these young photographers to become the champions of the international media.

Though Magnum was deprived of Bob in 1954 and Chim in November 1956, it was clear that the founders' 1947 dream had come true. Ten years after its inception, according to the knowledgeable Pierre de Fenoyl, the cooperative agency boasted the twenty-five best professional photographers from all over the world, members whose work struck a successful balance between the American and European schools. But to survive, it is not enough to be the best. The agency had to remain faithful to the spirit of its founders as well as maintain group cohesion and commercial efficiency. On these three points, Cornell Capa succeeded. He had joined the agency just after the death of his brother and, in 1956, took over the presidency for four years. During this shaky period, he brought to the company the active support of the New York associates as well as his own energy, technical skills, business mind, connections, and his typically American professionalism.

But as he expressed it himself, the variety of differences between Paris

after the war. There had to be some kind of concurrence between the Third Reich terror, the French *festive* uprising of 1936, and the succession of wars with the arrival of a unique instrument, the Leica. As early as 1932, André Kertesz adopted the Leica, a camera that immediately fascinated Cartier-Bresson and proved to be the ideal tool for news reporting. Finally, under the impulse of a few men, a new generation of photo-illustrated magazines appeared: *Vu*, *Match*, *Regards*, and *Picture Post* in Europe; *Life*, *Collier's*, and

Seymour Linden

Elliott Erwitt photographing President Kennedy on the publication of the book, PT109, *with photos by Erwitt, Washington, D.C., November 1961.*

The annual Magnum meeting.

Front row (from left to right): Inge Bondi, John G. Morris, Barbara Miller, Cornell Capa, René Burri, Erich Lessing. Between rows: Michel Chevalier. Back row: Elliott Erwitt, Henri Cartier-Bresson, Erich Hartmann, Rosellina Bischof-Burri, Inge Morath, Kryn Taconis, Ernst Haas, Brian Brake. Paris, 1950s.

and New York endangered the management and coherence of Magnum not only from an economic standpoint but also in the way the agency conceived its own future. Was it to become a mini or a maxi Magnum? HCB advocated the first option, which won out. Magnum remains a closed organization, limited to around fifty members with a light office structure (seventeen employees in Paris, more in New York, less in London where a branch was recently created).

And so, Magnum has remained in the hands of free-thinking men and women, an organization essentially based on the energy and the prestige of the individuals working for it and on the confidence that its production is of highly professional quality and the result of will and decision. In truth, the words "freedom of choice" sum up the spirit and the method of Magnum and apply to all its aspects, from the admission of a new member to photography itself. Eve Arnold, one of the first active members, wrote that "the tool in photography is not the camera but the photographer." But this tool, unlike two Leicas, can be splendid or mediocre.

Dick Rowan

Eve Arnold photographing Marilyn Monroe, Los Angeles, 1960.

The secret of Magnum is in the several, almost miraculous fusions since the Montparnasse meeting in 1934 and in the almost constant selection of the men and women most capable of preserving and developing its spirit: *being there* (the most accurate definition of news reporting), *choosing to be there*, and preferring a *durable meaning* to sensationalism: to say this is to refer to Marc Riboud, for example, who was and is the symbol of this very typical Magnum mixture.

Elliott Erwitt could have continued

Elliott Erwitt

Henri Cartier-Bresson, New York, 1955.

working on the fringe of Magnum because he was not so inclined to mix with the ferocious history of our time. He prefers children, musicians, actors, and dogs, "the quiet and simple flow of life." But this attitude is precisely what makes him an important associate of Magnum: the intimist humor is indeed one of Chim's legacies. "My photographs are political in a way: they intend to comment on the human comedy, and if this is not politics, what is?" Erwitt advises people to watch "from a safe distance," advice he does not always follow himself. If he kept away from the Vietnam War ("I'm not interested"), he did take big risks. "Being at the right place at the right moment"— his definition of photography—does not exactly correspond to his definition of the photographer: "a lazy man's profession."

"I go on" is how Bruce Davidson defines his work. Like Cartier-Bresson, he hasn't stopped shooting since he was ten years old. Three million shots in forty years is his estimate. He'd rather talk about "searching" than "hunting." He says he doesn't read or think but always spends his holidays with a camera in hand, working more and more in

landscape photography. He claims not to fit any of the classical categories which Dennis Stock defined: reporters, "playwrights," "musicians," and "architects." His main obsession when shooting is to learn. But also to cleanse himself.

Davidson acknowledges only one master: W. Eugene Smith. But the only influence that he admits to is that of his wife, an actress and psychotherapist. He has spent years preparing a major report on the World War II concentration camps. For him, Magnum is similar to an Indian tribe, and he likens its future to that of the Cheyennes or the Comanches: at best, it will survive.

To what extent can the news reporter get personally involved in his subject or merge with it? Faced with the sympathy he can feel, and a profound knowledge of a people, a land, or a society, can he remain free and sufficiently distant? These are the questions that a great many reporters, both photographers and writers, continue to ask themselves. Such is the case of Susan Meiselas, who has demonstrated her talent through her reports on South America, Nicaragua, and El Salvador, as well as the Philippines.

Meiselas' studies in ethnology led her

John Hillelson

Magnum meeting. Burt Glinn (center), Elliott Erwitt, Eve Arnold, Inge Morath, Ernst Haas, Erich Hartmann, Dennis Stock, New York, c. early 1960s.

to reflect on subjects that were as much deontological as ideological: when arriving in a traditional community, is one entitled to capture lives, faces, souls, and family life? Meiselas also wonders about another aspect of the profession, and a very disturbing one indeed: If Elliott Erwitt could not pre-vent his picture of Nixon with Khrushchev from being used to promote Nixon's political career, what could be said of Susan's shots in Managua and what she saw by two opposing and equally murderous propaganda campaigns? That is why she now tends to work outside Central America, al-

René Burri

Member collage.

Guy Le Querrec

The annual meeting, Paris, 1979.

ing together" mean overstepping the founders' objectives and lead to creating a sort of a sect, political party, or secret society?

The threat that Magnum has to deal with may be elsewhere than in the absence of a common dream. The risks consist mainly in the imperialism of television. As early as 1954, Robert Capa confided to Marc Riboud his alarm about the subject. Cornell Capa is obsessed with it: "Television transformed not only what news photographers do, but what they live on and how they live—their prints, sales, exhibits, publications, advertising. The need for images decreased in the printed media because of television. This situation accounts for the reduction of news reporting in an agency like Magnum, but a lot of opportunities remain to develop from now to the end of the century. The year 2000 will witness a new direction following in the wake of Henri Cartier-Bresson's tradition of surrealism and the search for form."

though she knows this type of problem can arise anywhere in the world.

Susan Meiselas is the second woman to become a vice-president of Magnum. Her European counterpart is Bruno Barbey, whose reputation and authority have recently been strengthened by the beautiful book on Poland that he did with Bernard Guetta.

Meiselas' responsibilities as a vice-president oblige her to ponder the meaning, the objectives, and the organization of the agency. She claims to have a large trust in the future and foresees expanding Magnum's activities. At the same time, she expresses some regret, reflective of her personality: "We don't dream together." But wouldn't "dream-

Most younger contributors to Magnum, such as Abbas, Salgado, Depardon, Franck, or Le Querrec, refuse to believe in a decline of news photography. They have quite the opposite experience and are assailed with magazine

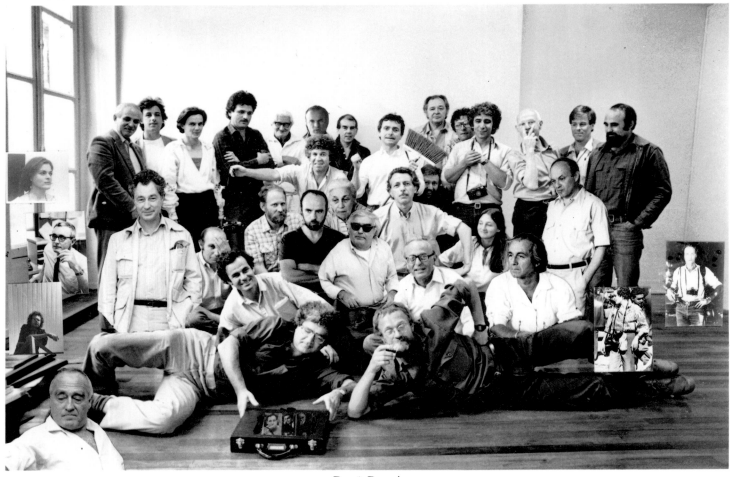

René Burri

The annual meeting, Paris, June 1982.

Alex Webb

Rubber stamps bearing each photographer's name, for use when
crediting Magnum photographers.

assignments, as much as ever. As for the atmosphere inside the organization, the memory of the friendship that brought about its creation is still kept alive. In one of the annual meetings of the "forty," such as the one held in Paris in June 1988, one can better measure what a common success is in a field where competition for fame is sometimes brutal. Three dozen of the most famous photographers of our time gathered from all over the world for a reunion to select their new companions from among the nominees of the last months. They spent four days debating, exchanging views, speculating about the future and the evolution of photography. Still, peculiar relationships tie this group of fervent—and famous—individualists together. One member, Richard Kalvar, calls these relationships schizophrenic.

Who could be a better judge than the current president, distant successor of Capa and Chim—Burt Glinn? He says, "Since photographers do not wish to surrender control over their lives to anyone, Magnum has never had a rational staff structure with one staff member at its head. The photographer officers have to serve as the unifying force in the structure and the various department heads report to him, somewhat like rebellious dukes would report to a part-time king. It is not easy and it is not good management but it is Magnum and we live with it. . . . In short, the president is the least among equals."

61

Elliott Erwitt
The annual meeting, Paris, 1988.

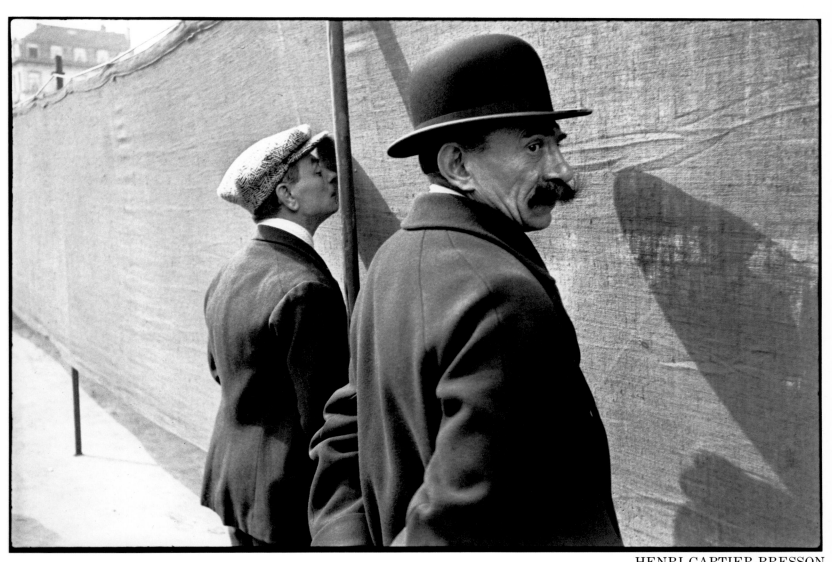

HENRI CARTIER-BRESSON

65

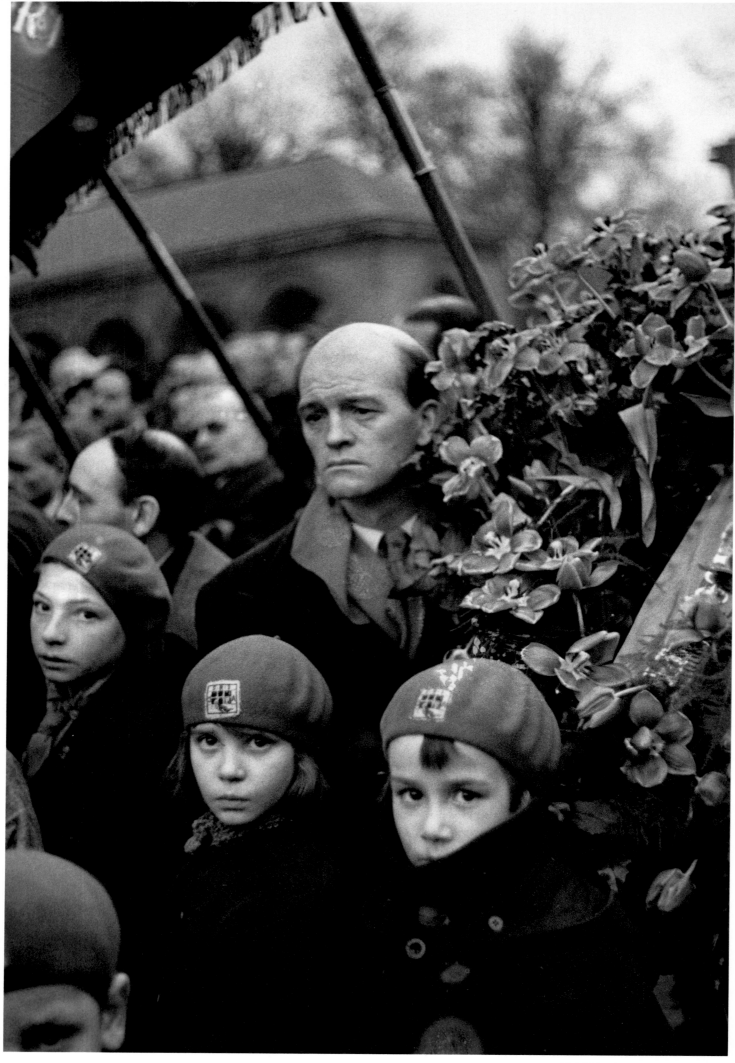

66

DAVID SEYMOUR (Chim)

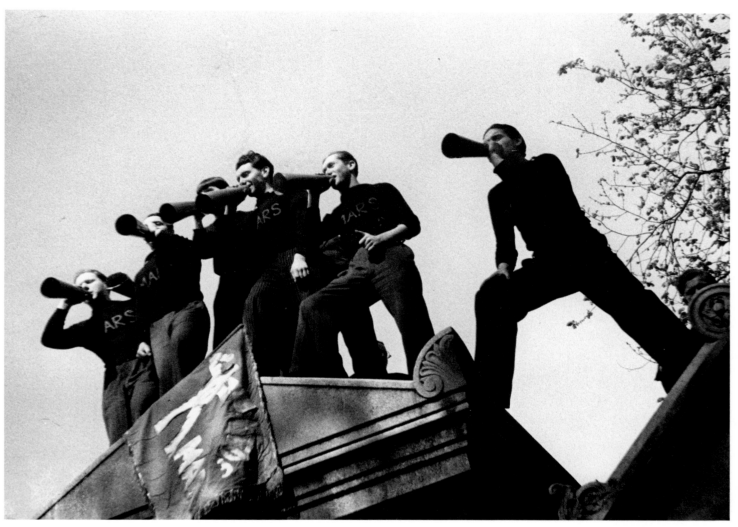

DAVID SEYMOUR (Chim)

Page 65: *Brussels, 1932.*
Left: *Demonstration at the funeral of novelist Henri Barbusse, Paris, 1935.*
Above: *Popular Front Demonstration, Mur des Federes, Paris, 1936.*
Overleaf: *Canteen for construction workers, Moscow, 1954.*

69

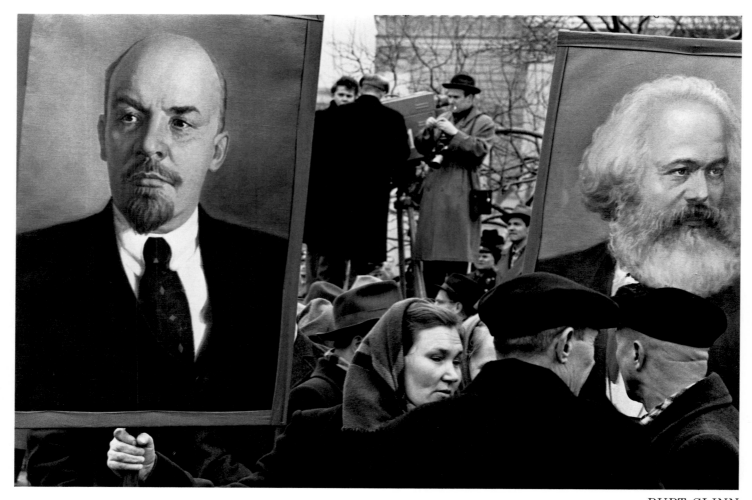

BURT GLINN

Above: *Official unveiling of a statue, Moscow, 1961.*
Right: *Uprising in Budapest, Hungary, 1956.*
Overleaf: *Invasion by the Warsaw Pact armies, Prague, 1968.*

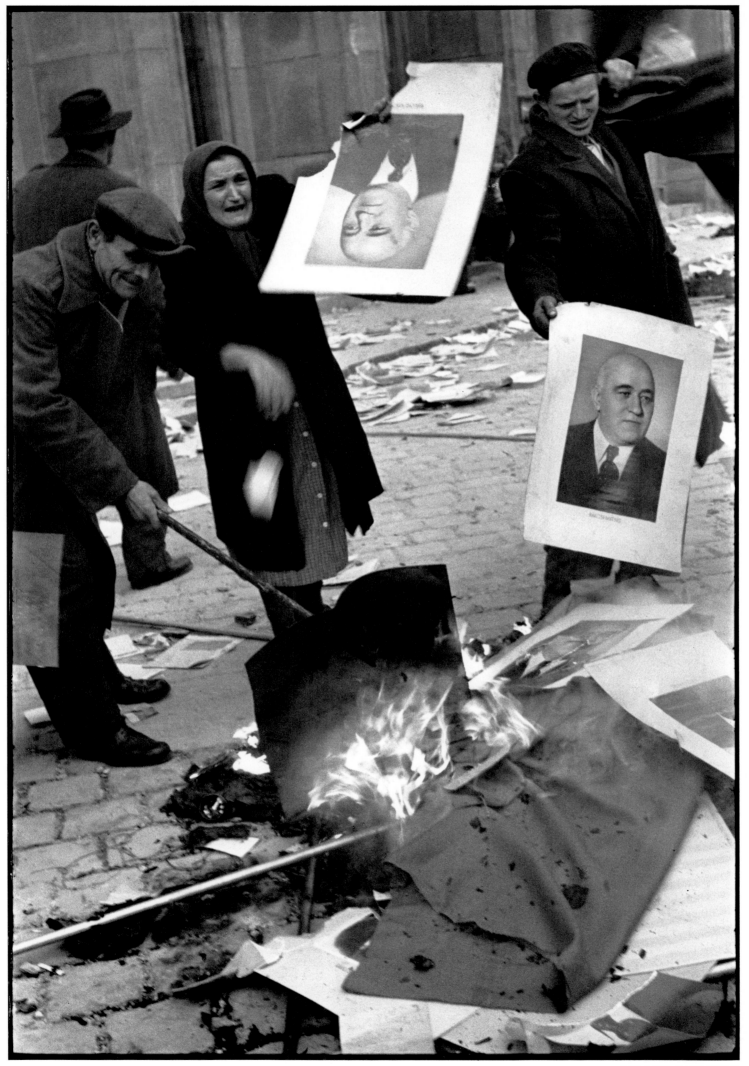

71

ERICH LESSING

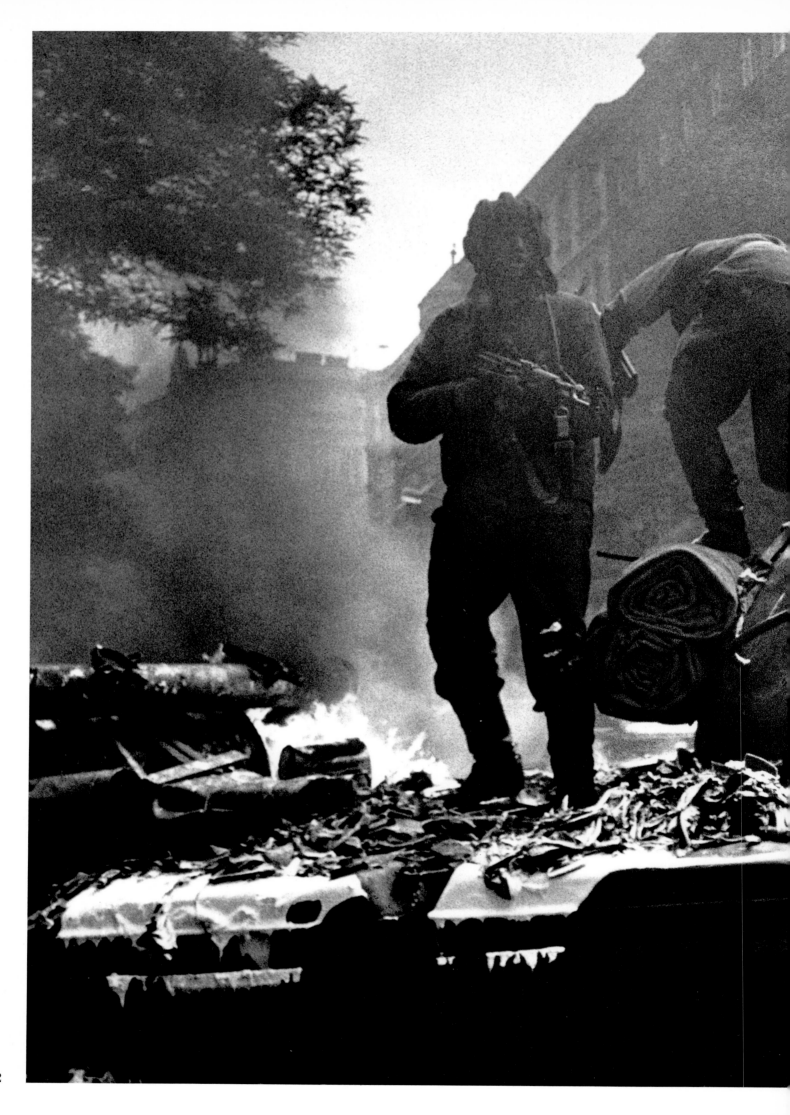

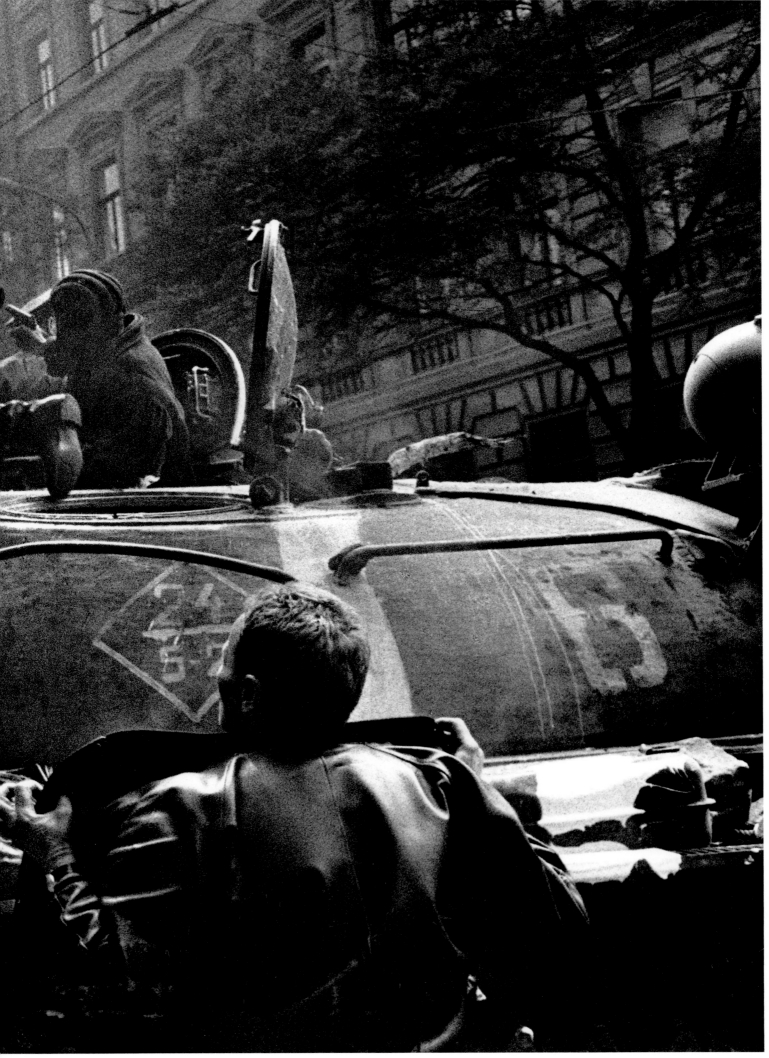

73

JOSEF KOUDELKA

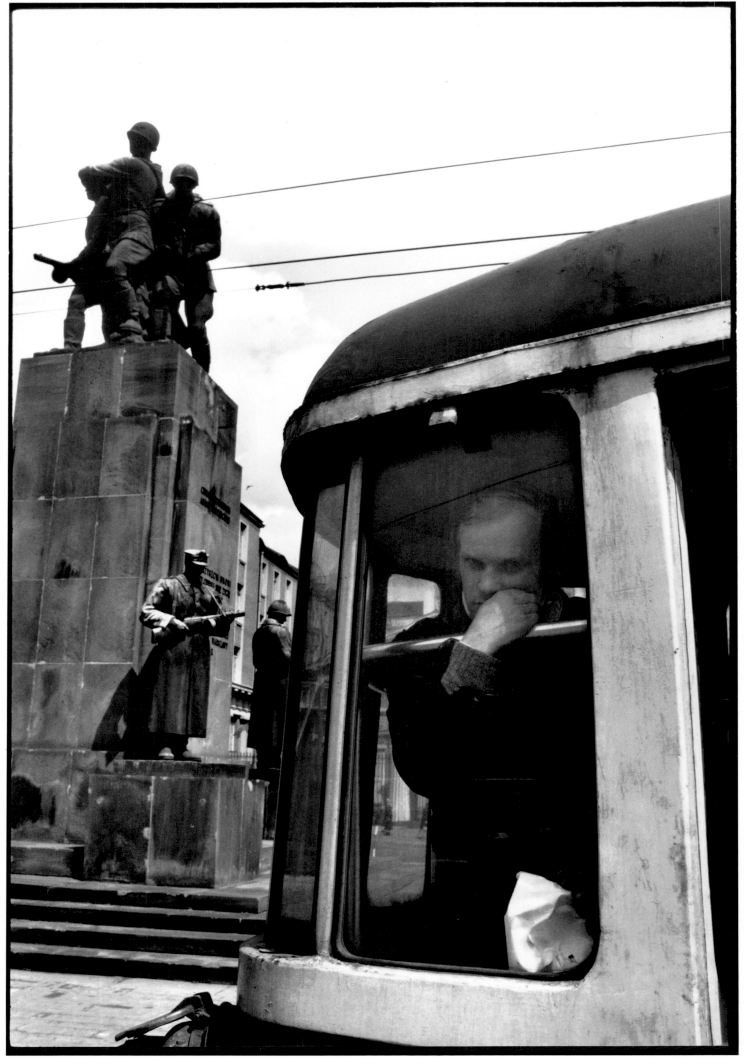

74

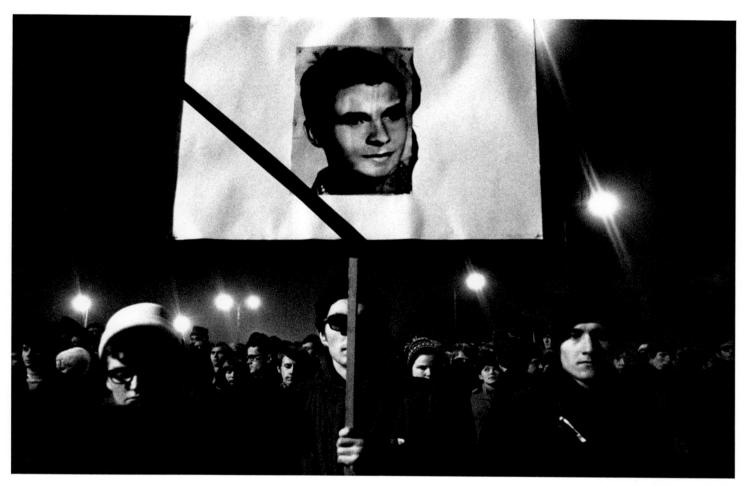

JOSEF KOUDELKA

Left: *The Brotherhood-in-Arms Monument, Warsaw, 1980.*
Above: *Mourning Jan Palach, who burned himself to death to protest the invasion, Prague, 1968.*

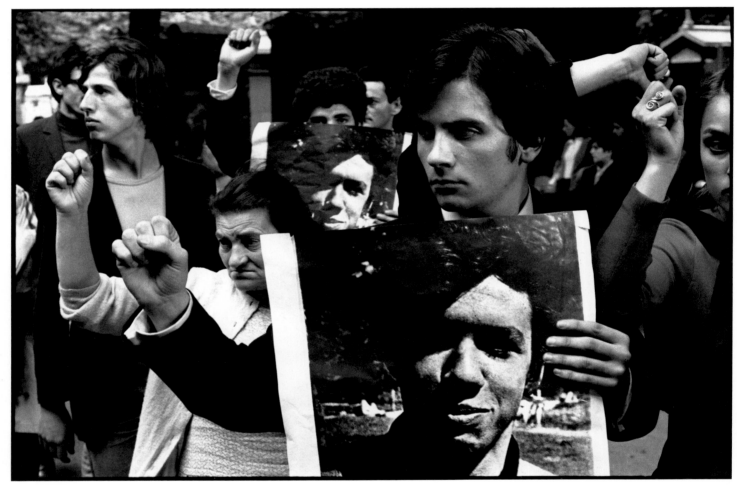

BRUNO BARBEY

Above: *Burial of Gilles Tautin, a Maoist killed during the May riots,*
Paris, May 1968.
Right: *Prague, 1968.*

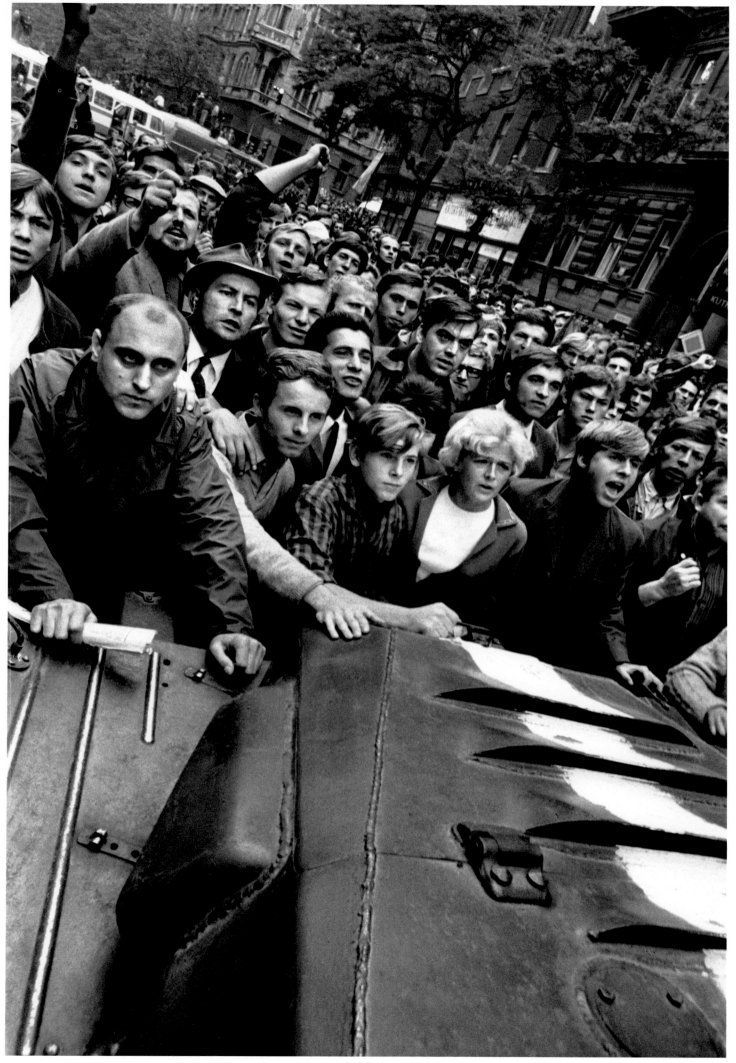

JOSEF KOUDELKA

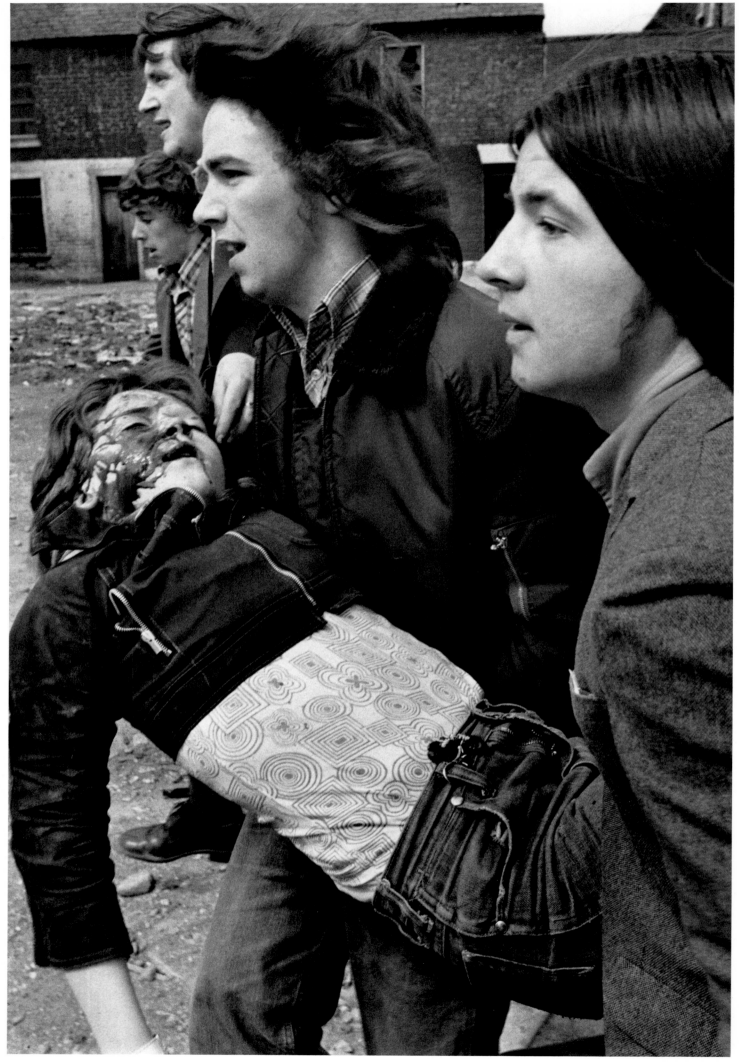

78

GILLES PERESS

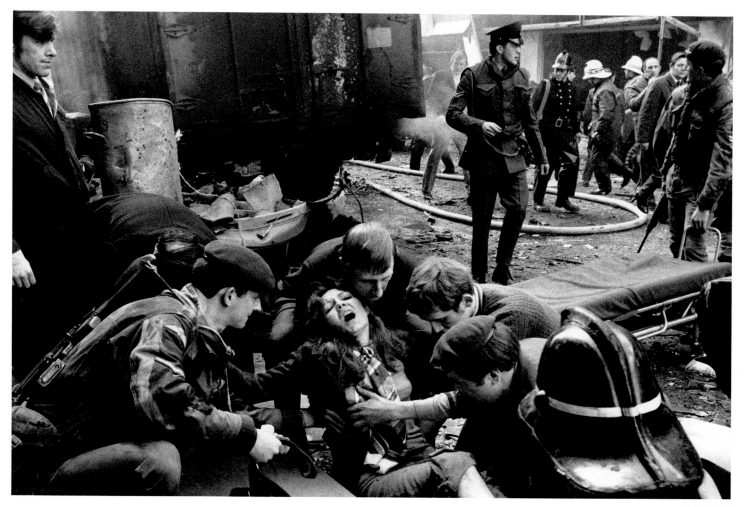

ABBAS

Left: *Riots in Belfast, Northern Ireland, 1971.*
Above: *Wounded by an IRA bomb explosion, Belfast, Northern Ireland, 1972.*

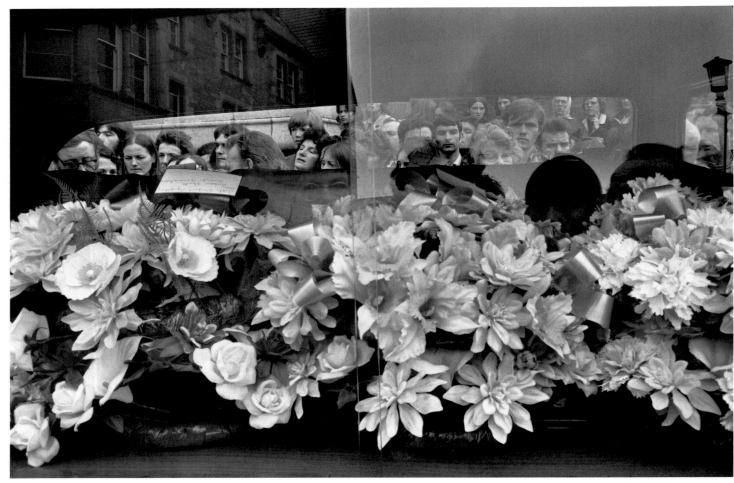

GILLES PERESS

Above: *Funeral of a civil rights marcher, Derry, Northern Ireland, 1971.*
Right: *"Bloody Sunday," Derry, Northern Ireland, 1971.*
Overleaf: *A punishment cell, Leningrad, 1988.*

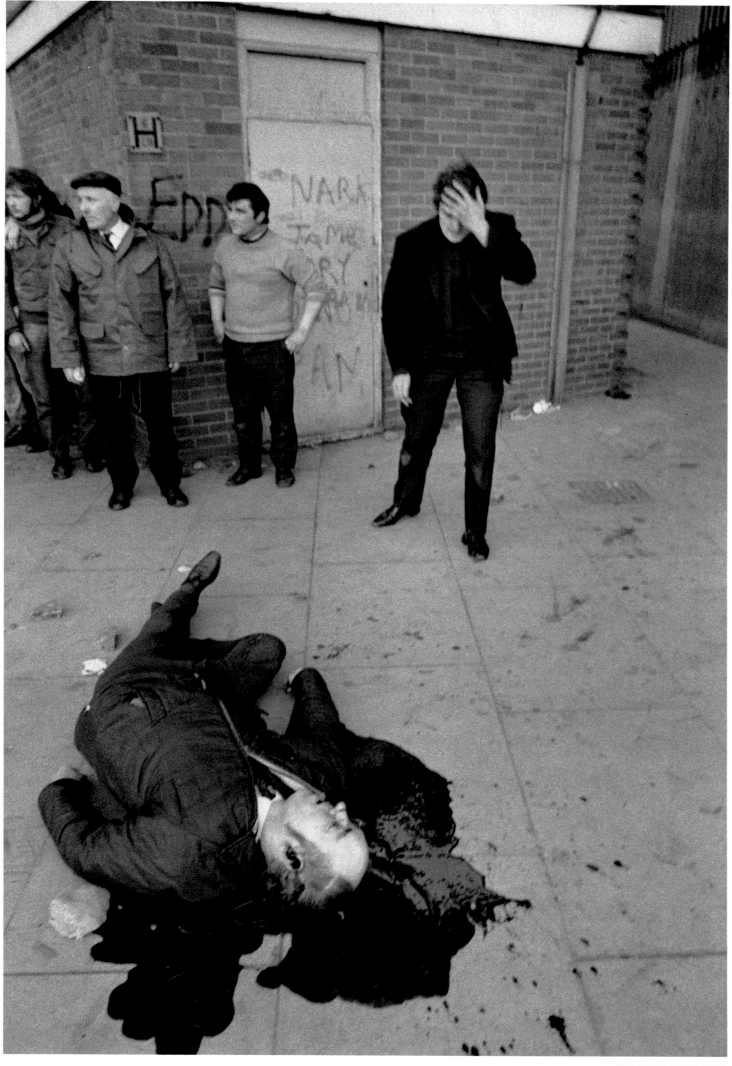

GILLES PERESS

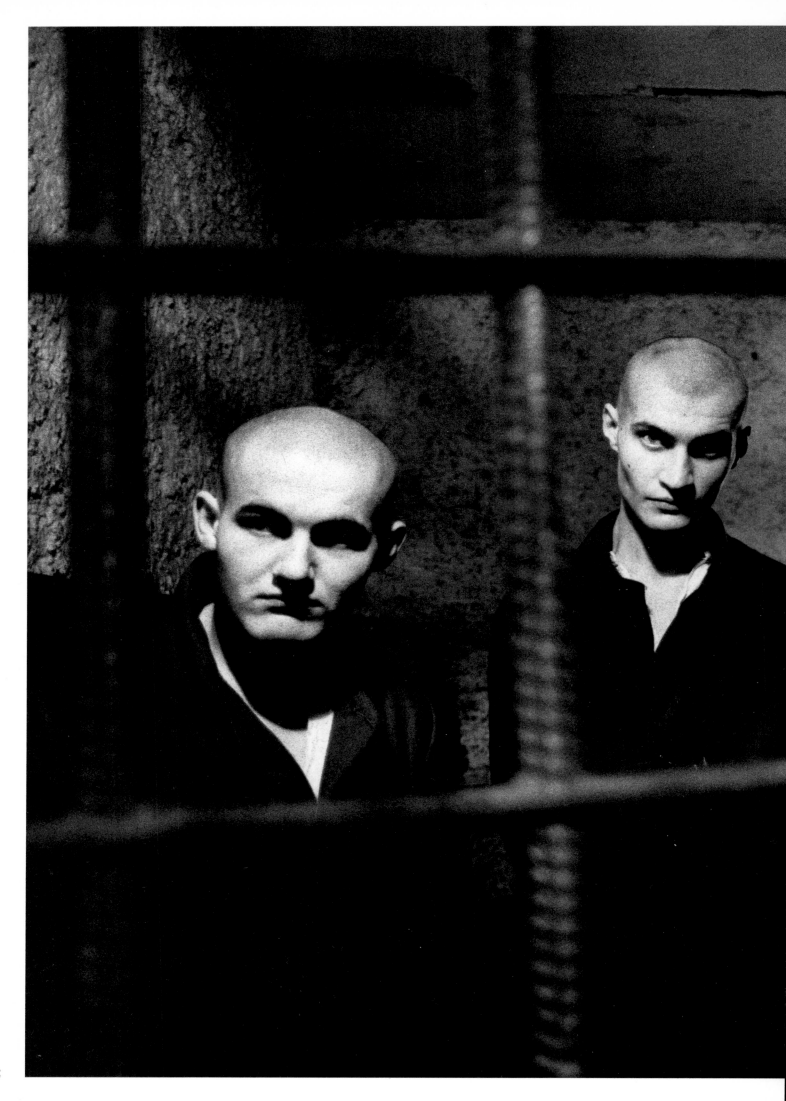

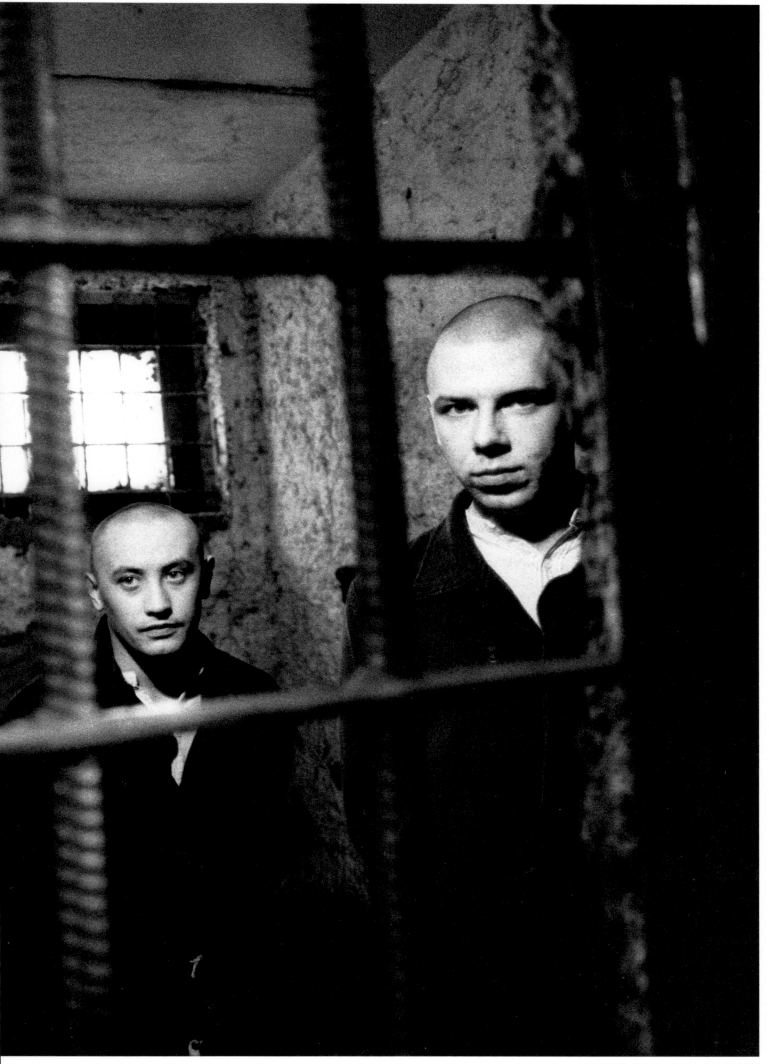

83

CHRIS STEELE-PERKINS

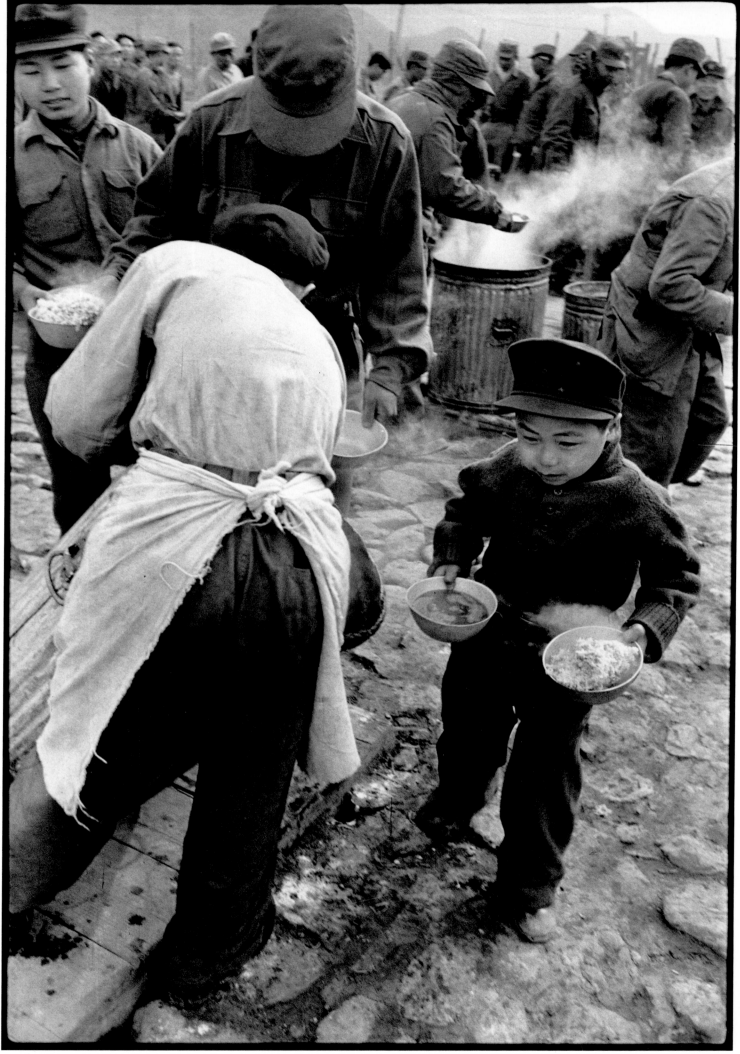

84

WERNER BISCHOF

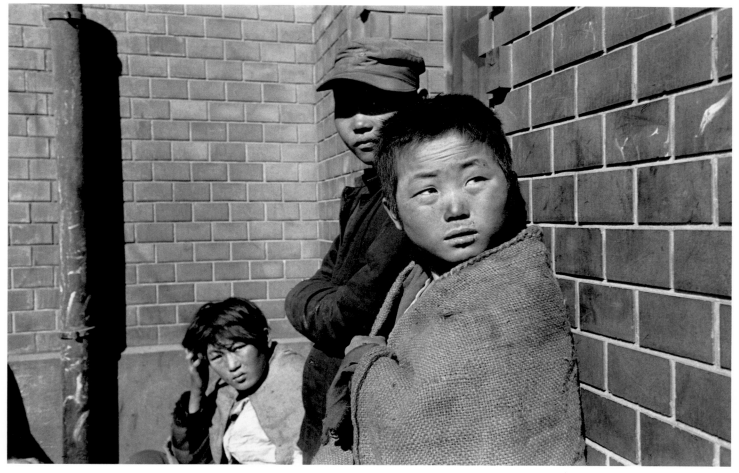

WERNER BISCHOF

Left: *Kŏje-do Island prisoner of war camp, South Korea, 1952.*
Above: *Refugee with G.I.s at Pusan train station, Korea, 1951.*
Overleaf: *Left-wing riot protesting the building of Narita Airport, Tokyo, 1972.*

85

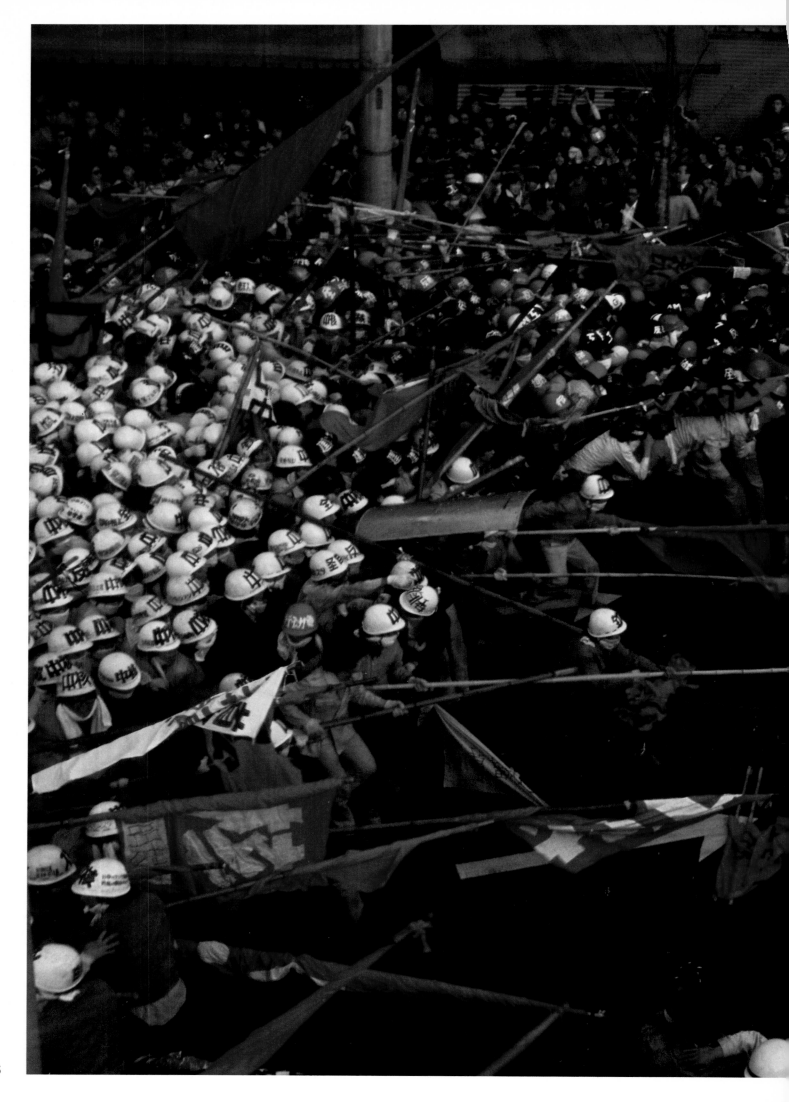

BRUNO BARBEY

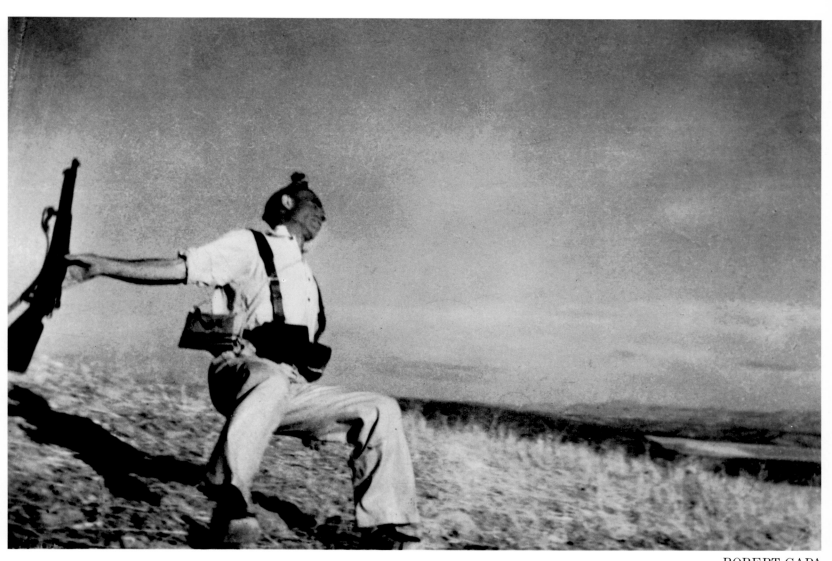

ROBERT CAPA

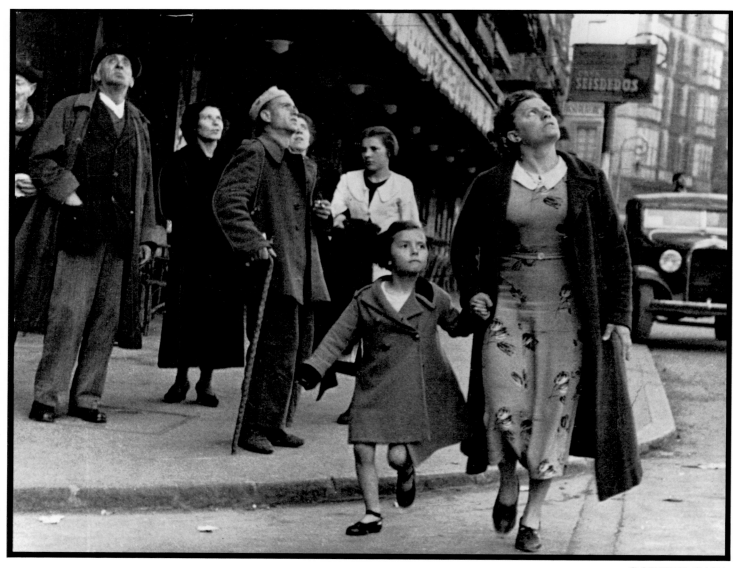

ROBERT CAPA

Page 89: *Loyalist soldier, Spain, 1936.*
Above: *Looking towards German Luftwaffe bombers flying over the
Gran Via, Bilbao, Spain, 1936.*
Right: *A woman is rescued from her home, wrecked by a V-1 bomb,
London, 1943.*
Overleaf: *A collaborator is paraded through the streets of Chartres
following liberation, 1944.*

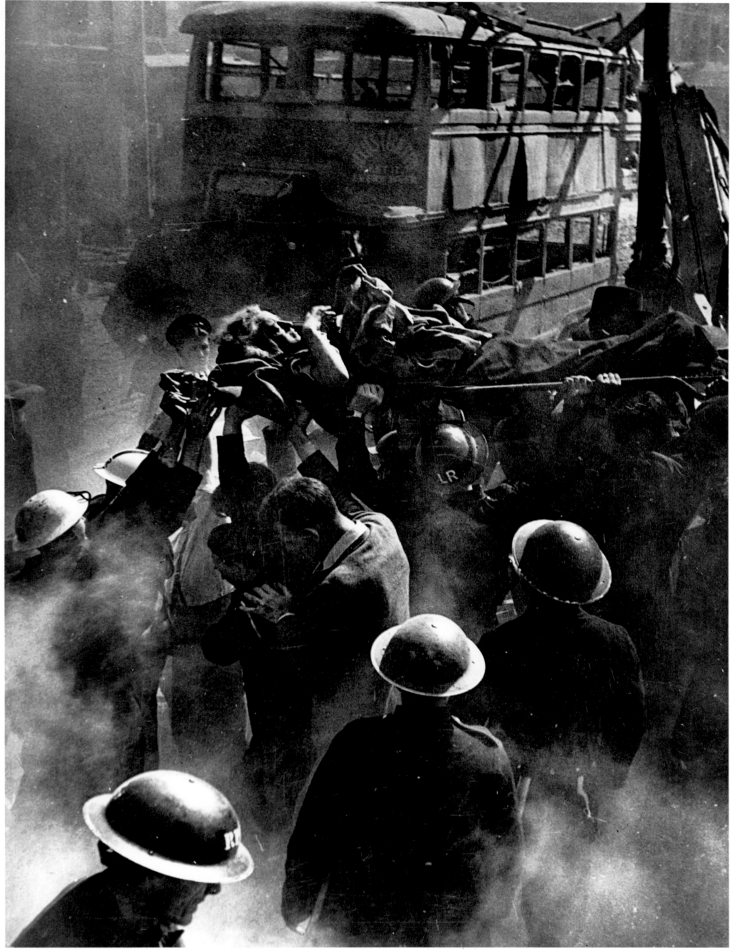

GEORGE RODGER

93

ROBERT CAPA

KRYN TACONIS

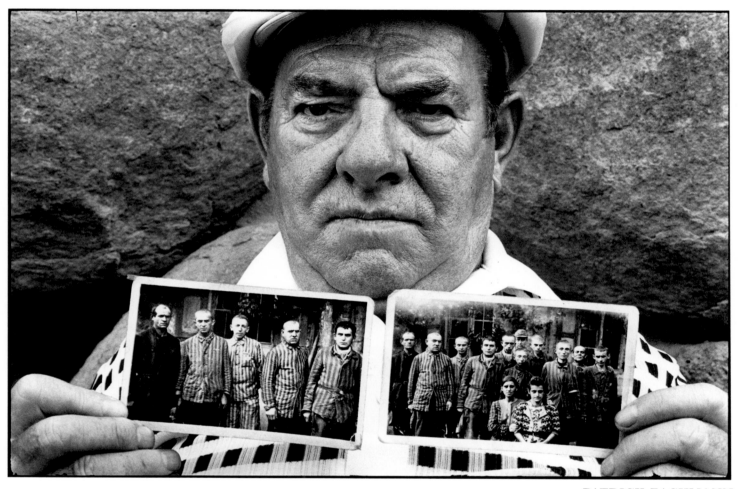

PATRICK ZACHMANN

Left: *German soldiers leaving the Netherlands, Dutch-German border area,*
May 1945.
Above: *Concentration camp survivor Yad Vachem, Jerusalem, 1981.*
Overleaf: *Bergen-Belsen concentration camp, April 1945, Bergen-Belsen,*
Germany.

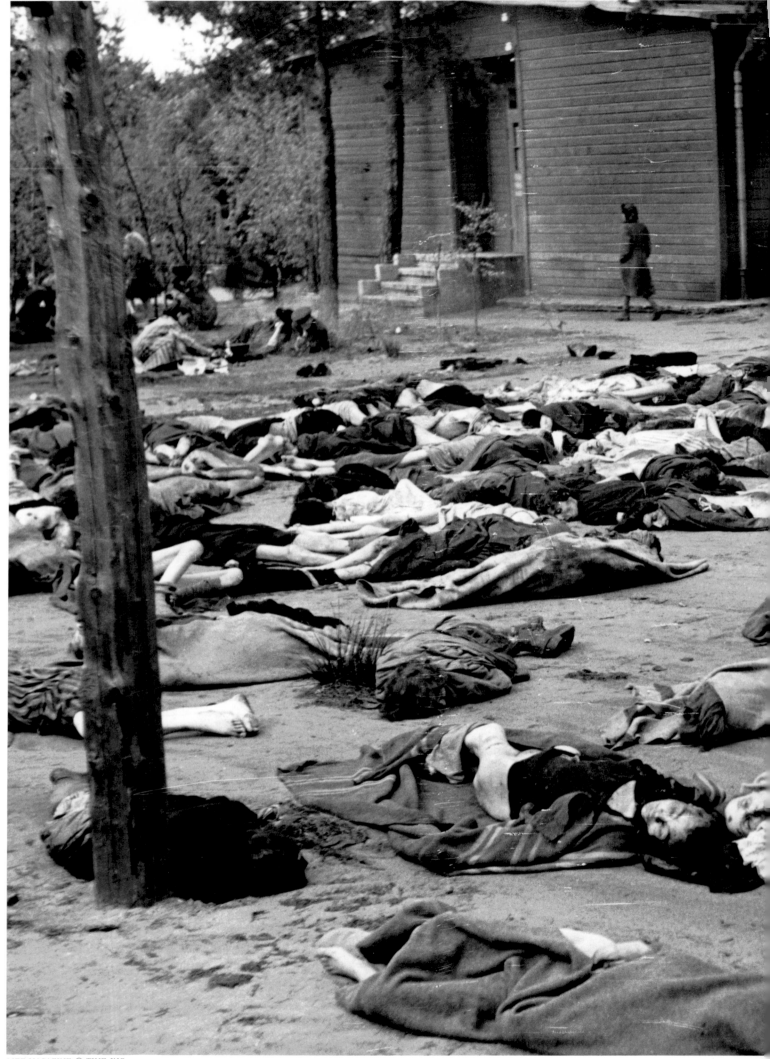

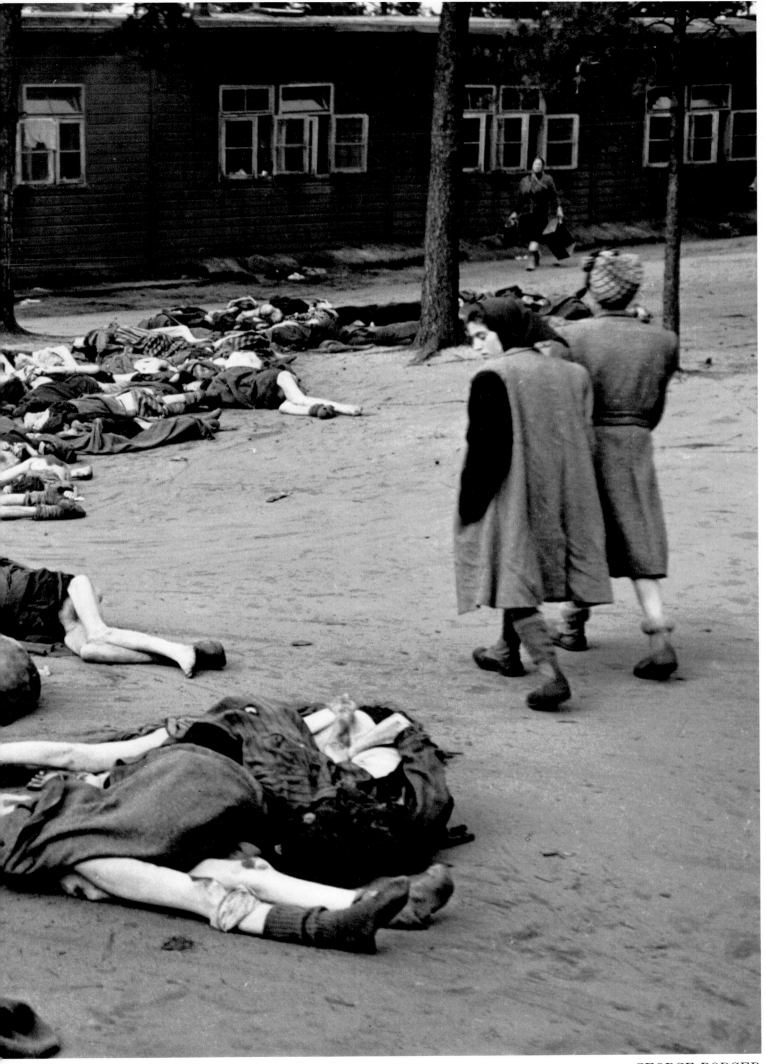

GEORGE RODGER

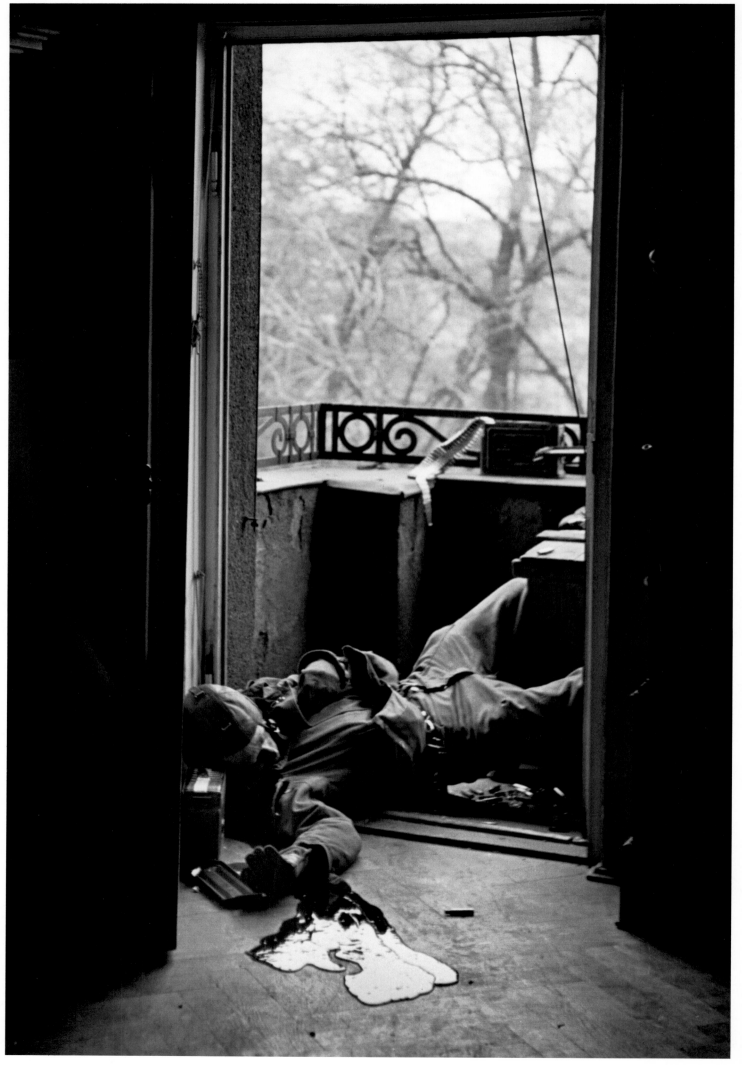

98

ROBERT CAPA

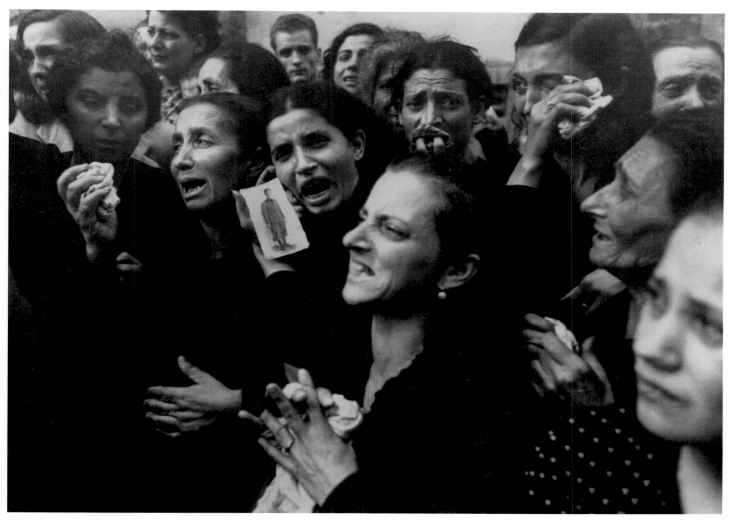

ROBERT CAPA

Left: *The last man to die, Leipzig, Germany, 1945.*
Above: *Mothers of Naples lament their sons, Naples, 1943.*
Overleaf: *Liberation of Paris, August 25, 1944.*

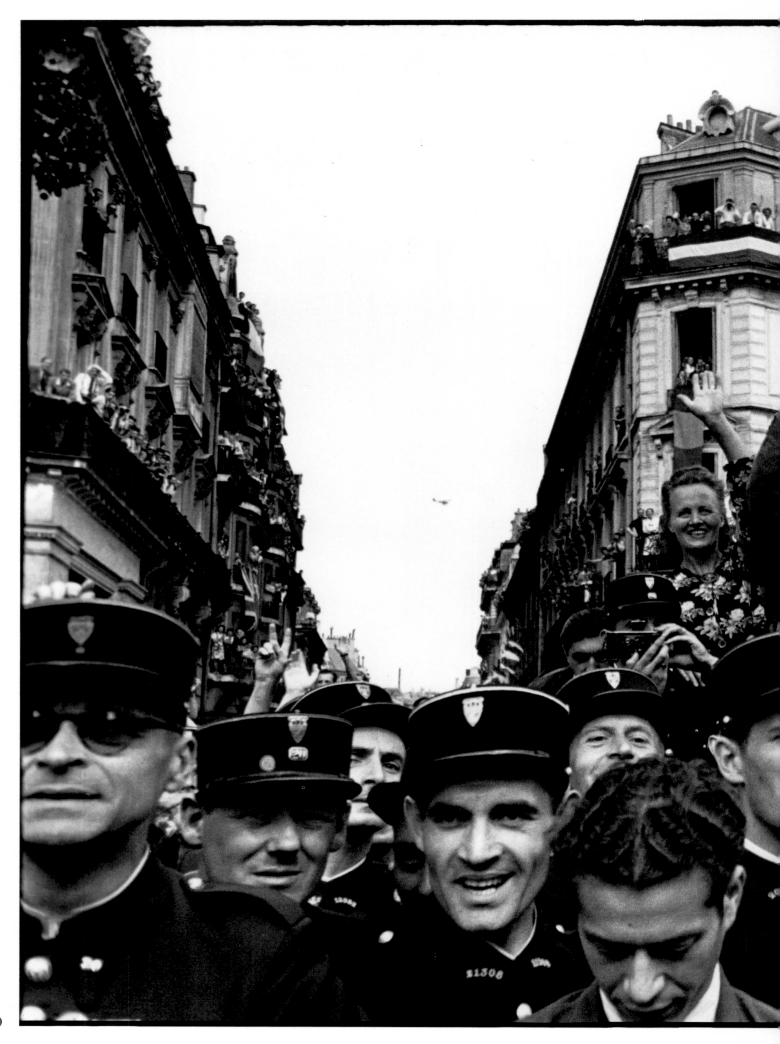

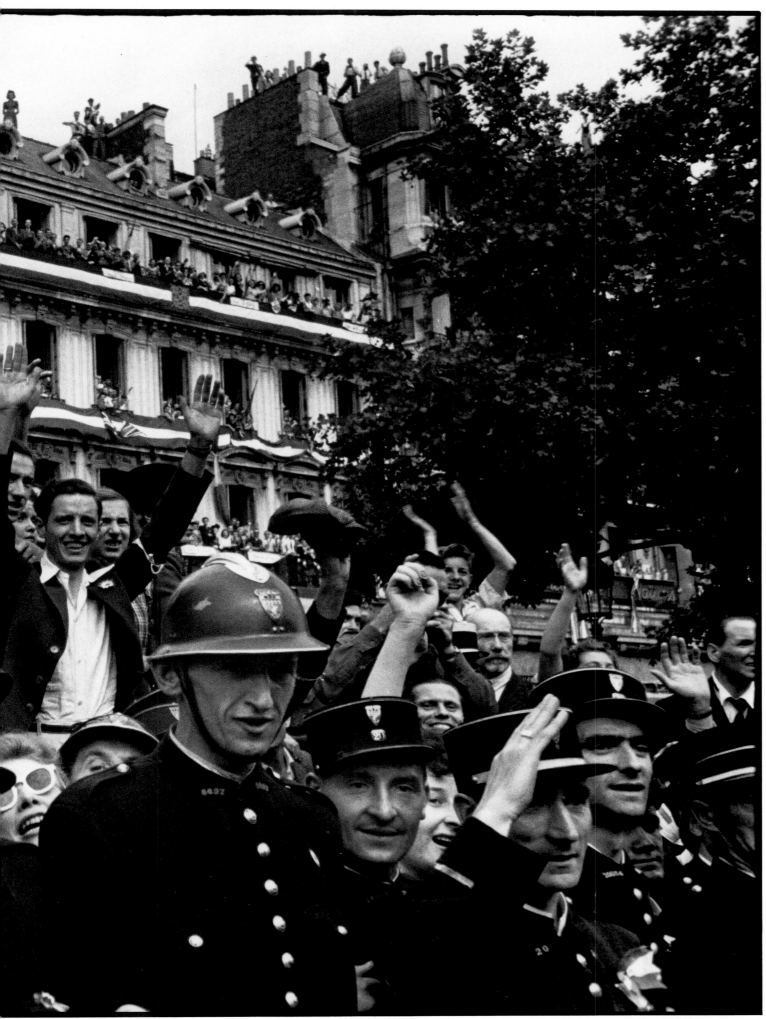

ROBERT CAPA

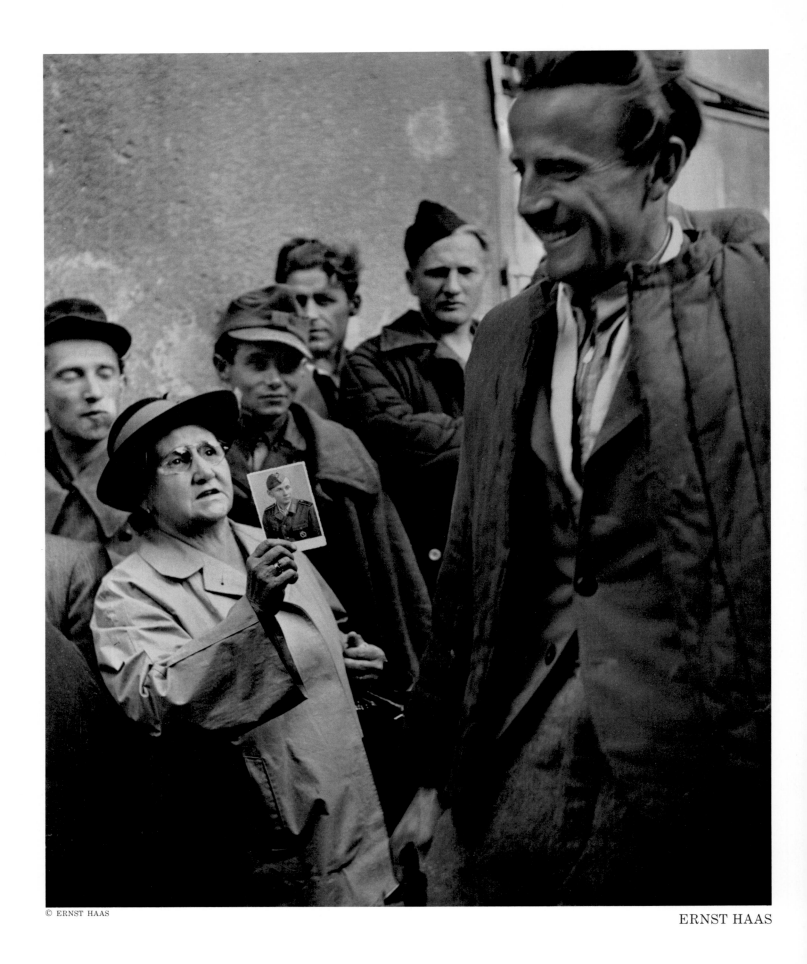

ERNST HAAS

102

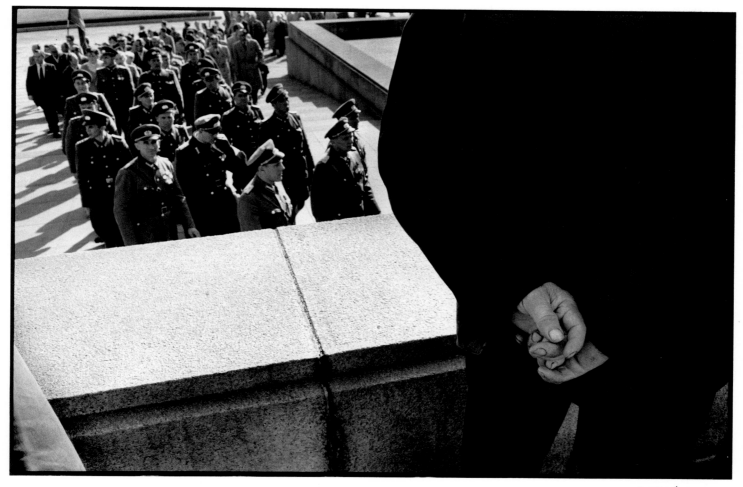

RENÉ BURRI

Left: *Homecoming of prisoners of war, Vienna, 1947.*
Above: *East German soldiers at the Russian War Memorial, East Berlin, 1959.*

DAVID SEYMOUR (Chim)

Above: *The Monte Cassino abbey, destroyed by German bombs, Monte Cassino, Italy, 1948.*
Right: *Überlingen am Bodensee, West Germany, 1965.*

LEONARD FREED

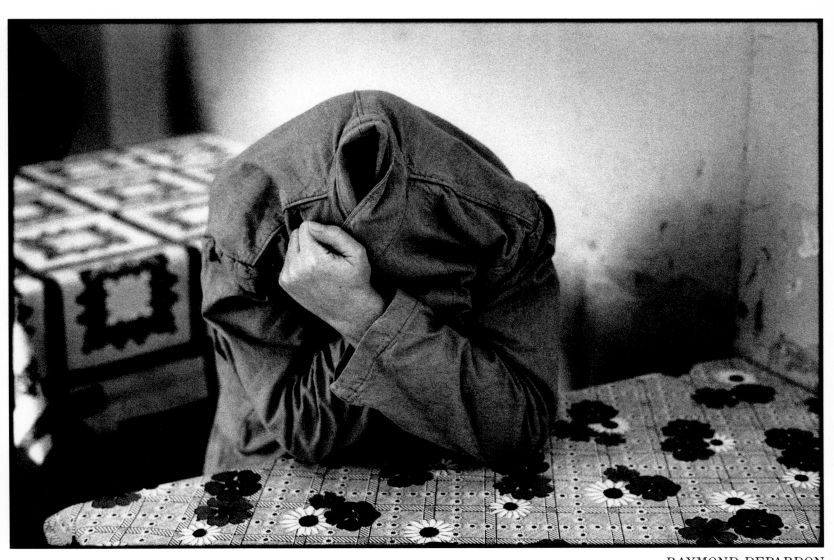

RAYMOND DEPARDON

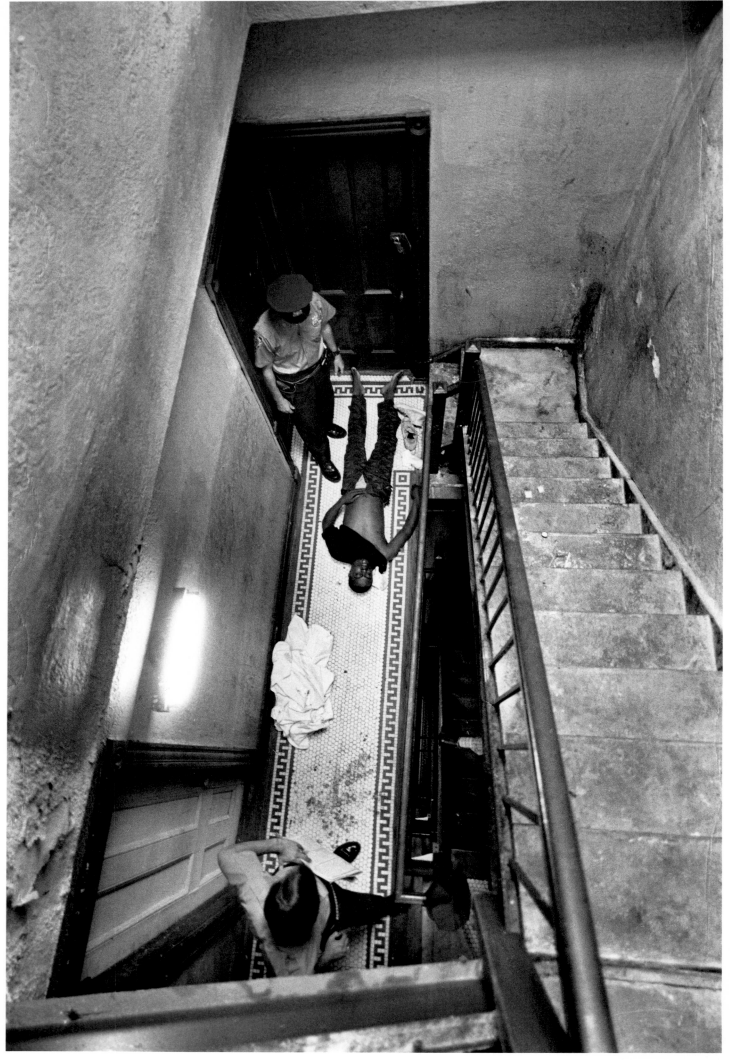

LEONARD FREED

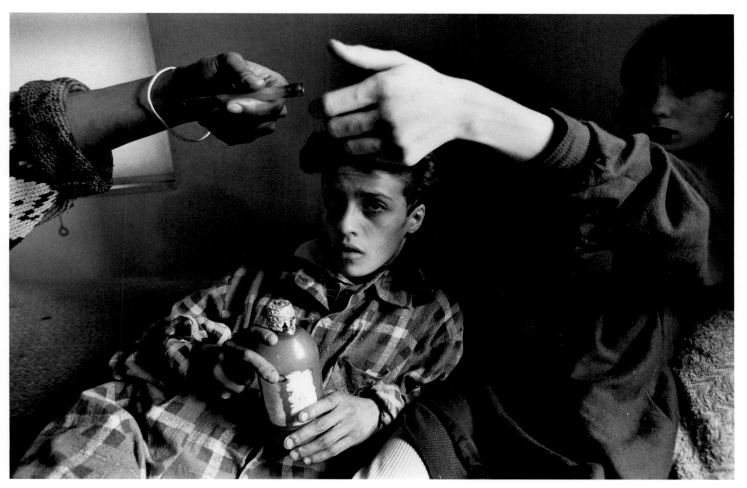

EUGENE RICHARDS

Page 107: *Asylum, Turin, Italy, 1979.*
Left: *Dead on arrival, Harlem, 1972.*
Above: *Crack den, New York City, 1988.*

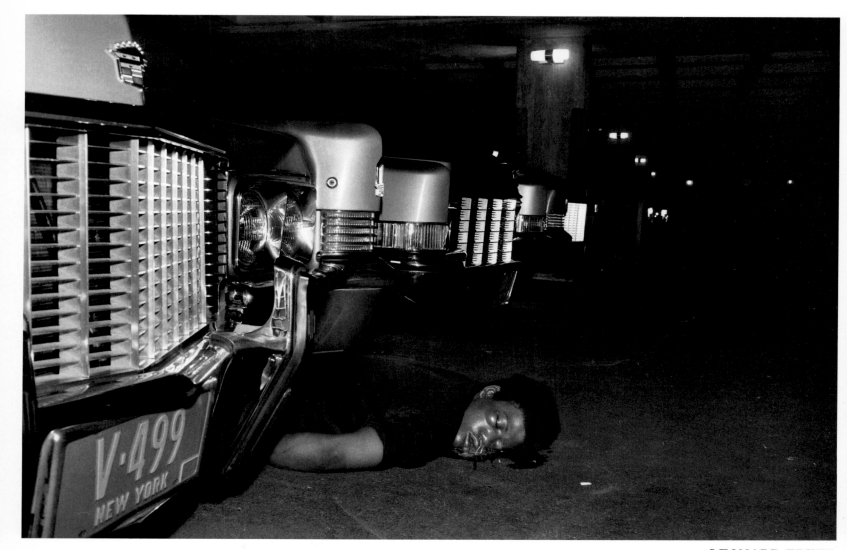

LEONARD FREED

Above: *Mob slaying, Harlem, New York, 1972.*
Right: *Harlem, New York, 1963.*
Overleaf: *Subway, New York City, 1979.*

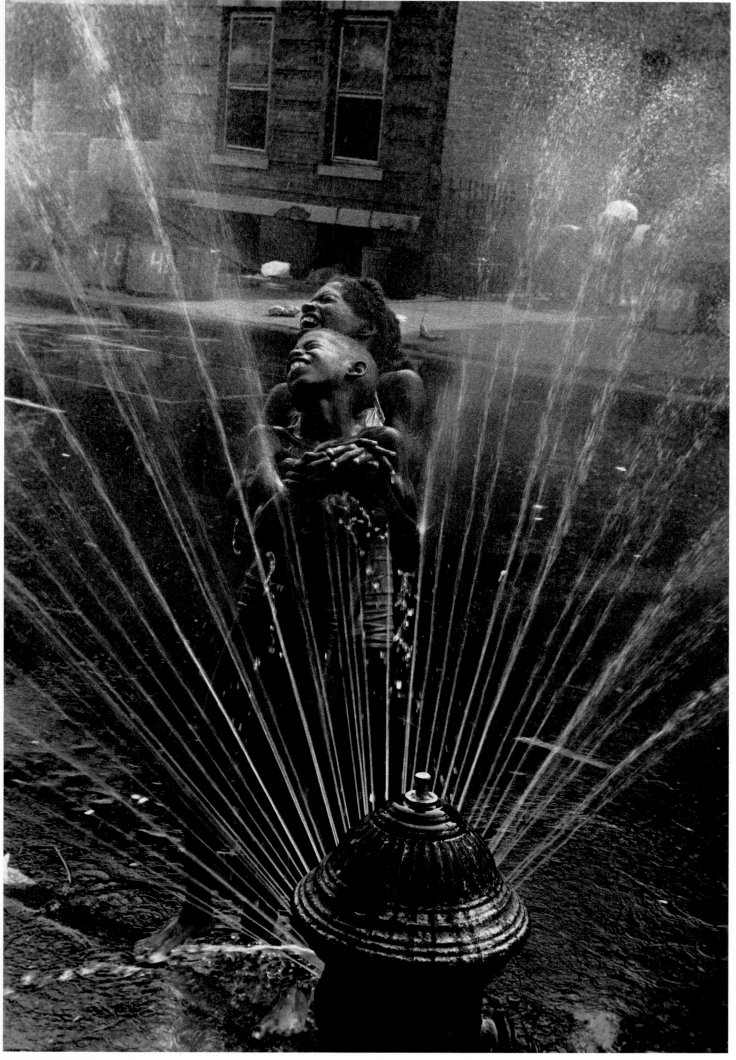

111

LEONARD FREED

BRUCE DAVIDSON

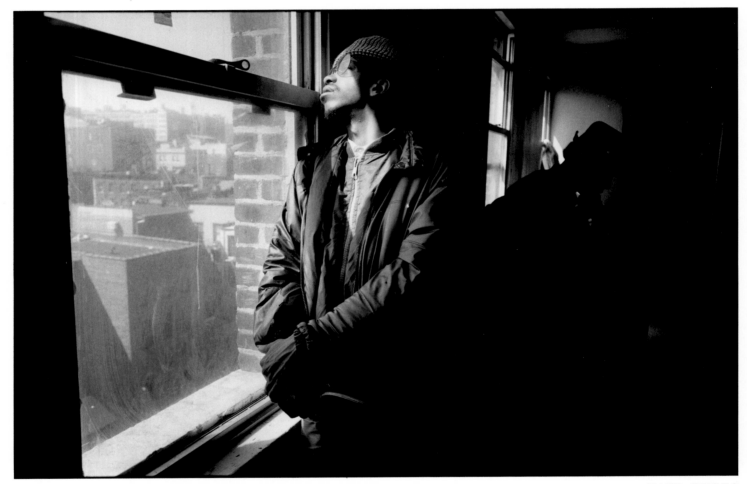

PAUL FUSCO

Above: *Single men's shelter, New York City, 1986.*
Right: *Harlem, New York, 1963*

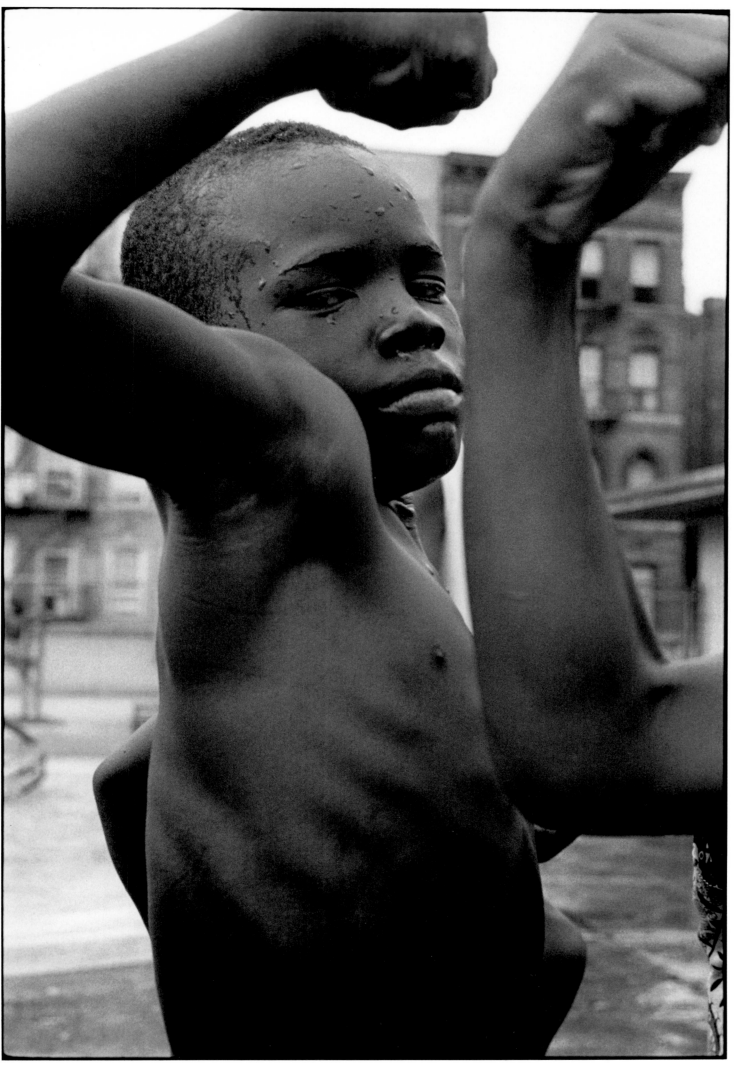

115

LEONARD FREED

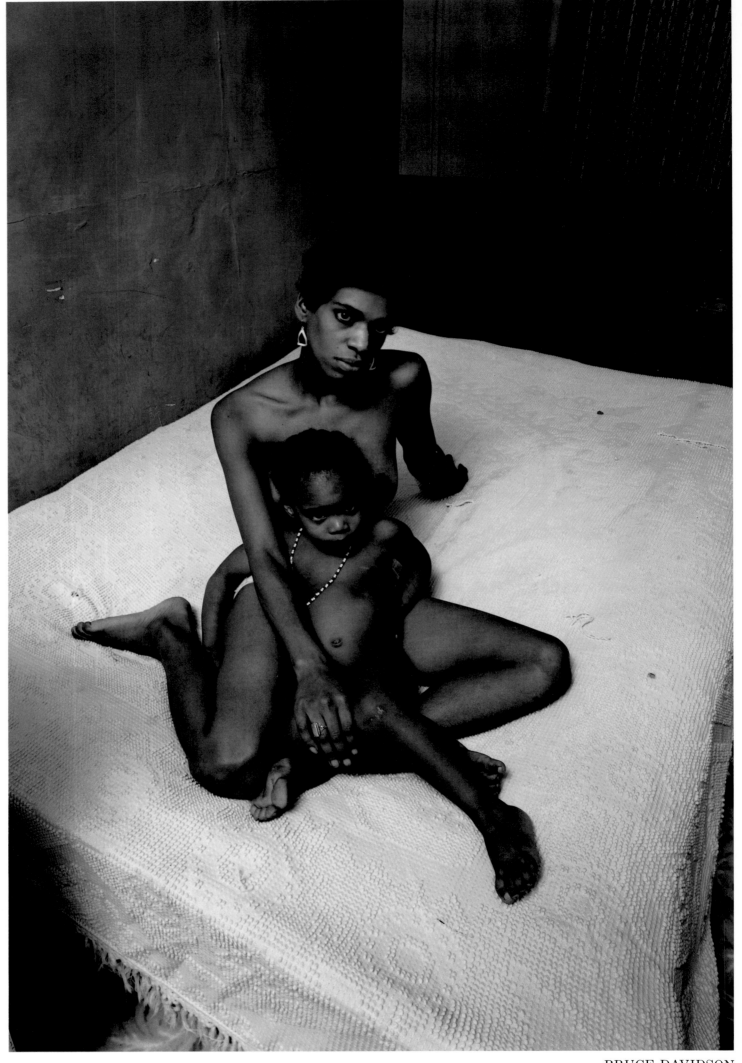

116

BRUCE DAVIDSON

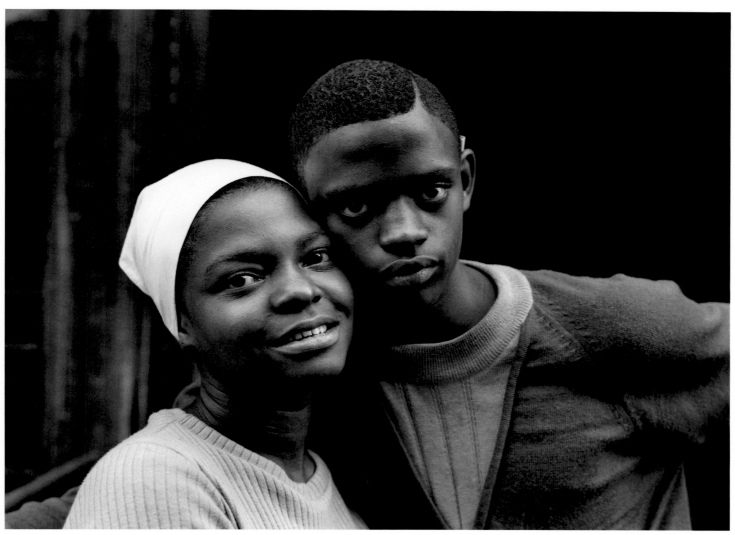

BRUCE DAVIDSON

Left: *East 100th Street, New York City, 1966.*
Above: *East 100th Street, New York City, 1966.*
Overleaf: *Ill sharecropper, Hughes, Arkansas, 1986.*

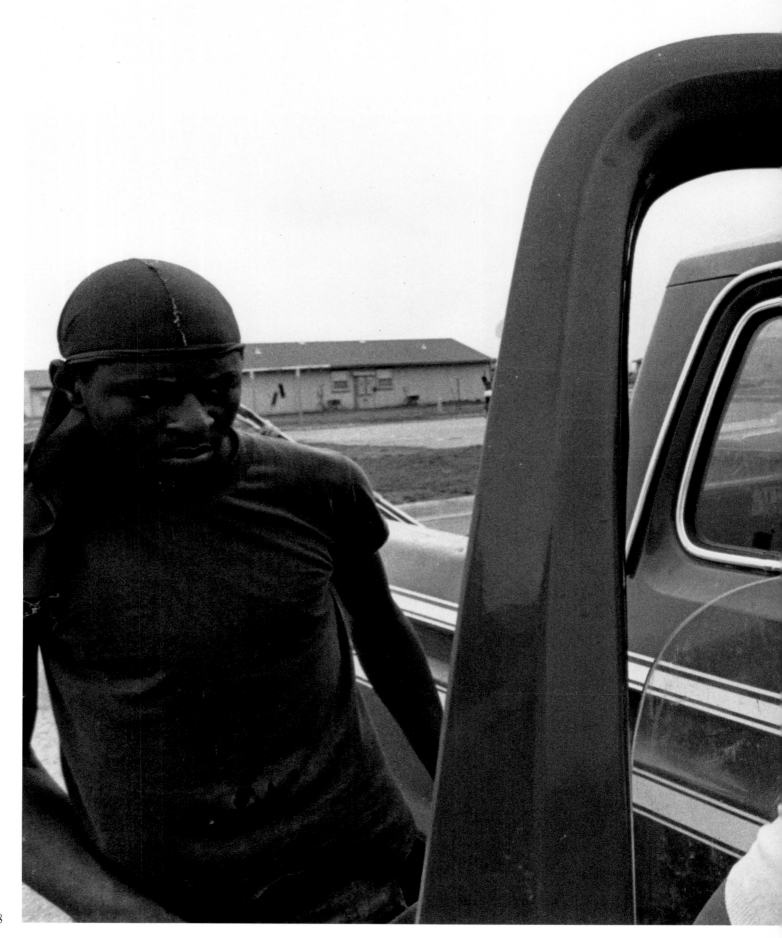

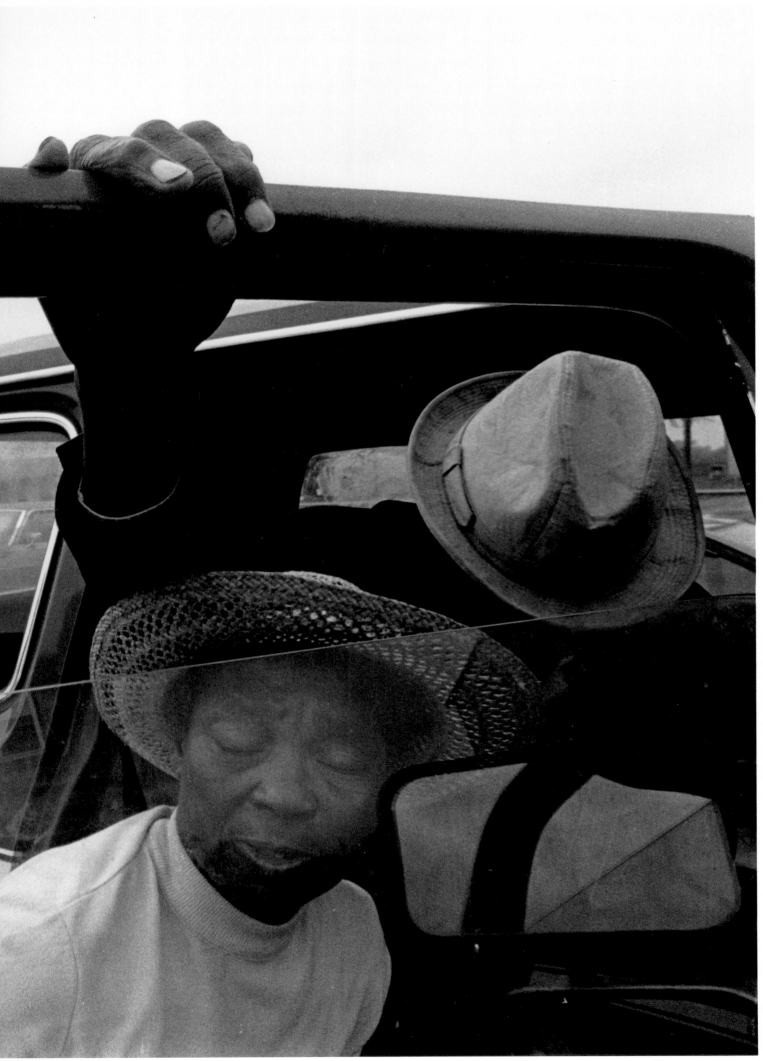

119

EUGENE RICHARDS

RAYMOND DEPARDON

Above: *Asylum, Trieste, Italy, 1977.*
Right: *Suspect in the back of a police car, New York City, 1978.*
Overleaf: *Asylum, Naples, Italy, 1979.*

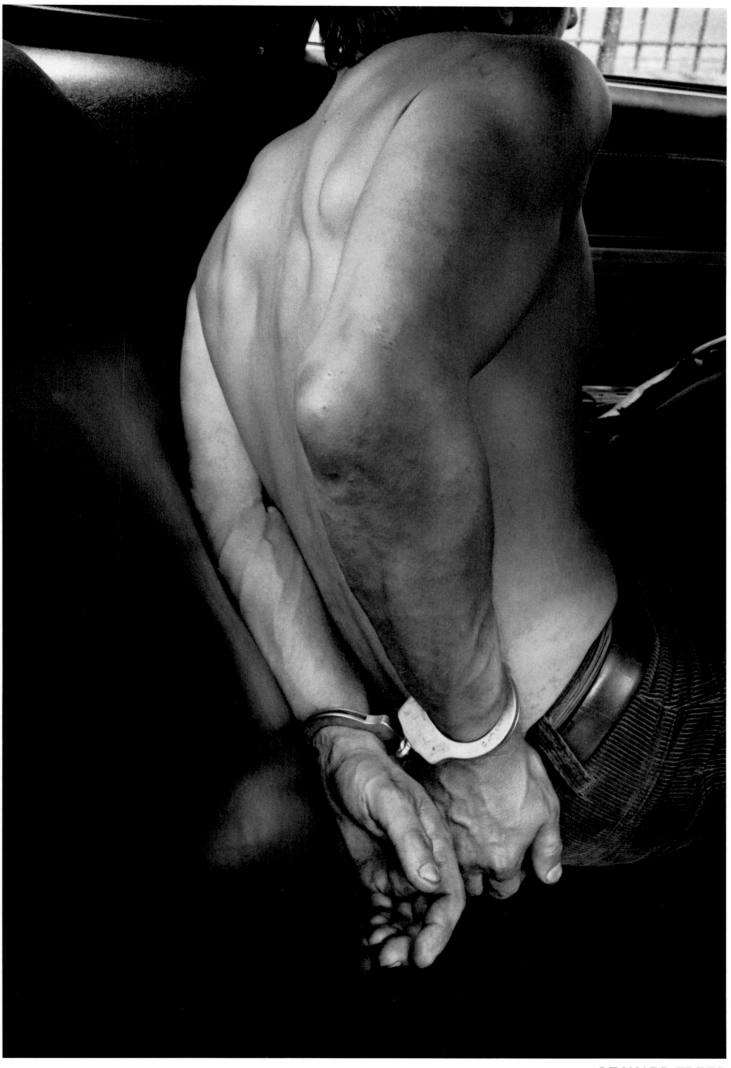

121

LEONARD FREED

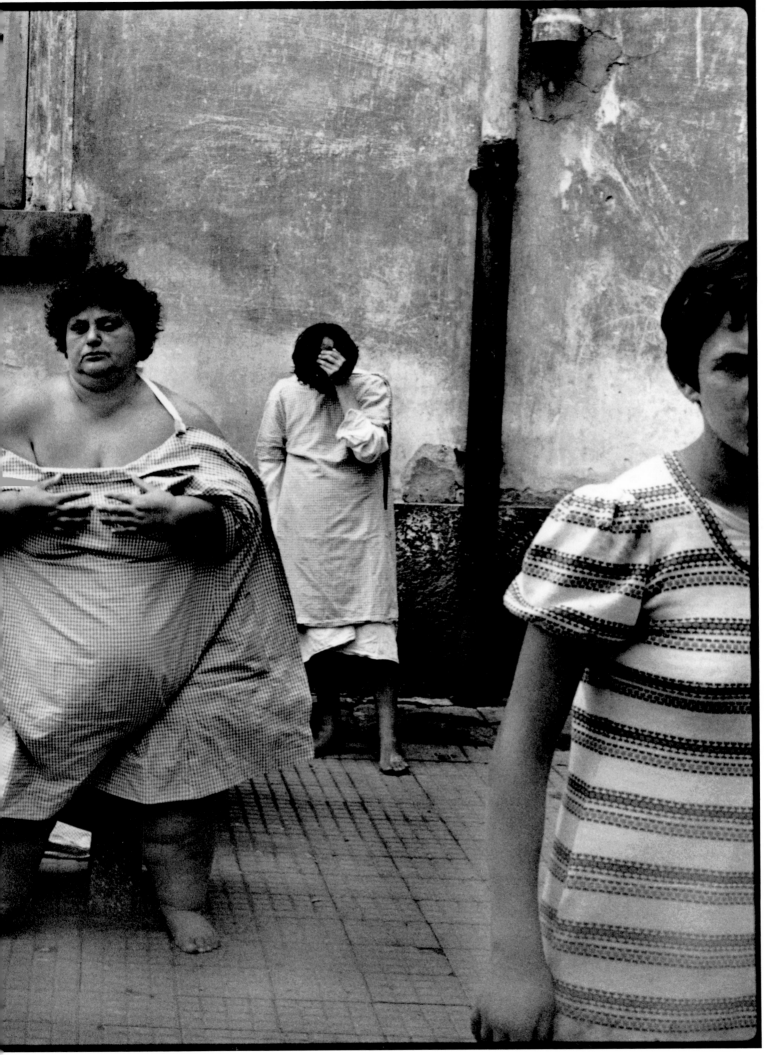

123

RAYMOND DEPARDON

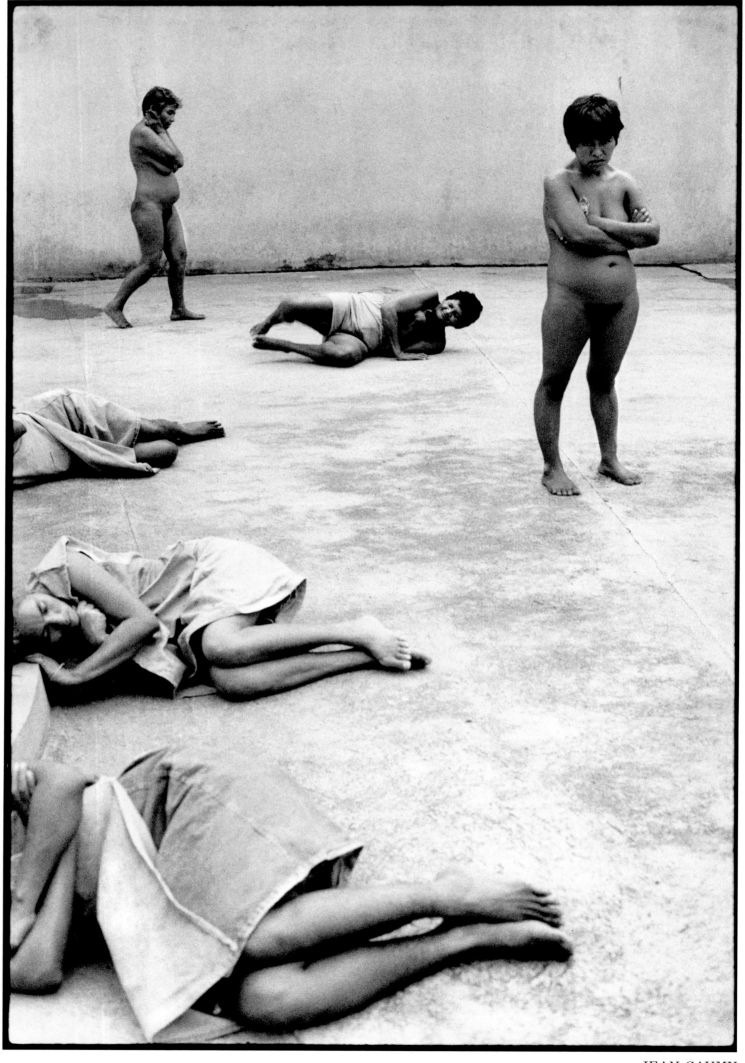

124

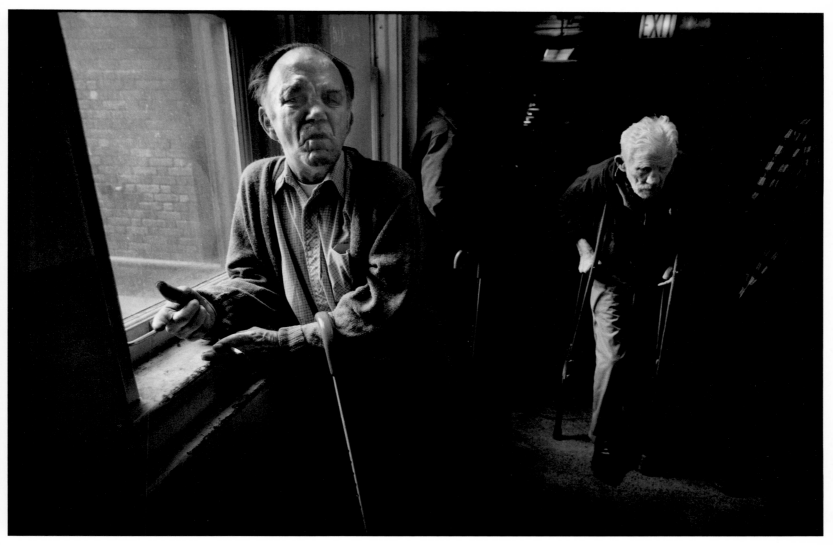

PAUL FUSCO

Left: *Psychiatric hospital of Soyapongo, San Salvador, El Salvador, 1985.*
Above: *Shelter for homeless men, New York State, 1986.*
Overleaf: *Single women's shelter, New York City, 1986.*
Pages 128–129: *Hospital for the criminally insane, Lima, Ohio, 1982.*

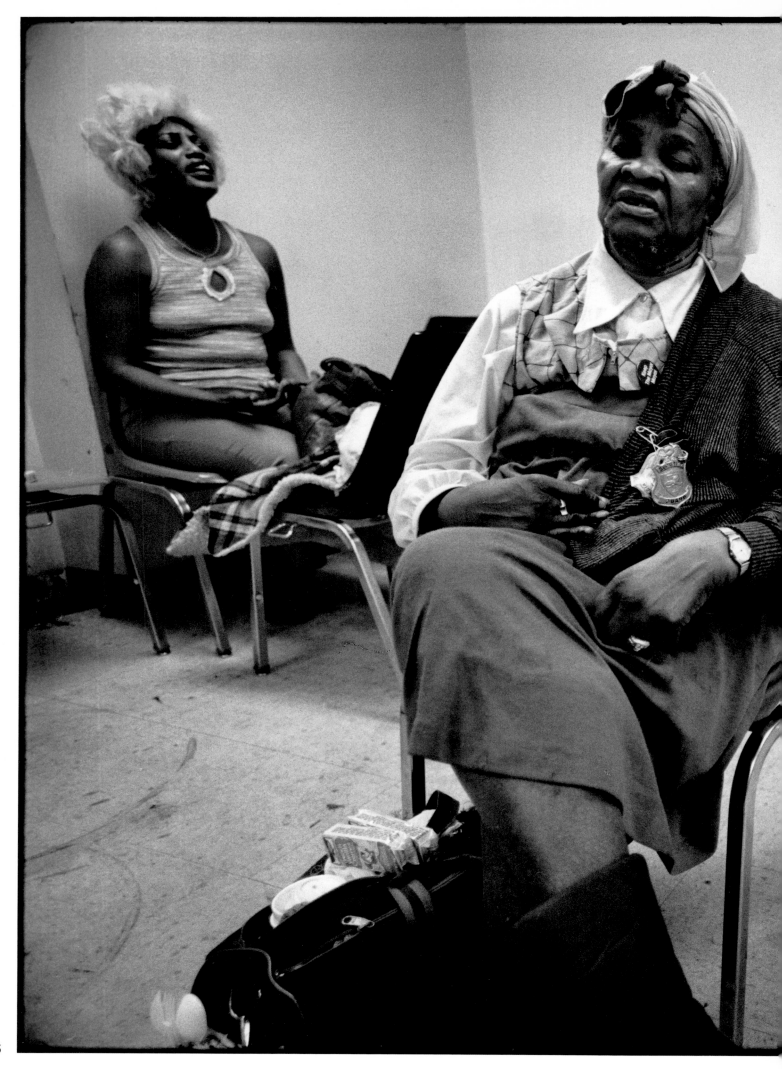

127

PAUL FUSCO

129

EUGENE RICHARDS

RICHARD KALVAR

RICHARD KALVAR

Page 131: *Paris, 1974.*
Above: *New York, 1979.*
Right: *Shopping center, Washington, D.C., 1961.*
Overleaf: *Rome, 1980.*

133

BURK UZZLE

135

RICHARD KALVAR

136

DAVID HURN

GUY LE QUERREC

Left: *M.G. car owner's ball, Edinburgh, Scotland, 1967.*
Above: *Le Palace, Paris, 1980.*
Overleaf: Bal du rat mort, *Oostende, Belgium, 1979.*

139

HARRY GRUYAERT

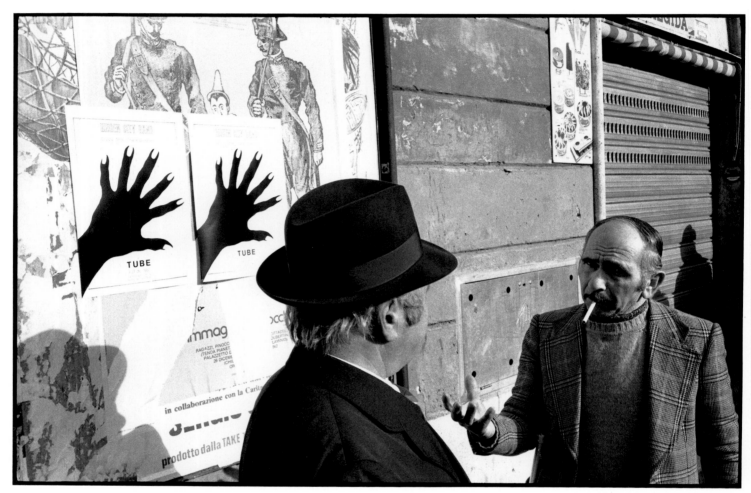

RICHARD KALVAR

Above: *Rome, 1982.*
Right: *Outside of Tiffany's, New York City, 1981.*
Overleaf: *The Royal Toxophilite Society, London, 1965.*

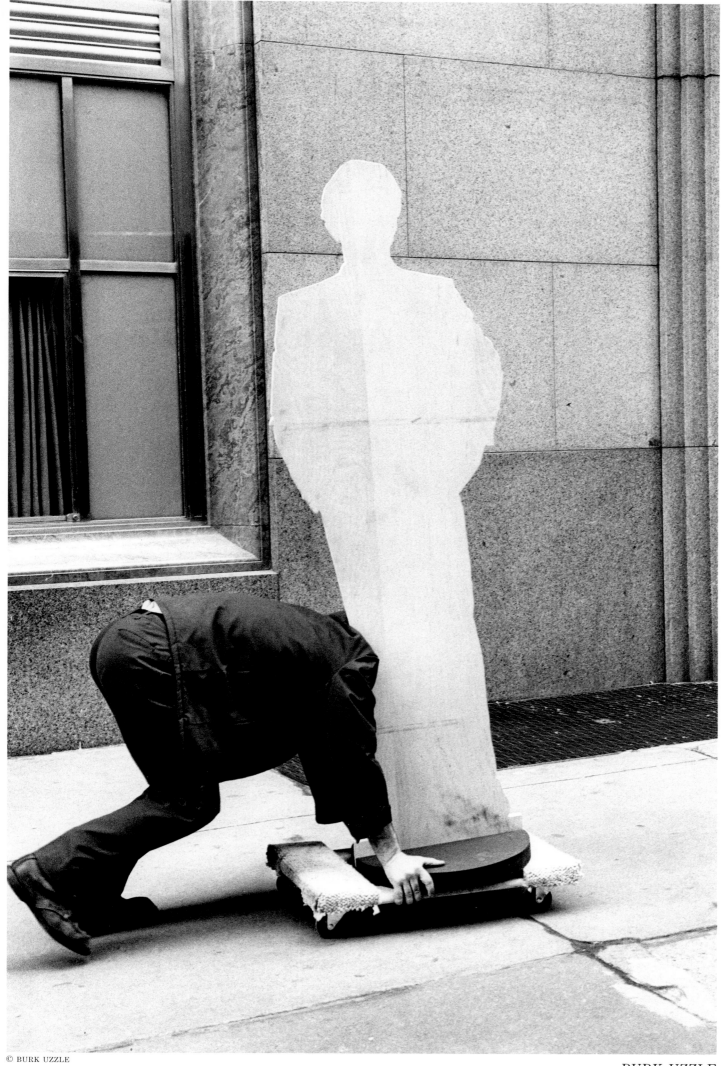

141

BURK UZZLE

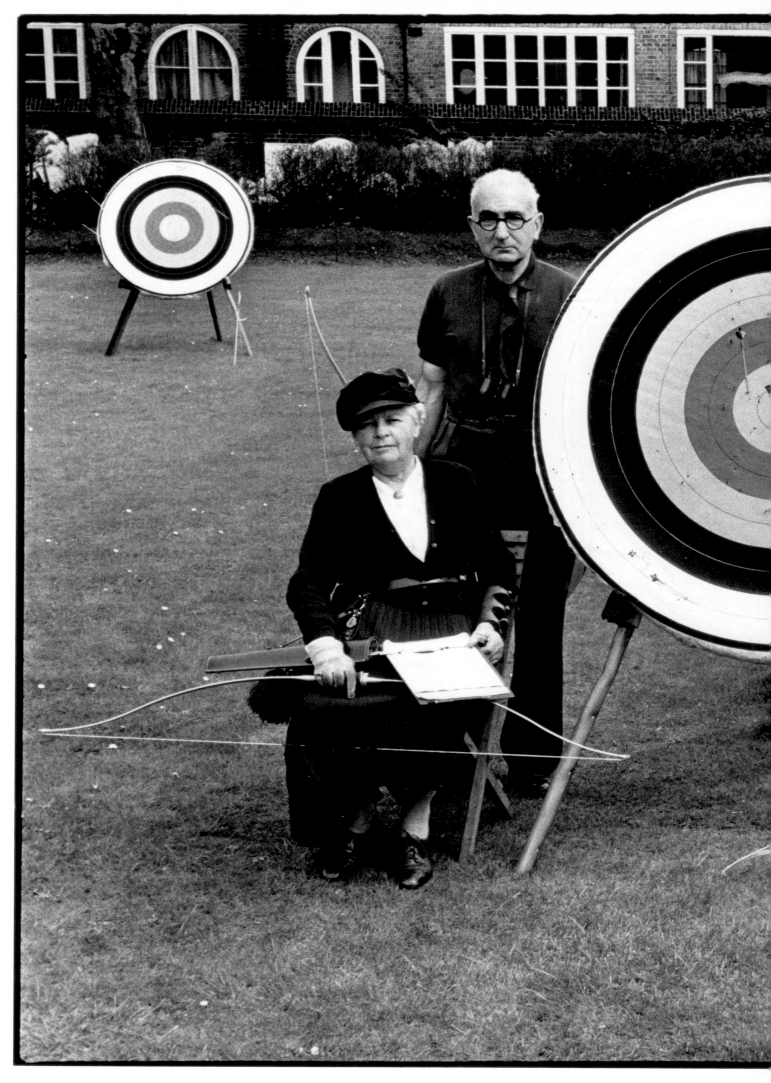

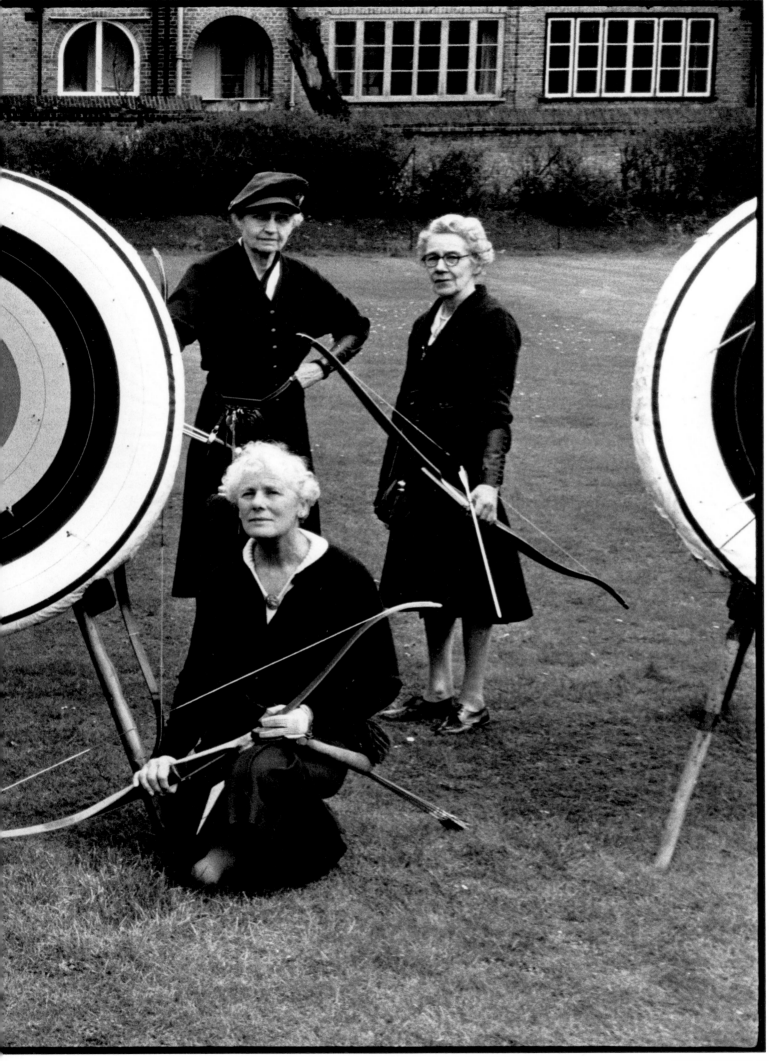

143

EVE ARNOLD

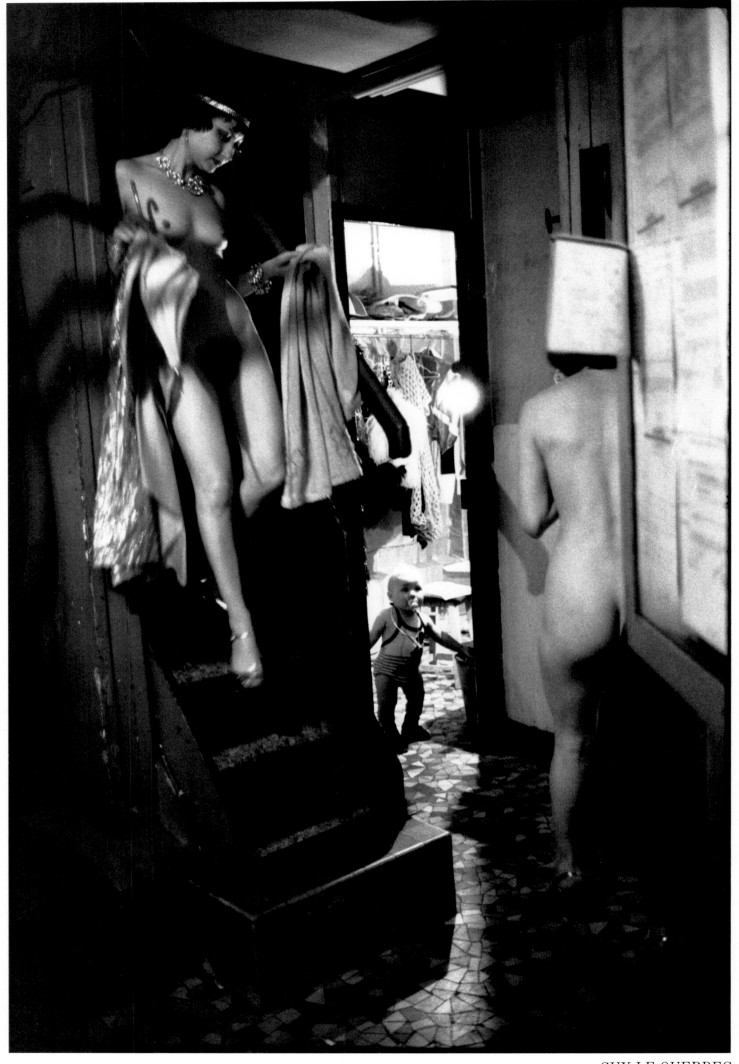

144

GUY LE QUERREC

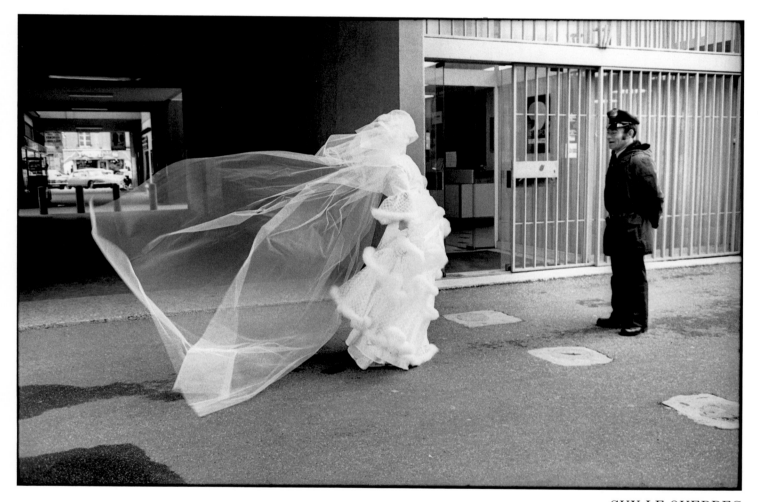

GUY LE QUERREC

Left: *Concert Mayol, Paris, 1979.*
Above: *Villejuif, Paris suburbs, 1975.*
Overleaf: *Naples, 1966.*

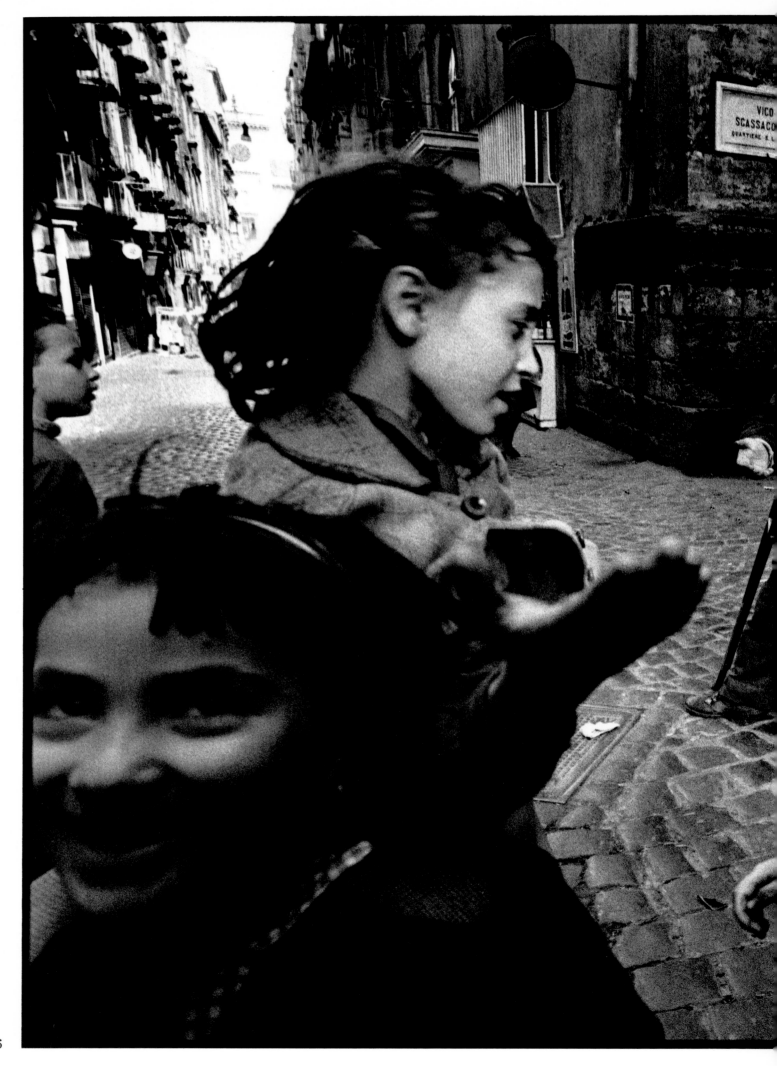

147

BRUNO BARBEY

148

RICHARD KALVAR

Left: *Ballycotton, Ireland, 1968.*
Above: *Rome, 1980.*

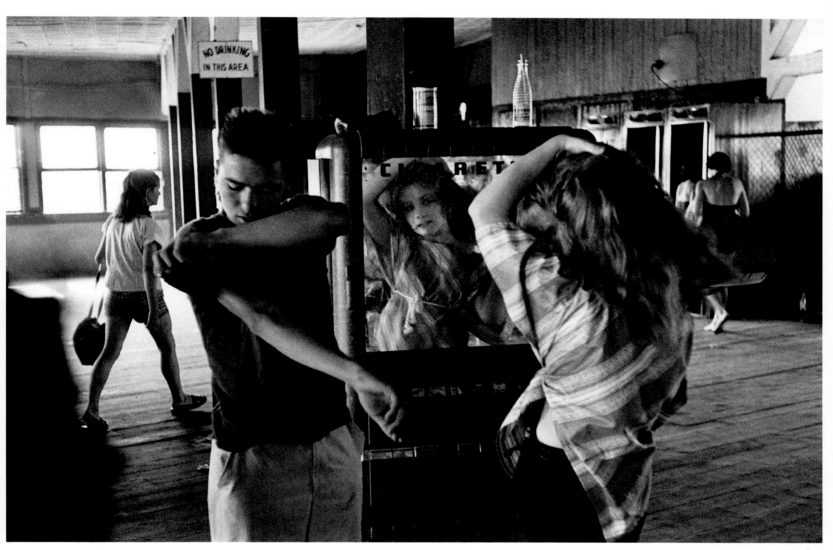

BRUCE DAVIDSON

151

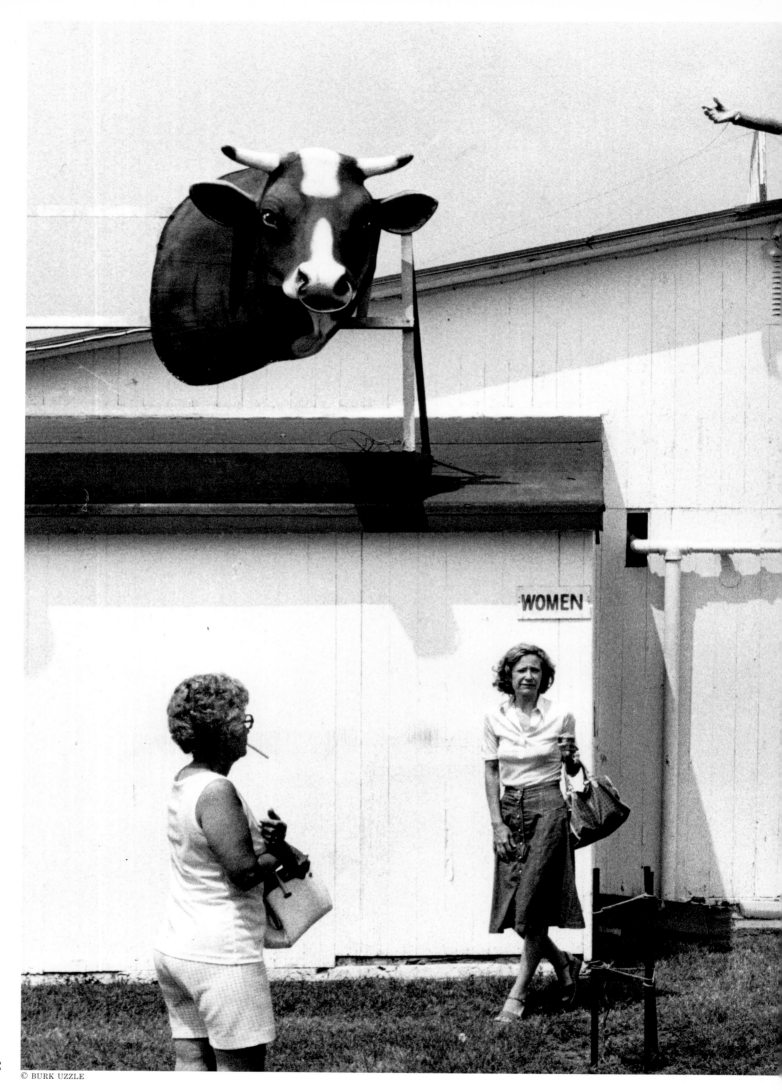

152

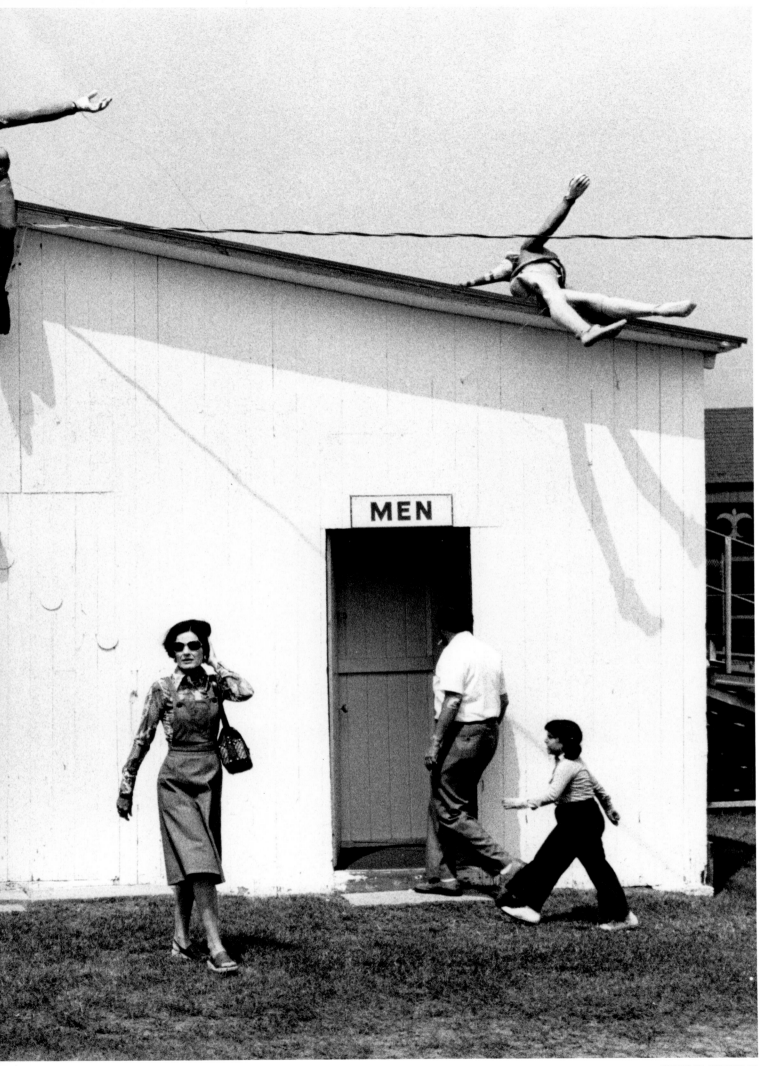

153

BURK UZZLE

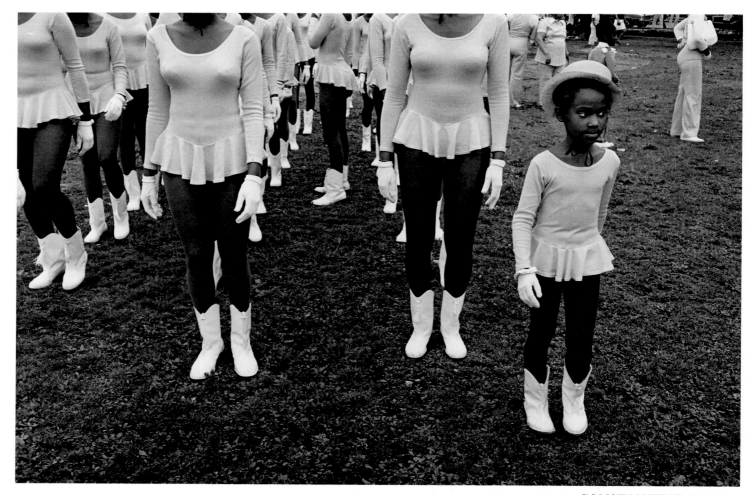

CONSTANTINE MANOS

Page 151: *Gang members, Brooklyn, New York, 1959.*
Pages 152–153: *County fair, Danbury, Connecticut, 1966.*
Above: *Shriner's Parade, South End, Boston, 1974.*
Right: *High school football game, Seattle, Washington, 1955.*

154

155

BURT GLINN

BURK UZZLE

156

CHARLES HARBUTT

Left: *Daytona Beach, Florida, 1963.*
Above: *Inauguration float, Washington, D.C., 1973.*
Overleaf: *Naval review, San Diego, California, 1982.*

159

ELLIOTT ERWITT

Above: *Pasadena, California, 1963.*
Right: *Onlookers at Goldwater's campaign headquarters,*
San Diego, California, 1964.
Overleaf: Fête Forain, *Zurich, 1980.*

BURT GLINN

163

RENÉ BURRI

ELLIOTT ERWITT

DAVID HURN

Left: *San Juan, Puerto Rico, 1978.*
Above: *Sun City, Arizona, 1980.*
Overleaf: *Le Brusc, south of France, 1976.*

MARTINE FRANCK

GILLES PERESS

Above: *Cannes Film Festival, France, 1985.*

JEAN GAUMY

Above: *Coney Island Aquarium, Brooklyn, New York, 1987.*
Overleaf: *Southern California, 1968.*

171

DENNIS STOCK

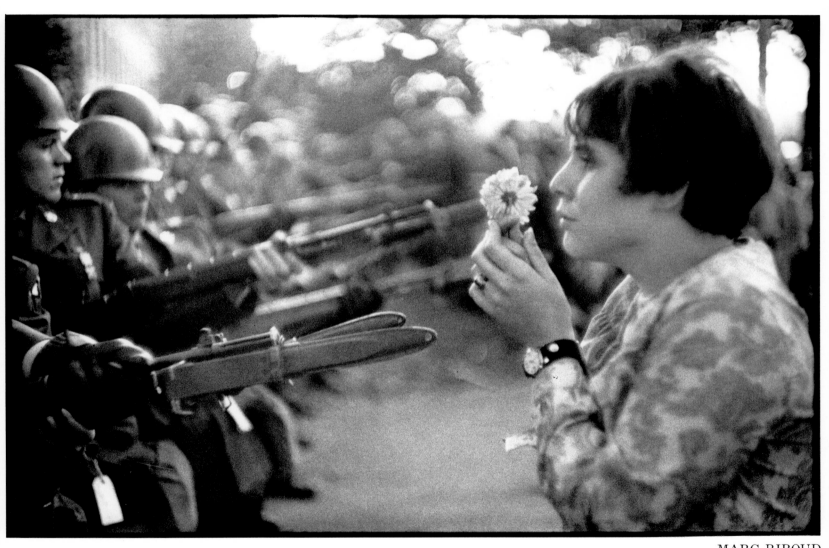

MARC RIBOUD

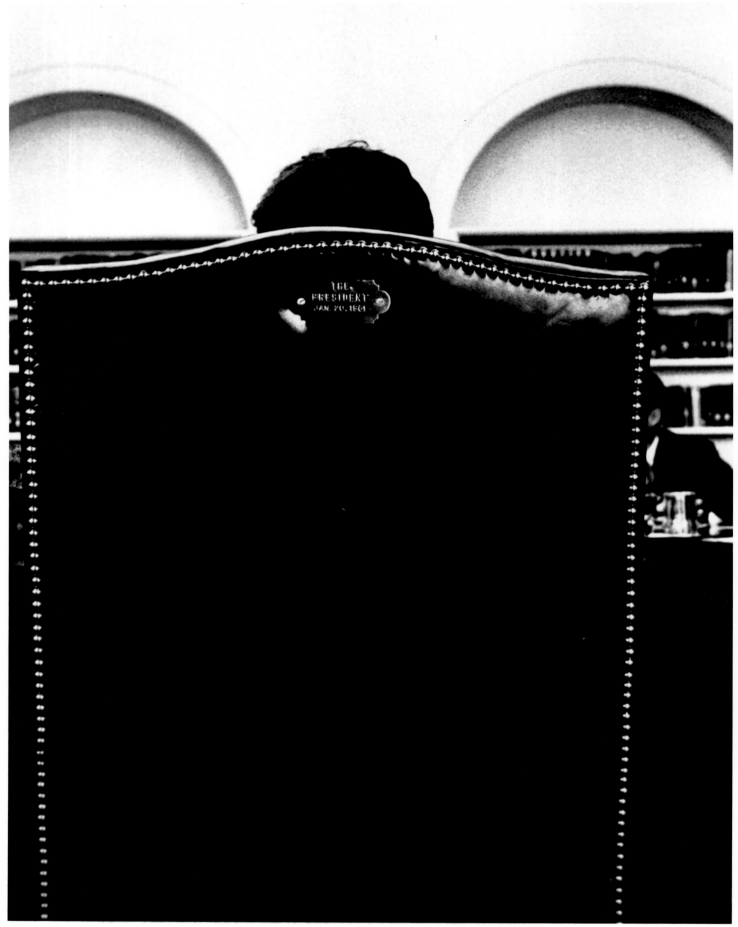

CORNELL CAPA

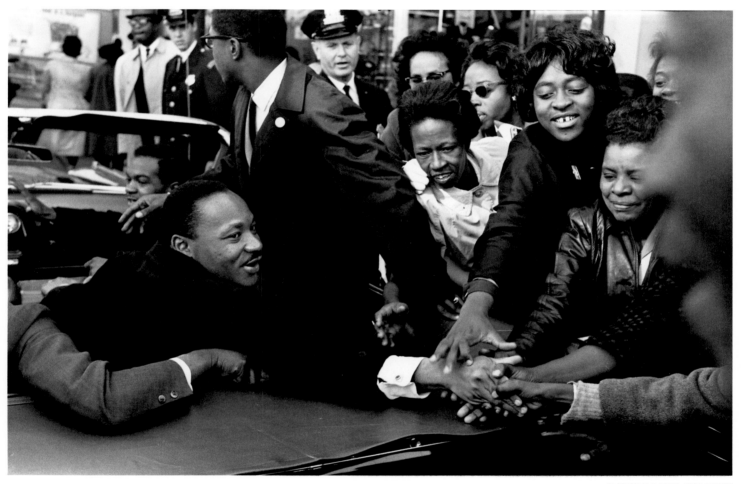

LEONARD FREED

Page 173: *Peace march, Washington, D.C., 1967.*
Left: *John F. Kennedy, Washington, D.C., 1961.*
Above: *Martin Luther King, Jr., after receiving the Nobel Peace Prize,*
Baltimore, 1963.

CONSTANTINE MANOS

Above: *Country church, Daufuskie Island, South Carolina, 1952.*
Right: *Ladies' Bible class in a storefront church, Chicago, 1946.*
Overleaf: *Republican Convention, Kansas City, Missouri, 1976.*

177

WAYNE MILLER

179

GILLES PERESS

ERICH HARTMANN

Above: *Poll watchers, Atlanta, Georgia, 1980.*
Right: *Nikita Khrushchev in front of the Lincoln Memorial,*
Washington, D.C., 1959.

BURT GLINN

182

MARK GODFREY

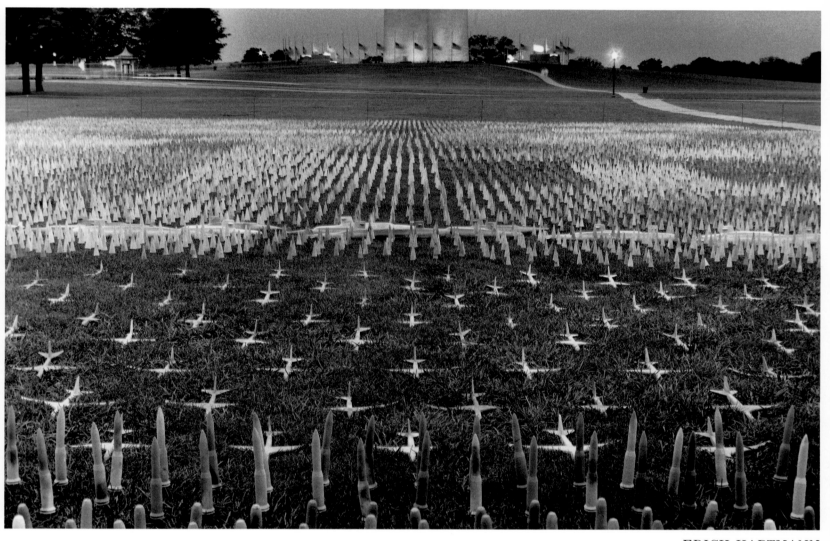

ERICH HARTMANN

Left: *A State of the Union Address, House of Representatives,*
Washington, D.C., 1976.
Above: *Antimilitary demonstration at the Washington Monument,*
Washington, D.C., 1987.

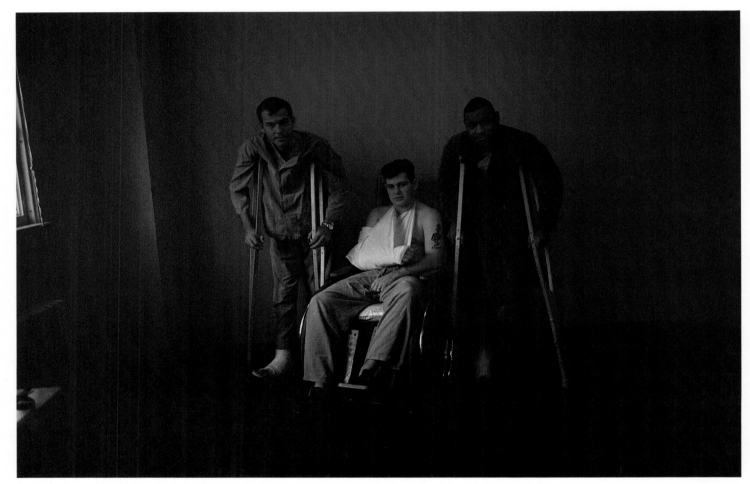

EVE ARNOLD

Above: *Returning veterans from Vietnam, Fort Bragg, North Carolina, 1967.*
Right: *Aunt at the funeral of her nephew killed in Vietnam,*
South Carolina, 1966.

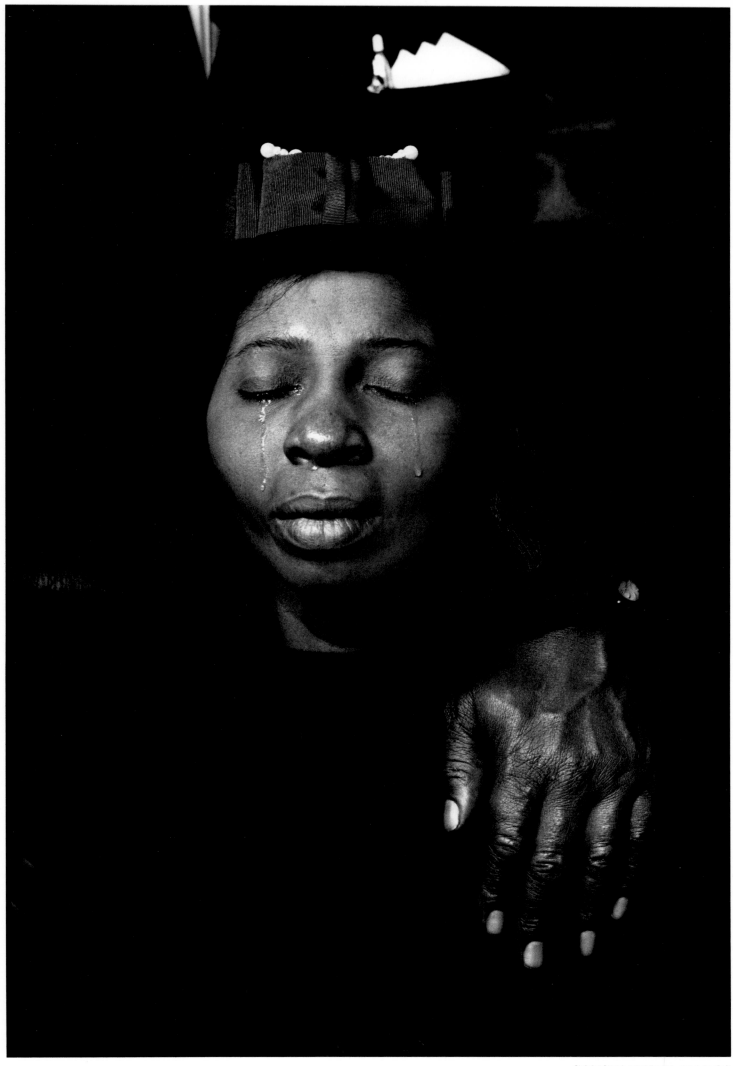

185

CONSTANTINE MANOS

PETER MARLOW

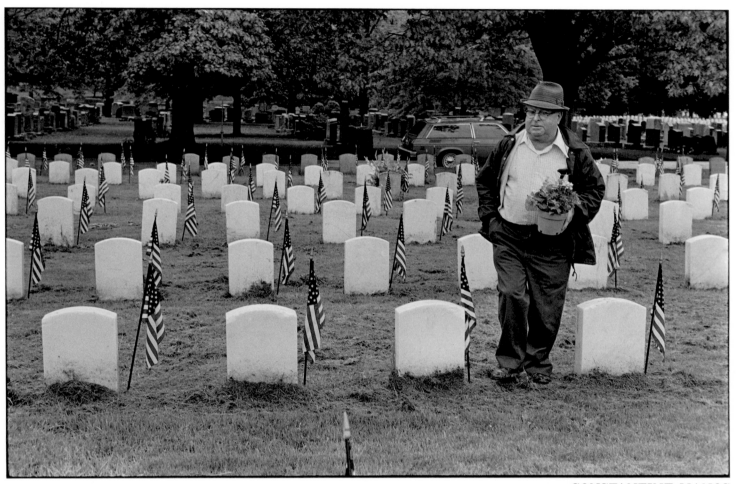

CONSTANTINE MANOS

Left: *Vietnam War Memorial, Washington, D.C., 1985.*
Above: *Memorial Day in a cemetery, Boston, 1974.*
Overleaf: *Seventh Avenue, New York City, 1986.*

ELI REED

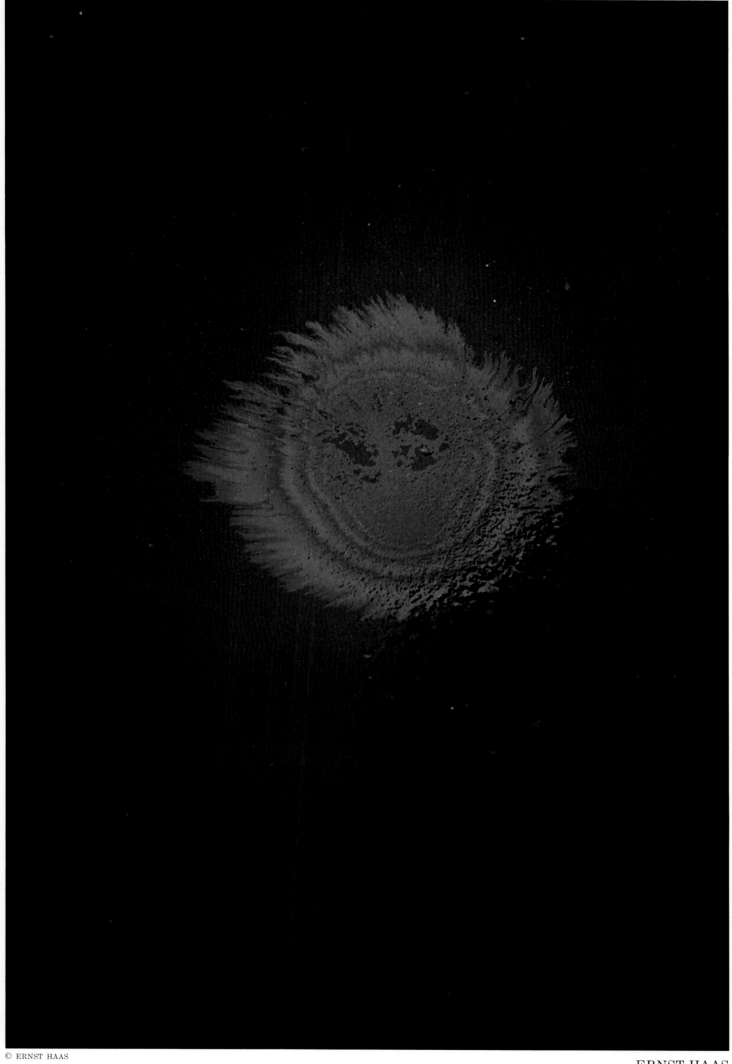

191

ERNST HAAS

192

ERNST HAAS

194

ERICH HARTMANN

Page 191: *Oil spill, New York City, 1952.*
Pages 192–193: *Reflection, Third Avenue, New York City, 1952.*
Left: *Rio de Janeiro, 1960.*
Above: *Paris, 1982.*

RENÉ BURRI

199

ERICH HARTMANN

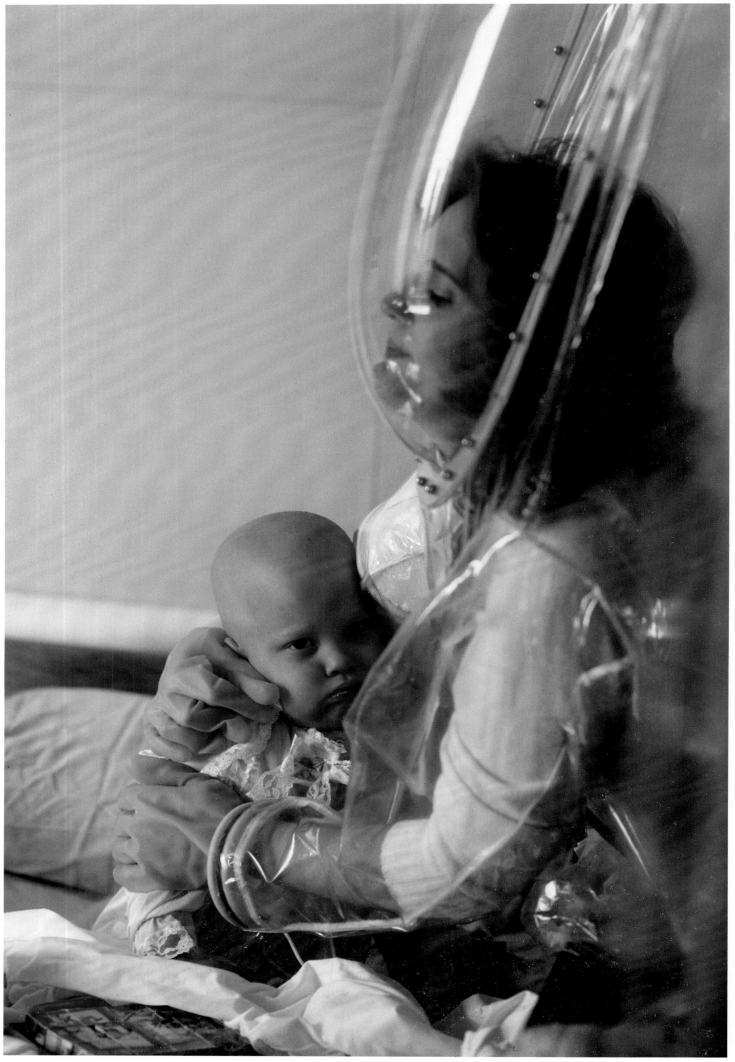

200

BURT GLINN

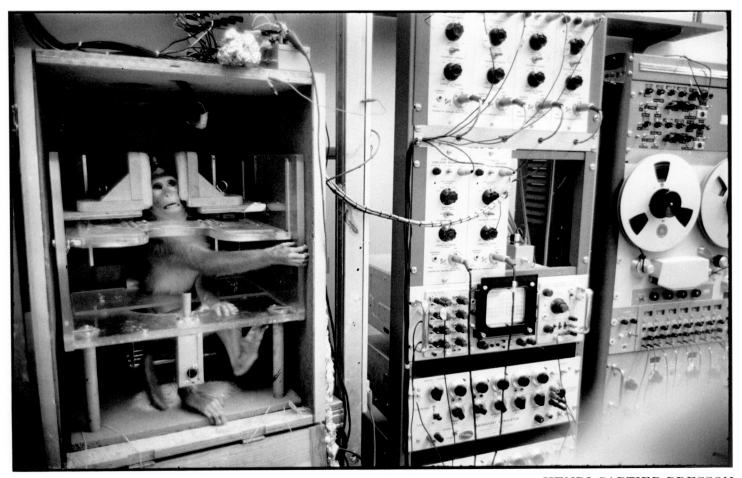

HENRI CARTIER-BRESSON

Pages 196–197: *São Paulo, 1960.*
Pages 198–199: *Power amplifiers for an IBM computer, 1982.*
Left: *Freddy Hutchinson Cancer Hospital, Seattle, Washington, 1985.*
Above: *Berkeley, California, 1967.*

201

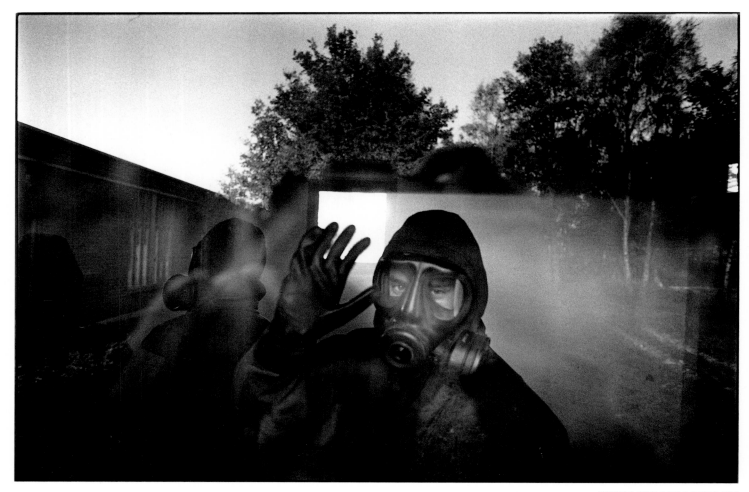

STUART FRANKLIN

Above: *Nuclear exercise at the Purbright Military Academy,*
Surrey, England, 1987.
Right: *New York City, 1977.*
Overleaf: *Traffic, New York City, 1963.*

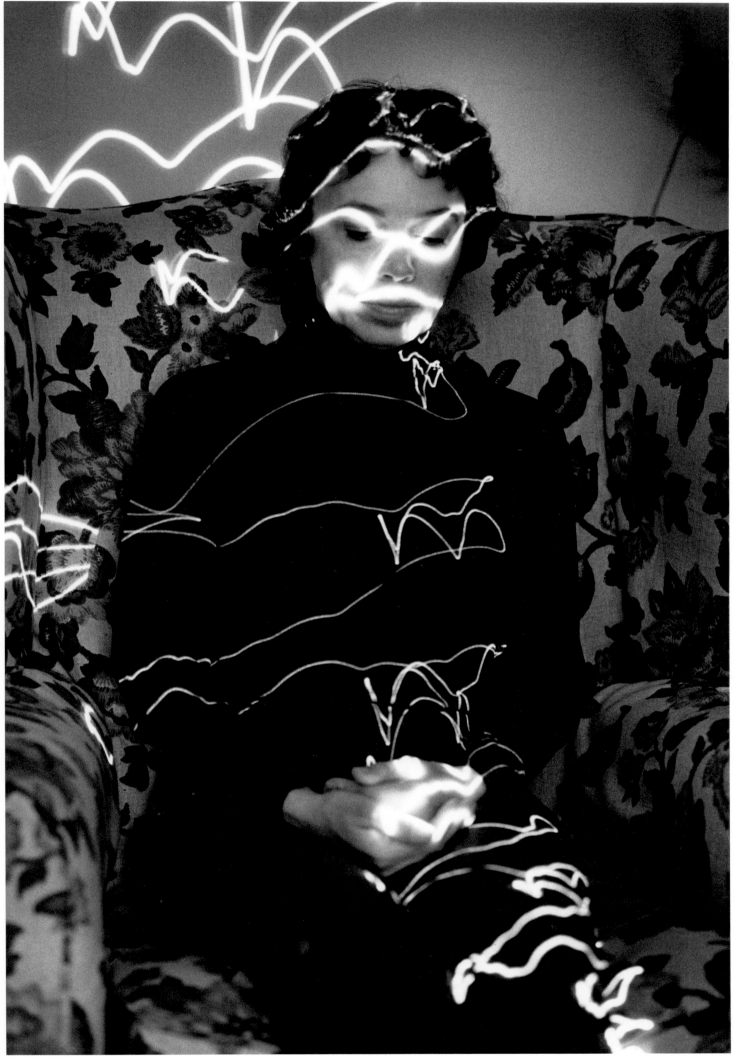

ERICH HARTMANN

204

ERNST HAAS

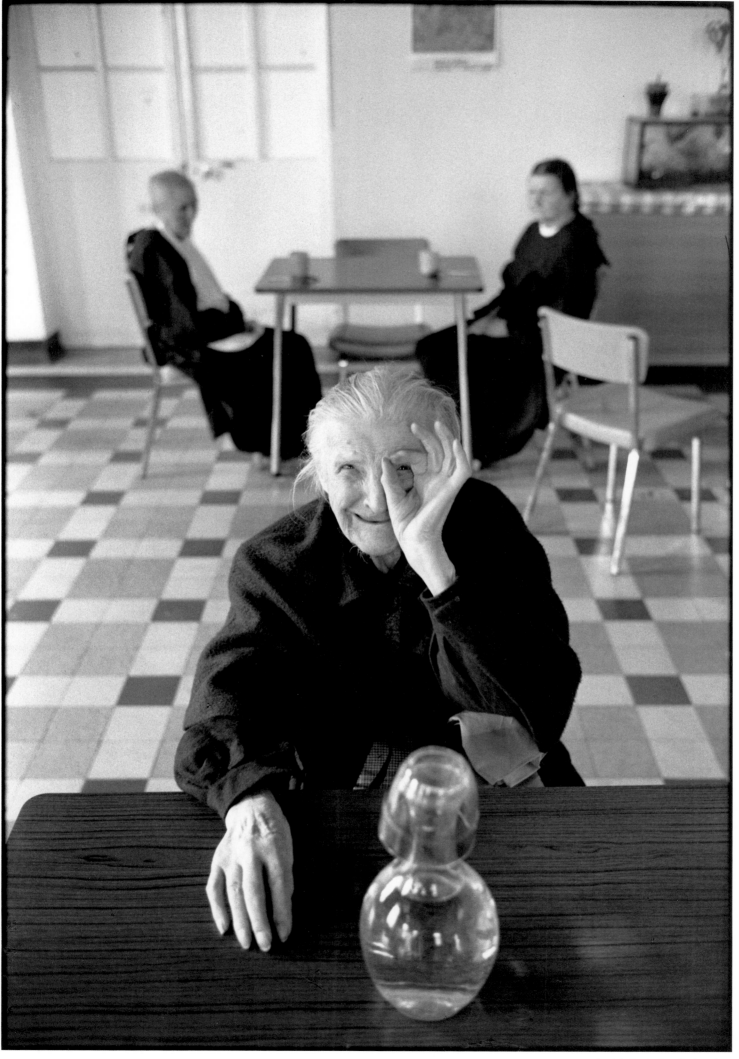

207

MARTINE FRANCK

208

STUART FRANKLIN

Page 207: *Old-age home, Ivry-sur-Seine, France, 1975.*
Left: *M. Friedman, electrician and Yiddish poet, with his wife, Paris, 1981.*
Above: *Children in a housing estate, Moss Side, Manchester, 1986.*

WAYNE MILLER

Above: *Westminster Dog Show, New York City, 1953.*
Right: *Castle Pub, London, 1976.*
Overleaf: *Junior ballroom dancing at the Savoy Ballroom,*
Bargoed, Wales, 1973.

211

CHRIS STEELE-PERKINS

213

DAVID HURN

214

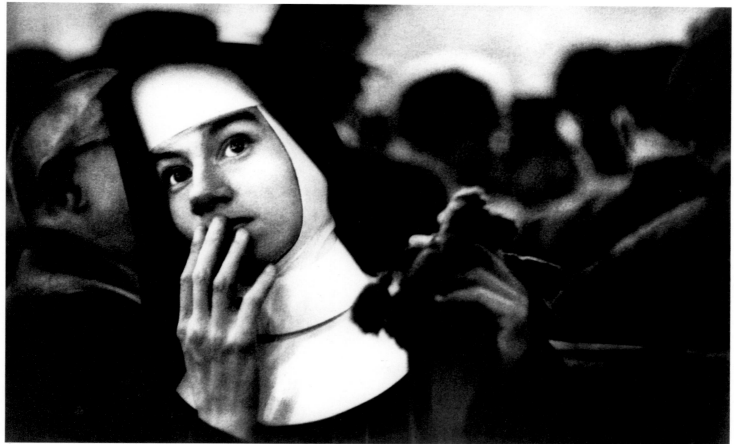

© W. EUGENE SMITH

W. EUGENE SMITH

Left: *Anniversary of the World War I armistice, France, 1977.*
Above: *Relief worker awaiting the arrival of survivors of the* Andrea Doria,
New York, 1956.

ELLIOTT ERWITT

Above: *New York City, 1974.*
Right: *M. and Mme. Boulogne, Villeurbanne highrise housing complex, France, 1984.*
Overleaf: *Village café, Lubéron, France, 1983.*

217

MARC RIBOUD

DENNIS STOCK

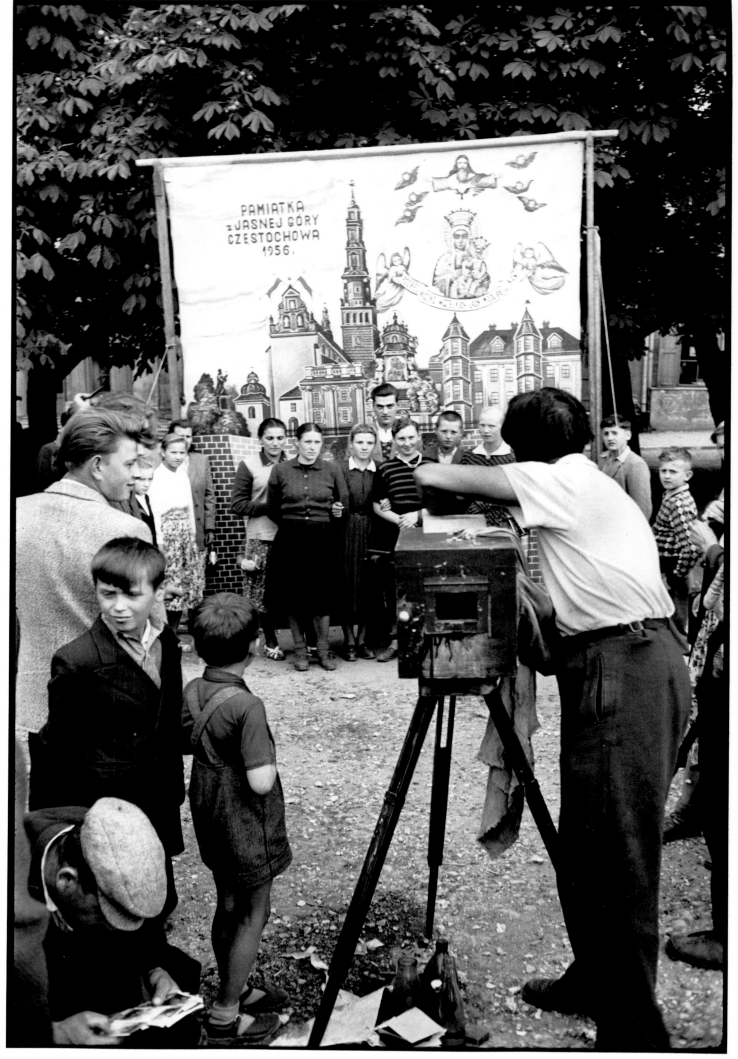

220

ERICH LESSING

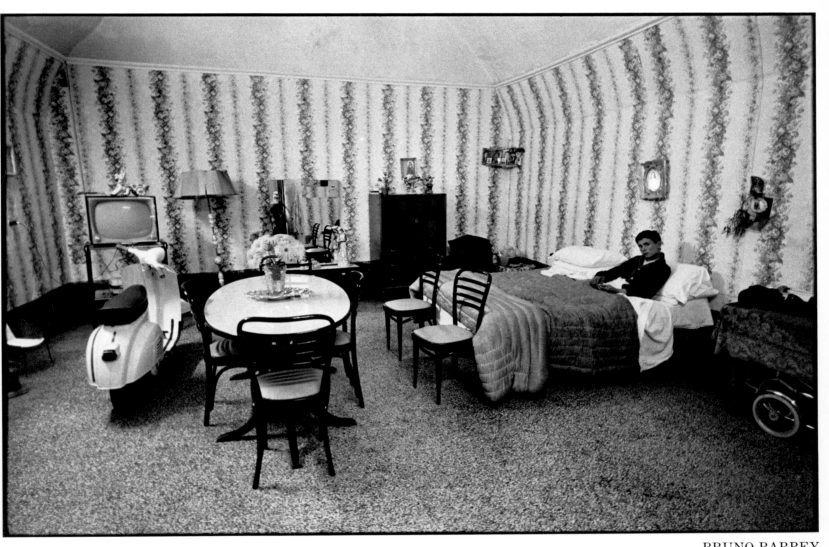

BRUNO BARBEY

Left: *Pilgrimage for the Black Virgin of Czestochowa, Poland, 1956.*
Above: *Naples, 1966.*

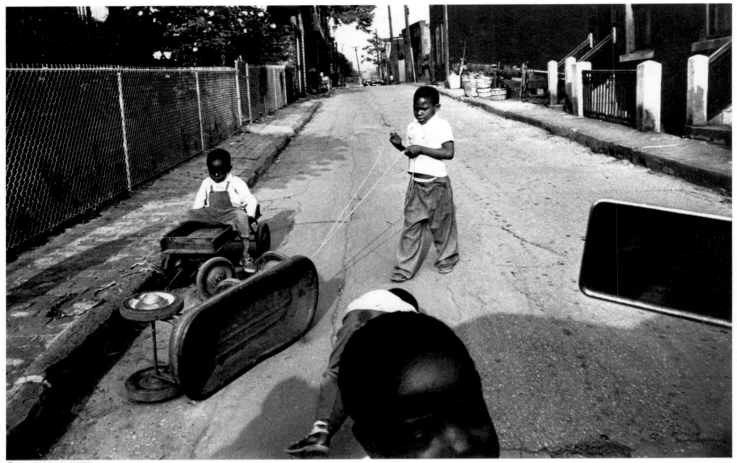

© W. EUGENE SMITH

W. EUGENE SMITH

Above: *Pittsburgh, 1955–56.*
Right: *Barcelona, Spain, 1951.*
Overleaf: *St. Paul's Church, Falls Road, Belfast, Northern Ireland, 1972.*

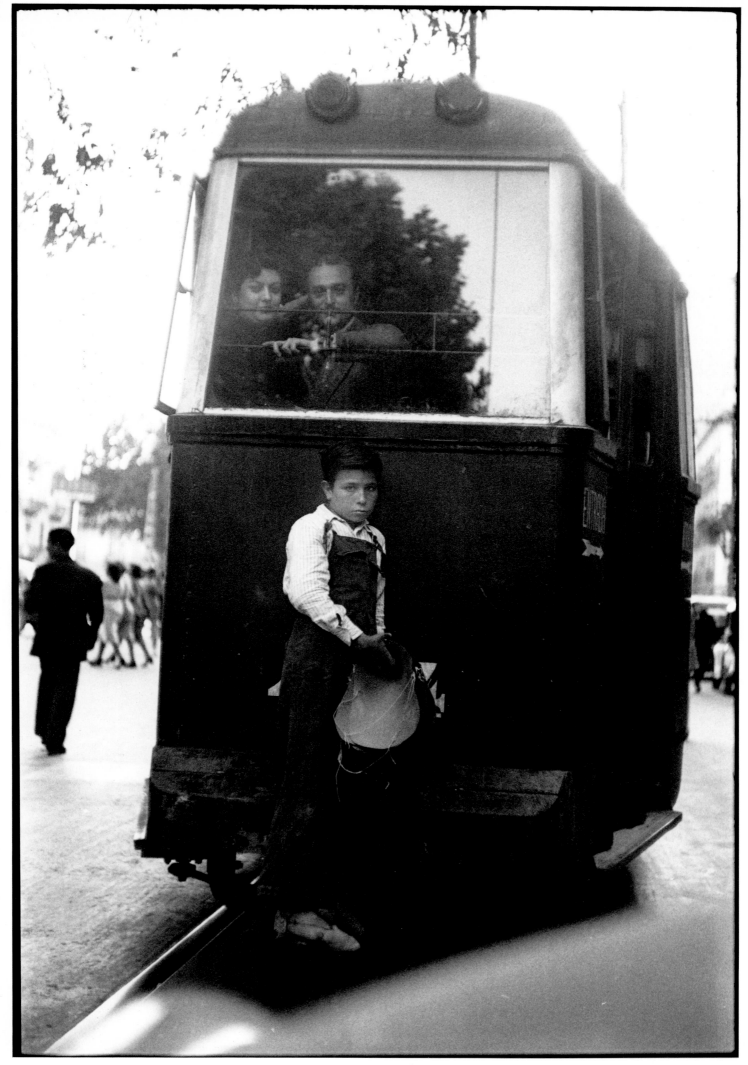

223

ELLIOTT ERWITT

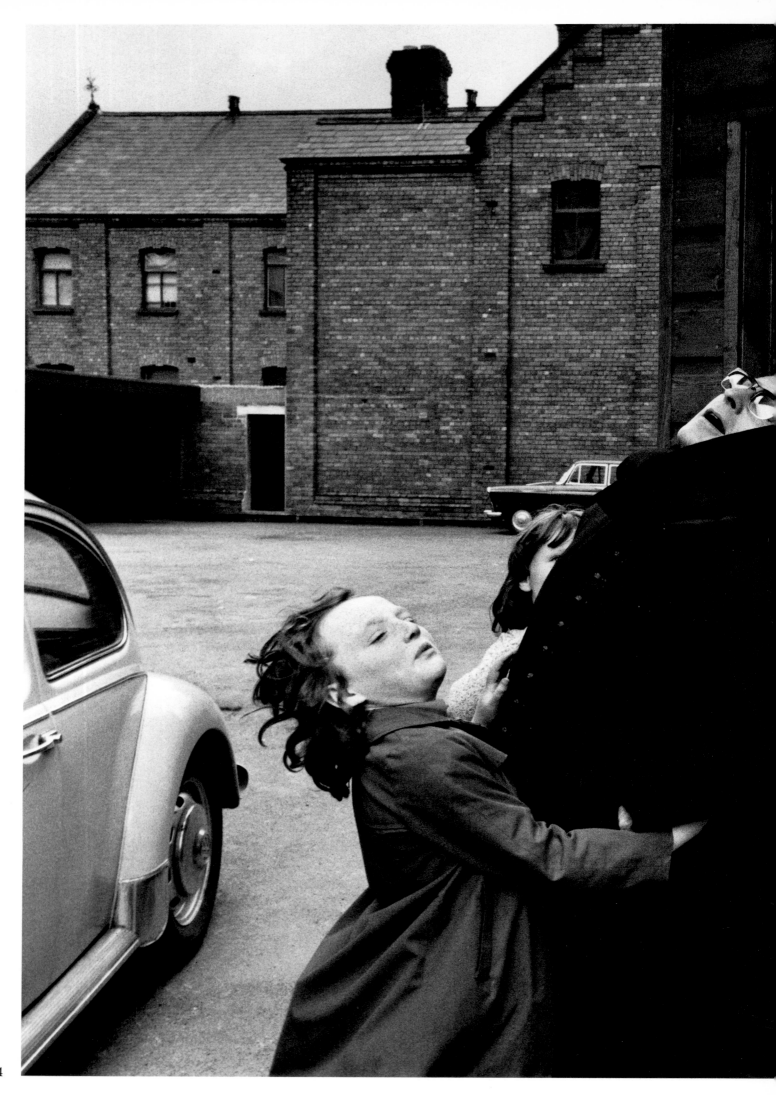

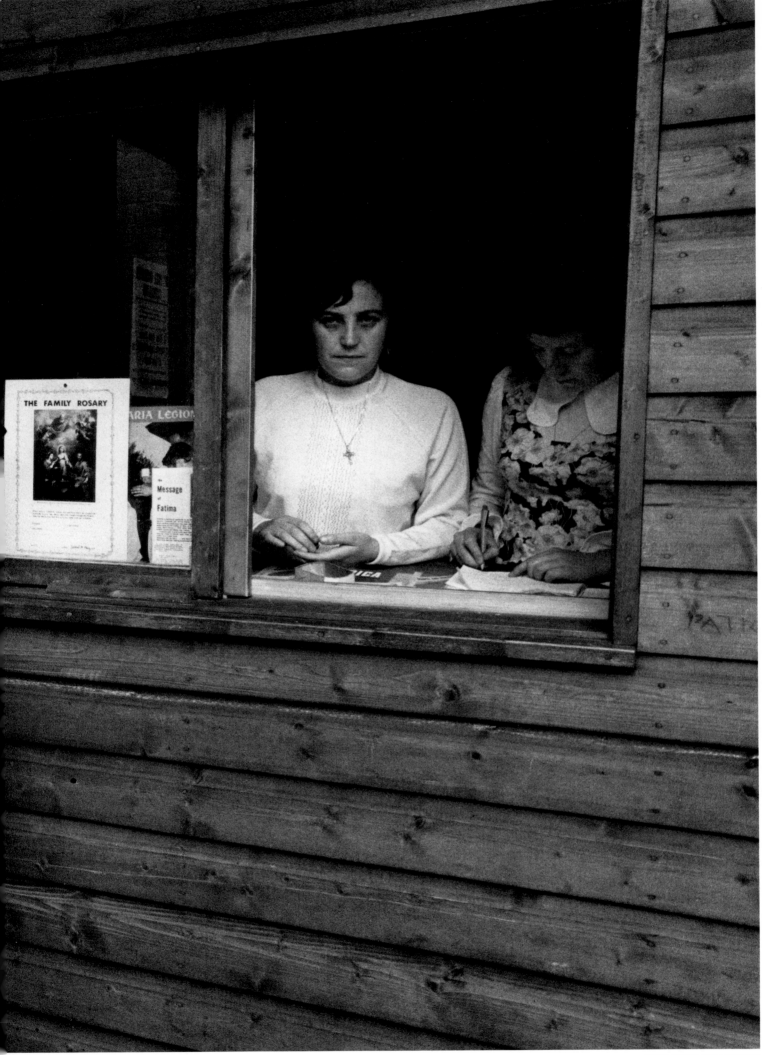

GILLES PERESS

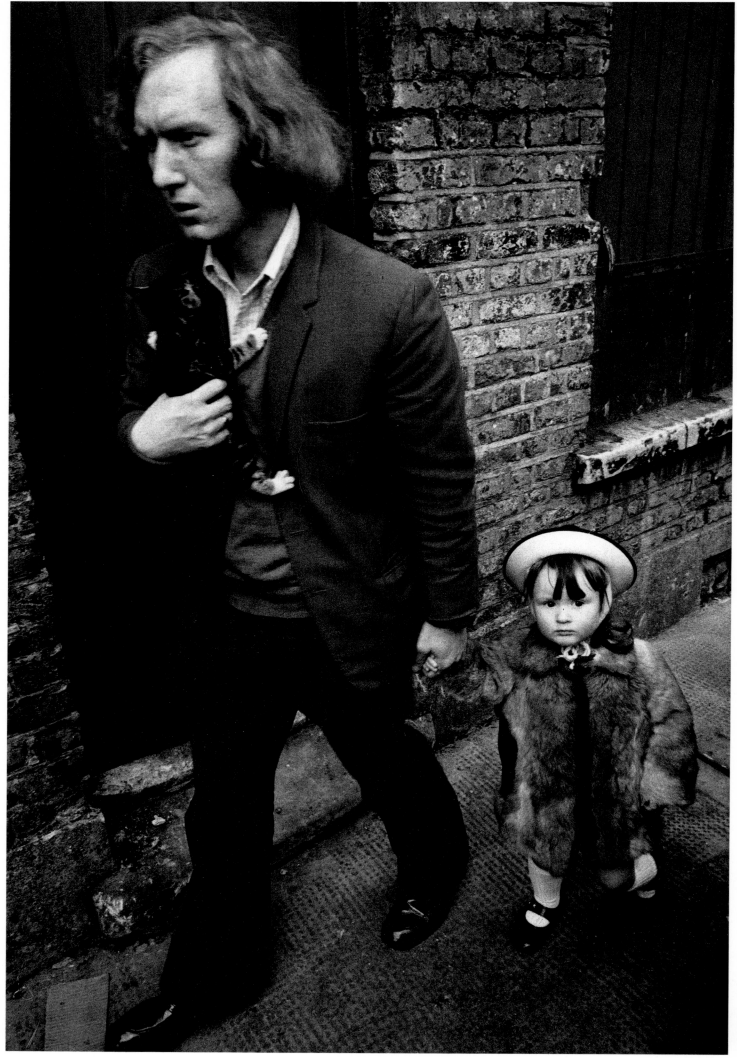

IAN BERRY

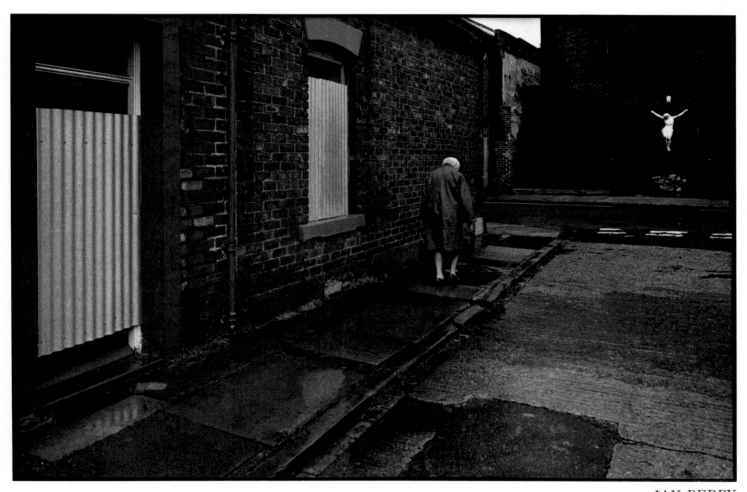

IAN BERRY

Left: *Whitechapel, London, 1972.*
Above: *Sunderland, Tyne and Wear, England, 1974.*
Overleaf: *New York City, 1953.*

ELLIOTT ERWITT

JEAN GAUMY

Above: *La dune de Pyla, France, 1984.*
Right: *Lubéron, France, 1976.*
Overleaf: *Promenade at Tenby, Wales, 1974.*

231

MARTINE FRANCK

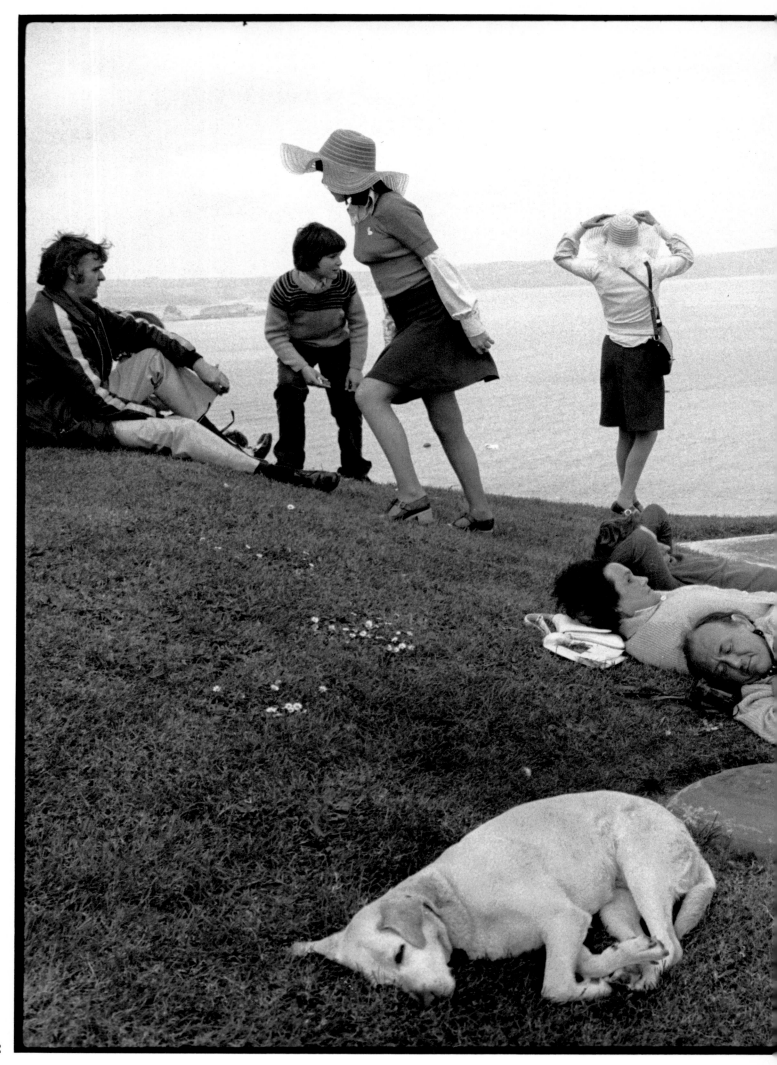

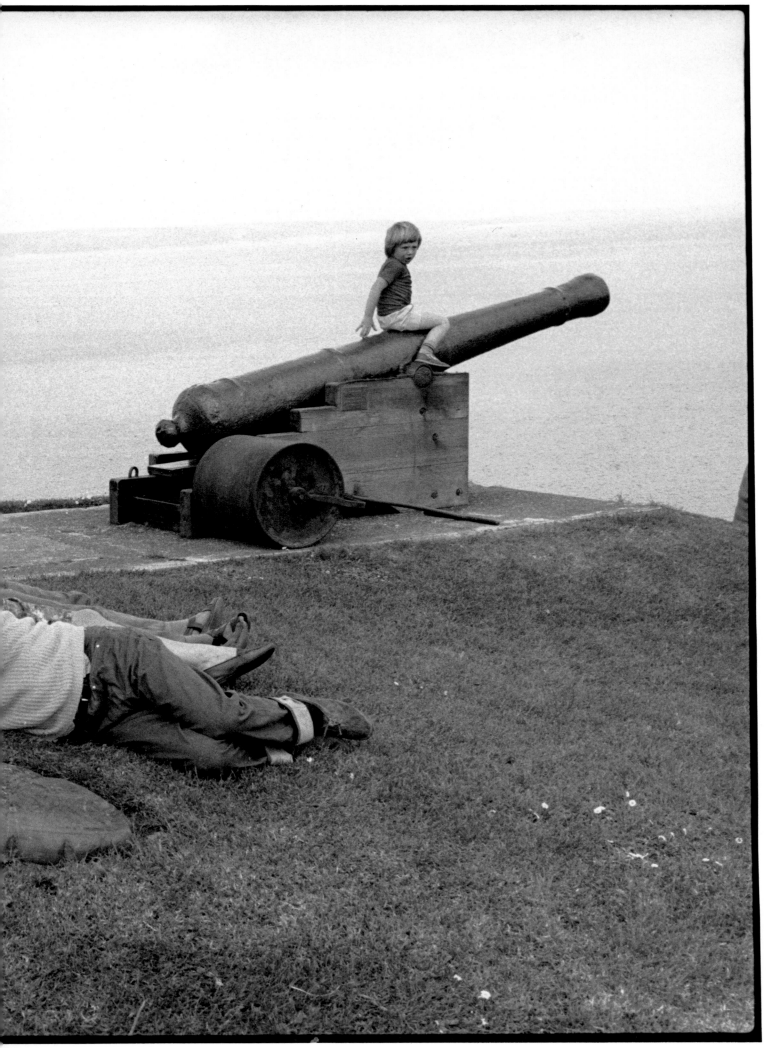

233

DAVID HURN

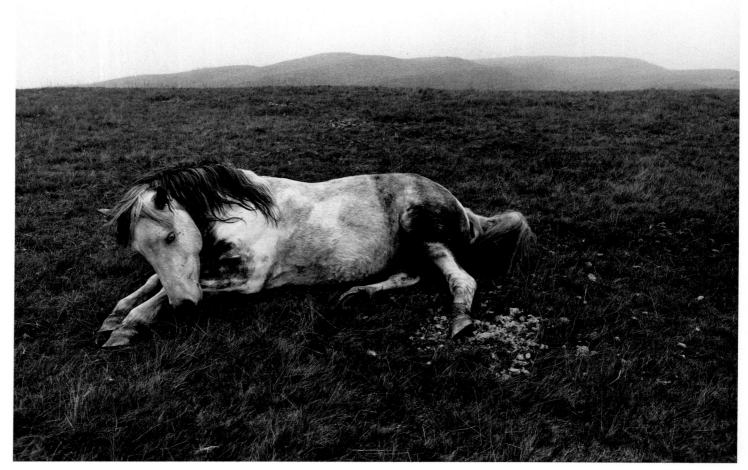

BRUCE DAVIDSON

Above: *Wales, 1965.*
Right: *Sheep sheltering on an artillery range, Mynydd Eppynt, Wales, 1973.*

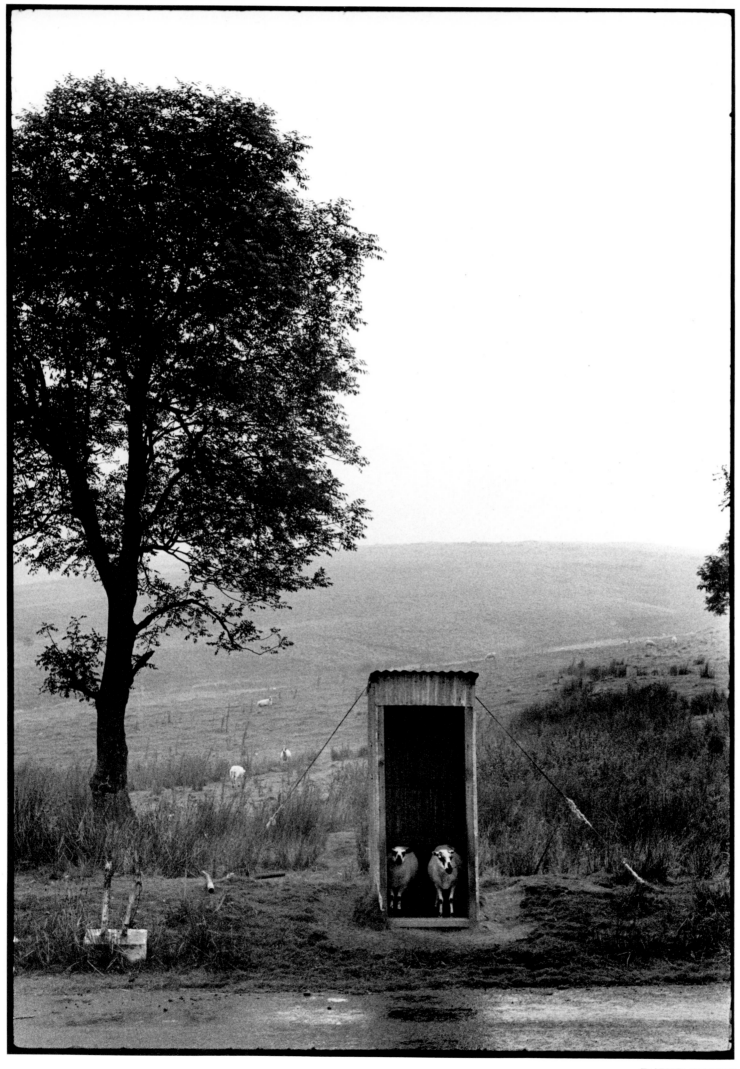

235

DAVID HURN

WERNER BISCHOF

236

CONSTANTINE MANOS

Left: *Iglesias, Sardinia, 1950.*
Above: *Village school, Ólimbos, Kárpathos, Greece, 1964.*

JOSEF KOUDELKA

Above: *Gypsies, Strážnice (East Slovakia), Czechoslovakia, 1965.*
Right: *Jewish wedding, New York City, 1954.*
Overleaf: *Mea Shearim, Jerusalem, 1967.*

239

LEONARD FREED

241

LEONARD FREED

242

CORNELL CAPA

DAVID SEYMOUR (Chim)

Left: *Torah study, New York City, 1954.*
Above: *The first boy born on the pioneer kibbutz of Alma, Israel, 1951.*

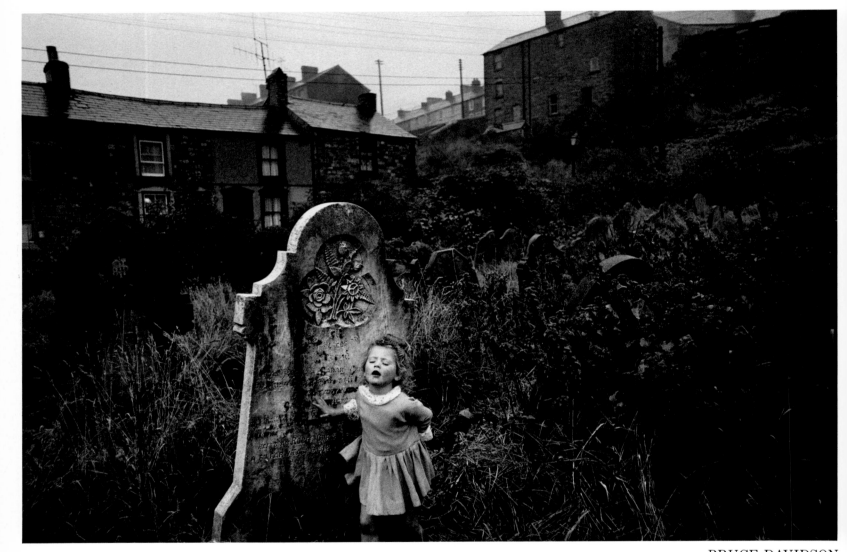

BRUCE DAVIDSON

Above: *Wales, 1965.*
Right: *Black Panthers, Chicago, 1969.*

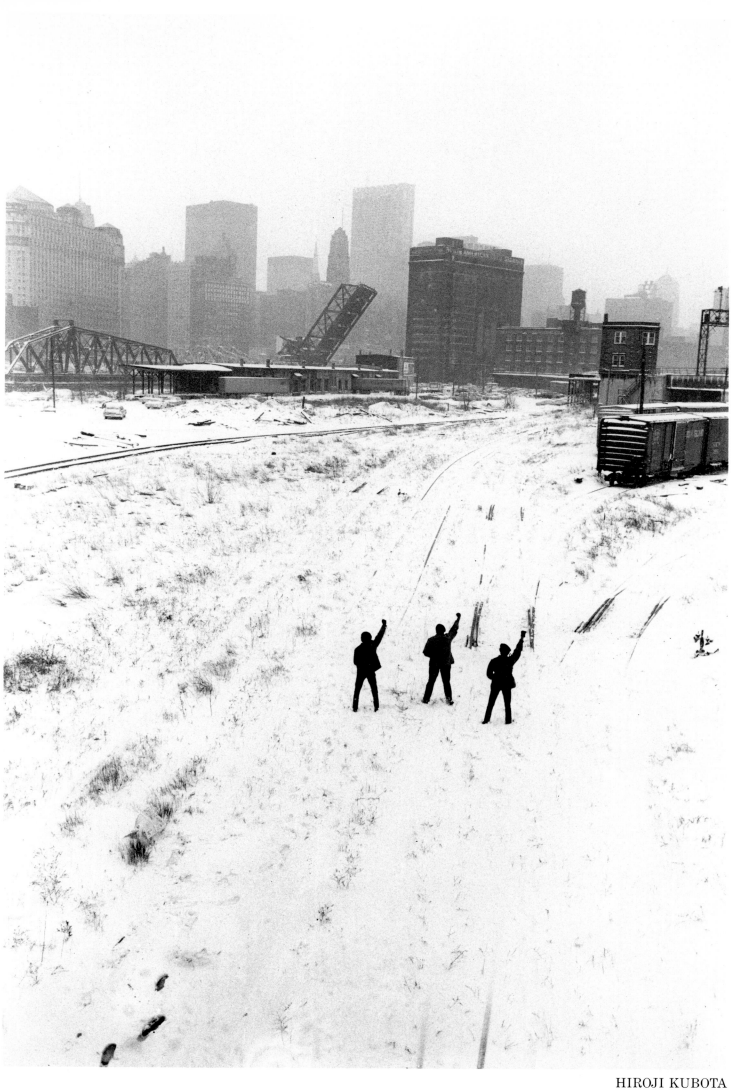

245

HIROJI KUBOTA

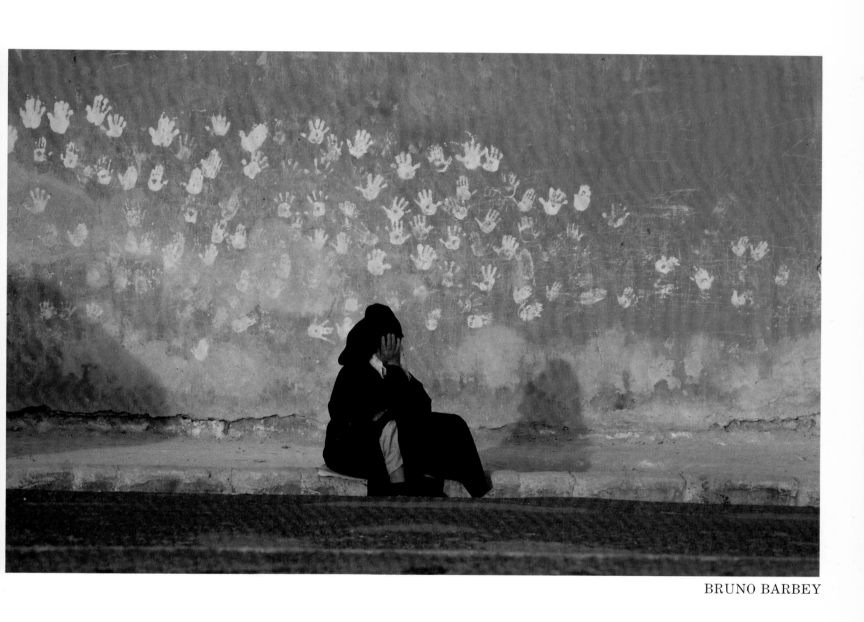

BRUNO BARBEY

247

HARRY GRUYAERT

HARRY GRUYAERT

Page 247: *Essaouira, Morocco, 1987.*
Pages 248–249: *Mosque entrance, Aït-Abrahim (near Marrakech),*
Morocco, 1977.
Above: *Essaouira, Morocco, 1976.*
Right: *Prayer in the Rub' al Khali, Saudi Arabia, 1974.*

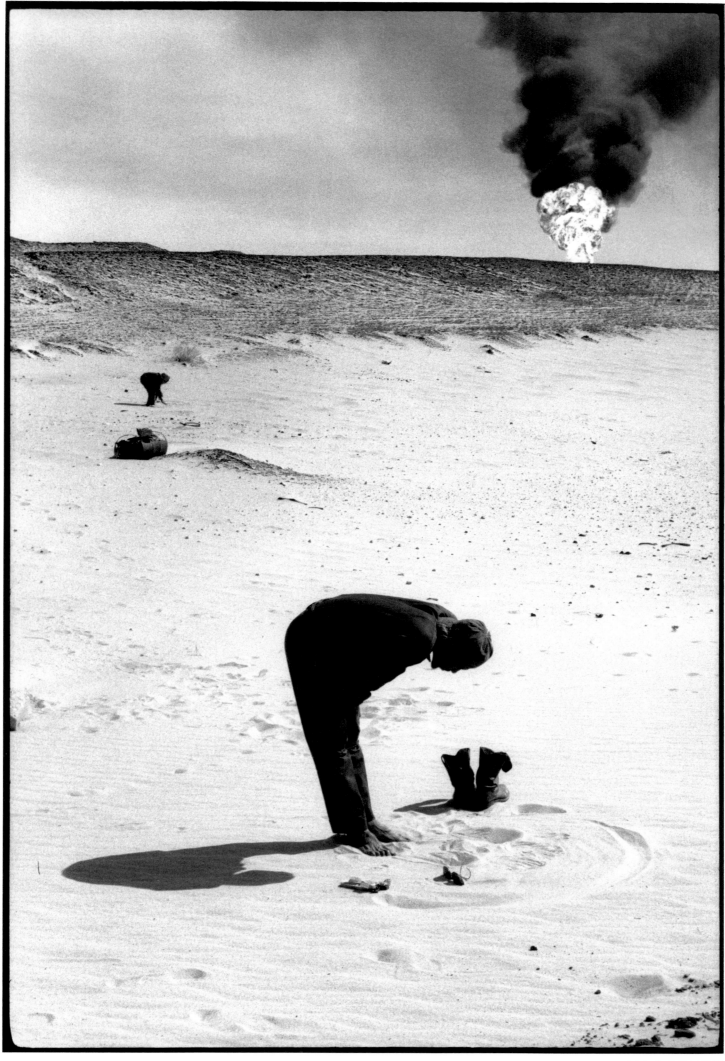

251

MARC RIBOUD

253

RENÉ BURRI

254

HARRY GRUYAERT

257

MICHA BAR-AM

258

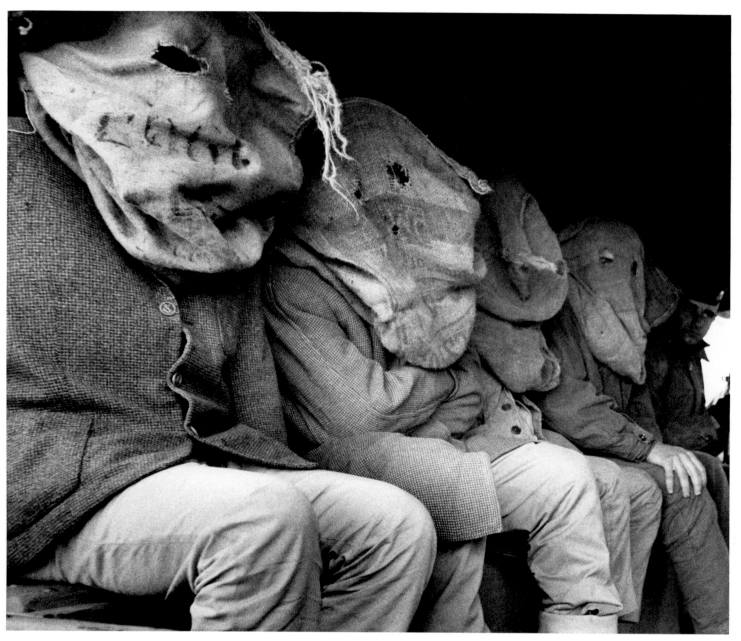

MICHA BAR-AM

Left: *Palestinian gathering, Taibe, Israel, 1980.*
Above: *West Bank, Israel, 1967.*

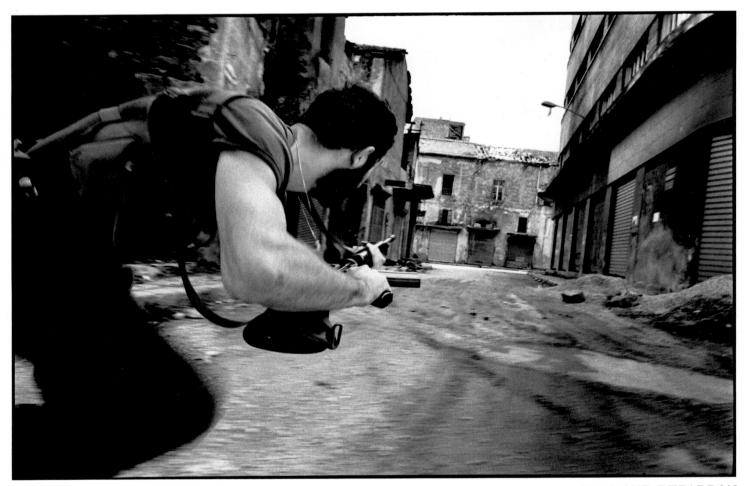

RAYMOND DEPARDON

Above: *Christian Falangist fighter, Beirut, Lebanon, 1978.*
Right: *Memorial photograph of a young Palestinian, Beirut, Lebanon, 1982.*

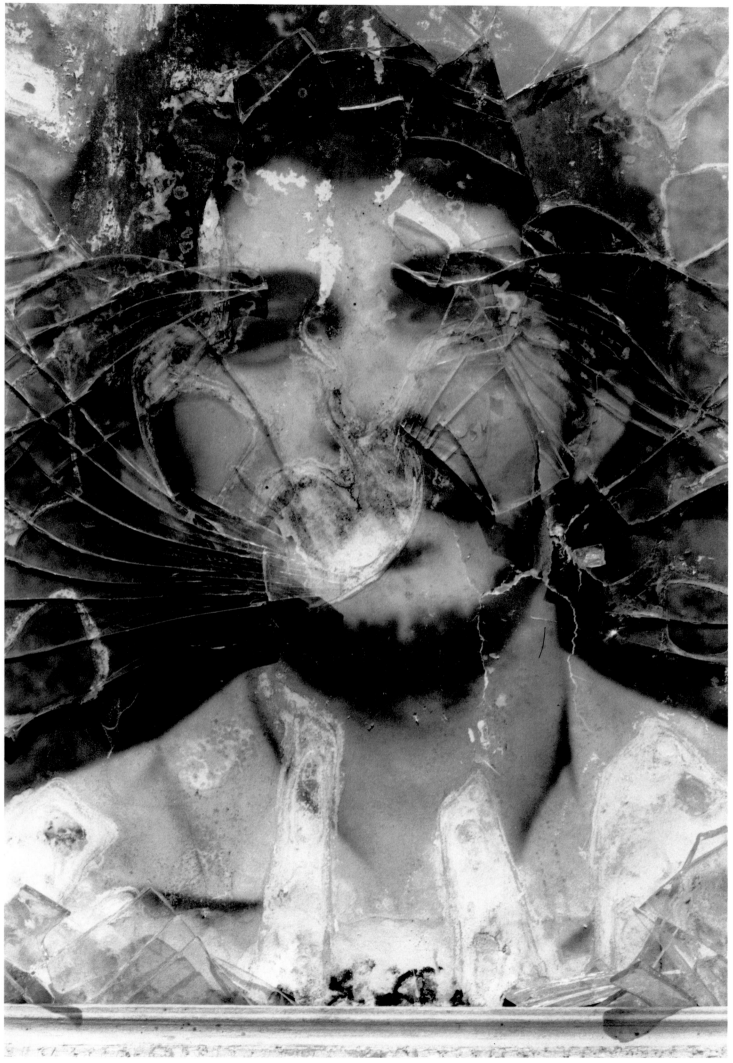

261

CHRIS STEELE-PERKINS

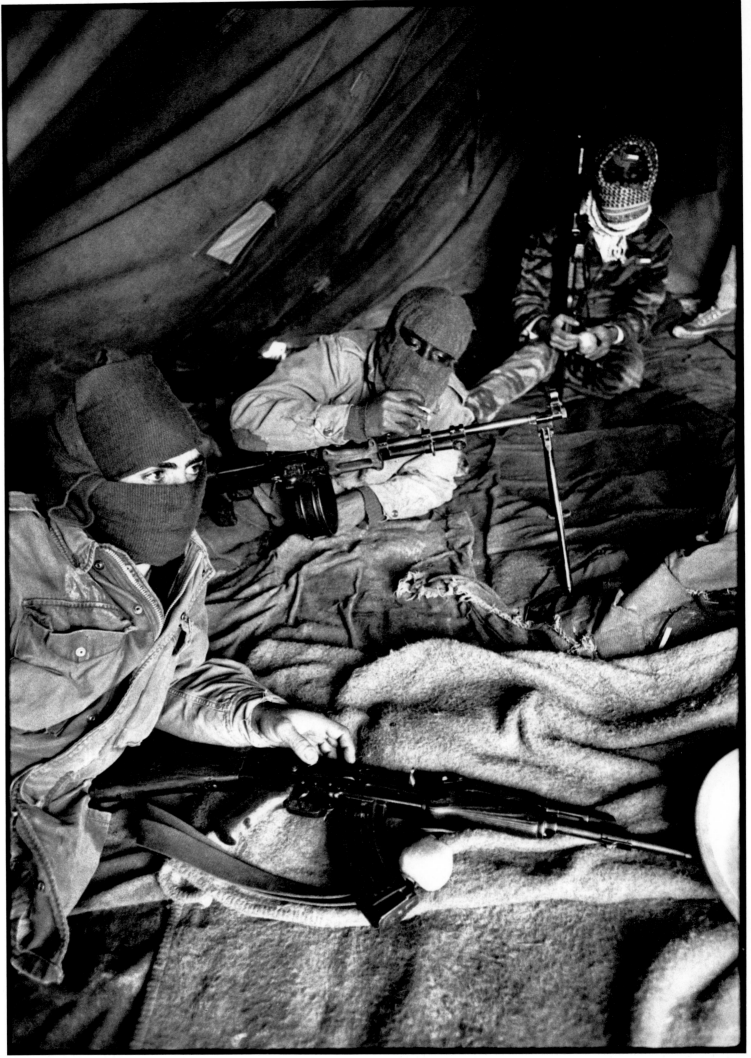

262

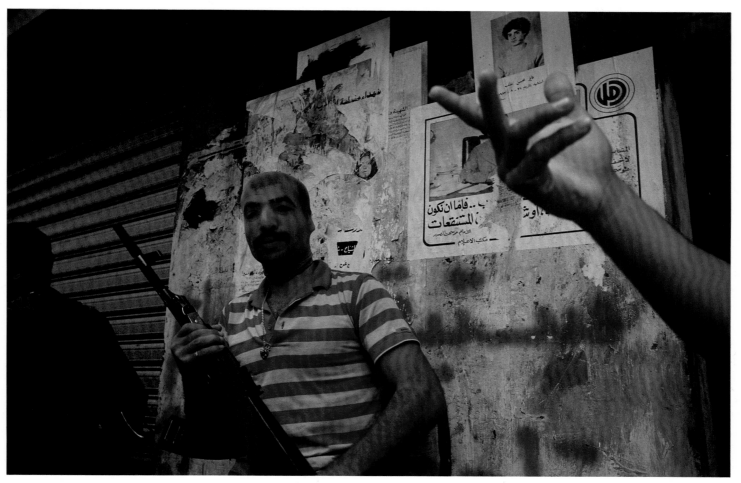

ELI REED

Left: *Al-Fatah commandos, Jordan, 1969.*
Above: *Amal militiamen in the southern suburbs, Beirut, Lebanon, 1983.*
Overleaf: *Women training northeast of Tehran, Iran, 1986.*

263

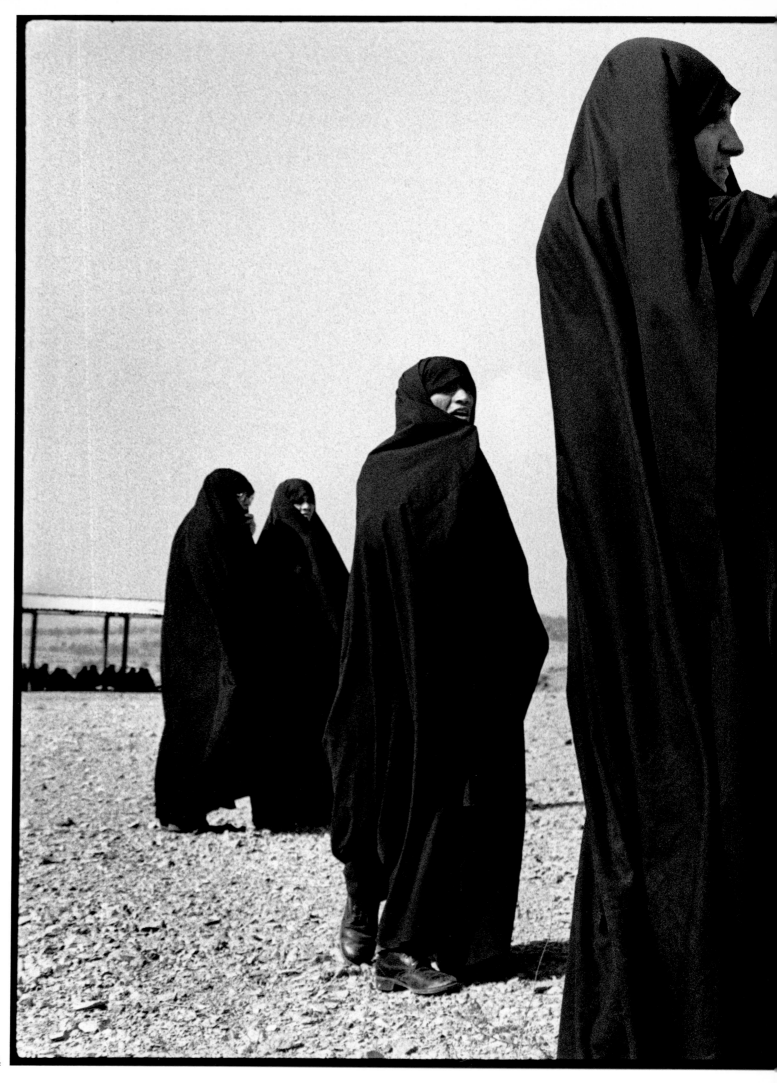

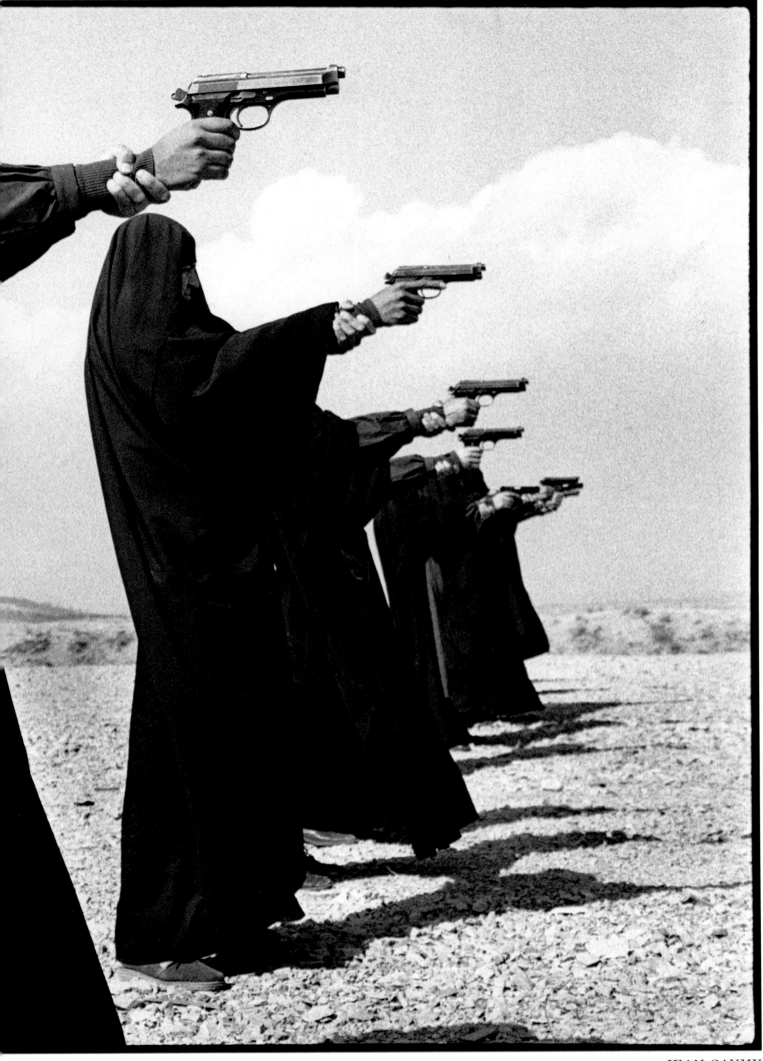

JEAN GAUMY

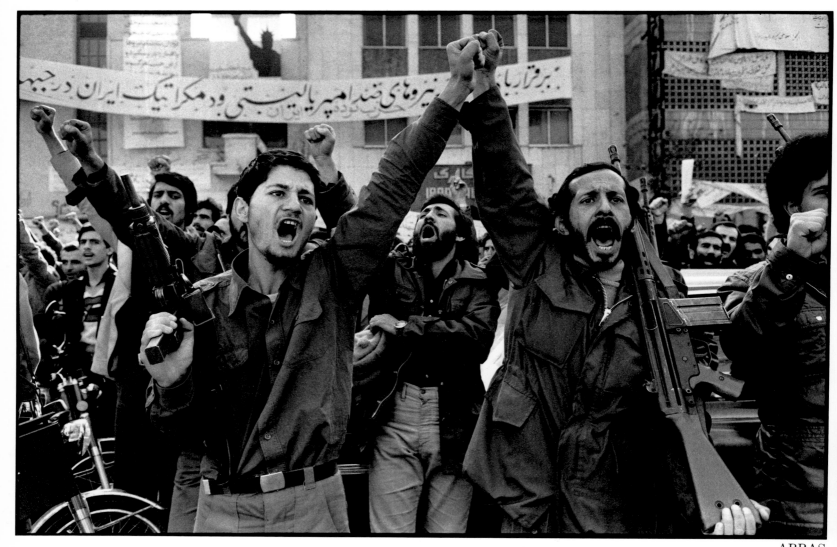

ABBAS

Above: *Iran, 1979.*
Right: *Anniversary of the Iranian Republic, Tehran, 1986.*
Overleaf: *Pro-Ayatollah Shariat-madari demonstrations, Tabriz, Iran, 1980.*

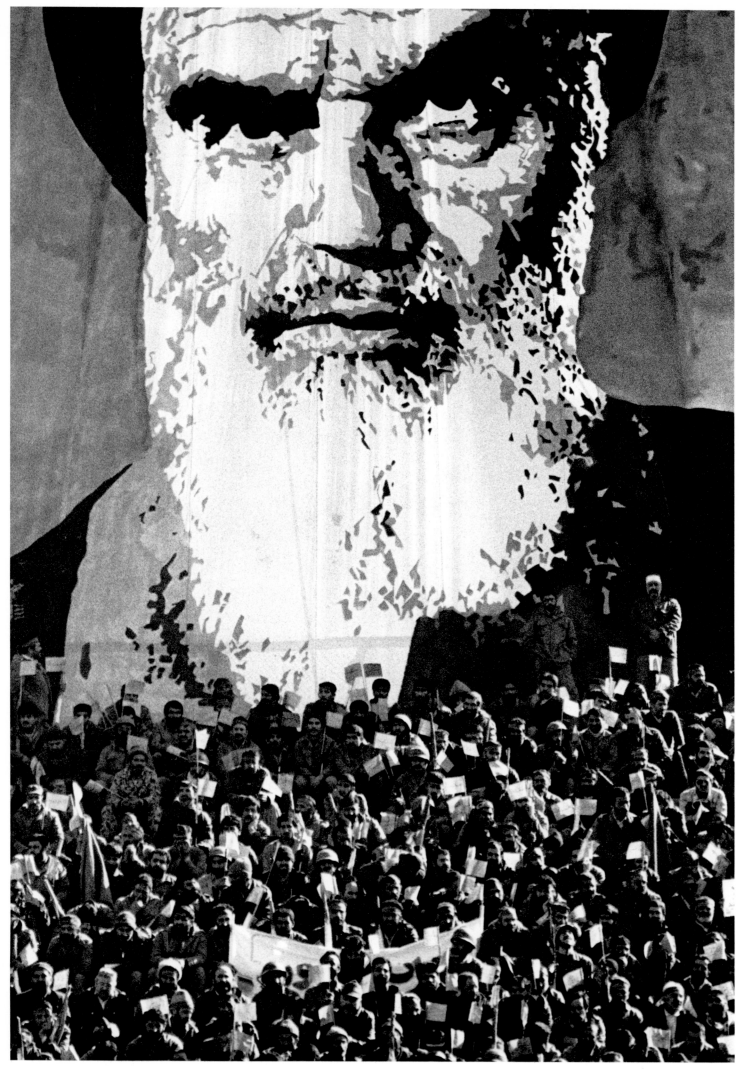

267

JEAN GAUMY

269

GILLES PERESS

271

GEORGE RODGER

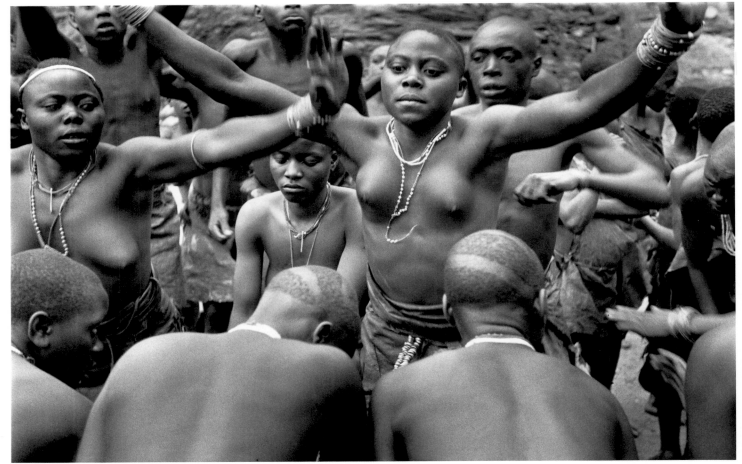

GEORGE RODGER

Page 271: *Fellow tribesman carries victorious Nuba wrestler,*
Kordofan, Sudan, 1949.
Above: *Girls of the Bachimbiri tribe in a courting dance,*
Uganda-Congo border, 1948.
Right: *Rhodesian refugees in a camp, Zambia, 1978.*
Overleaf: *Dust storm, Maseru, South Africa, 1960.*

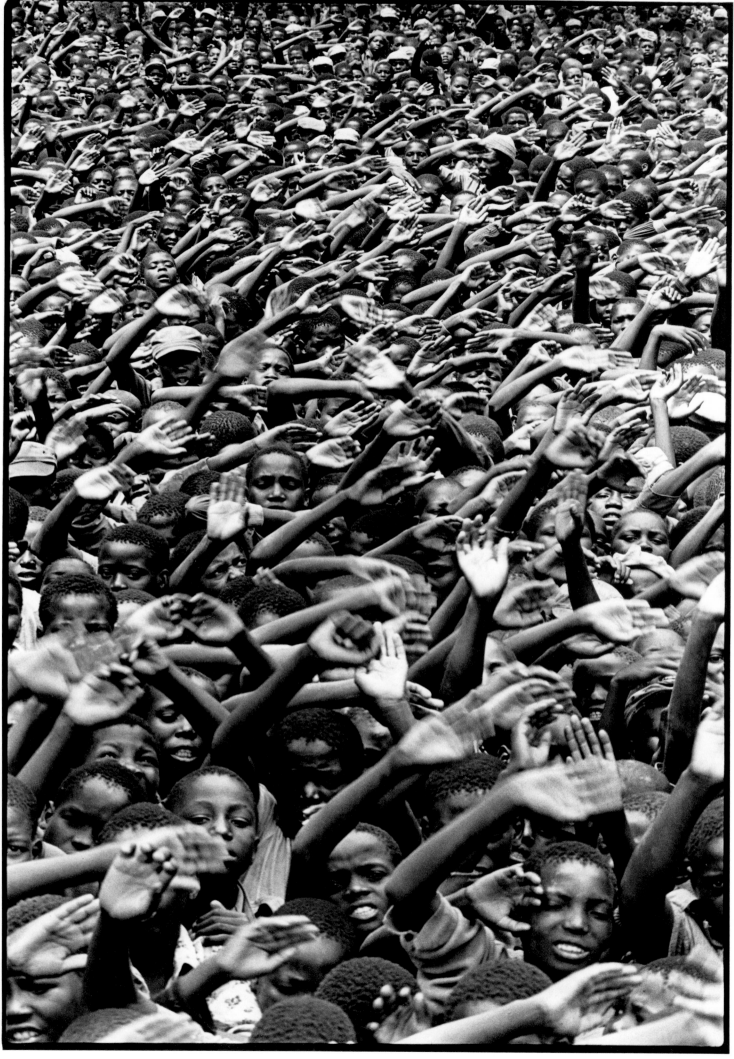

273

PETER MARLOW

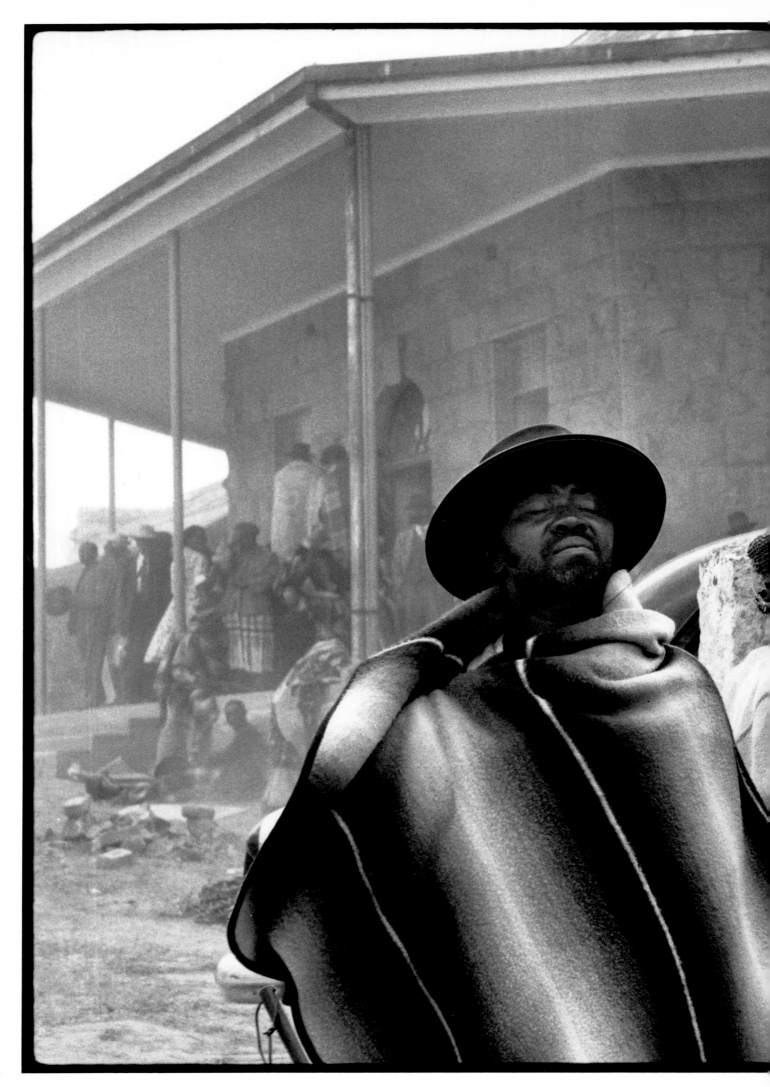

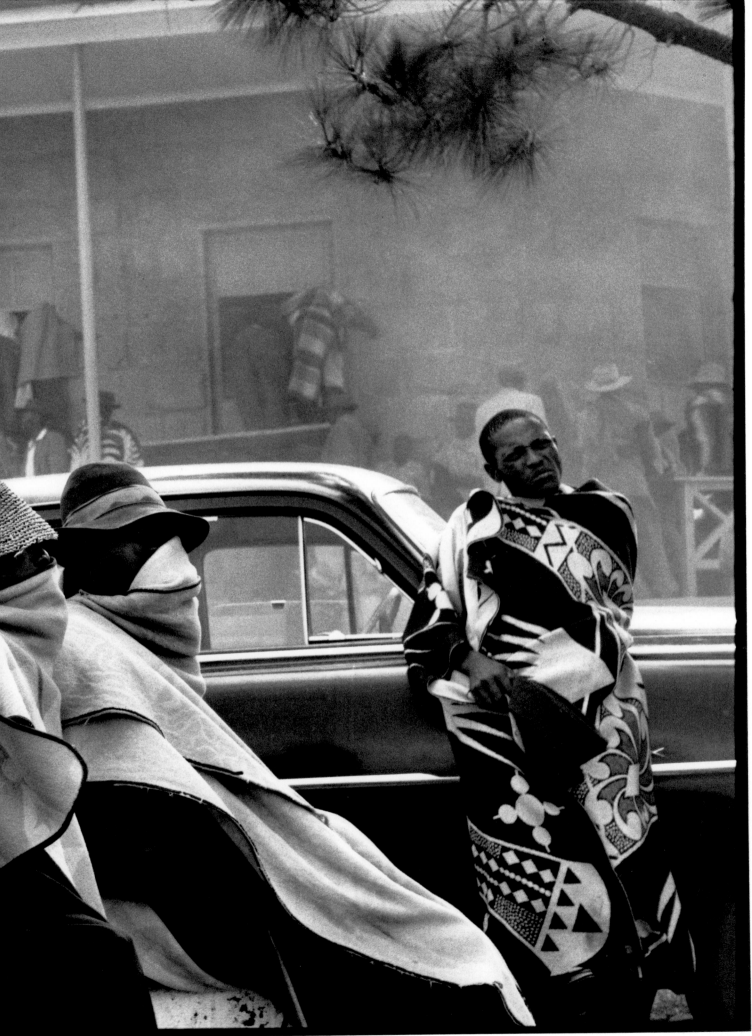

275

IAN BERRY

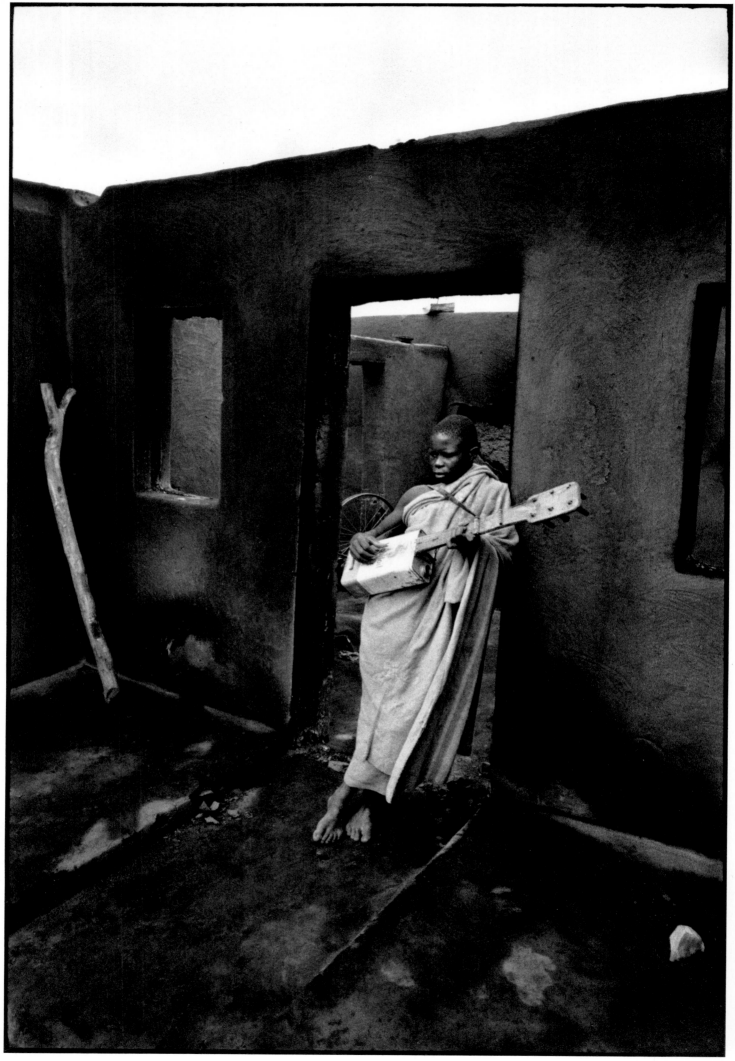

276

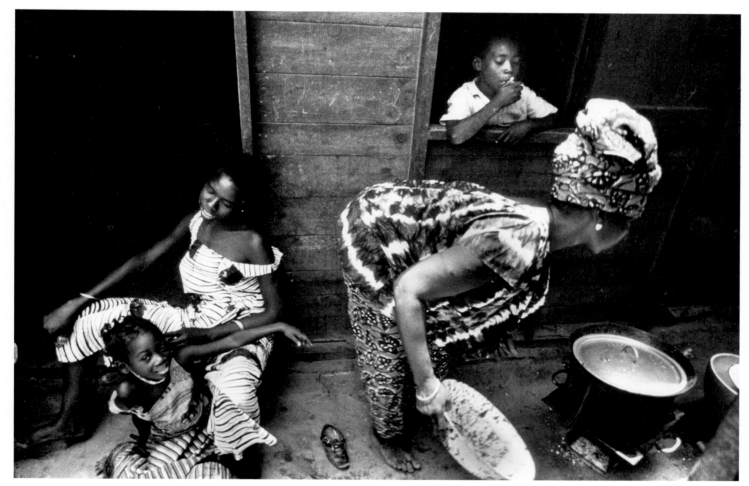

IAN BERRY

Left: *A house burnt down during a political raid, South Africa, 1961.*
Above: *Dakar, Senegal, 1972.*

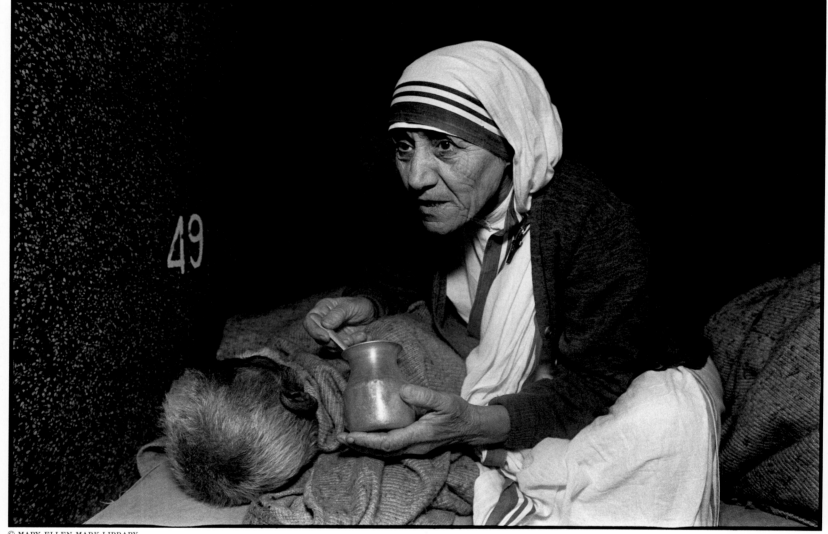

MARY ELLEN MARK

Above: *Mother Teresa at the home for the dying, Calcutta, 1980.*
Right: *Schoolchildren in the rain, Lesotho, South Africa, 1981.*
Overleaf: *Clinic in Ade, on the border between Chad and Sudan, 1985.*

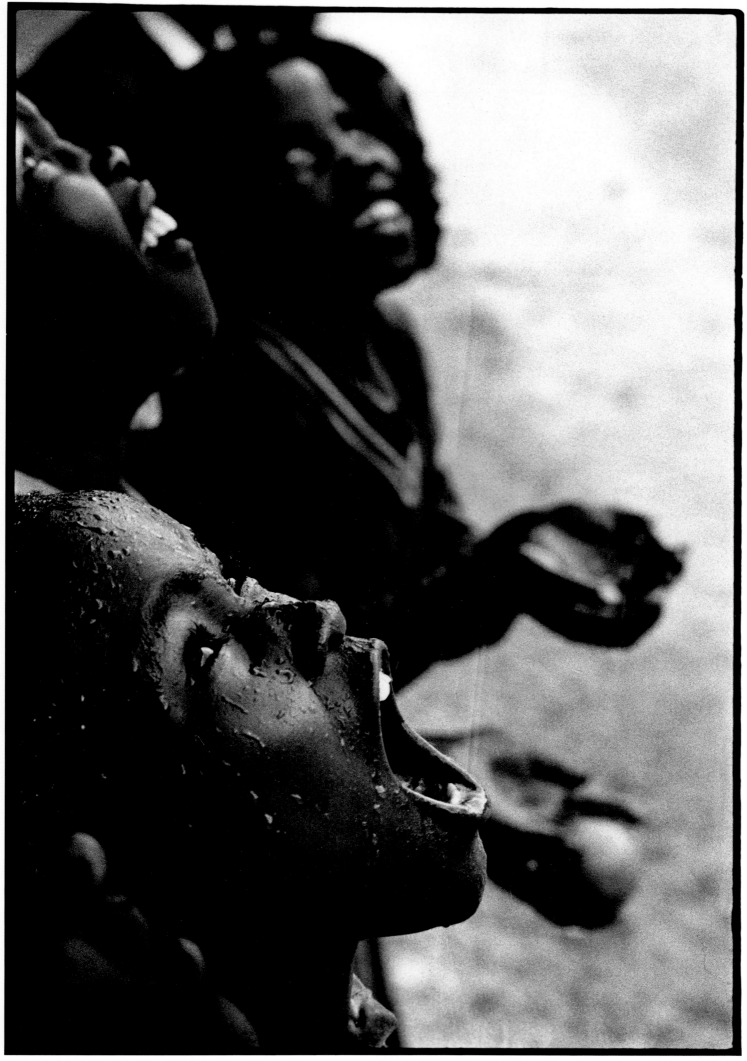

279

CHRIS STEELE-PERKINS

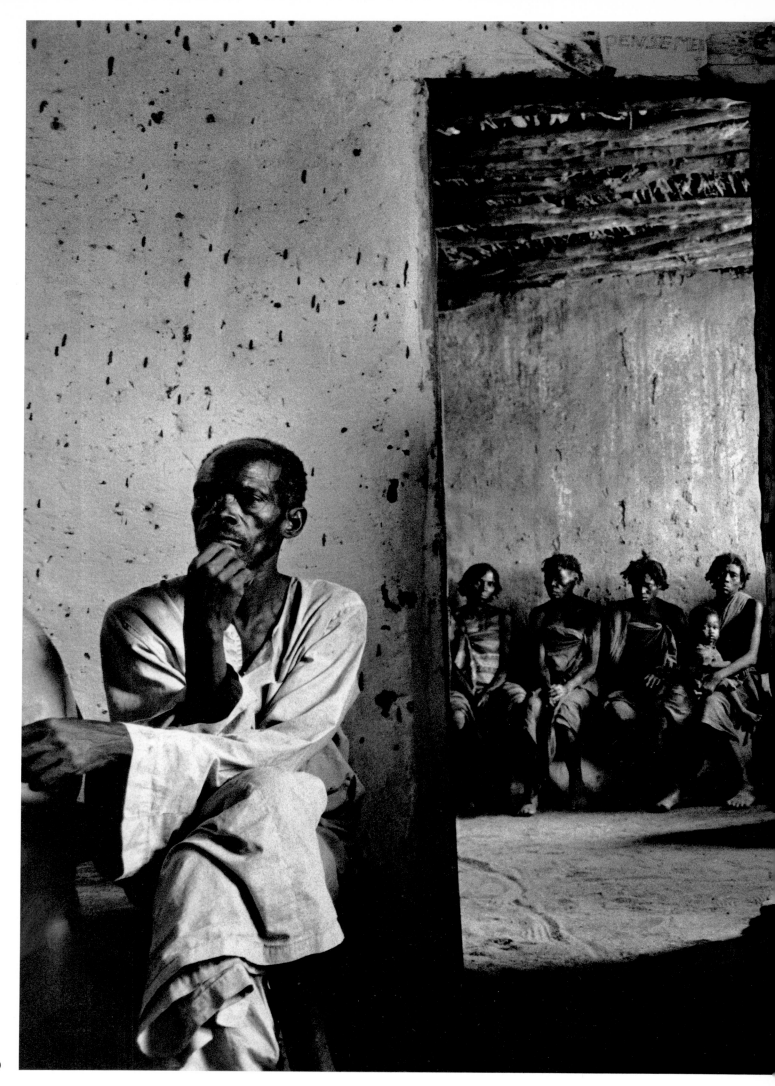

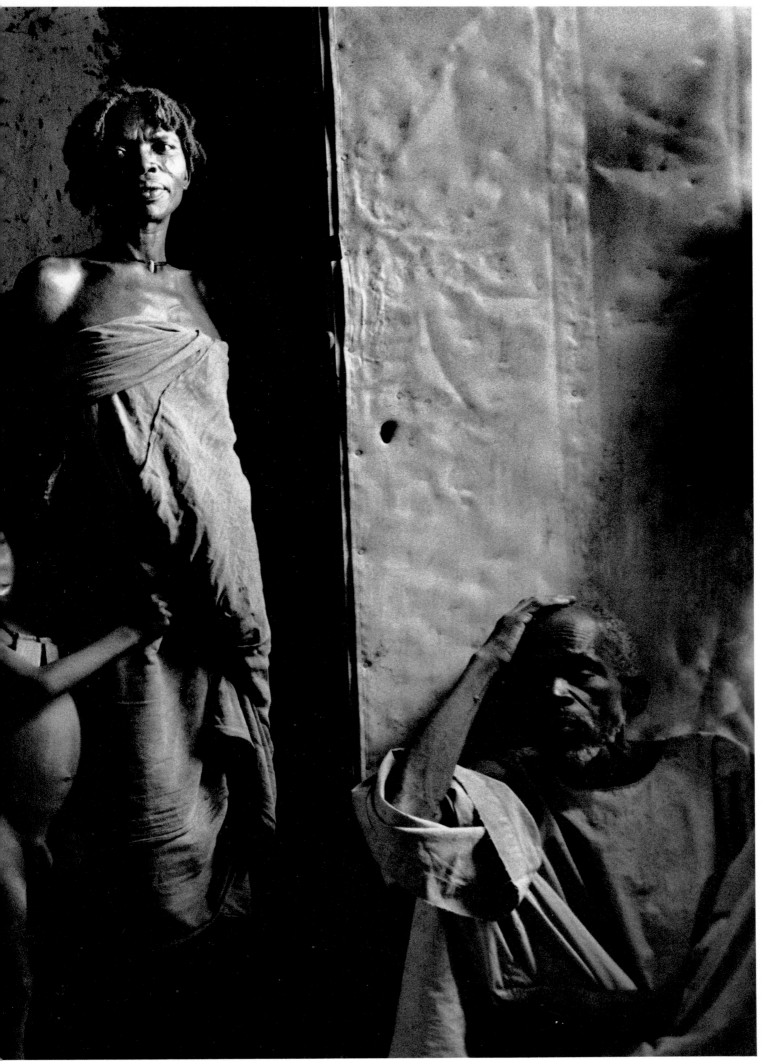

SABASTIÃO SALGADO

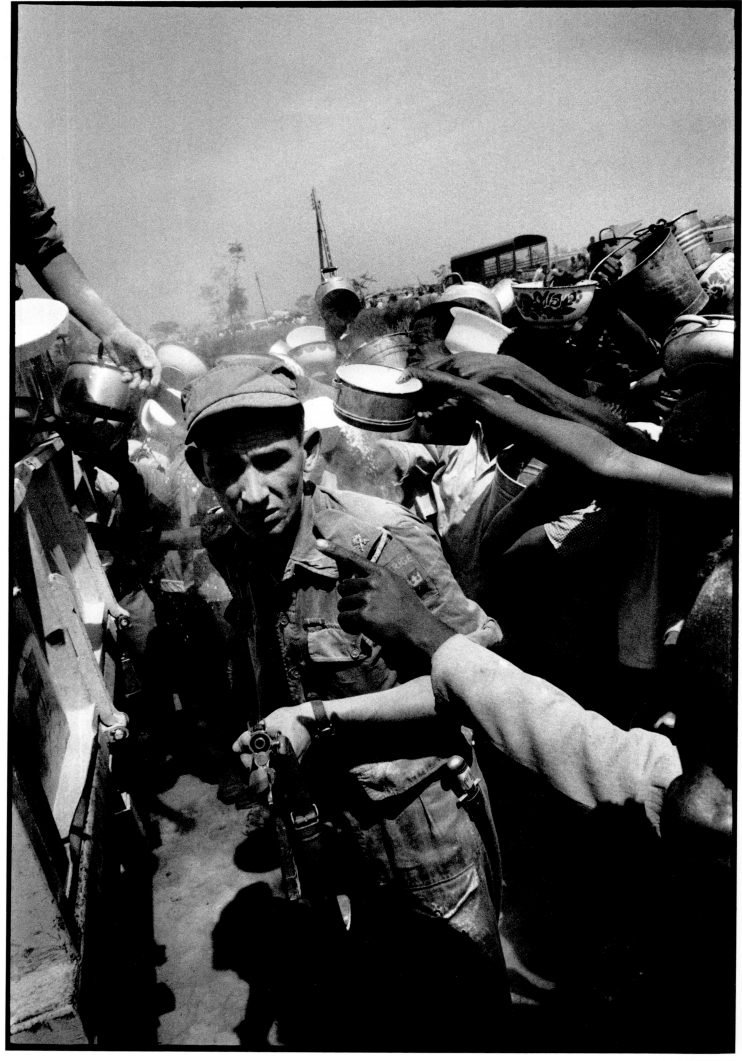

282

IAN BERRY

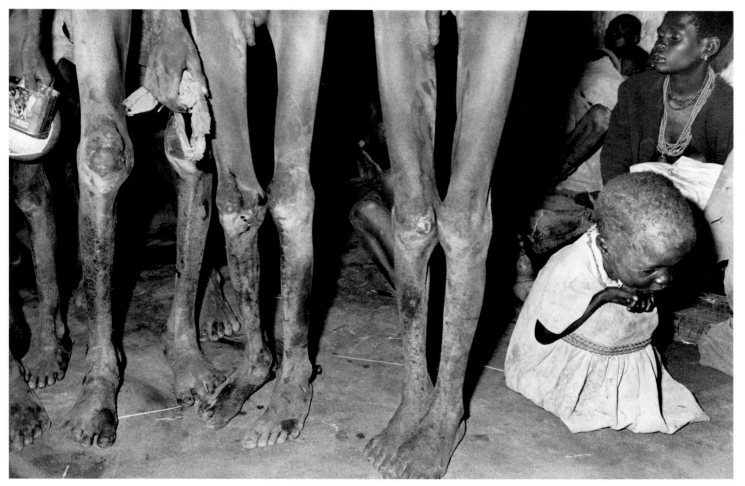

CHRIS STEELE-PERKINS

Left: *Katanga, Congo, 1961.*
Above: *Famine in Karamoja Province, Uganda, 1980.*
Overleaf: *Women and children cross what was once a lake, Mali, 1985.*

283

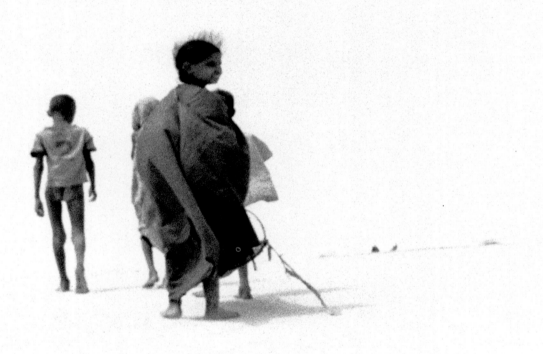

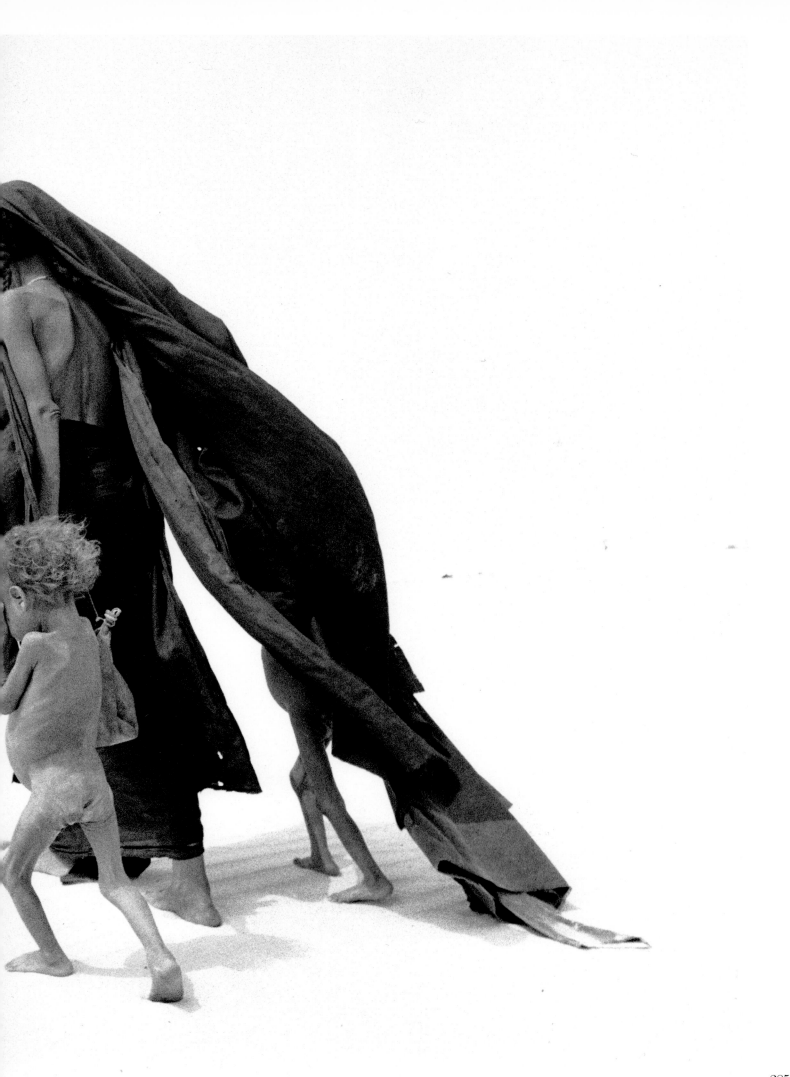

SABASTIÃO SALGADO

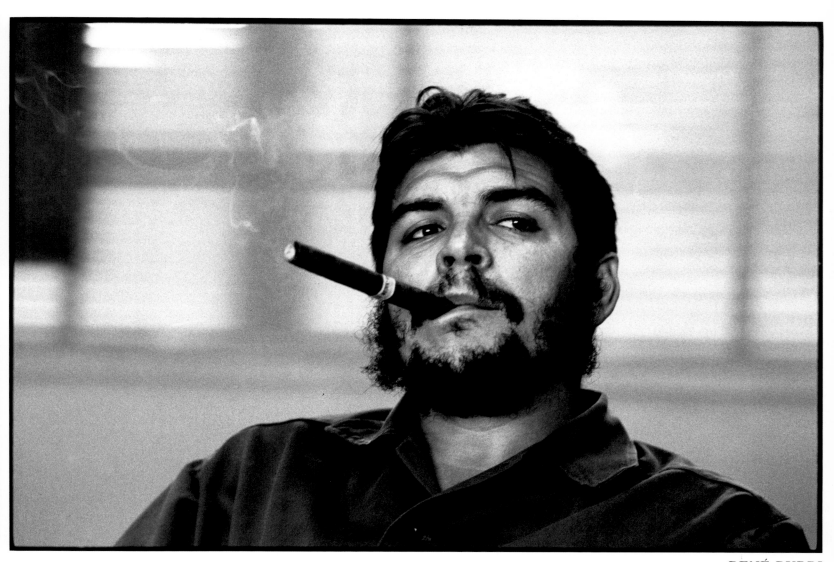

RENÉ BURRI

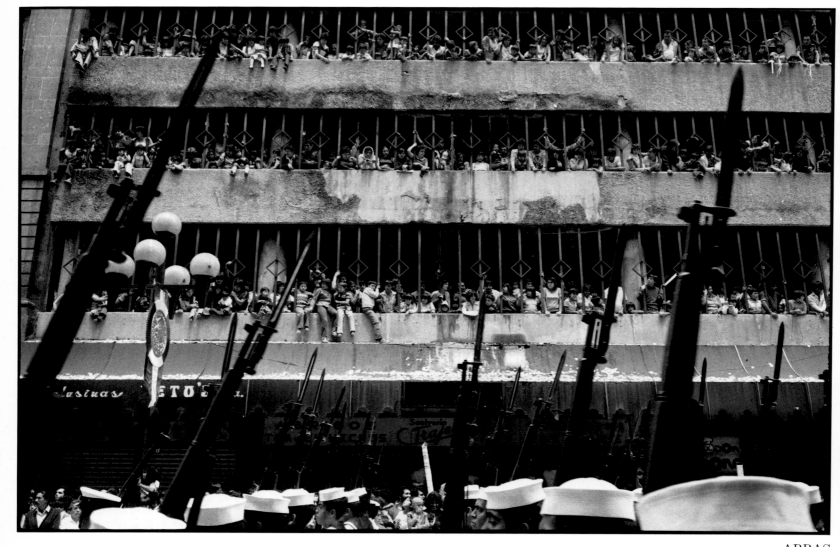

ABBAS

Page 287: *Che Guevara, Havana, 1963.*
Above: *Military parade, Mexico, 1983.*
Right: *Castro giving a speech en route to Havana, Santa Clara, Cuba, 1959.*
Overleaf: *Tenth anniversary of General Augusto Pinochet's coup d'etat,*
Santiago, Chile, 1983.

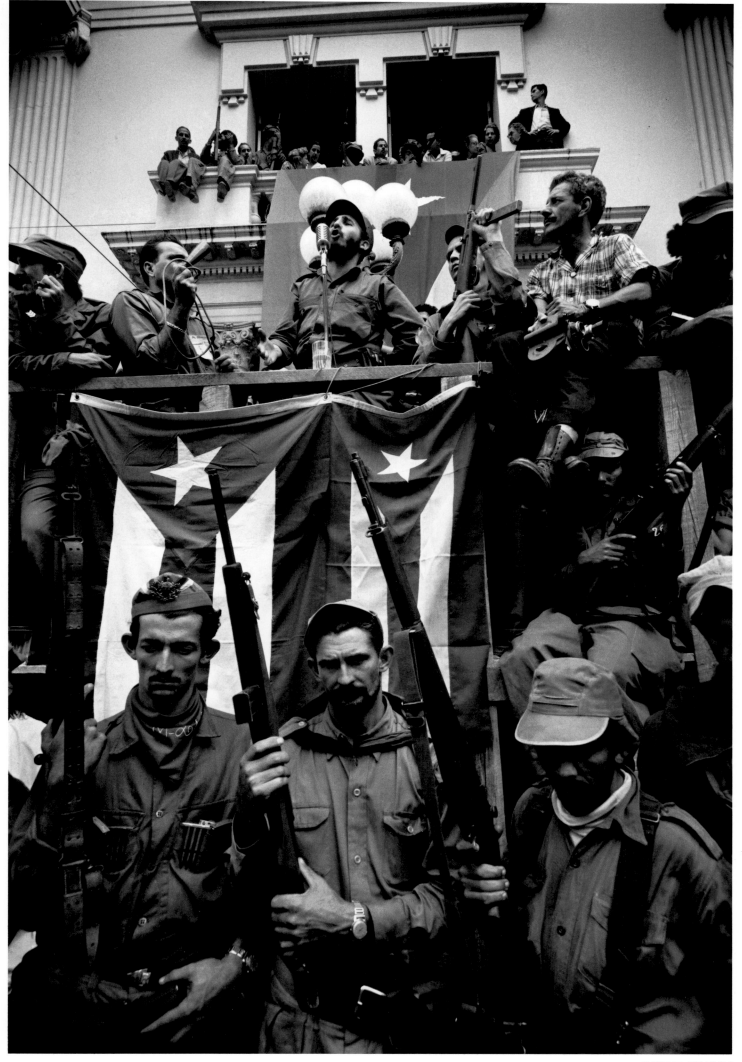

BURT GLINN

ABBAS

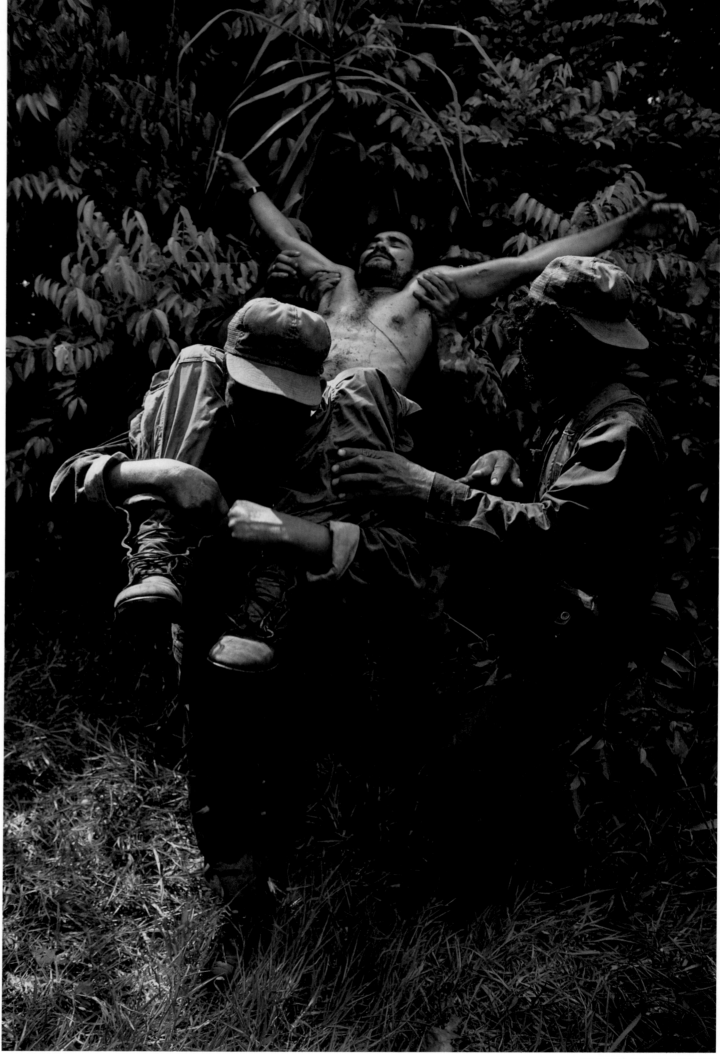

292

JAMES NACHTWEY

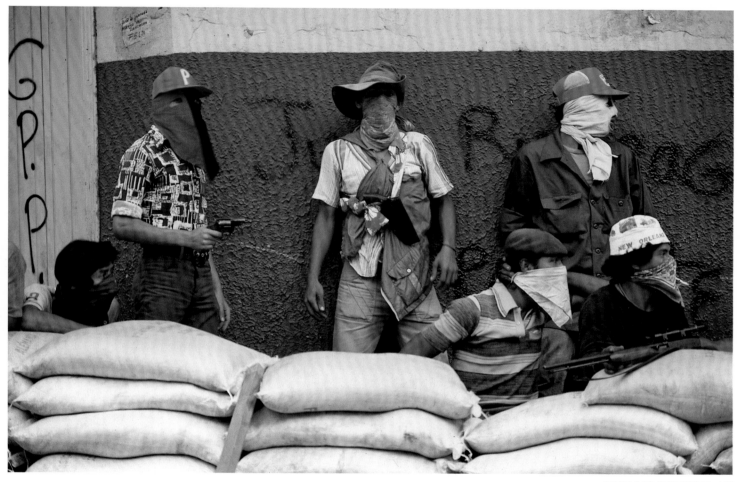

SUSAN MEISELAS

Left: *San Juan del Norte, Nicaragua, 1984.*
Above: *Awaiting counterattack by the National Guard in Matagalpa,
Nicaragua, 1978.*
Overleaf: *Car of Samoza informer burning in Managua, Nicaragua, 1978.*

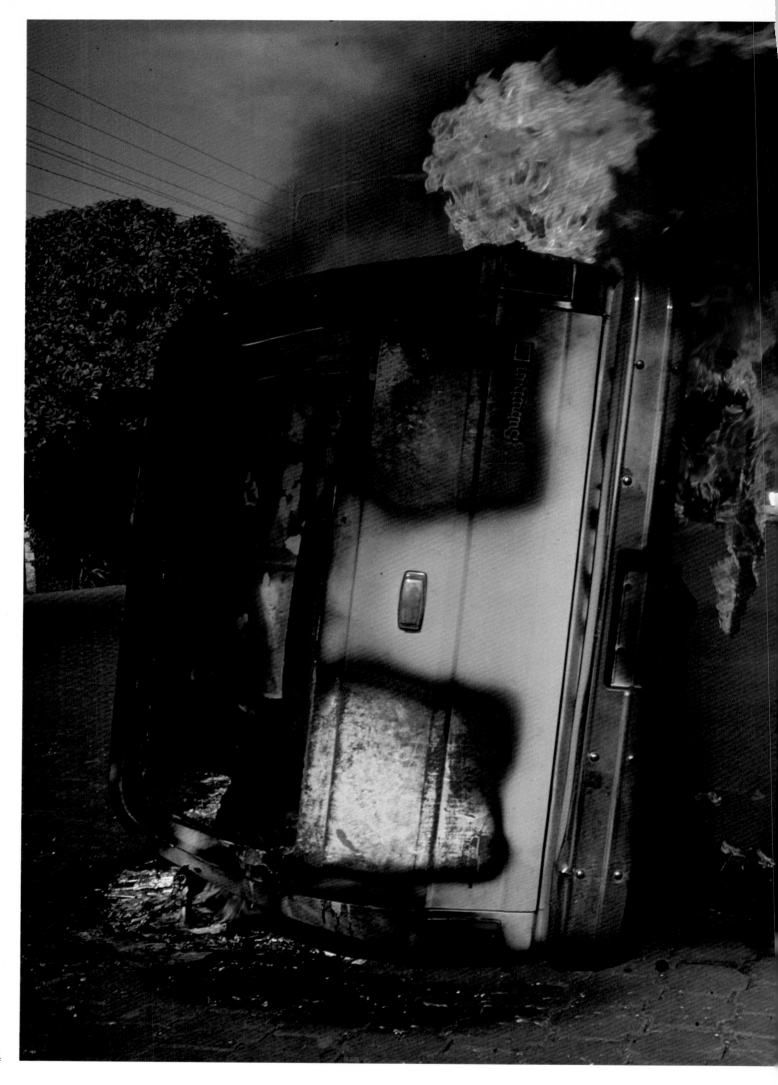

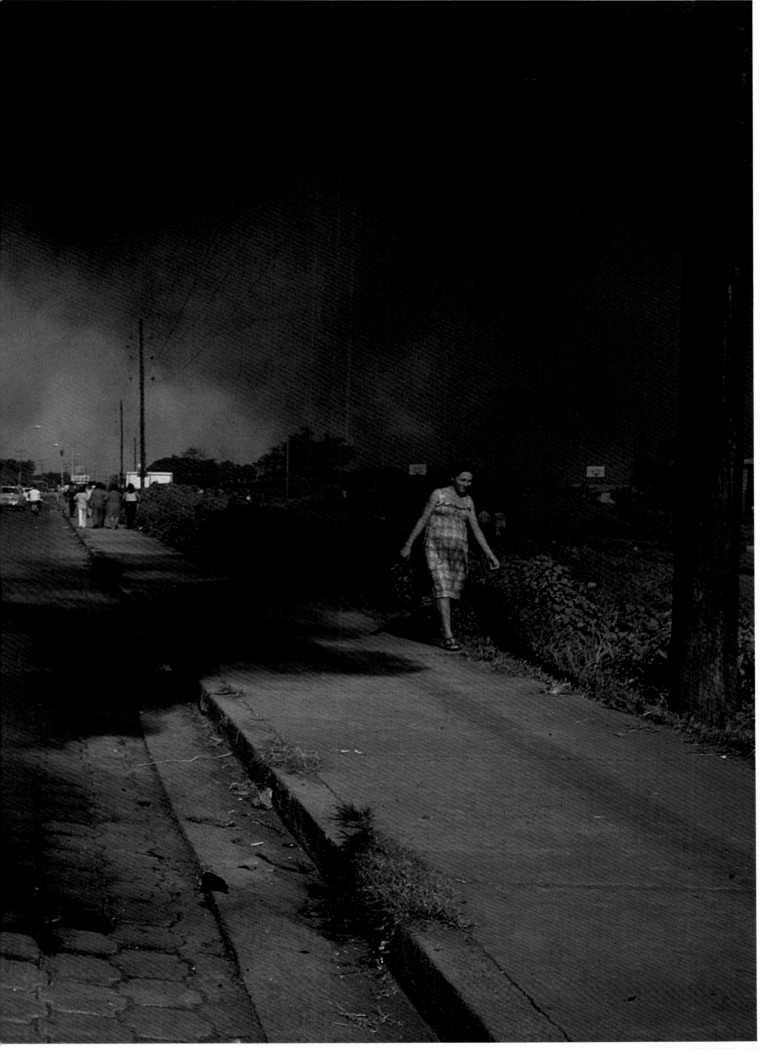

SUSAN MEISELAS

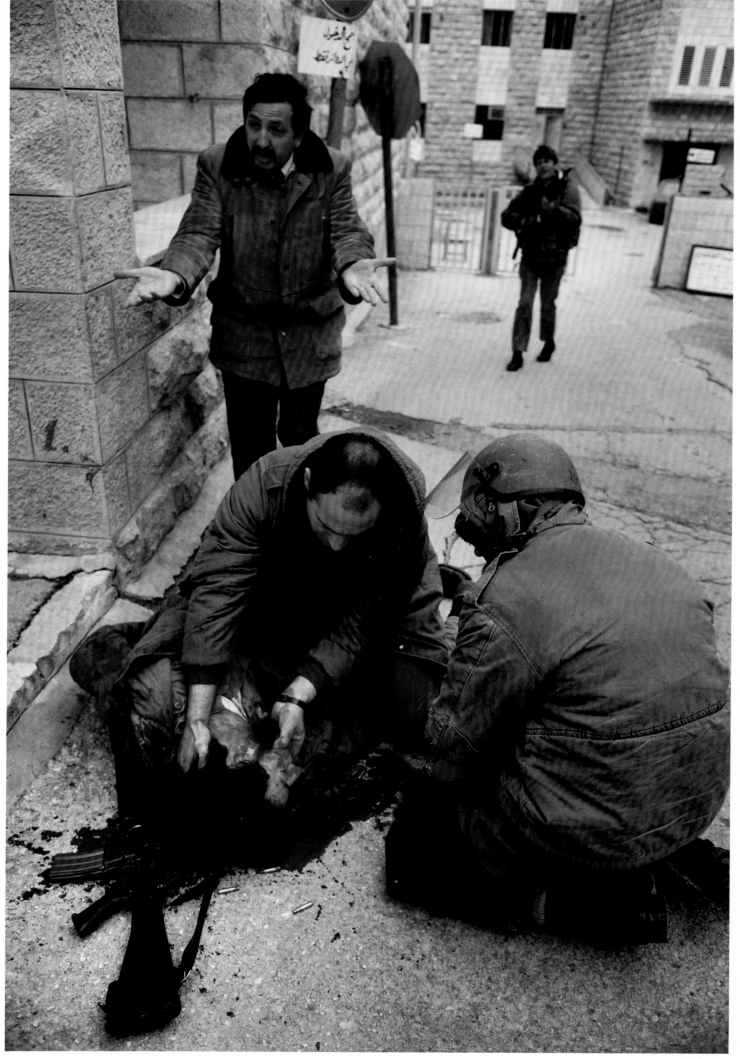

296

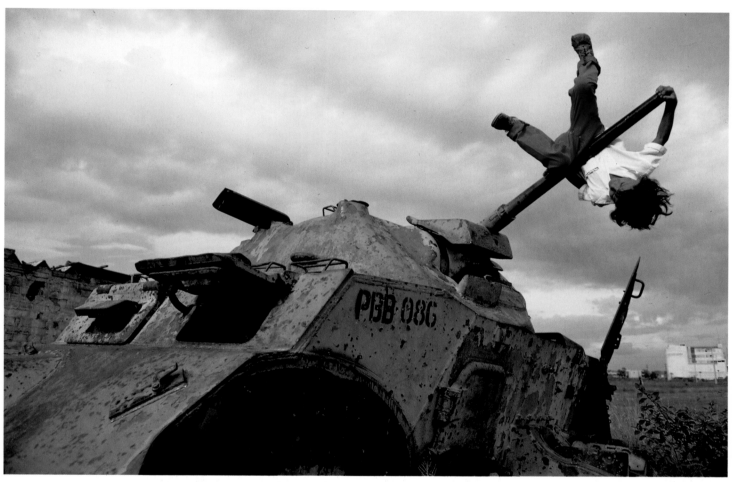

JAMES NACHTWEY

Left: *An Israeli soldier shot by a Palestinian, Bethlehem, Israeli-occupied*
West Bank, 1988.
Above: *Nicaragua, 1982.*

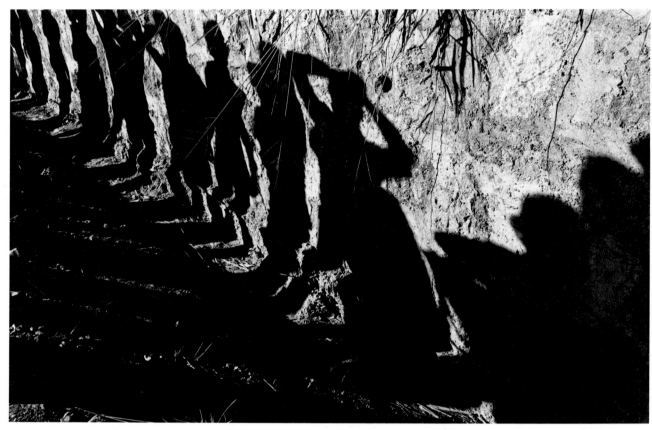

SUSAN MEISELAS

Above: *Soldiers searching bus passengers, Northern Highway,*
El Salvador, 1980.
Right: *U.S. Army training dogs for use in Vietnam; Okinawa, 1969.*
Overleaf: Cuesta del Plomo, *site of assassinations by the National Guard,*
near Managua, Nicaragua, 1978.

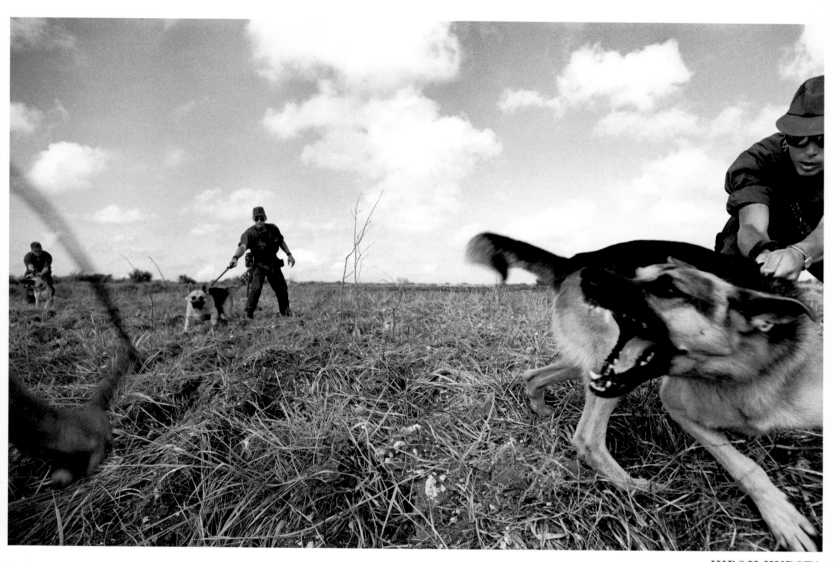

HIROJI KUBOTA

SUSAN MEISELAS

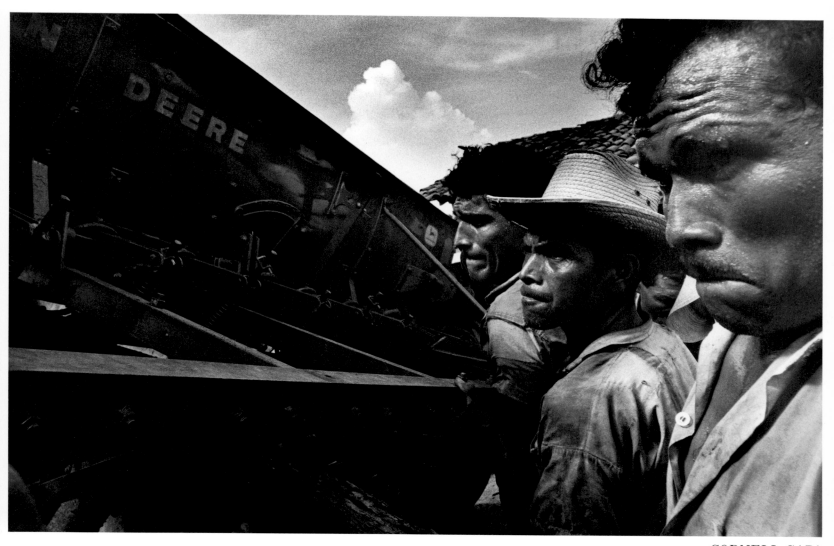

CORNELL CAPA

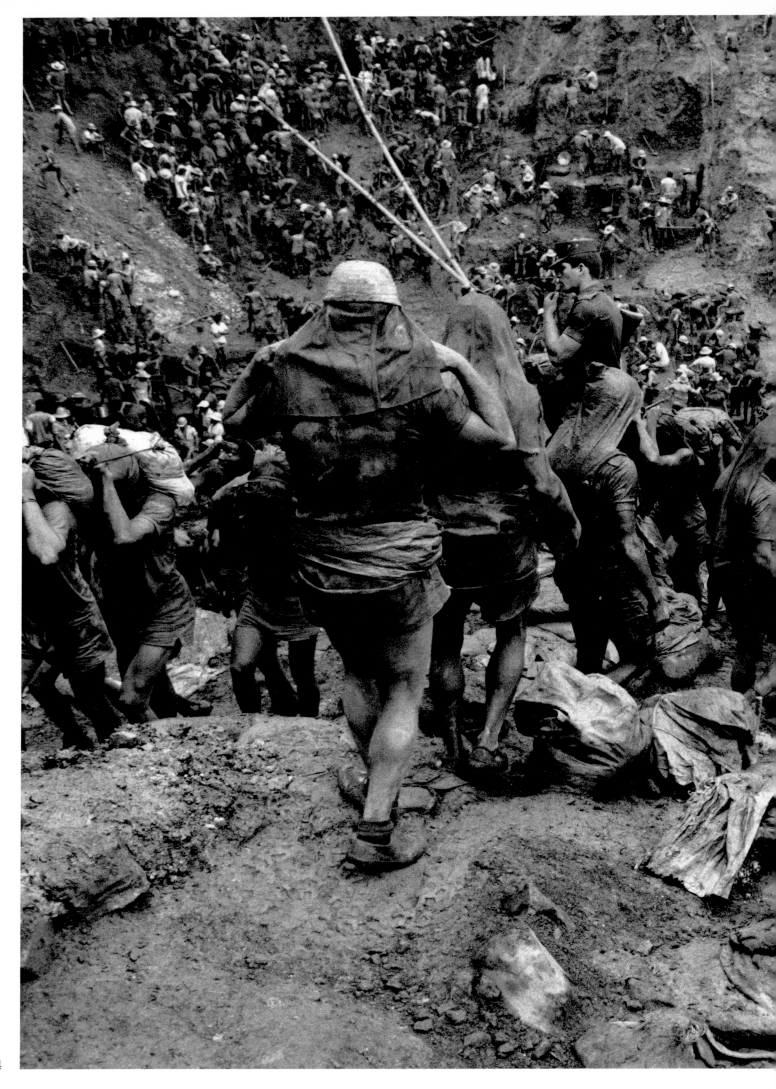

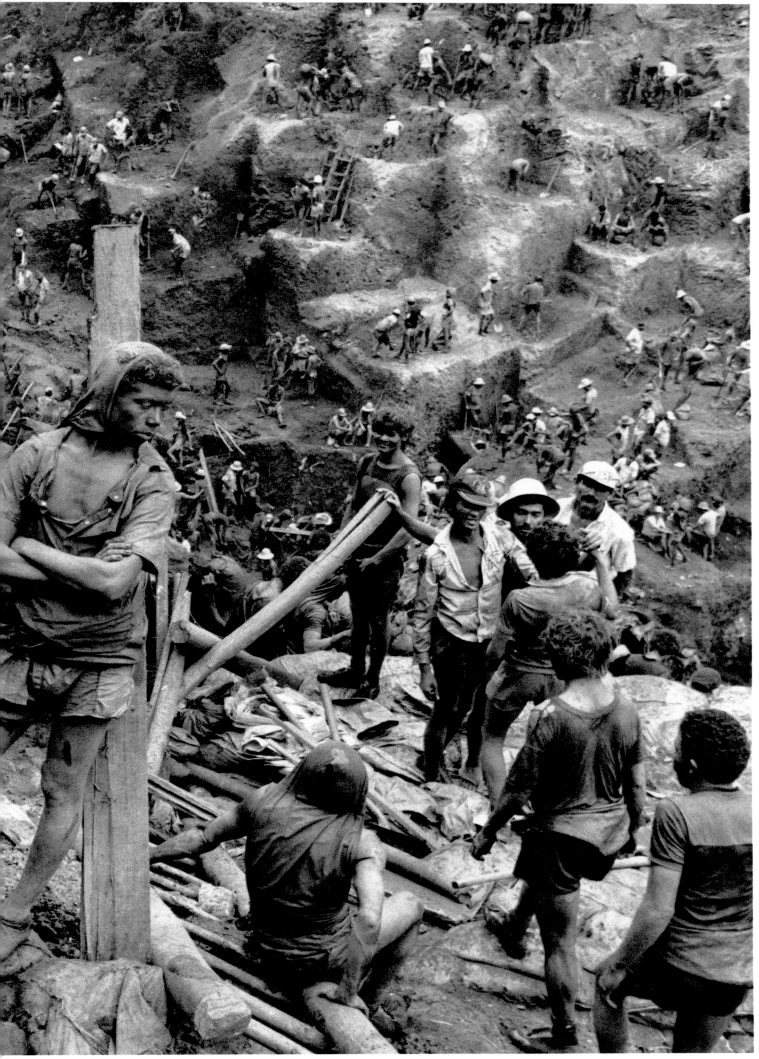

305

SABASTIÃO SALGADO

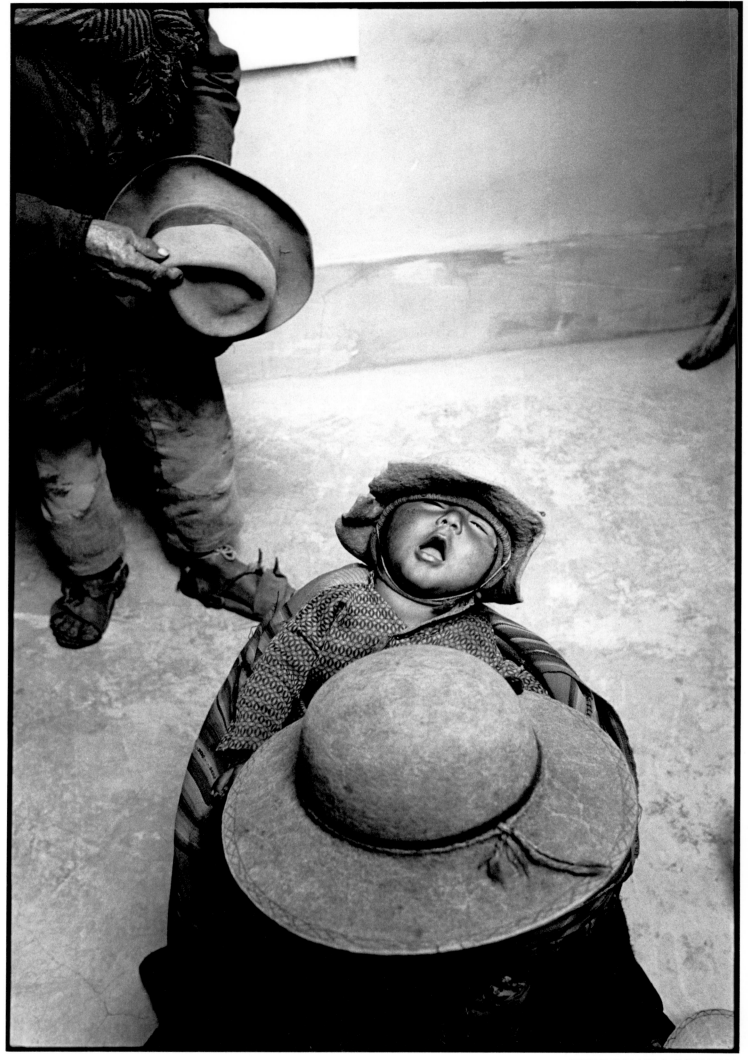

306

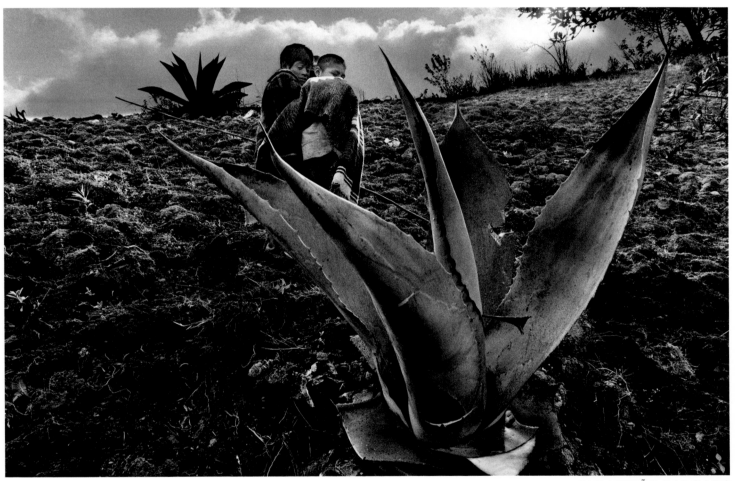

SABASTIÃO SALGADO

Page 303: *Banana workers, Honduras, 1970.*
Pages 304–305: *Serra Pelada goldmine, State of Para, Brazil, 1986.*
Left: *Camiri, Bolivia, 1986.*
Above: *Mexico, 1980.*

307

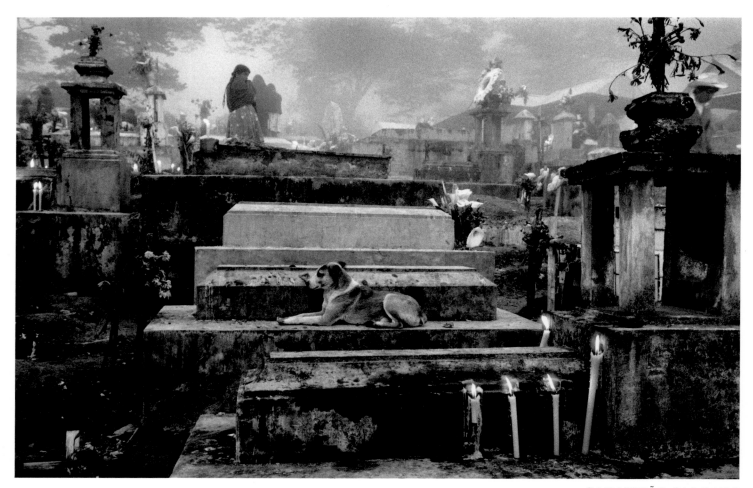

SABASTIÃO SALGADO

Above: *Mexico, 1980.*
Right: *In the Andes, near Cuzco, Peru, 1954.*

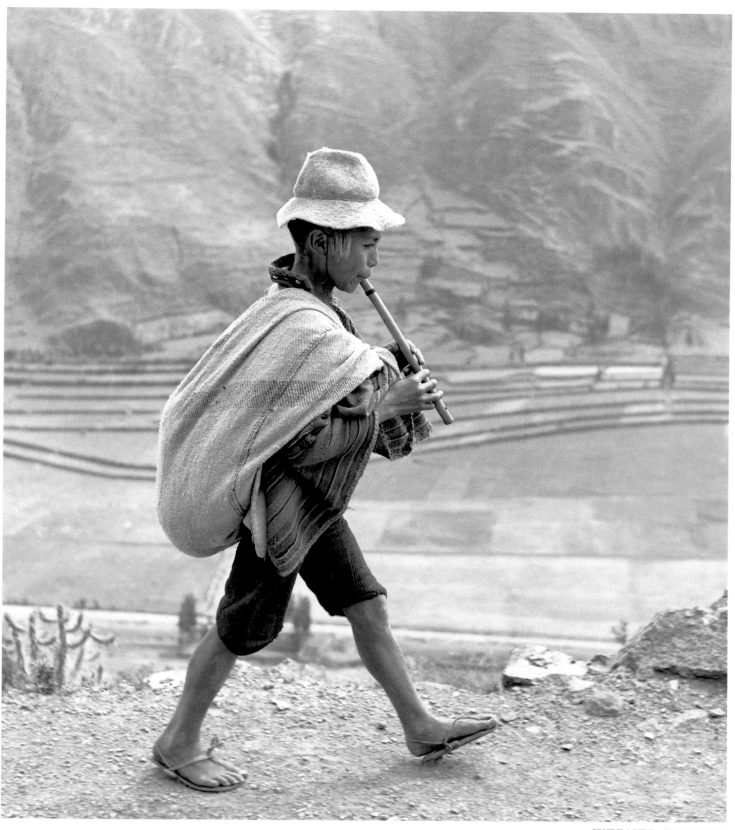

WERNER BISCHOF

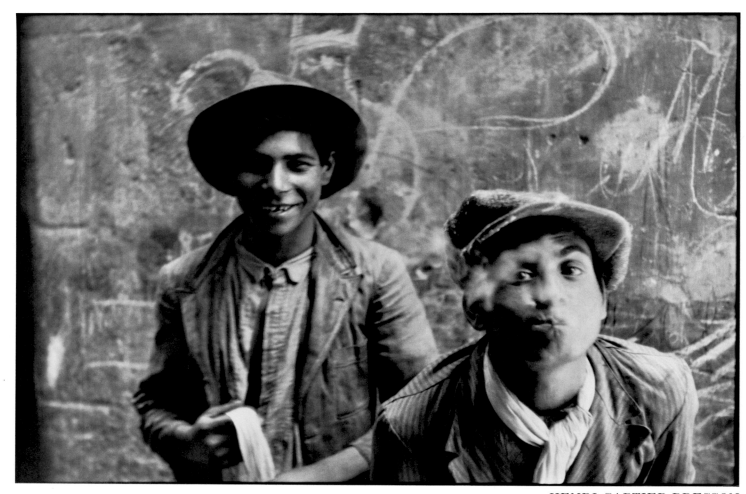

HENRI CARTIER-BRESSON

310

Above: *Gypsies, Grenada, Spain, 1933.*
Right: *Czechoslovakia, 1967.*

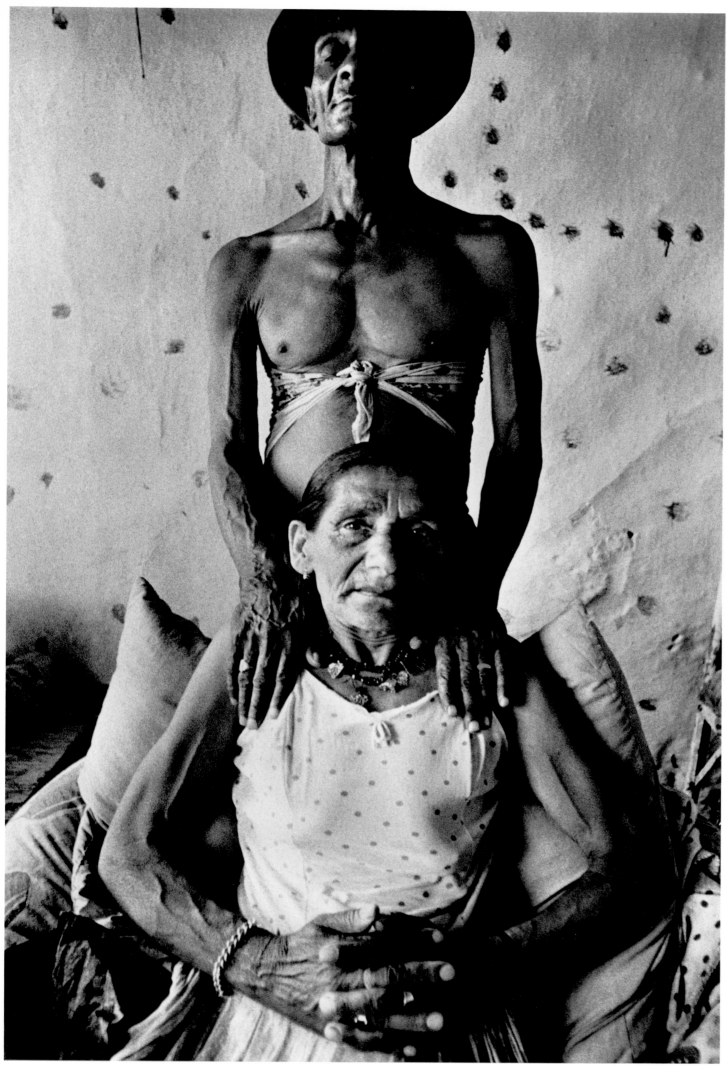

311

JOSEF KOUDELKA

312

JOSEF KOUDELKA

Left: *Tarrassa, Catalonia, 1955.*
Above: *Portugal, 1976.*
Overleaf: *Seville, Spain, 1934.*

315

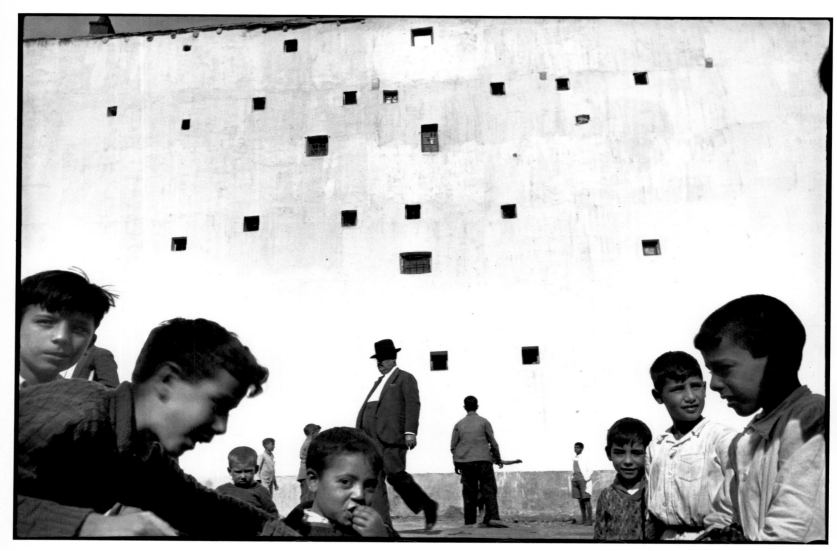

HENRI CARTIER-BRESSON

Above: *Madrid, Spain, 1933.*
Right: *Lola Ruiz Vilato (Picasso's sister), Barcelona, 1954.*
Overleaf: *France, 1973.*

316

317

INGE MORATH

319

JOSEF KOUDELKA

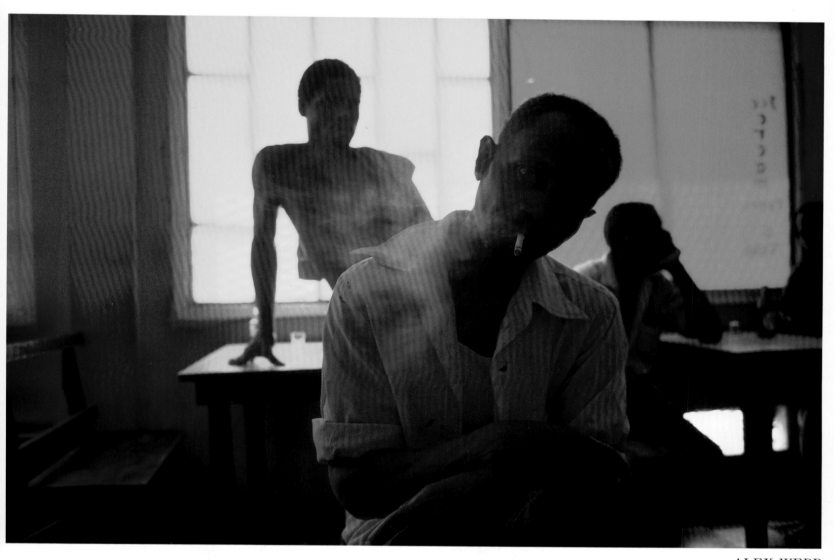

ALEX WEBB

323

ALEX WEBB

MARY ELLEN MARK

Page 321: *Grenada, 1979.*
Pages 322–323: *Dominican Republic, 1980.*
Above: *Falkland Road, Bombay, India, 1978.*
Right: Zona *(prostitution area), Salvador, Bahia, Brazil, 1979.*

325

MIGUEL RIO BRANCO

MICHAEL NICHOLS

MICHAEL NICHOLS

Pages 326–327: *Hutu boy, Rwanda, Africa, 1981.*
Above: *Komodo dragon (a type of lizard), Komodo Island, Indonesia, 1985.*

ALEX WEBB

Above: *Haiti, 1980.*
Overleaf: *The Amazon at Leticia, Colombia-Brazil border, 1966.*

BRUNO BARBEY

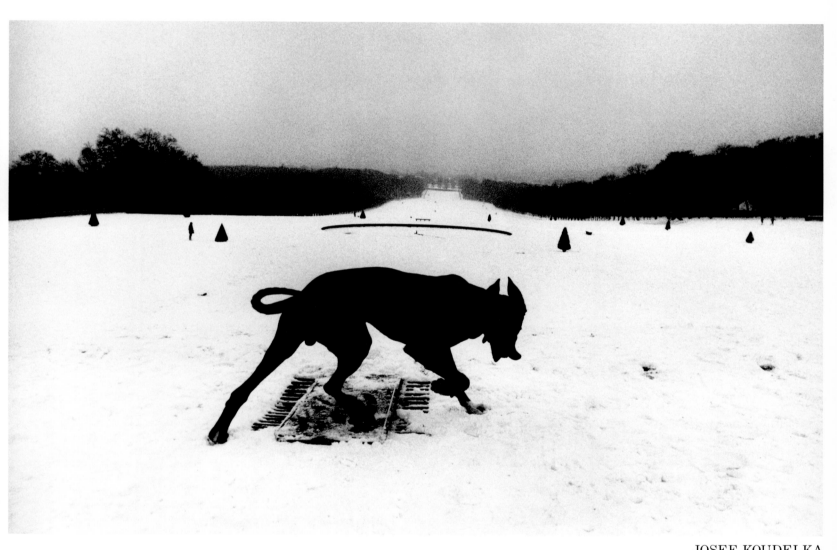

JOSEF KOUDELKA

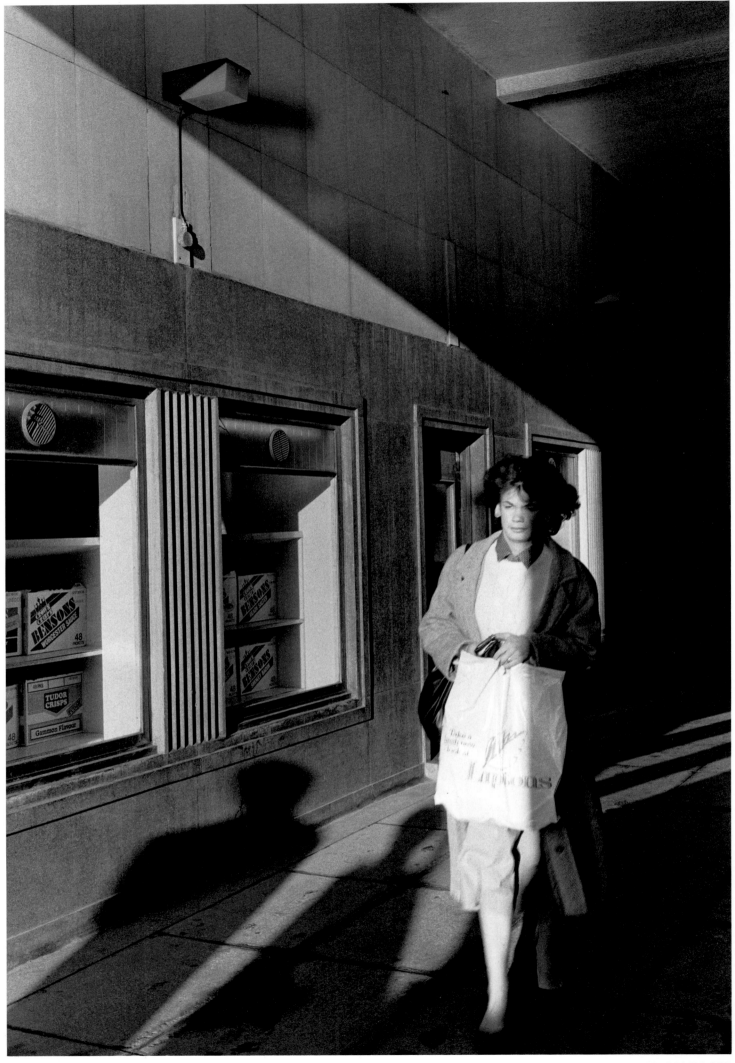

334

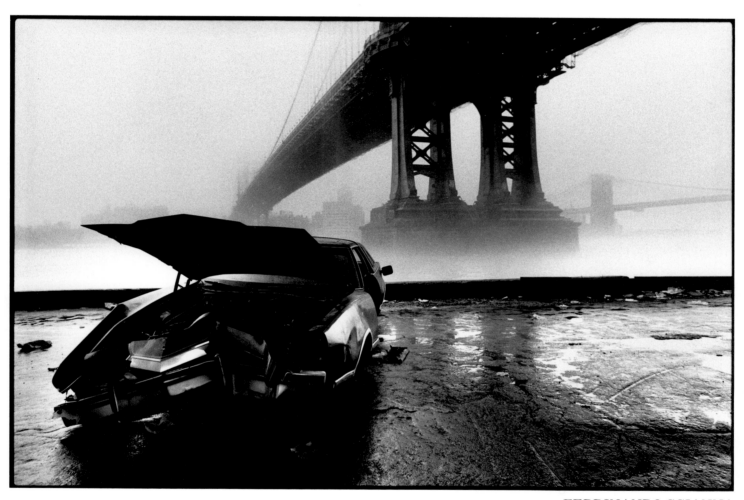

FERDINANDO SCIANNA

Page 333: *Sceaux Park, Sceaux, France, 1987.*
Left: *Woman on her way to work, Liverpool, 1987.*
Above: *On the East River, near the Manhattan Bridge, New York City, 1986.*
Overleaf: *Asylum, Naples, 1979.*

337

RAYMOND DEPARDON

FERDINANDO SCIANNA

Above: *Colombia, 1987.*

SERGIO LARRAIN

Above: *Paris, 1959*.
Overleaf: *Tennessee, 1986*.

EUGENE RICHARDS

SUSAN MEISELAS

Above: *Carnival strippers, Essex Junction, Vermont, 1973.*
Right: *Centralia, Kansas, 1956.*
Overleaf: *Valencia, Spain, 1973.*

343

ERICH HARTMANN

JOSEF KOUDELKA

ELLIOTT ERWITT

Above: *Orleans, France, 1952.*
Right: *Santiago, Chile, 1954.*
Overleaf: *Isle of Dogs, formerly the Victorian docking area, Thames River,*
London, 1983.

347

SERGIO LARRAIN

PETER MARLOW

WERNER BISCHOF

HIROSHI HAMAYA

WERNER BISCHOF

Page 351: *Pilgrim in front of the Kyomizu Temple, Kyoto, Japan, 1951.*
Pages 352–353: *Ayers Rock, Australia, 1975.*
Above: *Shinto priests in the garden of the Meiji Temple, Tokyo, 1951.*
Right: *Priests of the Meiji Temple, Tokyo, 1951.*

WERNER BISCHOF

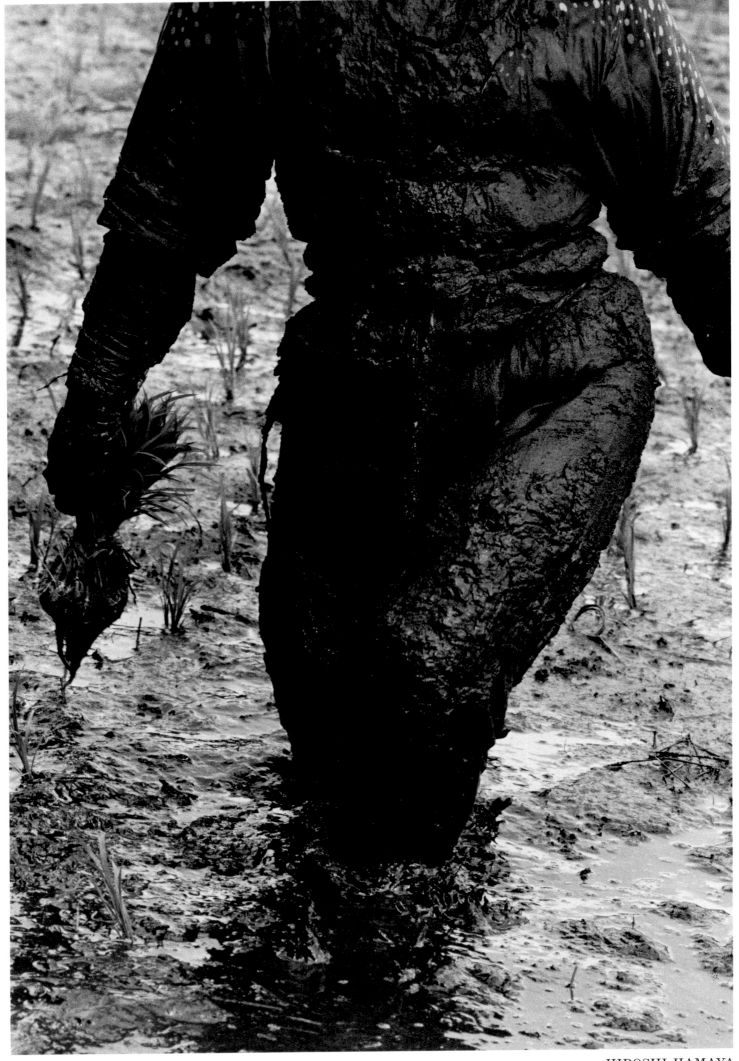

356

HIROSHI HAMAYA

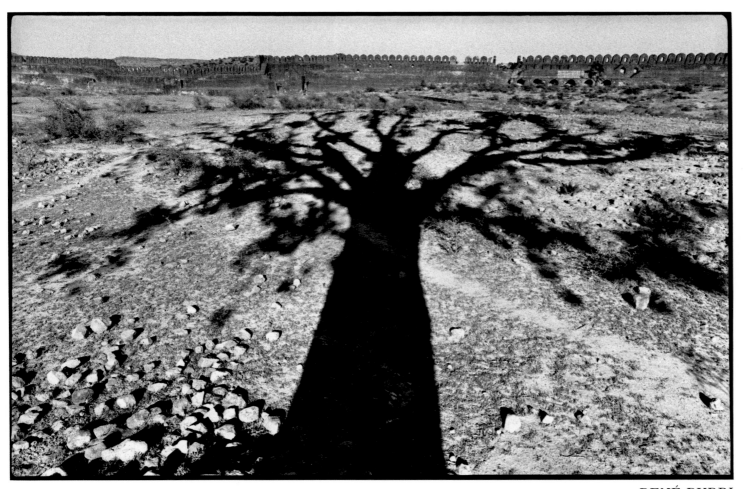

RENÉ BURRI

Left: *Woman planting rice, Toyama, Japan, 1955.*
Above: *Fort Rohtas, Pakistan, 1963.*
Overleaf: *Last days of the Kuomintang, Beijing, 1949.*

357

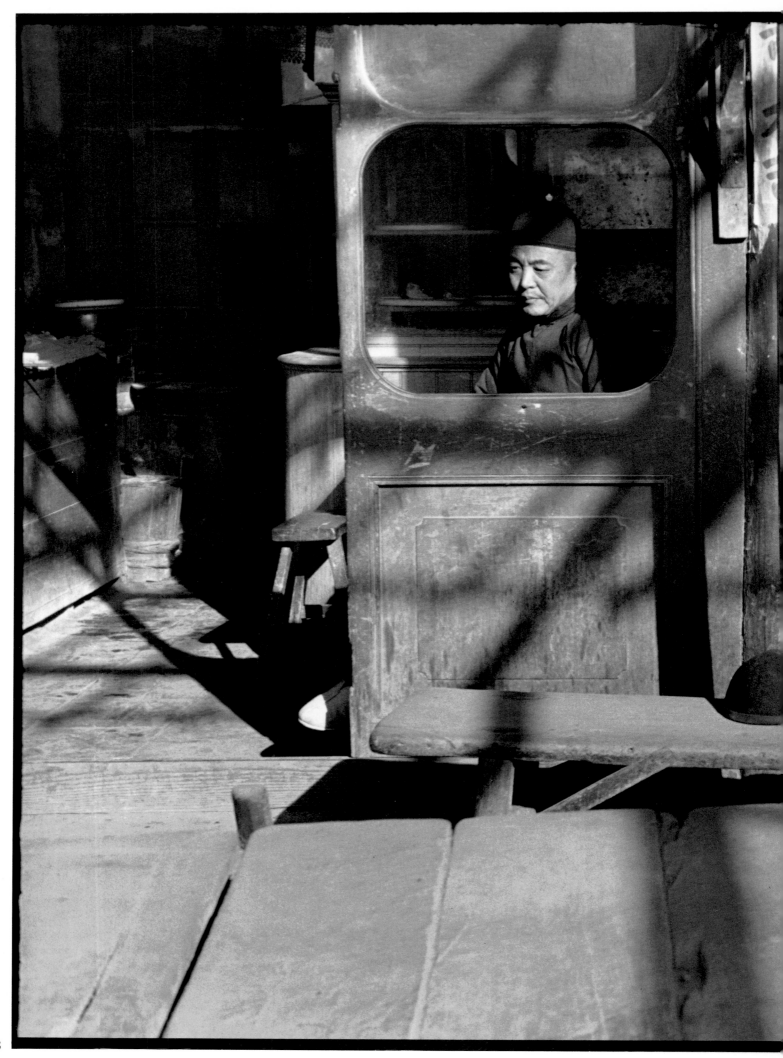

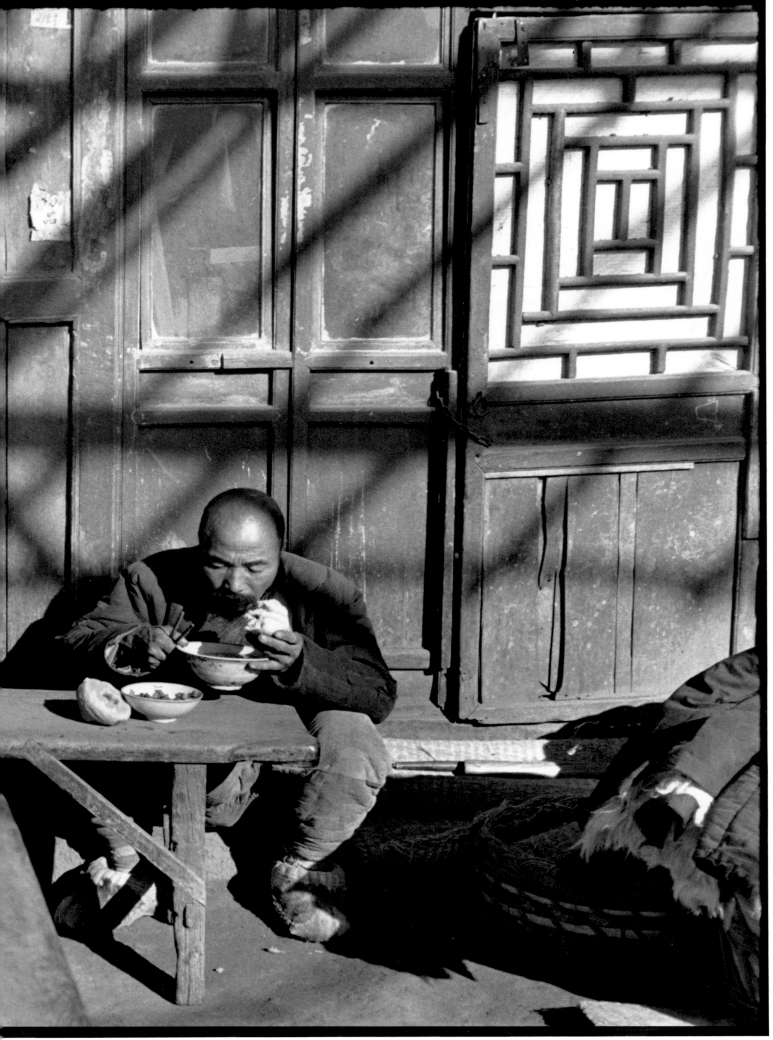

359

HENRI CARTIER-BRESSON

Above: *Bas-relief of a Buddha, Hangzhou, China, 1978.*

GUY LE QUERREC

Above: *Bao-Guang Monastery, Sichuan Province, China, 1984.*

MARC RIBOUD

Above: *A street in old Beijing, as seen from an antique dealer's, China, 1965.*
Right: *Refugees from mainland China, Hong Kong, 1948.*
Overleaf: *Worshipping the ancestors, Hangzhou, China, 1984.*

363

HENRI CARTIER-BRESSON

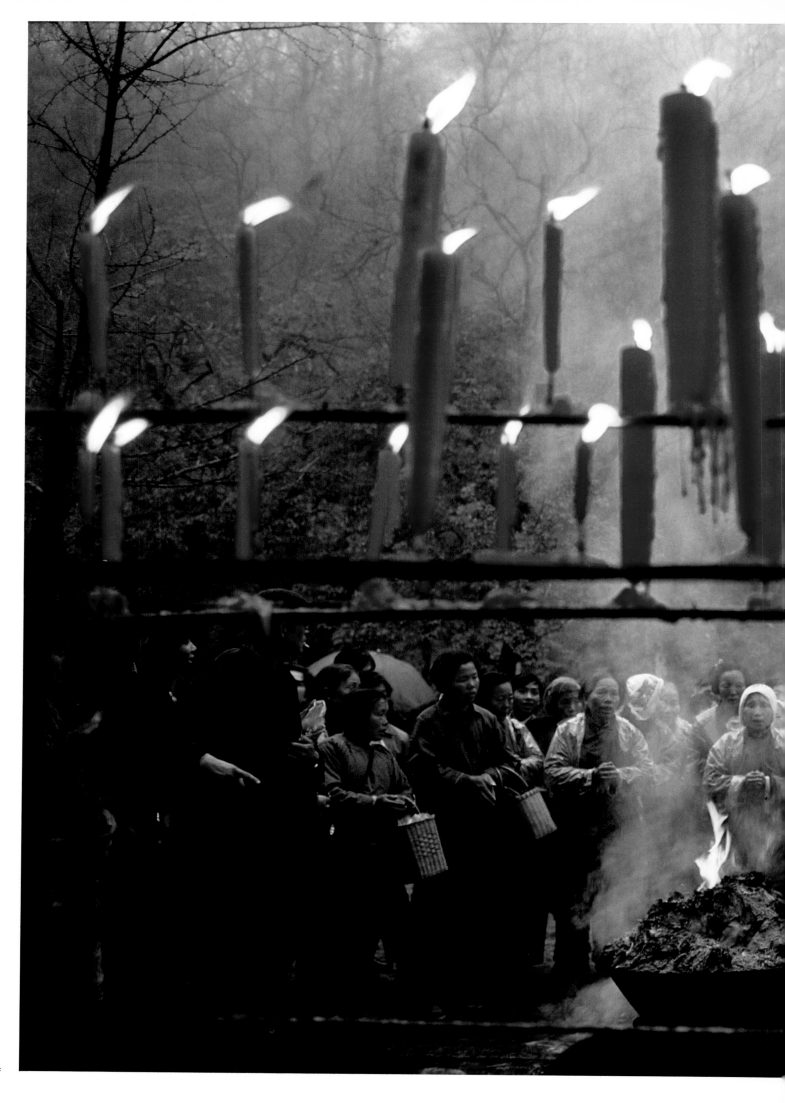

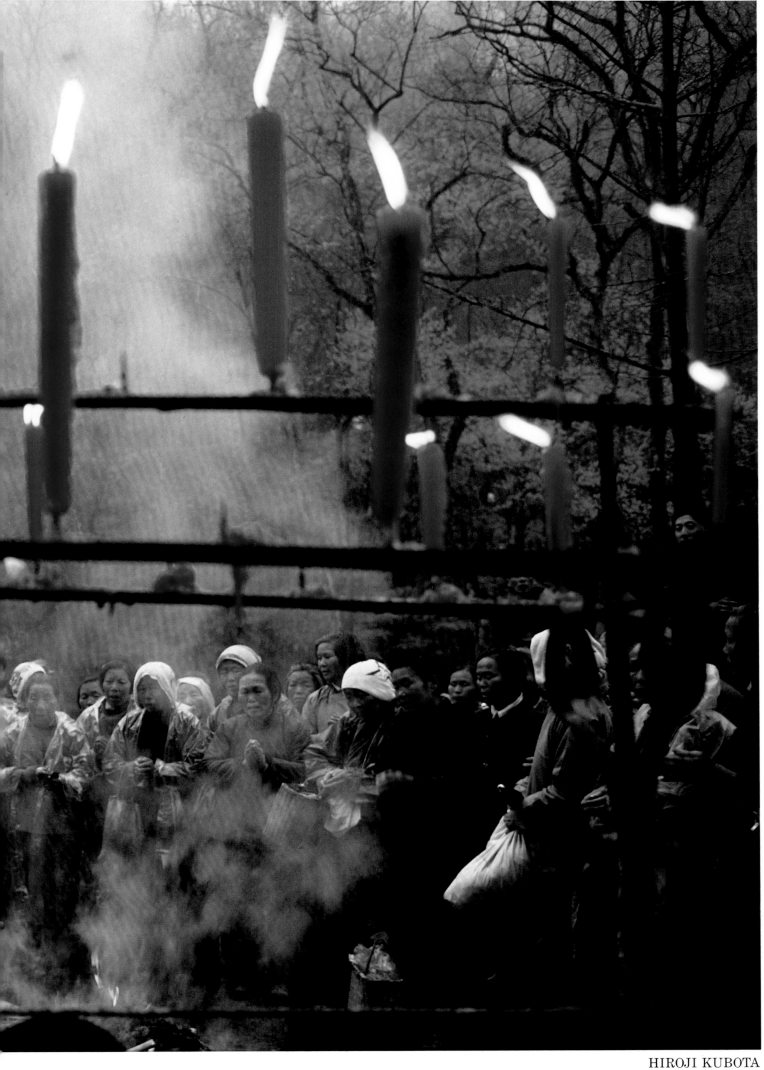

365

HIROJI KUBOTA

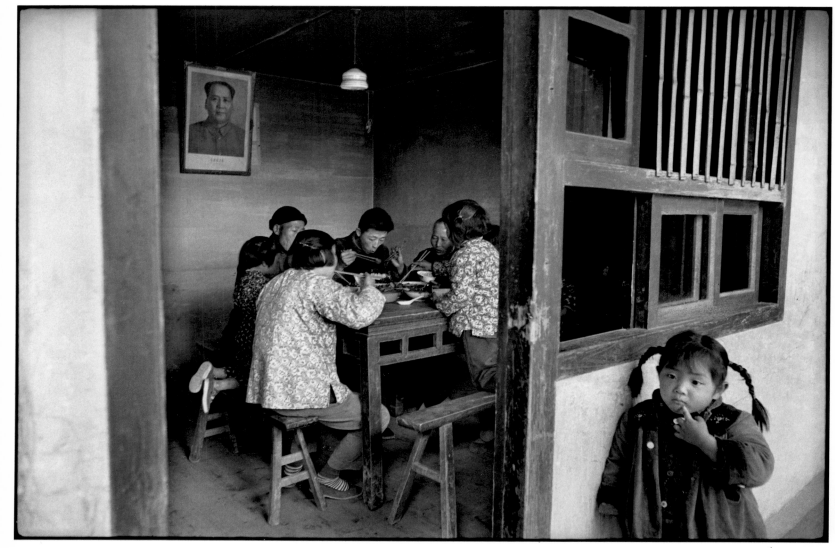

RENÉ BURRI

Above: *White Horse Commune, near Shanghai, China, 1964.*
Right: *The Great Wall, Hebei Province, China, 1971.*
Overleaf: *Japanese photo workshop, Karuizawa, Japan, 1958.*

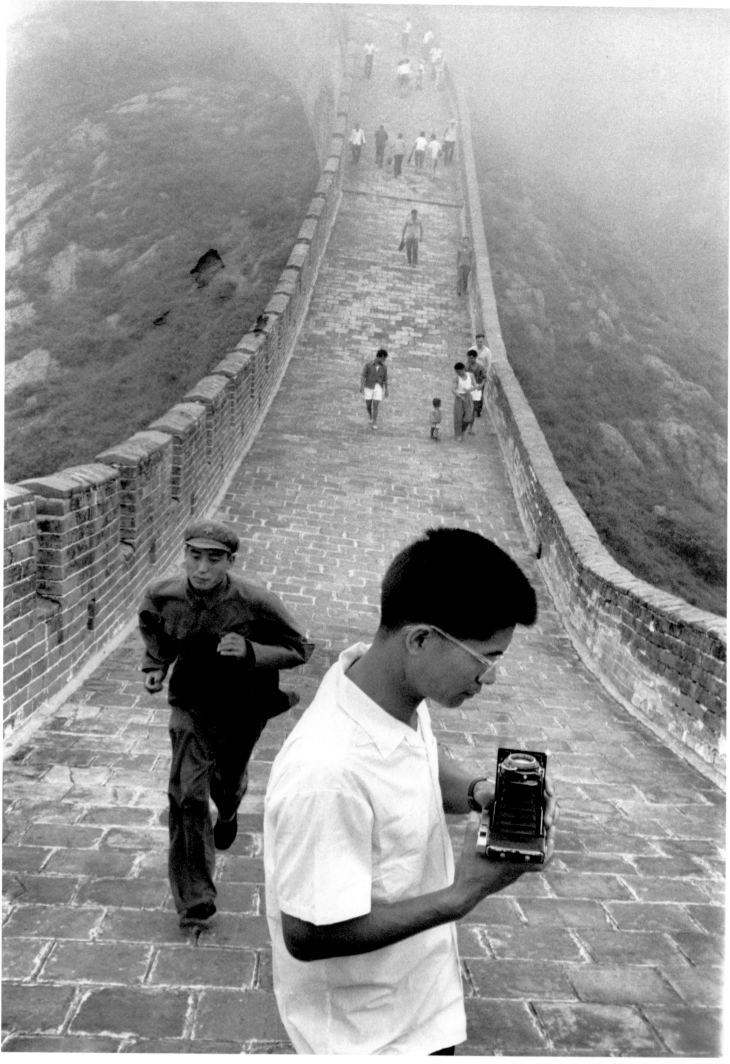

MARC RIBOUD

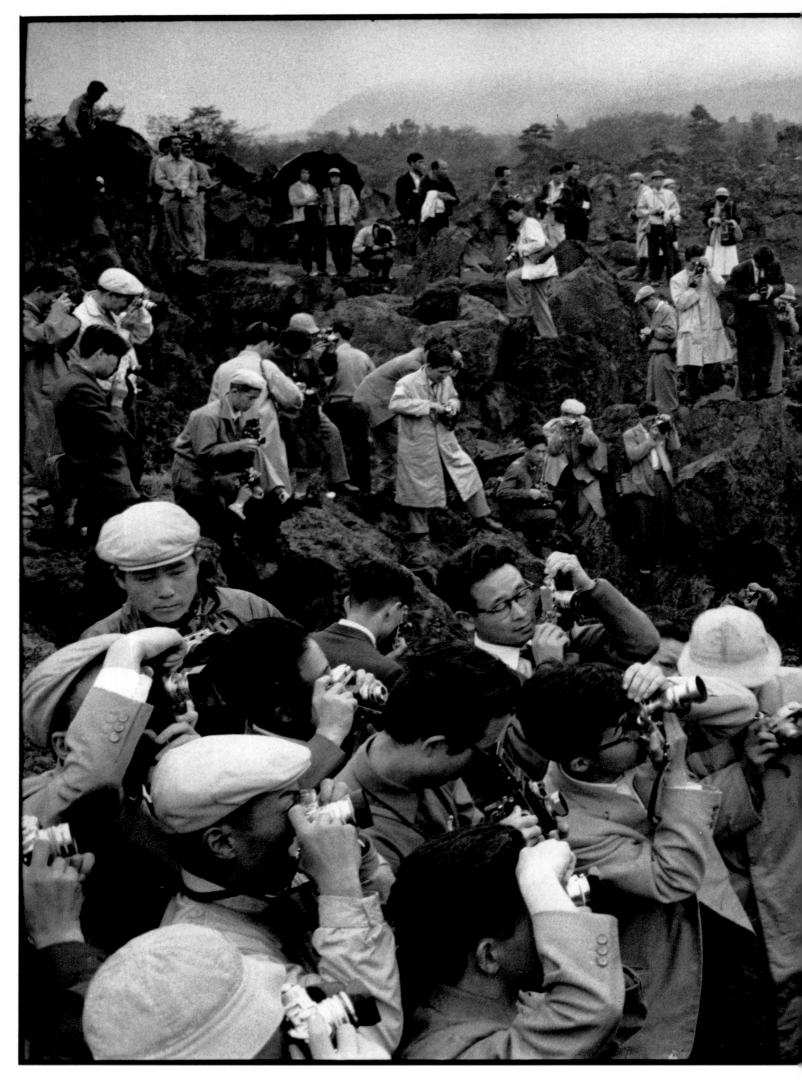

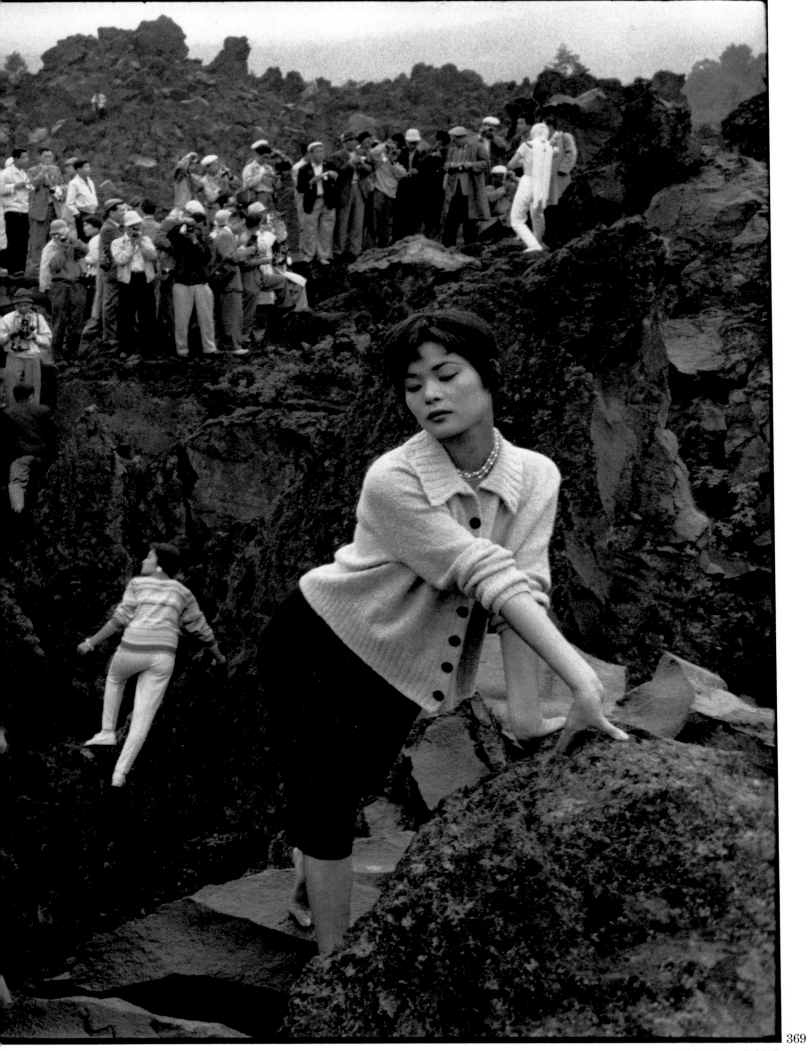

369
MARC RIBOUD

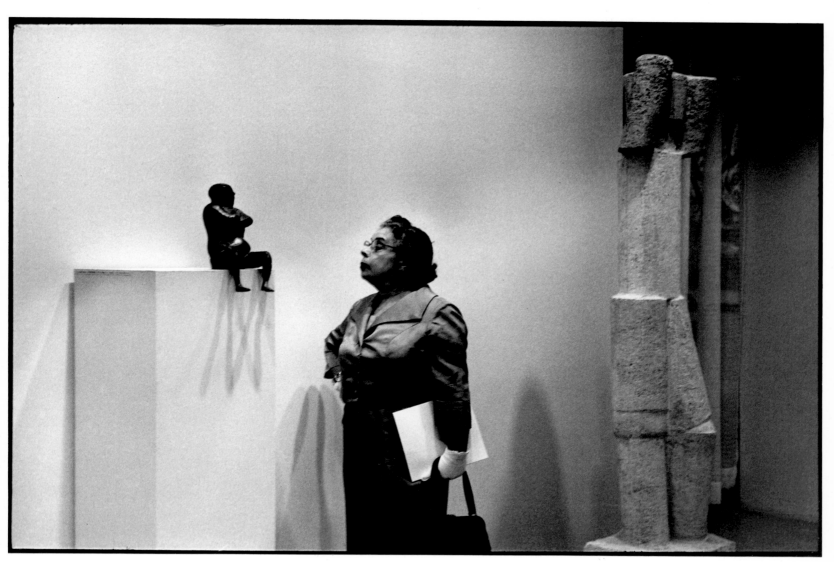

EVE ARNOLD

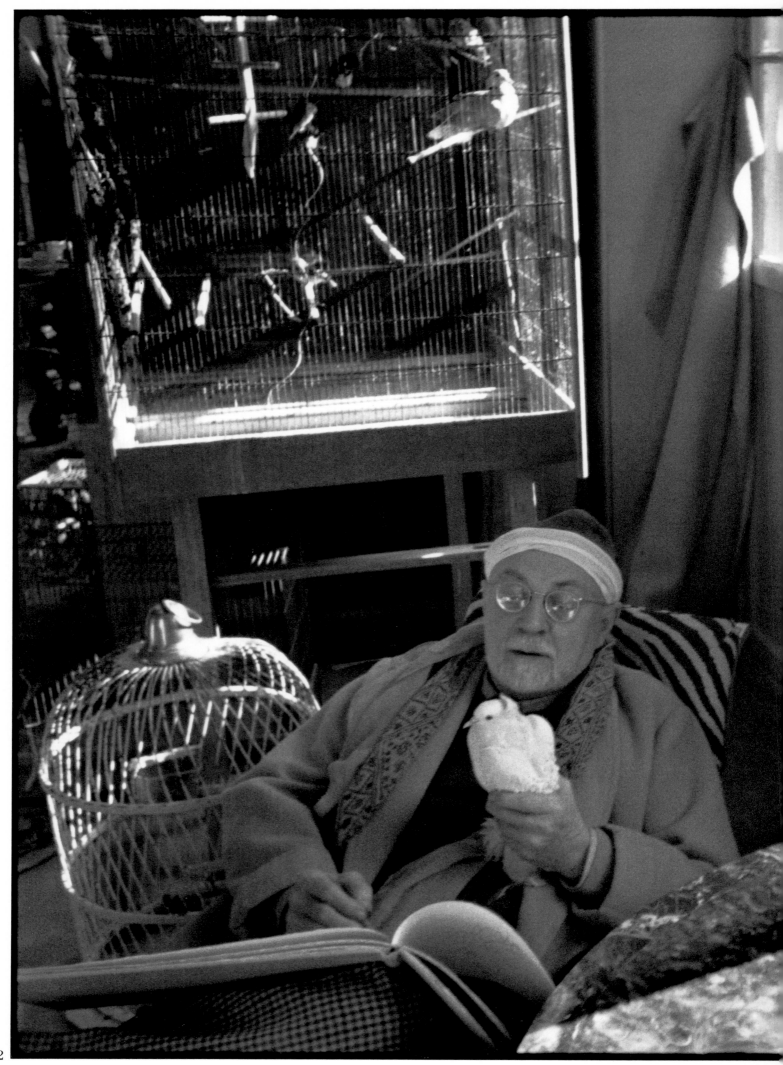

373

374

CORNELL CAPA

MARTINE FRANCK

Page 371: *Museum of Modern Art, New York City, 1959.*
Pages 372–373: *Henri Matisse, Vence, France, 1944.*
Left: *Bolshoi Ballet School, Moscow, 1958.*
Above: *Exhibition of Belgian art, Grand Palais, Paris, 1972.*

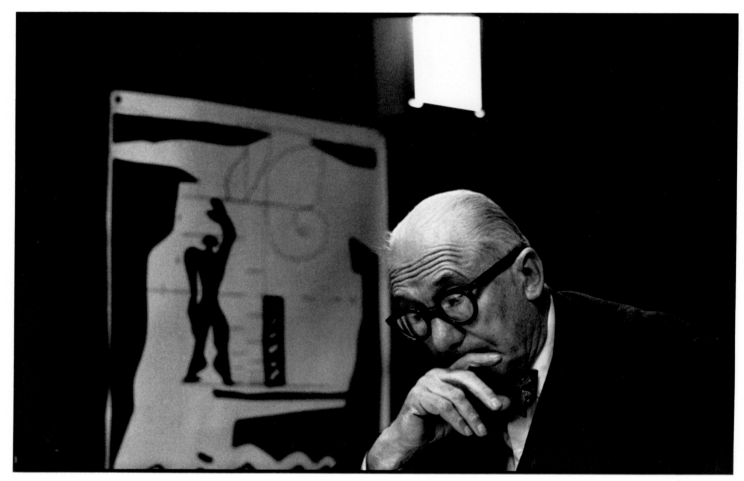

RENÉ BURRI

Above: *Le Corbusier in his studio, rue de Sevres, Paris, 1959.*
Right: *Alberto Giacometti's studio, Paris, 1960.*
Overleaf: *Metropolitan Opera rehearsal, New York City, 1978.*

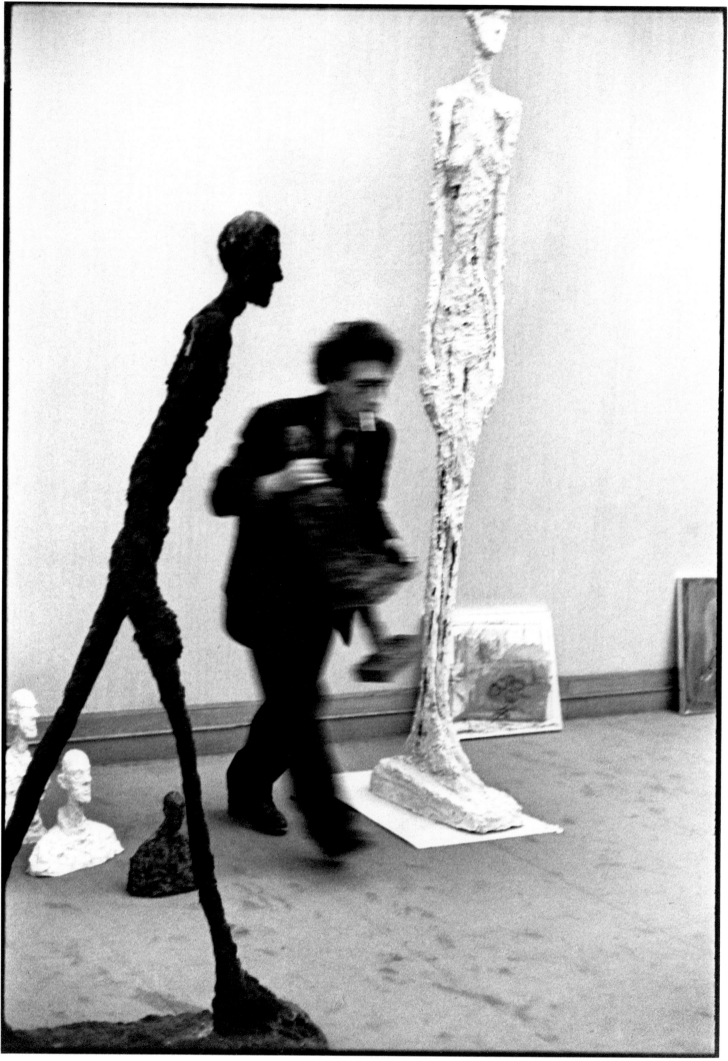

HENRI CARTIER-BRESSON

BURT GLINN

MARTINE FRANCK

Above: *The painter Avigdor Arikha, Paris, 1975.*
Right: *Saul Steinberg, New York, 1959.*

INGE MORATH

382

DAVID SEYMOUR (Chim)

Left: *Marilyn Monroe, Hollywood, 1960.*
Above: *Bernard Berenson at the Borghese Gallery, Rome, 1955.*
Overleaf: *Mrs. Evelyn Nash, London, 1953.*

385

INGE MORATH

GUY LE QUERREC

Above: *Dexter Gordon and Ron Carter on the movie set of*
Round Midnight, *1985.*
Right: *Louis Armstrong in his dressing room at the Latin Casino,*
Philadelphia, 1959.

387

DENNIS STOCK

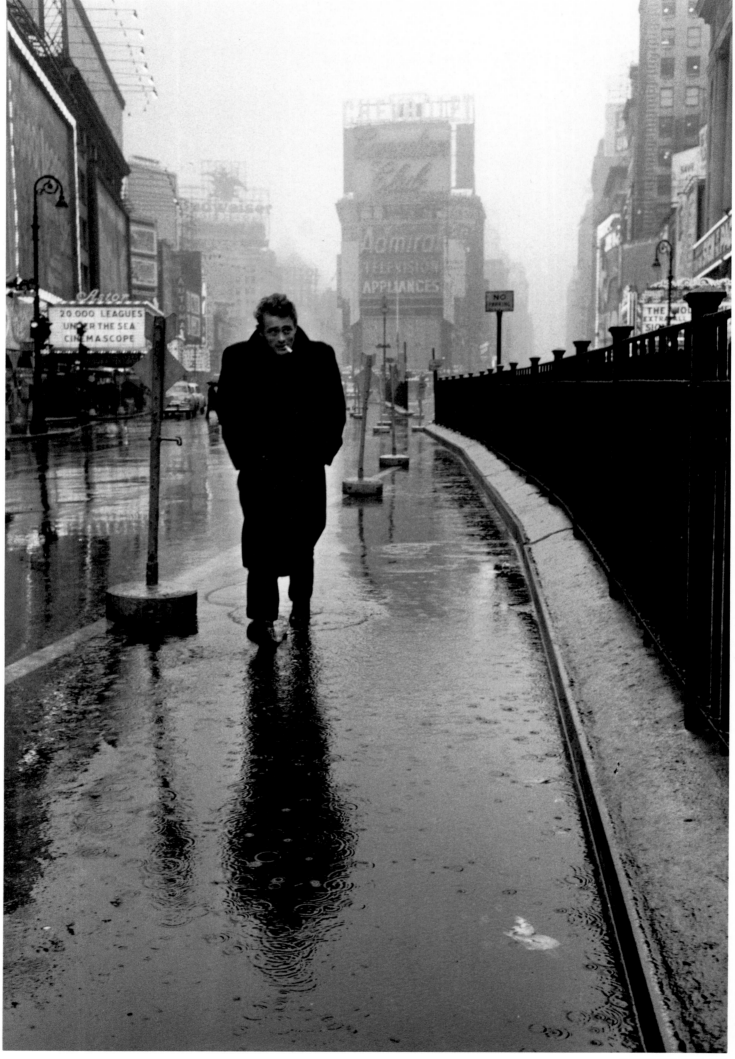

DENNIS STOCK

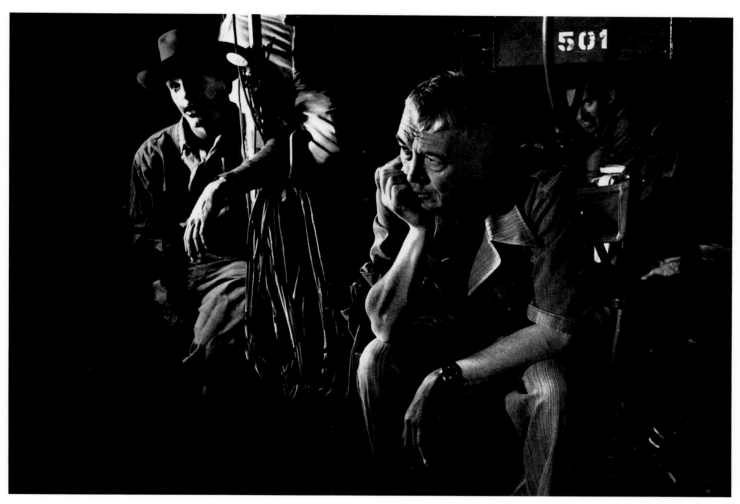

EVE ARNOLD

Left: *James Dean in Times Square, New York City, 1955.*
Above: *John Huston directing* The Misfits, *Nevada, 1960.*
Overleaf: *Mabel Godwin and Melissa Slolum at Arthur's nightclub, New York City, 1987.*

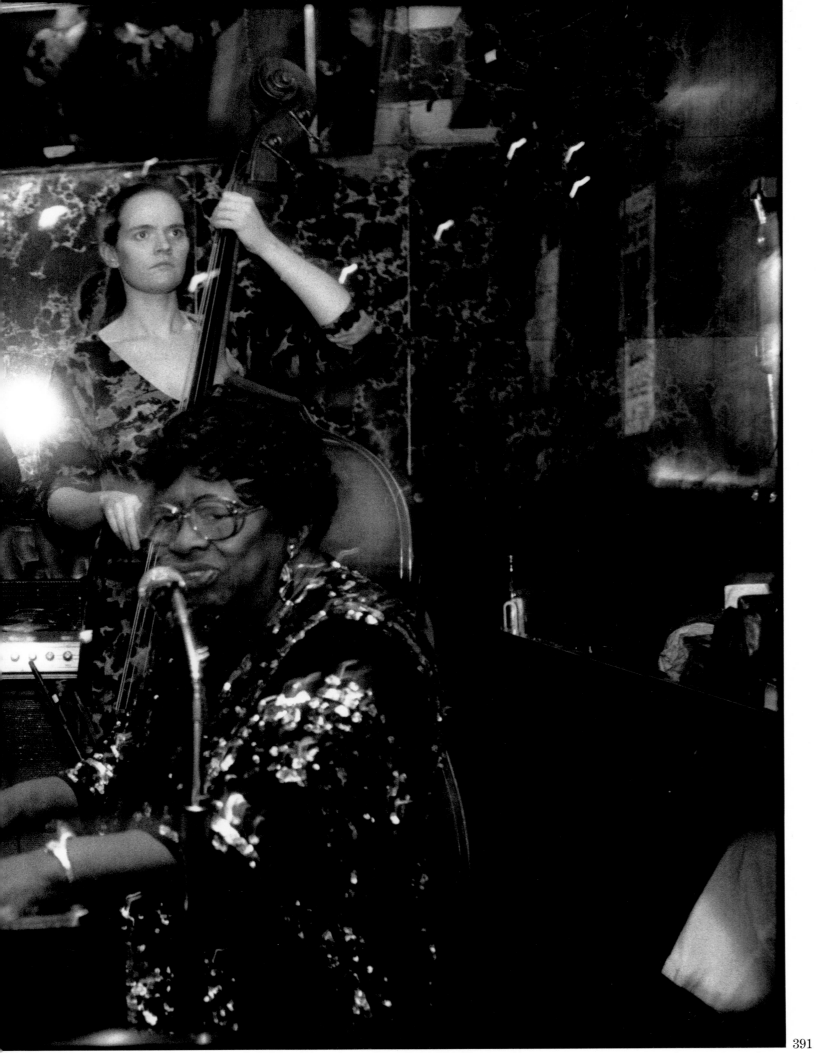

391

GUY LE QUERREC

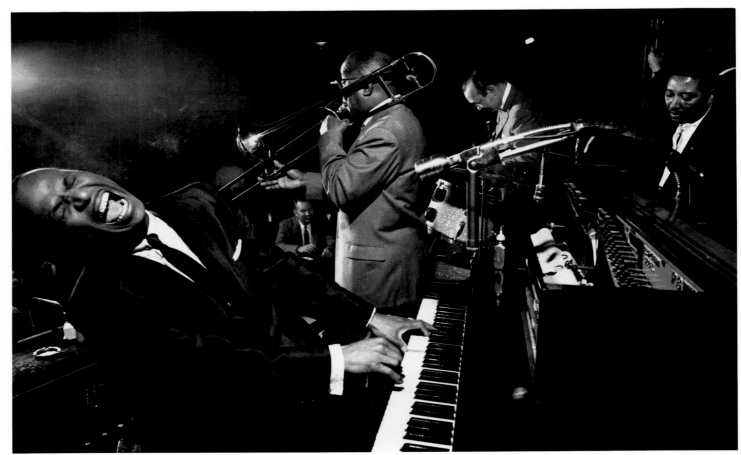

DENNIS STOCK

Above: *Earl Hines at the Hangover, San Francisco, 1958.*
Right: *Sammy Davis, Jr., New York City, 1959.*

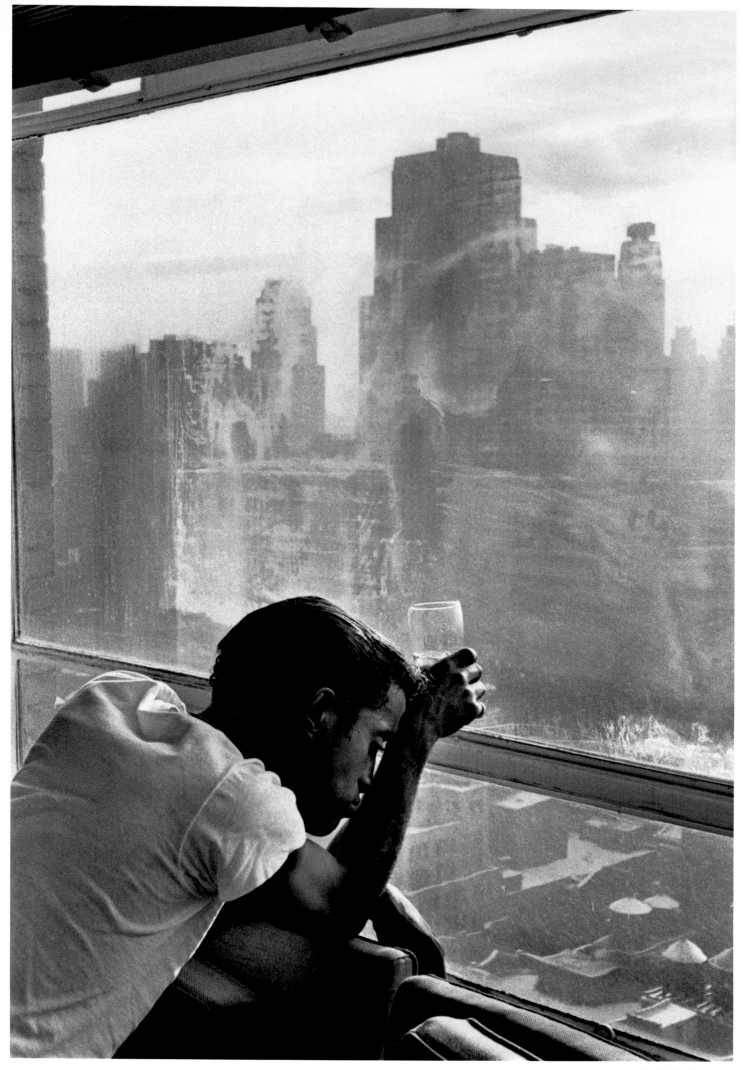

393

BURT GLINN

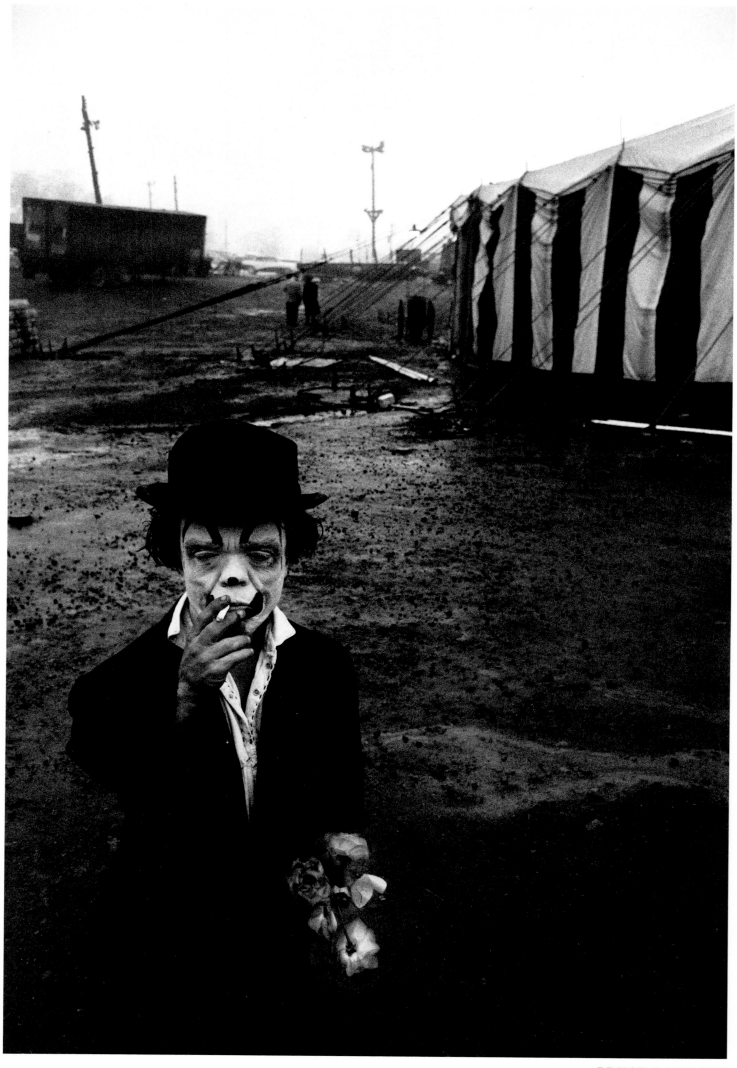

394

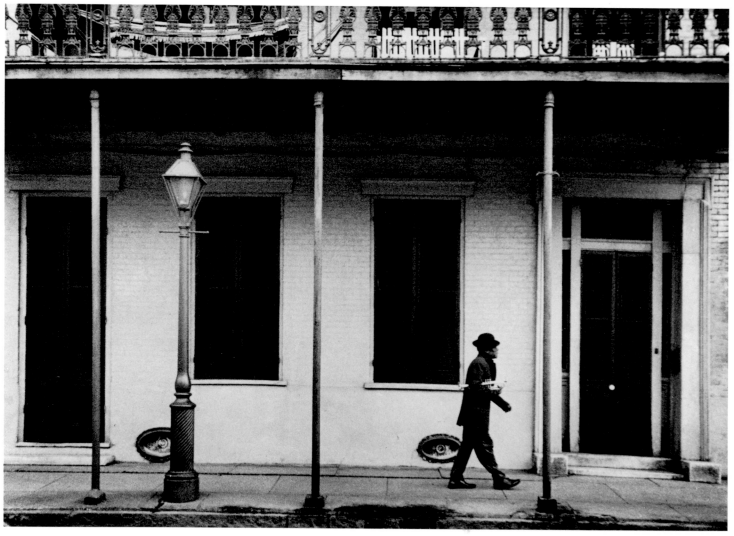

DENNIS STOCK

Left: *Circus dwarf, Palisades, New Jersey, 1958.*
Above: *Kid "Punch" Miller going home from work at 6 A.M.,*
New Orleans, 1959.

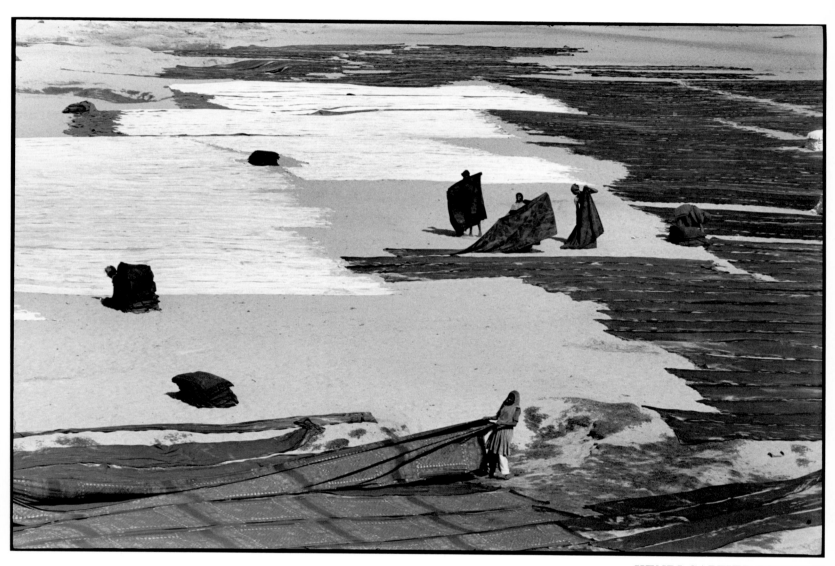

HENRI CARTIER-BRESSON

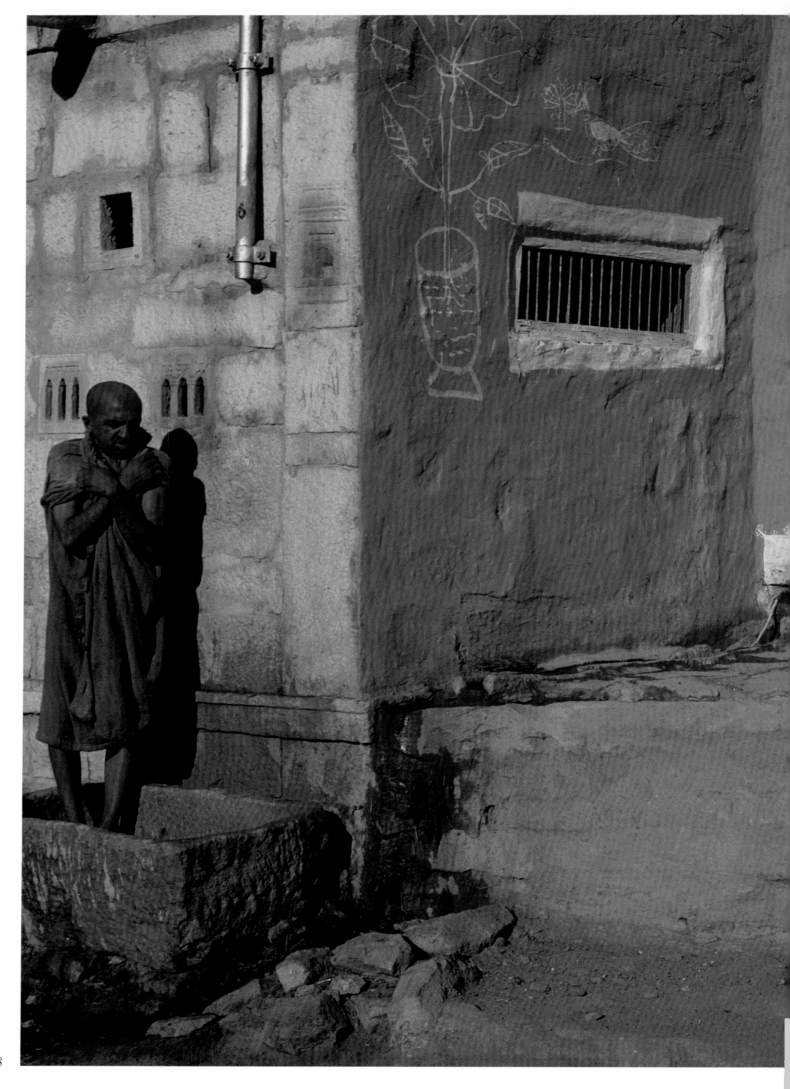

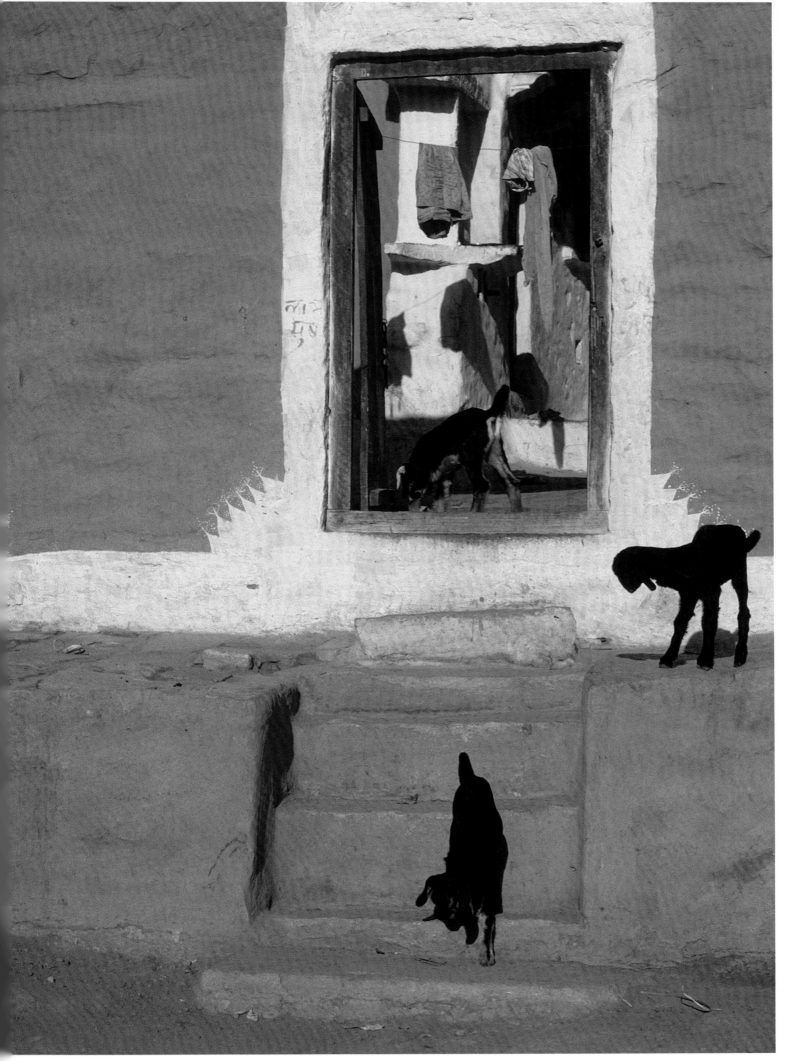

HARRY GRUYAERT

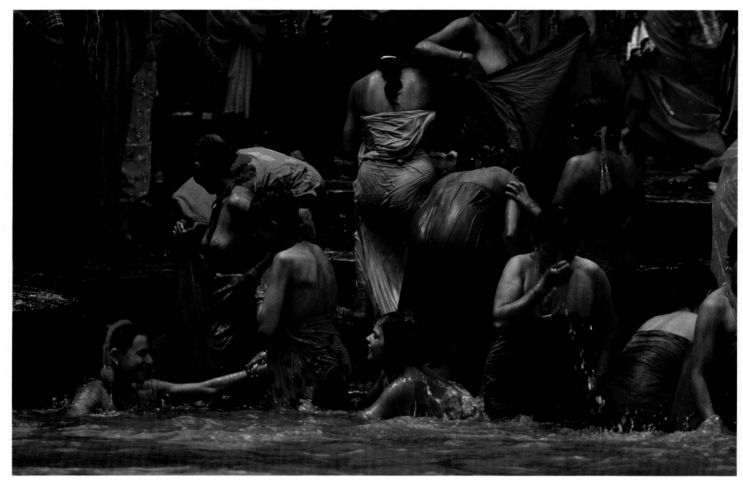

STEVE McCURRY

Page 397: *Ahmadabad, India, 1965.*
Pages 398–399: *Jaisalmer, India, 1976.*
Above: *Ritual washing in the Baghmati River, Kathmandu, Nepal, 1983.*
Right: *Early monsoon rains, India, 1960.*

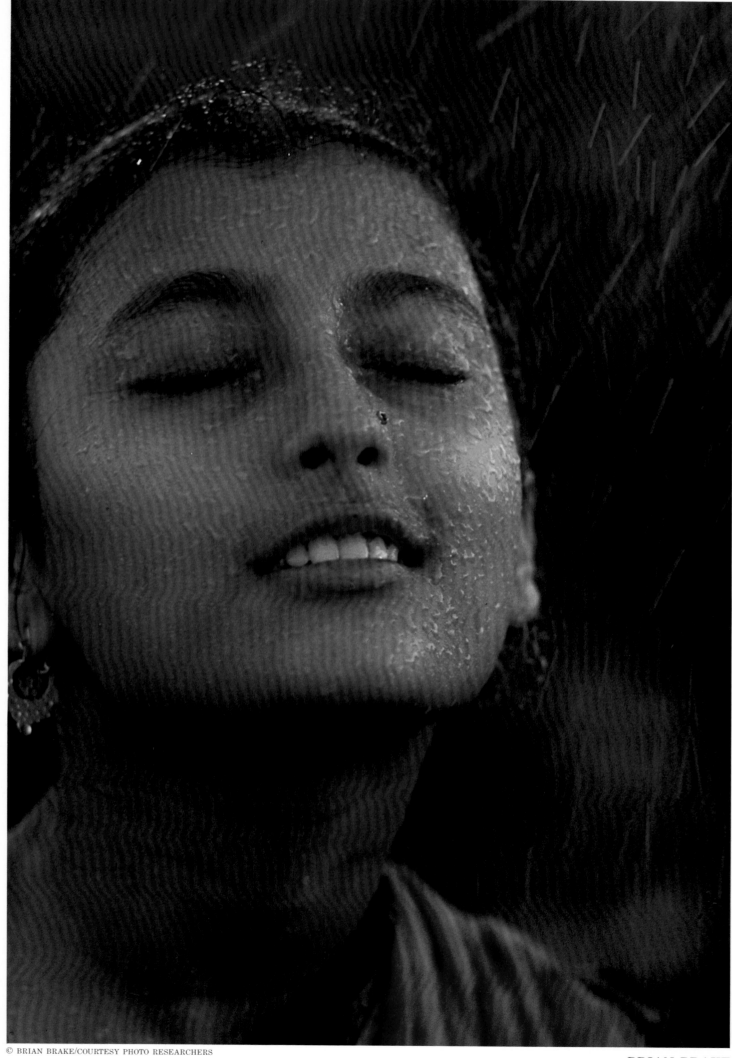

BRIAN BRAKE

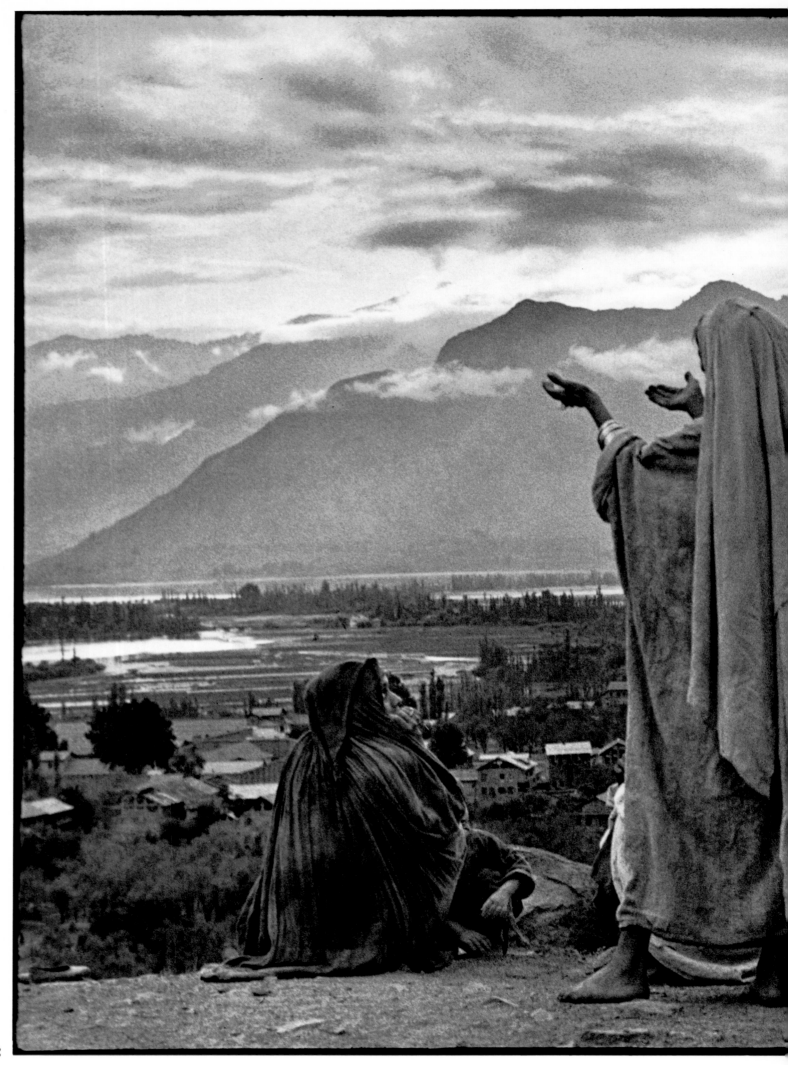

402

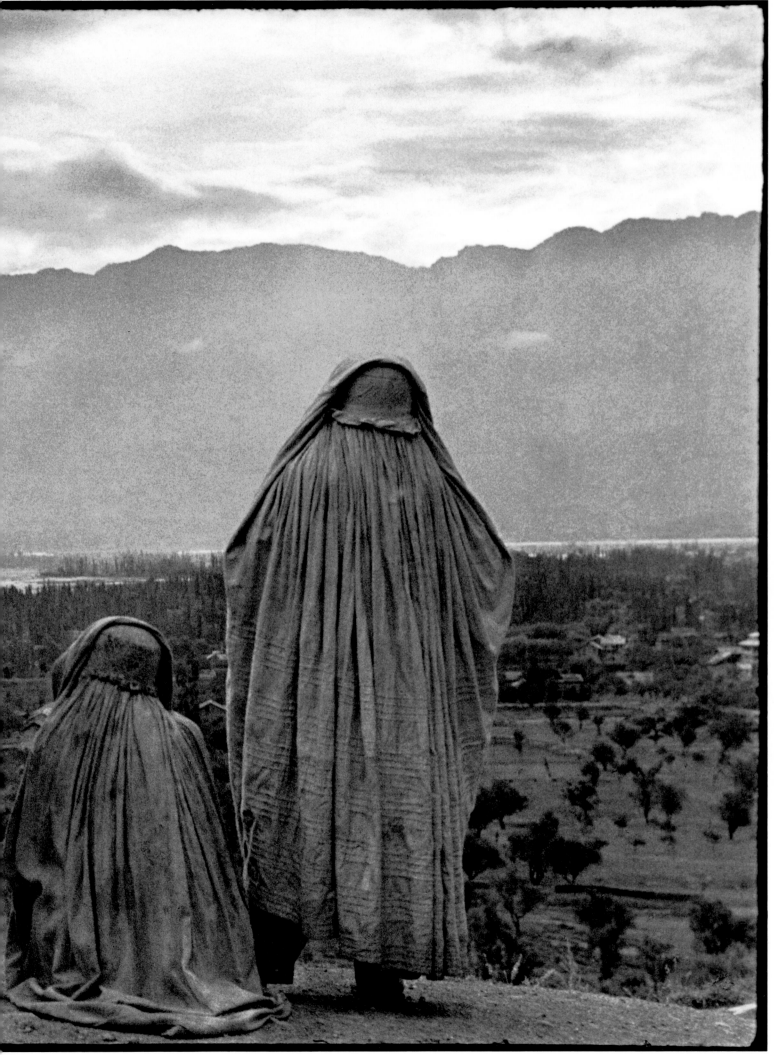

403

HENRI CARTIER-BRESSON

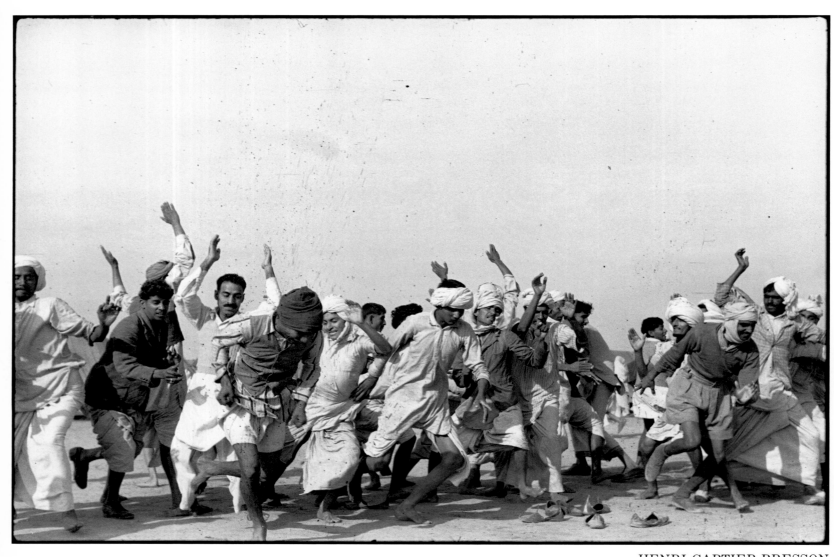

HENRI CARTIER-BRESSON

Pages 402–403: *Srinagar, Kashmir, 1948.*
Above: *Gymnastics in a refugee camp, Kurukshetra, Punjab, India, 1948.*
Right: *Famine in Bihar Province, India, 1951.*

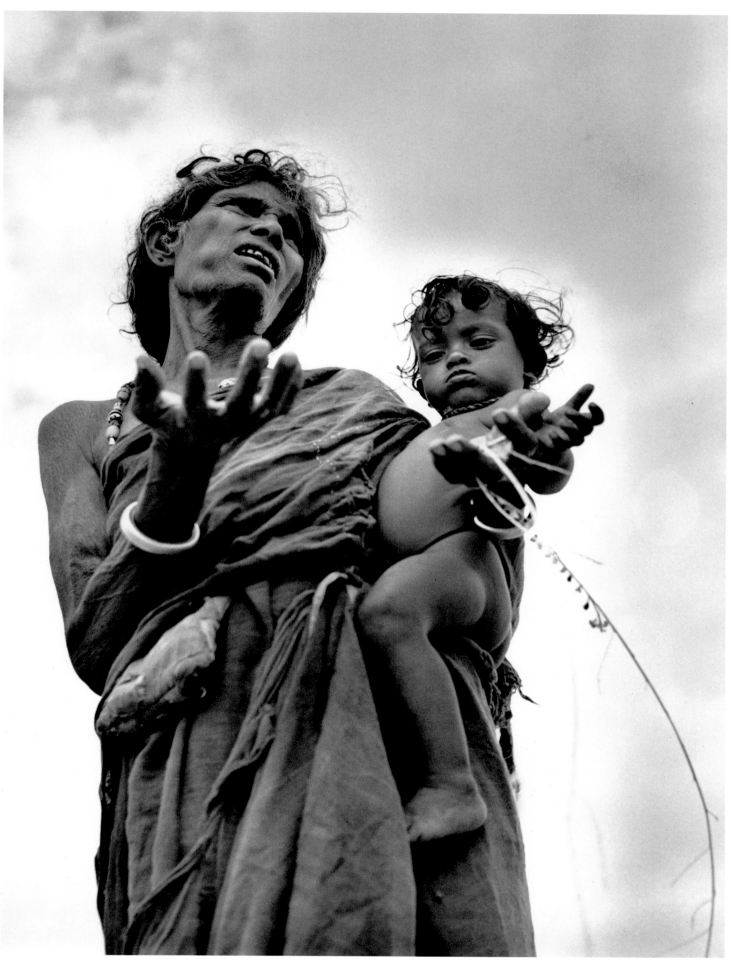

WERNER BISCHOF

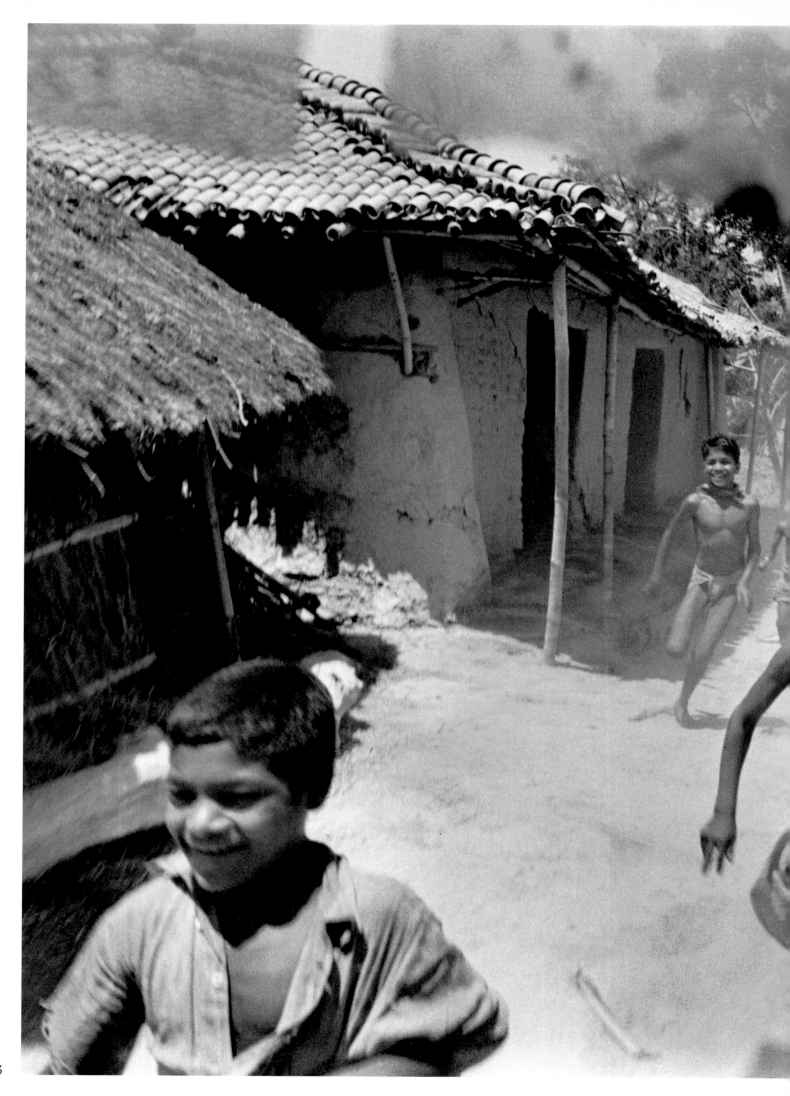

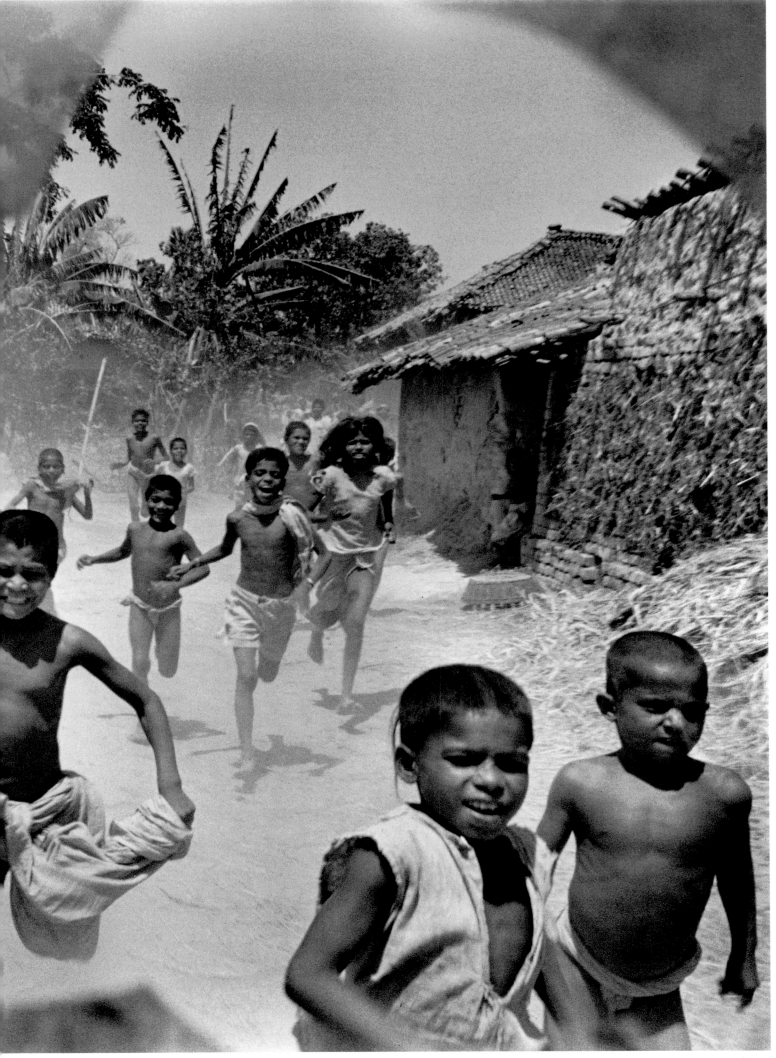

407

WERNER BISCHOF

408

BRIAN BRAKE

MARC RIBOUD

Pages 406–407: *Corn comes to the village, Bihar Province, India, 1951.*
Left: *Monsoon clouds, Ganges Delta, India, 1960.*
Above: *After bathing in the Ganges, Varanasi, India, 1956.*
Overleaf: *Bodybuilders and wrestlers on the Ghats River, Calcutta, India.*

RAGHU RAI

MARILYN SILVERSTONE

Above: *Varanasi, India, 1959.*
Right: *Bombay, India, 1977.*
Overleaf: *Bombay, India, 1981.*

413

BRUNO BARBEY

415
ALEX WEBB

What Is Magnum?

FRED RITCHIN

Magnum Photos was created in 1947, two years after the English photographer George Rodger, a veteran of the war in North Africa and Europe, went to Bergen-Belsen to cover the liberation of the concentration camp. He found it obscene to be attempting to frame the atrocities in his viewfinder, "getting the dead into nice photographic compositions," and forever abandoned the photography of war.

The two events seem related. George Rodger became a founding member of Magnum; soon after the agency was formed, he went off to Africa, a continent which at that time had hardly been photographed, for a two-year, 29,000-mile journey by Land-Rover to find and depict a purity of the human experience, "to get away where the world was clean."

One common conception of the documentary aspect of photography views it as a medium of commendable veracity, transparently mechanical, featuring a camera that "never lies," able to record in detail and virtual objectivity that which is in front of the lens. The photographers, acknowledged as a group to be courageous, even intrepid, are thought to simply release the shutter, albeit with greater or lesser degrees of visual flair.

If this were so, Magnum would not exist, for this view leaves out both an understanding of the inherent complexities of photography as an interpretive medium and the possibility of powerful individual differences among photographers. Most good photographers are aware, like Rodger, that the relationship between content and form is

fragile and easily betrayed, that the horror and stench, the apocalypse of dead bodies can come across in an image as strangely serene, even beautiful. They know that not only what is photographed is important, but the way in which it is portrayed will change its meaning, and that despite the plenitude of visible details available, the photograph often conceals more than it shows—and that what it shows may be highly ambiguous. Furthermore, the film records during such small bits of time that this book's four hundred pictures, representing over four decades of work, were most probably taken in a total of some four seconds—one second, more or less, per decade.

Those photographers working in the mass media are also aware that distant editors, exercising other points of

view and having the overriding stylistic or editorial interests of their own publication in mind, can markedly change the intended meaning of the photographers' images. This can be accomplished with captions and titles that redirect, or even contradict, the photographer's original intent, taking advantage of the image's ambiguity. The same picture of Mikhail Gorbachev, for example, whom the photographer may have wanted to portray as an intelligent, charismatic human being, can be alternately captioned as being of a patriotic hero or despicable tyrant in different publications.

It is also possible when cropping and sequencing photographs in a particular layout to transform and sometimes corrupt their intended meaning by creating different visual contexts: placing a car advertisement next to an image of famine victims might trivialize their desperate circumstance. Also, the personality of each individual publication can have a similar effect, so that the same photograph published in *Time* and *Playboy*, for example, may be read differently.

But the most evident modification is the selection of which images to publish. Unlike virtually any other communicator, the mass-media photographer frequently labors under the particular vulnerability of having to submit every image he or she has taken, or at least a significant variety of them, for someone else to choose from. It is evident that in making a portrait, for example, different facets of the subject's personality may be emphasized in a series of images, including nonrepresentative aspects. Allowing others to choose the image to be published diminishes the photographer's interpretive capability, at times to the point of distortion. Lee Jones, a former Magnum editor, finds the selection process "ludicrous—like tearing up Cézanne's sketchbook and taking one sketch."

In its best sense, although always a commercial venture, Magnum was created as an endorsement of the subtlety and potential of photography when practiced by gifted individuals, and as an attempt to empower photographers by providing them with an independent base and a collegial solidarity, a human warmth, from which to work. It attempted to provide the means, after the overwhelming exigencies of World War II, for photographers to travel, to see, to record, and to create, but without being forced to depend upon or follow the directives of any single publication or editor. "They are free people, too independent to tie themselves to one magazine," wrote Swiss photographer Werner Bischof in 1948, before deciding to join the agency. Less elegantly, with three founding photographers former *Life* magazine staffers, they were briefly referred to as the "Time Inc. Stink Club." (Magnum's first president, Rita Vandivert, had also worked for Time Inc. on newsreels at the March of Time in London.)

In his article "Random Thoughts of a Founder Member," Rodger recalls that Robert Capa, Magnum's principal founder and early guiding force (he had been envisioning the creation of the

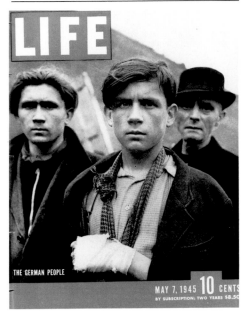

William Vandivert

The cover of Life *vol. 18, no. 3 (May 7, 1945), featuring the article, "The German People."*
(Life *Magazine © Time Inc.*)

agency since the 1930s), had an admirable grasp of the photographers' stature after the war. "He recognized the unique quality of miniature cameras, so quick and so quiet to use, and also the unique qualities that we ourselves had acquired during several years of contact with all the emotional excesses that go hand in hand with war. He saw a future for us in this combination of mini cameras and maxi minds."

In a significant departure from conventional practice, and as an attempt to safeguard the photographers' freedoms, Magnum was set up as a cooperative agency. Photographers would make the decisions and hire staff members to assist them, rather than work under the direction of agency heads, who were themselves responding to the urgent needs of the marketplace. Each of the seven original shareholders (Capa, Cartier-Bresson, Chim, Rodger, William and Rita Vandivert, and Maria Eisner) put in $400 to get the agency going. (Eisner had already represented several of the photographers during the prewar years at her agency, Alliance Photo, before she ran Magnum's first Paris office from her apartment.) While Magnum still very much depended upon assignments and the sharing of the fees between photographer and the agency, the international group of founding photographers established another principle, again a departure, which would cause problems with certain publications. The requirement was that the photographers, rather than the publications in which their images appeared, would retain the rights to their photographs. (Due in part to Magnum's example, and to vigorous efforts by the American Society of Magazine Photographers, the retention of copyright is now standard practice for freelancers.)

This safeguarding of rights helped Magnum photographers to survive financially, allowing them to spend significant amounts of time working on major stories, either on assignment or at their own initiative, and then to sell or resell their work to publications in many countries to support themselves and their future ventures. At the same time, this contributed to a strengthened sense of authorship, the creation of new markets for their work, and an enhanced ability to control its uses (for example, photographers can refuse to have their pictures sold to a publication whose point of view they find abhorrent). "If it wasn't for Magnum at the very beginning," says longtime member Elliott Erwitt, "most of us wouldn't own our work now." George Rodger, for example, recently estimated that he's still averaging one sale each month from his trip to Africa forty years ago.

Somewhat paradoxically, Magnum was founded to assert the independence of strong-willed, motivated people by putting them in a group—one able to provide a barrier, however permeable, to outside pressures ("a co-operative [that] doesn't co-opt," as longtime member Burt Glinn put it, perhaps too optimistically), while eliciting sufficient interest from publications based upon the generally high quality of the photographers. There would be burdens as well: the pressures of running an agency when one would rather be out photographing, severe and re-

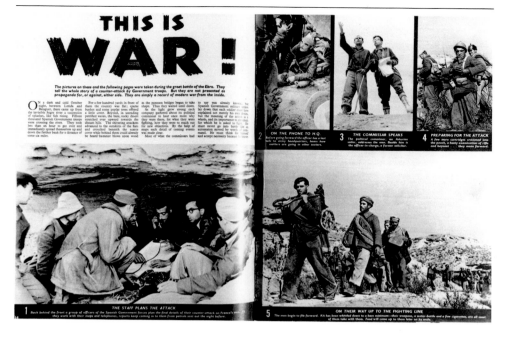

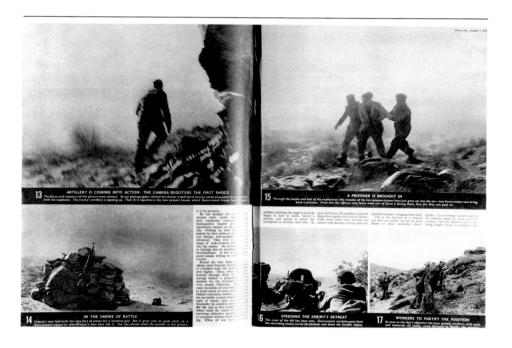

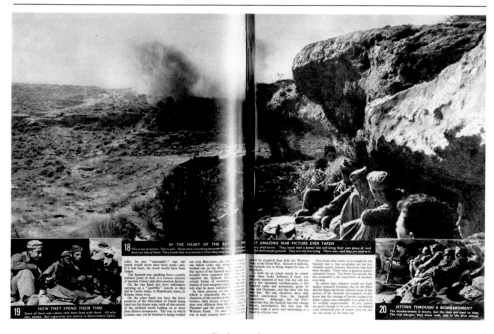

Robert Capa

"This Is War," Picture Post *vol. 1, no. 10 (December 3, 1938).*

curring financial crises, and sometimes bitter disputes among members who had become bound together, for better or worse, in a kind of family. To many, a remarkable aspect of this agency is that, despite severe problems and setbacks, including the premature deaths in 1954 of Capa and Bischof and two years later of Chim, who had taken the reins after Capa's death, it survives.

But Magnum has done considerably more than survive, and considerably more than exude an aura of adventure and strong personalities. Its photographers have largely succeeded in being both witnesses to an age and its interlocutors, in sharply articulating their individual insights, reflections, and doubts concerning far-flung worlds both public and personal, and in the process also playing key roles in the creation, definition, and enlargement of their medium. In the history of photography, the sustained breadth, diversity, and inventiveness of the best of their visions, realized over more than forty years, constitutes among the richest of legacies and, if one is so inclined, greatest of challenges.

Magnum would almost certainly never have been formed if, in 1931, seventeen-year-old André Friedmann, the middle child of dressmakers, had not been expelled from his native Hungary for some leftist, antigovernment activities. Soon bereft and deciding between careers in agriculture and journalism, the young refugee would come to a third and fateful choice. "While pursuing my studies, my parents' means gave out, and I decided to become a photographer," Friedmann stated, "which was the nearest thing to journalism for anyone who found himself without a language."

Just five years later, the resourceful Friedmann, now living in Paris, had not only found his vocation and a new name, Robert Capa, which he and his girlfriend, Gerda Taro, had chosen as part of a ploy to enhance his marketability, but a new language as well. He had begun to distinguish himself with his up-close, vivid photographs of the Spanish Civil War, the much-watched prelude to World War II, capped by a photograph first published in *Vu* magazine—a month before his twenty-third birthday—of a Loyalist soldier falling at what appears to be the moment of his death. This image has become one of the most celebrated photographs in the annals of the medium,

perhaps the most famous war photograph of all time, and, in recent years, one of its most controversial.

Not only did the war dramatically pit fascist and antifascist forces against each other, but it was also ideally timed for a photojournalist: war broke out in 1936, the same year that *Life* magazine would sell out its first issue—all 466,000 copies—and within the first decade of the birth of Europe's picture magazines, featuring publications such as Germany's *Berliner Illustrirte Zeitung* and *Münchner Illustrierte Presse*, France's *Vu* and *Regards*, and England's *Picture Post*.

The outbreak of the Spanish Civil War also followed soon after the introduction of small, portable cameras that, combined with more light-sensitive films, allowed the photographer significant flexibility in covering fleeting events. Photographers of war were no longer confined to static, safe situations far from the front lines or to photographing the residue of war after the battle was over.

This new flexibility, when combined with what seemed to be the camera's reliability as witness and the apparent ease with which photographs could be understood, made reportorial photography an influential, exciting, and pervasive medium. Using a style of realism and immediacy it embraced the never-before-seen, the exotic and foreign, the intimate lives of strangers, as well as the next-door. "To see life; to see the world; to eyewitness great events; to watch the faces of the poor and the gestures of the proud; to see strange things—machines, armies, multitudes, shadows in the jungle and on the moon . . . to see and to take pleasure in seeing; to see and be amazed; to see and be instructed," read, in part, Henry Luce's 1936 prospectus for *Life*

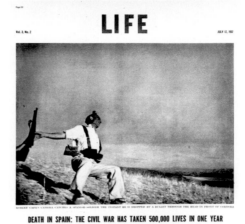

Robert Capa

"*Death in Spain: The Civil War has taken 500,000 Lives in One Year.*" Life vol. 3, no. 2 (July 12, 1937).

magazine. Photography, although utilized somewhat differently in various countries, was generally offered as a particularly vibrant and often entertaining way for the reader to become informed; and as an alleged equivalent of sight, it could be presented as a virtual substitution for the experience itself.

Capa's personal courage, intelligence, and photographic style—direct, exciting, intimate, and empathetic, if at times somewhat visually awkward—was ideal for a new and curious readership. He was proficient enough at photographing both the battle itself as well as its powerful impact on soldiers and civilians that, in 1938, as he was just turning twenty-five, a *Time* magazine critic assigned him in a review to a pantheon of "perhaps half-a-dozen living photographers who are seriously and solely engaged in making the camera tell what concentrated truth they can find for it." One of the others cited was Capa's future colleague at Magnum, Henri Cartier-Bresson, whose approach to "concentrated truth" would both complement and rival Capa's.

The early amazement and stress upon photography's reportorial powers was such that one of Capa's stories from Spain that same year was simply and emphatically titled "This Is War!" in England's *Picture Post*. His images were presented as "the finest pictures of front-line action ever taken," and Capa was called "the Greatest War-Photographer in the World." The reaction to his photographs, at the end of this first decade of modern photojournalism, was itself vivid. "You can almost smell the powder in this picture," stated a caption next to a smoke-filled image of a man with a rifle crouched behind a former machine-gun nest.

"In the Heart of the Battle: The Most Amazing War Picture Ever Taken," was the title written under an image of

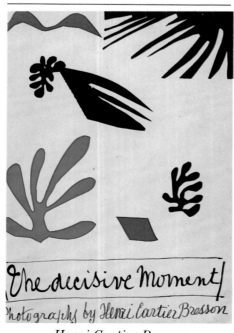
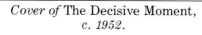

Henri Cartier-Bresson

Cover of The Decisive Moment, *c. 1952.*

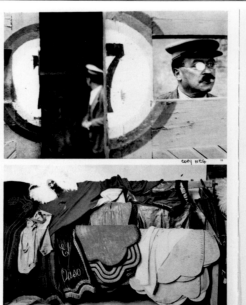

Henri Cartier-Bresson

A page spread from The Decisive Moment.

soldiers casually sitting under an overhanging rock for protection. "This is not practice. This is war," the caption stated, and continues with what now appears to be more than a bit of hyperbole, a relatively early instance of a magazine's fascination with war as a spectator sport. "These men crouching beneath the ledge feel the shock of every shell-burst. They know that a better aim will bring their own piece of rock down on top of them. They know that in a minute's time they may be ordered forward over the shell-swept ground. They are not worrying. This is war, and they are used to it."

Suffering from a surfeit of imagery of war and destruction, a contemporary viewer might find these images tame, even restrained. But in the 1930s the relative rawness, intimacy, and violence of Capa's photographs took some getting used to, for various reasons. *Picture Post*, in the story with "the finest pictures of front-line action ever taken," felt it necessary to point out that Capa's photographs of a counterattack by government troops in Spain "are not presented as propaganda for, or against, either side. They are simply a record of modern war from the inside."

Although photojournalism should not be confused with official propaganda, this last statement is itself a vast, if typical, oversimplification that conceals photojournalism's essential dependence, like all other communications media, on its author or authors. If two photographers went to the same battle, the resulting pictures would reflect each photographer's individual understanding, background, personality, and abilities, making the battle seem to varying degrees heroic, wanton, brutal, or bizarre. "Simply a record of modern war from the inside" would be impossible.

Of course, the publication's point of view would come into play as well. Capa's sympathies were, fortunately for him, shared by many publications during the Spanish Civil War. But he was not always so fortunate. For example, according to Richard Whelan, Capa's biographer, his 1936 photograph of Alsatian women in traditional dress giving a leftist salute was cropped by *Vu* to show only one face and no salute. The image was labeled "The True Face of Alsace," and was used on the cover to introduce an article that took a rightist point of view. Moreover, on the following day the back cover of *Regards*, for

Ernst Haas

"*Images of a Magic City*," Life (September 15, 1953). (© Ernst Haas)

an article on the tragedy of girls gone astray, carried a photograph that Capa had taken of his girlfriend. Pierre Gassmann, a longtime colleague, recently recalled a Capa image of the Paris stock exchange that appeared, to Capa's considerable consternation, in a pro-Nazi magazine with an anti-Semitic caption.

It becomes clear that for all of photography's reportorial power, there remains a profound ambiguity which is responsible for much of its subtle shadings, its ability to reflect the mood of a situation while being both more and less than factual, and allows as well for much of its distortion at the hands of others. The single most remembered image by Capa during this period, the falling Spanish soldier, exemplifies the

paradox that a photograph, so good at transcribing visual details, may represent the essence of a situation while perhaps being less than factually correct.

In recent years this slightly blurred image of a man dressed in a white uniform and wielding a rifle has become quite controversial as critics question whether it indeed was of a man falling in the heat of battle and at the very moment of his death. As Phillip Knightley pointed out in *The First Casualty*, what value would the image have had if captioned, "A militiaman slips and falls while training for action"? One cannot be sure from the image itself that the man has been shot, only that he seems to be falling.

But called, as *Life* captioned it, "the instant he is dropped by a bullet

421

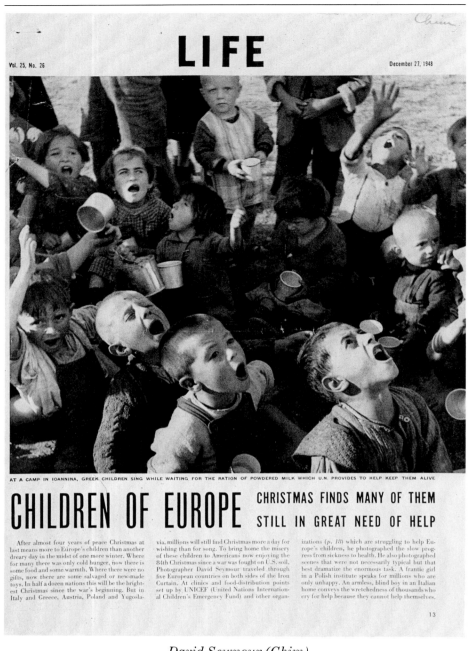

David Seymour (Chim)

"Children of Europe," Life (December 27, 1948).

to the agency. While Capa thought of himself as a reporter and established for himself an important journalistic legacy, particularly due to his coverage of war—Capa would also photograph the Japanese invasion of China, World War II, Israel's War of Independence, and the struggle against the French in Indochina, where he was killed by a land mine at the age of forty—Cartier-Bresson came to photography from painting, strongly influenced by surrealism.

Born in 1908 to a wealthy French family in the textile business, Cartier-Bresson broke away early, enamored of the emphasis on personal intuition and the anti-institutional revolt of the emerging movement of surrealism. He read widely (Engels, Freud, Joyce, Rimbaud, Saint-Simon, and Schopenhauer, among others), studied with several teachers his first love of painting, and at the age of twenty-two went to Africa, where he hunted by the light of an acetylene lamp strapped to his head. Two years later, in 1932, at almost the same young age at which Capa would be called "the Greatest War-Photographer in the World," Cartier-Bresson began a three-year period of photographing in Europe and Mexico, years which have been described, with considerable justification, as "one of the great, concentrated episodes in modern art" by Peter Galassi, curator of a recent exhibit of this work at New York's Museum of Modern Art.

Working with a Leica, a small, quiet 35-mm rangefinder camera whose use

David Seymour (Chim)

"Children of Europe," Life
(December 27, 1948).

through the head," the image becomes a symbol of the heroic but unsuccessful attempt by the Loyalists to stand up to the might of the fascists, and its truth is, in a symbolic sense, irrefutable. It furthermore becomes a symbol, as it has over the years, of the fight for freedom and democracy against right-wing dictatorship.

It is evident, whether or not the photograph actually was of a man at the moment of his death, that photography, even of the most realistic type, can articulate truths even though the facts may be wrong and, conversely, can also be quite wrong as to the essence of a situation despite getting the facts right. This makes the conventional emphasis on photography as simple mechanical transcription appear even more shortsighted. "It is a cut of the whole event," John Hersey quotes Capa as saying, "which will show more of the real truth of the affair to someone who was not there than the whole scene." The journalistic convention, however, asks that one begin with the factual, even when making major statements. In Spain, Capa asserted, "the truth is the best picture, the best propaganda." Factuality is a convention that, as we shall see, has become, a half-century later, increasingly vulnerable.

The artist, of course, is not limited by the same concerns. It is his or her prerogative to make statements, major or minor, including comments on contemporary society, using fictions. It is primarily from art that Henri Cartier-Bresson, the other looming influence of Magnum's founding generation, came

has since become almost a Magnum trademark, Cartier-Bresson photographed the street; he found a visual coherence within fragmentary instants, what he called "the organic coordination of elements seen by the eye." His photographs from this period tend to emphasize the immediacy and com-

Robert Capa

"Women and Children in Soviet Russia," Ladies' Home Journal *(February 1948).*

plexity—the whole piece—of the seeing itself, locating a visual geometry and eluding a narrative. "In photography there is a new kind of plasticity," Cartier-Bresson wrote in 1952, "product of the instantaneous lines made by movements of the subject. We work in unison with movement as though it were a presentiment of the way in which life itself unfolds. But inside movement there is one moment at which the elements in motion are in balance. Photography must seize upon this moment and hold immobile the equilibrium of it." This is his theory of the "decisive moment," a highly celebrated and extraordinarily influential genre of photography.

Although Capa and Cartier-Bresson would become friends and work together, first for the Communist daily *Ce Soir* with Capa's longtime friend and their future Magnum colleague, Chim, and then a decade later in Magnum itself (it is from this troika as well that Magnum sprung), the differences in approach represented by Cartier-Bresson and Capa are significant not only in that they highlight a palpable tension in the evolution of photojour-

nalism itself, but also because between and around these approaches the antecedents of much of the creative tension, confusion, innovation, and self-absorption of succeeding generations of Magnum photographers can be found. Reflecting the pedigrees of Capa and Cartier-Bresson more than forty years after the agency began, some of the younger photographers at Magnum's 1988 annual meeting found themselves in heated discussion, stimulated by a film on their deceased colleague Werner Bischof, asking themselves not for the first time the question of whether they are really journalists or artists.

The early work by Cartier-Bresson, like Capa's imagery, tended to depict life in slices, but they were cut differently. Capa's photographs, while empathetic, intelligent, human, were usually predicated and contextualized by the news value associated with them; they lacked the visual self-sufficiency of his colleague's imagery. (Magnum photographer Eve Arnold, upset and disappointed when looking for the first time at Capa's contact sheet, was reassured by *New Yorker* writer Janet Flanner, who said, "My dear, history

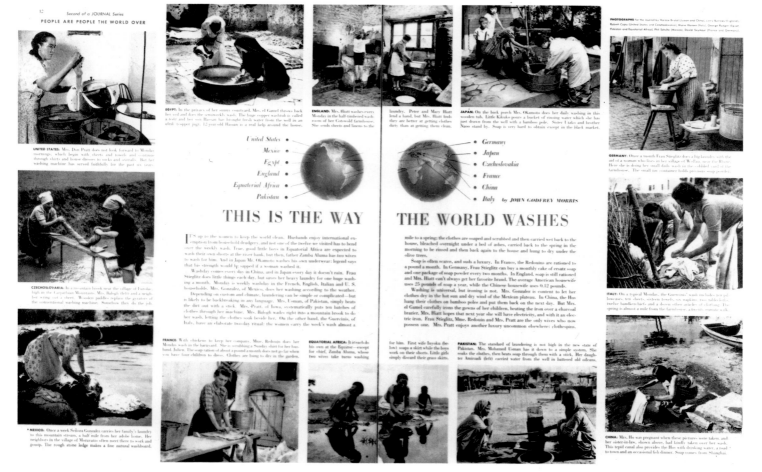

Magnum Group Project

"People are People the World Over," Ladies' Home Journal, *1948.*

isn't well designed.") Conversely, while Cartier-Bresson's photographs did shift appreciably with the approach of World War II and in its aftermath, moving towards the more journalistic, they still relied primarily on the premise that if broadly journalistic approach and attained fame, for example, by going ashore to photograph in the extraordinarily dangerous landing at Normandy on D-day, Cartier-Bresson did the journalistically unconventional by constraints of conventional journalism. Allowing photographers the freedom to have and express their own point of view, although apparently rarely talked about in Magnum's early days, was in large measure the reason for the

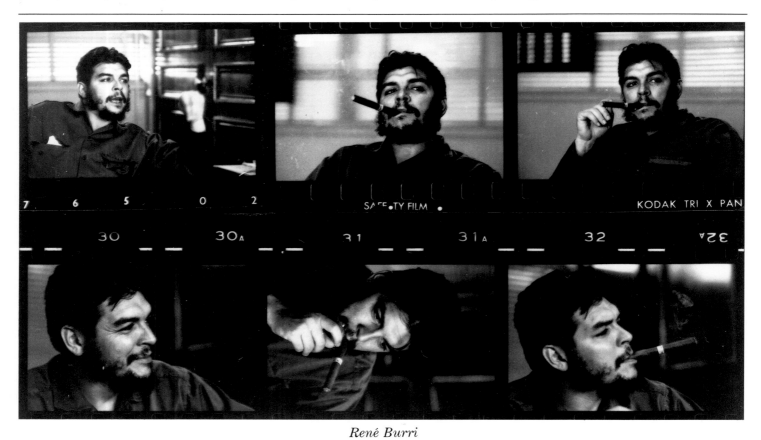

René Burri

Contact sheet of Che Guevara, Havana, Cuba, 1963.

the everyday is articulated sharply enough, its essence can be sensed (although probably not understood). His photographs depended more on the elicited texture of a scene, its form, than the harder currency of key players and events. (He recently compared himself to Capa by referring to his former colleague as an "adventurer with an ethic," and to himself as also an "adventurer," but one with more of an "aesthetic.")

Cartier-Bresson, faithful to his own curiosity, his intuitive sense (he uses the French word *goûter*, which he demonstrates in person by repeatedly and vigorously sniffing the air, as if sampling the "smell" of a situation), his delight in seeing for its own sake, and still imbued with some of the self-sufficiency of the artist, never seems to have completely embraced the implicit and, at the same time, relatively recent social contract of the photoreporter as the reader's up-close, no-nonsense, translucent surrogate to emerging history, making sure to cover all that which, because of the nature of the event, was conventionally thought of as important. While Capa chose the more

photographing, on assignment, a celebrated series of images of spectators on the periphery at the 1937 coronation of King George VI, preferring them to the main event.

Yet the difference is more fundamental. While Capa was an early and key developer of the up-close method of reporting ("If your pictures aren't good enough, you aren't close enough," maybe his most famous statement), Cartier-Bresson helped to fashion another social contract in which the photo-reporter's loyalty to his or her own point of view is asserted as the necessary and evident prism through which the reader will see the world unfold. "A photographer must always work with the greatest respect for his subject and in terms of his own point of view," he wrote. It is the second part of this statement that many within and without the field of photojournalism prefer to de-emphasize, even ignore.

But it is the second part of this statement that defines, to greater and lesser extents, the underpinning of every photographer within Magnum, including Capa, whose point of view emerged powerfully while working within the

agency's creation as an independent organization.

"Editors when they instruct a photographer always want him to say *some*thing," wrote Magnum's current president, Burt Glinn, over twenty-five years ago. "A great photograph should say everything. This week's magazine wants to say that American soldiers are in Laos, or French soldiers are in Algeria, and that the weather is hot or it is cold, and the army was advancing or was retreating. But the great war photographs of Capa or of Duncan are not just for this week's magazine—they are for all the time, and they say more important things than what the score is." This unease, these questions, have been grappled with by each generation of Magnum photographers in, as René Burri put it, their "destructive, creative stubbornness." It is an uncomfortable, at times adversarial, occasionally transcendent role.

"We often photograph events that are called 'news' but some tell the news step by step in detail as if making an accountant's statement. Such news and magazine photographers, unfortunately, approach an event in a most

424

pedestrian way," Cartier-Bresson told Byron Dobell in *Popular Photography* magazine in 1957. "It's like reading the details of the Battle of Waterloo by some historian: so many guns were there, so many men were wounded—you read the account as if it were an itemization. But on the other hand, if you read Stendhal's *Charterhouse of Parma*, you're inside the battle and you live the small, significant details. . . . Life isn't made of stories that you cut into slices like an apple pie. There's no standard way of approaching a story. We have to evoke a situation, a truth. This is the poetry of life's reality."

Inge Bondi, who worked on Magnum's staff for twenty years, was asked in a 1955 radio interview, "What is a photojournalist?" she responded: "A photojournalist is a reporter, commentator and sometimes even a poet rolled into one—who works with his camera to record the atmosphere and the spirit of a place or event." In its simplicity, this is an excellent description of Magnum and other like-minded photographers, and less a description of conventional photojournalism, with its comparatively limited goals that preclude, for the most part, commentary and poetry. One might say that although Capa and Cartier-Bresson emerged from opposite ends of this spectrum—reporter and poet—Capa's work can also be seen as powerfully tragic epic poetry, and Cartier-Bresson's reporting was at times superb, such as at Gandhi's funeral. It is in large measure their ability to skillfully navigate this range that has long distinguished Magnum photographers. "Do we really only want to be a catalogue of history?" Ernst Haas wrote in 1960. "For me history is only a part of what I am interested in and that is reality."

And in fact, it was Haas and the photographer he credited as his inspiration, his colleague Werner Bischof, who began seriously reacting against reportage (they were the first two photographers to be taken on as members subsequent to the founding generation). While Cartier-Bresson was becoming more involved with reportage, Bischof was complaining of his frustration with magazines, contrasting the intensity of the tragedies around him, such as the immense famine in India, with the short attention span of the media. "I am powerless against the great magazines—I am an artist, and I will always be that," he wrote. Partially as a result,

he had decided to also try his hand at filmmaking when he died in an accident in the Peruvian mountains. Haas, after working for a short time reporting the devastation of Europe after the war (which included a moving series of black-and-white images of women in the Vienna train station, where they held up photographs of loved ones, hoping a passerby might know the missing person's fate), became fascinated by color and motion. Traveling back and forth across the English Channel, he would observe the patterns that the birds made, and worked for long periods to create memorable, experimental essays that included one on New York, detailing in luminous, abstract, semi-liquid color banal details—shop windows, litter, sidewalks, reflections, and another on bullfighting, emphasizing its red blur. "I am in search for images

which reflect myself as much as it reflects the subject matter," Haas wrote in 1960. "I am not interested in shooting new things. I am interested to see things new. In this way I am a photographer with the problems of a painter, the desire is to find the limitations of a camera so I can overcome them. . . ."

While the diversity of approaches that have become apparent throughout Magnum's existence are fascinating, it would be mistaken to attribute them always and solely to individual temperaments. They are also a reflection of the many cultures the photographers came from and lived within, and even color the terminology that can be applied to what the photographers were attempting. For example, one basic but subtle distinction must be made between the

Brian Brake

Spreads from "C'est la Mousson qui Arrive," Paris Match *no. 650 (September 23, 1961).*

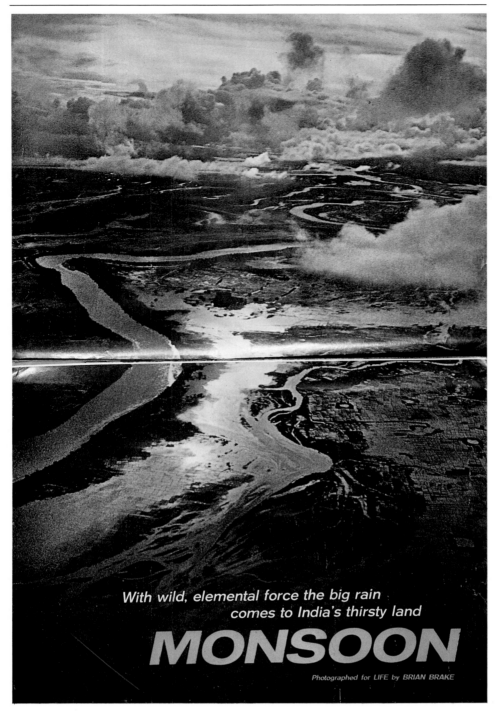

With wild, elemental force the big rain
comes to India's thirsty land

MONSOON

Photographed for LIFE by BRIAN BRAKE

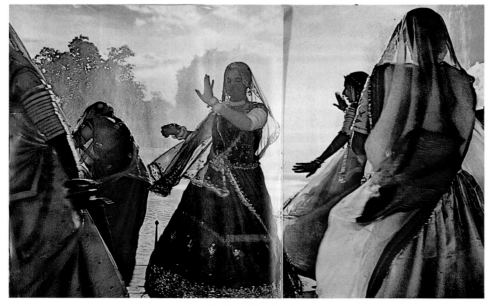

Brian Brake

Spreads from "The Monsoon," Life (September 8, 1961).

concepts of photojournalism as used in the United States and reportage as used in France. *Vu* magazine, a French picture publication that preceded *Life* by eight years, proclaimed itself "conceived in a new spirit" and possessor of a "new formula: worldwide news in illustrated reportage." Its goals, although described quite similarly to those of *Life*, were also significantly different: "There doesn't exist here a picture magazine which expresses the speeded-up rhythms of present-day life: political events, scientific discoveries, disasters, explorations, sporting feats, theatre, film, art, fashion. . . . Animated like a fine film, *Vu* will be awaited each week by its readers."

On the other hand, *Life*'s prospectus began: "To see life; to see the world; to eyewitness great events; to watch the faces of the poor and the gestures of the proud; to see strange things—machines, armies, multitudes, shadows in the jungle and on the moon. . . ." It was as if, in the case of *Life*, one could target events, people, and places, and by the act of seeing *them* "be amazed . . . and be instructed," whereas in the case of *Vu*, "animated like a fine film," there was an attempt to express the rhythm of life, not simply the targeted objects of one's attention. This comparison begins to delineate not only the differences between American-style photojournalism and French-style reportage, but also some of the different tendencies evident in the work of Capa and Cartier-Bresson, and that of Magnum photographers in recent years.

At the time of Magnum's formation the emphasis was initially on reporting, reflecting in part a commonality of painful experience and a curiosity and hope for a newly reopened world. At that time, remembers Bondi, "artist" was "a very, very dirty word." The war had profoundly affected all of the first member photographers, and not only because most were photographing it. Rodger had had to walk "three hundred miles through the bamboo forest and what seemed like a thousand mountain ranges" to escape the Japanese in Burma, and Cartier-Bresson spent much of the war as a German prisoner and, after escaping on his third try, in the French Resistance. Chim, who received a medal for his work in American intelligence, lost his parents to the Nazis (his father was a publisher of Hebrew and Yiddish books). Out of all this, as well, came Magnum.

426

Chim, for example, worked for two years for UNESCO photographing the plight of children, particularly the orphaned and maimed, who suffered through the war in Europe. He made an almost unbearable image of a young girl standing mute before the chaotic scribbles she made when asked to draw a picture of her home, and a memorable series of photographs of a little girl in Greece trying on, in awed delight, her first pair of shoes. Rodger worked for *Life* for two years, then escaped to Africa. Capa floundered as a photographer, working in Hollywood, losing his focus, finding some of it again in several trips to Israel during its founding.

Cartier-Bresson, who worked on a film about the reintegration of prisoners after the war, explained a little bit about what it meant for him to emerge from the war into Magnum in an interview with Hervé Guibert in *Le Monde*:

"Back in France, I was completely lost. At the time of the liberation, the world having been disconnected, people had a new curiosity. I had a little bit of money from my family which allowed me to avoid working in a bank. I had been engaged in looking for the photo for itself, a little like one does with a poem. With Magnum was born the necessity for telling a story. Capa said to me: 'Don't keep the label of a surrealist photographer. Be a photojournalist. If not you will fall into mannerism. Keep surrealism in your little heart, my dear. Don't fidget. Get moving!' This advice enlarged my field of vision."

"I think that what really held them together was a kind of hope for a better world," said Bondi, who began at Magnum in 1950. "Nobody at Magnum was

Elliott Erwitt

On the set of The Misfits, *Nevada, 1960.*

ever outspoken about their politics. . . . they believed they could do it with pictures." (Although, according to Cartier-Bresson, they would refuse to work in activities they construed as encouraging war.) The early days of the agency, said Lee Jones, former New York bureau chief, was a time "when people really believed you could make the world a better place," when there was almost a competition among photographers to find a worse wrong to right. Nor were they particularly outspoken about their photographs, according to early members, who remember photographers returning from trips talking mostly about what they had seen, not the photographs they had taken.

The sense of renewed possibility and curiosity would infect the postwar era for many, and made the creation of Magnum well-timed. Once again big magazines such as *Life*, *Holiday*, and *Paris Match* were looking for pictures. Magnum had its share of major scoops and stories, such as Robert Capa's first look, uncensored, behind the Iron Curtain at the Soviet Union with the writer John Steinbeck, published originally in *Ladies' Home Journal* (for which Capa, according to the *Journal*'s picture editor, John Morris, later executive director of Magnum, would be paid $20,000 to Steinbeck's $3,000). There were also Capa's and Chim's work in Israel; and Cartier-Bresson's landmark 1948 coverage of India at the time of Ghandi's assassination, and his work in China during 1949, the pivotal year when the Communists took control of the government, as well as his coverage of Indonesia's independence and again the Soviet Union. First new member Werner Bischof went to report from Japan, famine-stricken India, and Korea during the conflict. There was also Rodger filing weekly stories, with his own typed text, from tribal Africa (which are said to have sold consider-

Ernst Haas

The Misfits, *Nevada, 1960. (© Ernst Haas)*

ably better in Europe than the United States), and Chim's photographs for UNESCO and from the Vatican and Greece as well as Haas's color reportages. There was also work to be done photographing on the set of John Huston's movies, assorted group endeavors, and a variety of smaller stories and assignments.

soon added a number of younger, talented members (Bischof and Haas) and within five years of its founding, Eve Arnold, Burt Glinn, Erich Hartmann, Erich Lessing, Marc Riboud, Dennis Stock, and Kryn Taconis. (Inge Morath, who became a photographer the following year, was already working at Magnum as a writer and researcher.)

why just six women have, to this point, become Magnum member-photographers). Leonard Lyons, the *New York Post* columnist, published a 1956 item to this effect: "LOVE: Magnum, the co-op formed by some of the world's top cameramen, assigns its men to cover stories in distant parts of the world. That's why they prefer cameramen who are

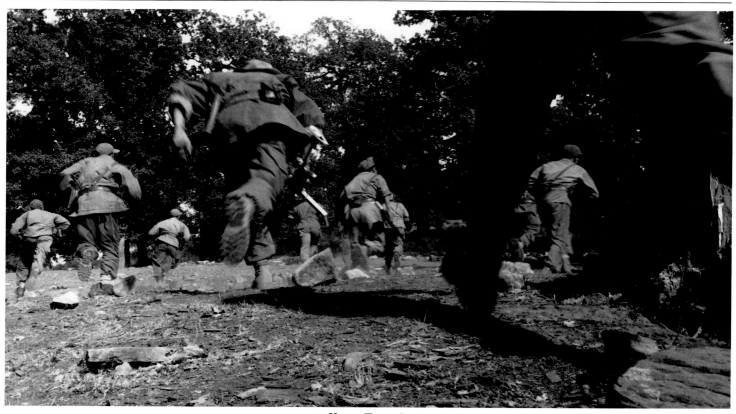

Kryn Taconis

Front de Liberation Nationale de l'Algerie. Soldiers run for cover as a French observation plane approaches. Algeria, 1957. (Kryn Taconis/National Archives of Canada/PA-170104)

In those days a photographer had a significant advantage: large areas of the world had virtually never seen a photographer. One could choose to go almost anywhere one wanted, even without an assignment, as Rodger points out, because in the early days one could "take pictures of just about anything and magazines were clamoring for it; the mistake was in thinking that it would continue." Magnum's first move was to loosely divide the world into flexible areas of coverage, with Chim in Europe, Cartier-Bresson in India and the Far East, Rodger in Africa, and Capa at large and replacing Vandivert in the United States.

Magnum's photographers had several advantages. One was that after the war there were very few freelancers who knew their way around the world, and Magnum had a sizeable percentage of them, including some of the most prominent photographers anywhere. They

Two early arrivals, Dennis Stock and Elliott Erwitt, placed first and second among 1,730 entrants in *Life* magazine's prestigious 1951 Young Photographers contest in the category "Picture Story." (Robert Frank, Alfred Gescheidt, and Ruth Orkin were among the other distinguished winners.)

As a group, they had traveled widely, could speak a variety of languages, and were privy to a great number of contacts. And they had mobility: René Burri, who began at Magnum in 1955, remembers attending events with a small Leica, "making snaps between things" while others were burdened with much more extensive equipment. There was also the freedom of movement permitted by few family responsibilities. (Vandivert, who had a year-old child, recently said that parenthood was fundamental to his decision to leave the new agency; it is also an explanation, although only a partial one,

unencumbered—who can be free to fly at a moment's notice. One member-photographer sent a cable from Salzburg: 'Am being married here tomorrow. Do not worry. Am not in love.' "

The agency had another advantage in the charm and energy of Capa, their "ideas man." "His sense of the newsworthy was uncanny and he could snuffle out a story like a truffle hound," wrote Rodger. Capa also made big-money deals, knew important writers (such as Ernest Hemingway, John Hersey, and Irwin Shaw) and editors (Len Spooner of England's *Illustrated* helped greatly from Magnum's founding by arranging a "first-look" contract for England), and had girlfriends who knew important people. He also inspired, and was trusted by, his sometimes temperamental colleagues, believing both in their independence and their need to take assignments for the agency's survival. The perspective of the younger photog-

428

rapher was that he was "rooting for your potential," recalls Morath. Her sense was that "He made you a fighter. He wasn't going to hold your hand." Upon assuming Magnum's presidency in 1960, Ernst Haas wrote, "I remember that I joined Magnum because I trusted Capa and felt understood even without words. So did Werner. This trust never ceased to exist even after tremendous fights and controversies about the nature of photography based on a deep-founded friendship for each other."

Capa held together the disparate personalities and navigated the vagaries of the business, aided in part by a sense of humor: ". . . the photographers in New York complain about the New York office," Capa wrote to Haas in 1953, "the photographers in Europe complain about the Paris office; the editors complain that they have too much Magnum or that they have too little Magnum; so everything is going in right order and steady progress is taking place."

"Under all the flamboyance he had a very soft and gentle and understanding side to him," remembers Rodger. But he could also be tough, even with Cartier-Bresson. Responding to his French colleague's complaint in 1953 about expenses that had already been attended to, Capa remarked: "All you must do, are the photos, but if every three or four days you want to gently fidget about another subject already taken care of, and if it's good for your soul, there's nobody who will stop you or get angry. Otherwise, all goes well enough, and I wish you a good rest of your

travels in this beautiful spring. If Eli [Cartier-Bresson's wife] wants to buy Roman statues, don't put them in the car, because it could make the tires burst. Take the caps off the lenses when you make pictures, don't piss in doubtful toilets, brush your teeth morning and night, and don't use newspapers for the other needs, because you are a rich photographer, accompanied by an exotic wife, helped by a first class assistant working for a great publication." It was signed, "your Capa."

Capa would also take some of the agency money and bet on the horses. He went to the race course and Haas went to Indochina, remembers Burri. He often made deals at the pinball machine in his favorite bar (Chim, more diffident, is said to have hung back at his table, waiting to see who Capa attracted) and met with people while reading the newspaper in his bathtub.

Capa had the rare gift of getting "drunk with the right people at the right place at the right moment," according to Pierre Gassmann, who printed Magnum's first negatives. Also, according to Glinn, he "reflected a lifestyle editors aspired to."

Cartier-Bresson, when not traveling (he lived for three years in the Far East, during which time he had little to do with Magnum's internal activities), filled the role of artistic conscience, as well as at times a kind of prickly political conscience for the group. In 1961 he described his role to Cornell Capa, Robert's younger brother, who had joined the agency after his brother's death, as "to offer intellectual and aesthetic guidance, as Bob thought my role in Magnum was."

In a 1954 letter sent to clients in six European countries, the request was made that "the text and captions for

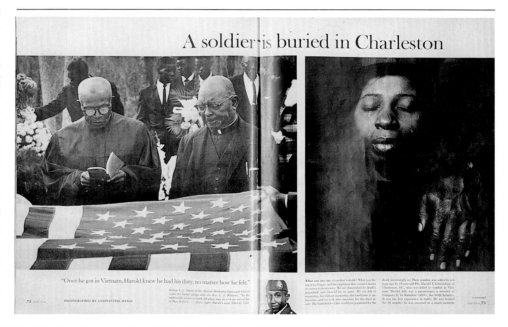

A soldier is buried in Charleston

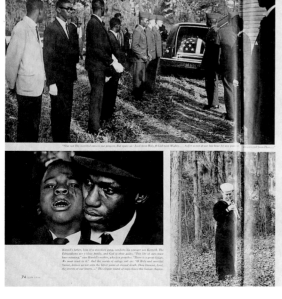

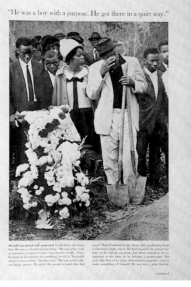

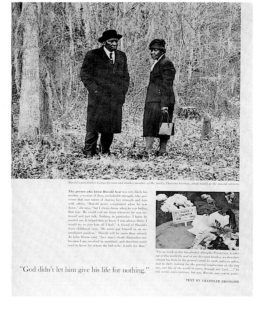

Constantine Manos

"A soldier is buried in Charleston." Look *Magazine (May 31, 1966).*

Henri Cartier-Bresson's essay on China, which has been sent to you . . . are fully respected. We would like to be assured that only an accurate translation of the words will be used in the magazines. No changes either in the spirit or the actual meaning of the text and captions will be allowed." The letter reproduces a copy of the stamp, omitted from the back of the photos, which reads, "This photograph can be reproduced only with the accompanying caption or with text strictly in the spirit

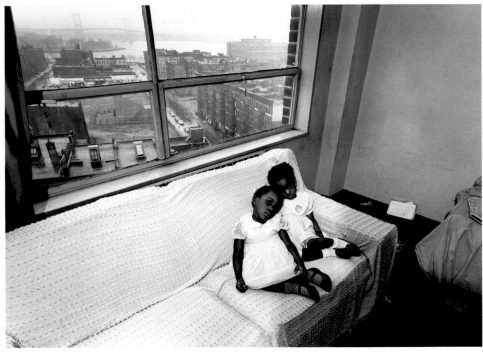

Bruce Davidson
A print from East 100th Street, *c. 1970.*

East 100th Street

photographs by
Bruce Davidson

Bruce Davidson
Cover of East 100th Street, *c. 1970.*

of its caption." The same was done, according to then-president Maria Eisner, when Capa returned from the Soviet Union and, afraid of the anti-communist sentiments of the time, asked that publications respect the captions that had been provided. Such a request was part of what she characterized as a political consciousness that raised Magnum above the level of a commercial agency.

Chim functioned as Capa's "great big shadow," says Rodger. He was better at finances and organization, and was responsible for Magnum's initial by-laws, an "intellectual businessman" as Glinn put it. Chim was capable, according to Rodger, of making "even the most cock-eyed scheme not only feasible but financially stable." After Capa's death Chim took over for two years, until his own accidental death by gunfire in 1956 at the Suez Canal, four days after the cease-fire. Cultured and modest, but with his own toughness, a lover of fine wines and good food ("Chim avoided ostentation as if it were the Automat," wrote Horace Sutton in the *Saturday*

Review), he made pictures that radiate a gentle sensitivity, an awareness of suffering and a quiet dignity, almost as if he were attempting to restore a more distinguished order to a senseless world. "Chim picked up his camera the way a doctor takes his stethoscope out of his bag," wrote Cartier-Bresson after Chim's death, "applying his diagnosis to the condition of the heart; his own was vulnerable."

It was also a collegial and down-to-earth time. "You were among friends who were passionately involved," says Morath. It was a time when more successful photographers were helping the less successful. "When we started it is Capa's money and George's that supported us, then Chim's, now it is George, Werner and mine," explained Cartier-Bresson in a 1952 letter to a colleague. Photographers would come back from trips and show each other and the staff their pictures, at times working through the night to help each other edit on deadline. It was also a period before photographing for corporate reports became a way to earn a living for many of Magnum's photographers.

They also attempted major projects that took advantage of their experience and numbers. Although not Magnum's finest work, such projects did help the agency establish itself. "People Are People the World Over," a major project for *Ladies' Home Journal* involving three Magnum founders, was begun in the spring of 1947. Appearing monthly

for a year, it focused on twelve farm families in as many countries, with themes such as "Woman's World Revolves Around the Kitchen," "This is the Way the World Washes," and "This is the Way the World Shops." Capa (United States and Czechoslovakia), Rodger (Egypt, Equatorial Africa, and Pakistan), and Chim (France and Germany), took the majority of stories.

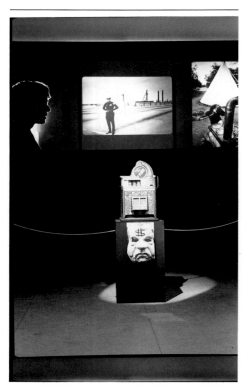

Charles Harbutt
Part of the America in Crisis exhibit. Museum of Modern Art, New York. (© Charles Harbutt)

430

For *Holiday* magazine, and widely syndicated, there would also be Capa's brainchilds: "Generation X," about children coming of age after the war who "will have the biggest say in the course of history for the next fifty years," and a project on women and one on children. These stories kept the photographers traveling, going to places which they could not otherwise afford to get to and where they then could stay on to do other stories. These projects also introduced Capa as a packager of stories, a skill he did not live long enough to develop (many predict that had he lived he would have gone into television). It has been asserted that "People are People the World Over" helped inspire Edward Steichen when, a few years later, he created "The Family of Man," the most widely seen and influential pho-

the bathtub at Magnum's small Paris office, supposedly on top of Capa's negatives), and, along with other nonmembers such as Gisèle Freund, Fenno Jacobs, Herbert List, Homer Page, and Max Scheler, would contribute a percentage of his fees. Professional, and nonprofessional, photographers whose careers were of a less journalistic nature would be represented to some extent, too: for instance, Ansel Adams, Richard Avedon, Edward Weston, and the documentary photographer Dorothea Lange, as well as the model Suzy Parker and the actor Yul Brynner. This practice has diminished with Magnum's expansion (there are now thirty-three members) and formalized, post-Capa, into what is now a three-tiered entry system: a photographer must first be elected a nominee, then an associate,

and then voted on to become a member. There are certain photographers labeled correspondents—Miguel Rio Branco, in Brazil; Raghu Rai, India; and Micha Bar-Am, Israel—who are too far away to take advantage of the New York, Paris, or newly founded London office, and older members who have decided to reduce their involvement by becoming contributors. (Although never a Magnum member, Hiroshi Hamaya, renowned in his native Japan, has been a contributor since 1961.)

After the death of much of Magnum's leadership in the mid-1950s, there followed a difficult decade or so, years when, as Burri put it, younger photographers "suffered very much from the severeness." Intense personal disagree-

Philip Jones Griffiths

Cover of Vietnam Inc., *c. 1971.*

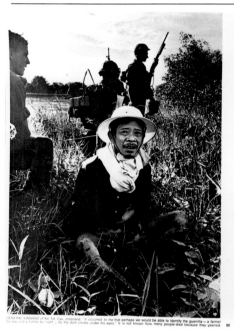

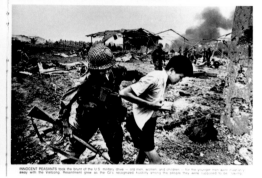

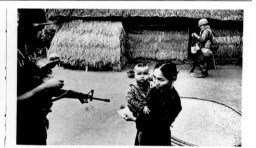

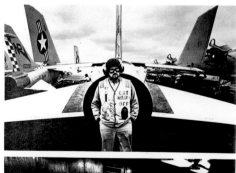

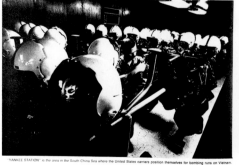

tography exhibit ever made. In fact, Magnum photographers were credited with over 10 percent of the 503 images in the show, and Wayne Miller, who would later become a Magnum member and president, worked on the show as Steichen's assistant.

In Magnum's early years, primarily to supplement the members' income and to provide a stable of potential members, Magnum would sign on other photographers to work as stringers or contributors with the agency. (In a 1952 report to his fellow members, George Rodger pointed to some eighty nonmembers working with the New York and Paris offices.) So that Carl Perutz, for example, would be photographing at the Lido nightclub (and sleeping in

Philip Jones Griffiths

Assorted pages spreads from Vietnam Inc.

ment and confusion surfaced about the agency's future, its viability after the reeling loss of three such influential members. "We are no longer a small group of creative photographers who are to some extent directing the editorial pages of the picture magazines," one of Magnum's extended-family members, wrote from abroad in 1956. "We haven't had a really good idea since Capa died." John Morris, who became executive editor of both offices in 1953 and would remain for eight years, provided some continuity and stability. Michel Chevalier, from *Paris Match*, joined the Paris bureau in 1957 to provide more journalistic punch.

Cornell Capa, Robert's younger brother, became a member, forsaking a successful career at *Life* magazine, and in 1956 was made president. Rodger and Cartier-Bresson, the two surviving founders, provided some of the guidance. "Here I come back to my mania on quality and vision in Magnum," Cartier-Bresson would write to Cornell and Morris in 1958. "How can you expect some one who is not any better than any of the many photo-reporters who get there to get any thing else than the others??? It is not by pulling the magic name of Magnum, especially when it is

ous factions. Cartier-Bresson would come to be viewed, as Erwitt put it, as "sort of the saint, the keeper of the flame." But he was more a critic than practical leader. Yet some, like Glinn, assert that "If Capa lived, Magnum would not have survived," since he was thought to be losing interest in photography for the newer medium of television. Riboud remembers Capa saying in their last conversation before his fatal trip to Vietnam that, because of the advent of television, photography was finished. Instead, photographers and staff rallied to ensure that the agency would continue.

But such altruism cold not last forever, as evidenced by a much-remembered two-page memo, written by photographer Elliott Erwitt in 1961. Addressed to "Everybody at Magnum," it can still be found hanging in the photographers' room in the Paris office. Titled "Why are we in Magnum?", the memo's first page is filled with questions. "Is it because it's practical and we'll all be rich? Is it because we want to be listed on the same sheet as HCB [Cartier-Bresson]? Is it a hobby? Is it a habit? Is it plain laziness? Is it for the value of our name as a bargaining point? Is it for the glory of our external

time' bit? . . . Is it because we stand for a certain quality, human and photographic, and can impose it best together? Is it all, some or none of these?"

He goes on, asking members to examine their own activities because "we are drifting relatively conceptless and into antagonistic situations between some photographers, between some staff and combinations of both (what comes to mind is stupid, destructive and in most cases infantile)." He asks them to remember that "Selflessness, as much as it can be practiced within our individual make-up, is an essential Magnum ingredient. When there isn't enough of it a concerted effort must be made to overcome the green monster of jealousy and greed to attain a minimum standard of collective spirit." He ends with a P.S.: "The past has shown that the intensity of Magnum happiness is directly related to satisfying production and subsiding financial problems. . . . we must pay the price of our past irresponsibility and weakness."

Throughout all of this, significant work was being produced: Marc Riboud's four-month trip to China in 1957 (he was the first western photographer there since Cartier-Bresson

Abbas

Cover of the German edition of Geo *featuring photo essay on Iran, August 1984.*

Abbas

A page spread from Geo.

done as La Fontaine said by 'a frog who wants to make himself as large as the ox'. . . . If there is no personal vision in photography what can we do?"

Never again would Magnum have a single acknowledged leader, capable of directing and reconciliating its numer-

image? Is it because as a group we can accomplish more than as individuals in the photo jungle? Is it because we are selflessly interested in the future of photography and want to help develop now people for the greater glory of . . . , etc.? Is it the 'historians of our

eight years before), Glinn's special issue of *Holiday* magazine on Japan, Russia, and Mexico, René Burri's book, *The Germans*, and W. Eugene Smith's, who was in Magnum for only two years, massive work on Pittsburgh. The young American photographer Eve Ar-

Gilles Peress

Cover of Telex Iran, *c. 1983.*

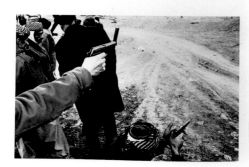

Gilles Peress

A spread from Telex Iran.

nold was covering the Black Muslims in the United States. She was also forming a photographic relationship and friendship with Marilyn Monroe, while Dennis Stock was working with James Dean.

Political coverage included Cornell Capa photographing John F. Kennedy at the White House (Magnum published a book with several photographers' work, *The First Hundred Days*, which covered the JFK presidency). Burri and Glinn covered Cuba during Fidel Castro's ascent to power, while in Europe Erich Lessing reported on the Hungarian revolution (after which, asserting that photographs document the world without changing it, he turned to producing staged essays that attempt to evoke previous eras).

There was also group coverage of Queen Elizabeth's trip to the United States, as well as the historic visit of Soviet leader Nikita Khrushchev. Glinn delights in the story of how he photographed Khrushchev at the Lincoln Memorial, which he told to writer Esther Samra. While all the other photographers were focusing on Khrushchev's face, Glinn worked from behind, creating a portrait of the back of Khrushchev's unforgettable head with the Lincoln Memorial behind it. Glinn not only feels he got the better image, but the other photographers were forced to include him in their images.

There were other major reportages as well, such as Brian Brake's much-published 1961 color story on the monsoon in India, for which Magnum grossed about $75,000, according to John Morris. "Magnum had more success than anybody else at internationalizing stories," Morris recalls. But supplemental income was necessary, which included work on movie sets. One of Magnum's most extended group efforts occurred in 1960, when six photographers took turns working in pairs to record the at times tumultuous filming of John Huston's film, *The Misfits*, featuring Montgomery Clift, Clark Gable, and Marilyn Monroe. Advertising and annual reports were beginning to be talked about as well. Erich Hartmann and Elliott Erwitt, even Cartier-Bresson, would make forays into these areas for IBM and the government of Puerto Rico, among other clients.

"As I am sure you have all heard Capa say, and as all of you have probably figured out for yourselves long since, editorial photography has become a luxury which, in order to make money, one can ill afford unless this is backed up by industry and advertising," wrote Pat Hagan from the New York office in 1952 to all shareholders. Hagan continued: "If this market of advertising and industry is to be opened up, it can only be done by exceptional material, not by Coca-Cola type pictures. Advertising agencies interested in us expect to see pictures of the kind we publish in *Life*, *Look*, *Vogue*, *Harper's Bazaar*, etc." The opening of these markets was a trend which would create much ambivalence and dismay within Magnum's ranks. Now, however, there are a few photographers—Davidson, Fusco, Glinn, and Manos—who work large parts of the year illustrating annual reports for large companies and some fifteen more who do it part-time to supplement their income. (Advertising never caught on significantly.) Much of the appeal is that the pay has always been considerably greater (four to eight times) than that of editorial work. Also, interesting magazine stories are increasingly difficult to come by and often formulaic enough so that, according to one photographer, annual reports are now just as honest.

While many arguments have been made over the years within the organization against this kind of prettifying

work, there was one unfortunate instance in this early period when Magnum bowed directly to outside pressures to subvert journalistic work. In 1957 Kryn Taconis, a young Dutch photographer, covered the Algerian war from among the guerrillas fighting the

with certain European members threatening to resign if the syndication was carried out. It was thought not be in Magnum's spirit, having nothing to do with photography, and there were suspicions that the diary may have been tampered with by the CIA. Some may

taking place, when it doesn't involve a great deal of money and when one is near by one must stay photographically in contact with the realities taking place in front of our lenses and not hesitate to sacrifice material comfort and security.

This return to our sources would keep our heads and lenses above the artificial life which so often surrounds us. I am shocked to see to what extent so many of us are conditioned—almost exclusively by the desires of the clients.

I know everybody has his problems and is doing what he can. I am writing this without hard feelings, but: *Vive la revolution permanente et le respect de la vie.*

Raymond Depardon

Correspondance New Yorkaise, c. 1981.

During the 1960s Magnum photographers embarked upon a number of major reportages. The Vietnam War was reported both from the North—Marc Riboud—and the South—Philip Jones Griffiths and Donald McCullin, among others. (McCullin, in recent years perhaps the premier photographer of war, left Magnum before becoming a member.) The American peace movement was covered, as were the civil rights movement (Davidson and Freed) and the Six-Day War (Barbey did early work on the Palestinians). The 1968 Soviet invasion of Czechoslovakia was photographed by foreigners Ian Berry, who had previously been covering South Africa, and Marilyn Silverstone, and by Josef Koudelka, a Czech whose pictures were first published anonymously to protect him and his family. For this work Koudelka would win the Overseas Press Club's Robert Capa award "for superlative photography requiring exceptional courage and enterprise abroad."

French. Magnum had an exclusive which it refused to distribute, from a fear within the French contingent that their office would be closed down by the hostile French government. It was a difficult blow for the young photographer, who resigned three years later, and certainly not Magnum's finest hour.

After the deaths of Magnum's first two leaders (Capa and Chim, both Europeans with American citizenships), the New York and Paris offices began to disagree, representing cultural and political, even class, differences. For a long time, the Paris-based photographers were suspicious that photographers in the New York branch were too interested in making money. This distrust reached a peak during a rancorous 1968 dispute over an attempted syndication of Che Guevara's diary,

have feared that it was also anti-Che. Magnum spent some $20,000 in lawyers' fees and other expenses before Fidel Castro released a copy for free.

But despite the problems and adjustments of this period, there was still a vision to be trumpeted, which Cartier-Bresson was happy to do in a remarkable 1962 memo addressed to "All Photographers," concerning "some thoughts . . . accumulating in me for quite a few months."

I wish to remind everyone that Magnum was created to allow us, and in fact to oblige us, to bring testimony on our world and contemporaries according to our own abilities and interpretations. I won't go into details here of who, when, what, why and where, but I feel a hard touch of sclerosis descending upon us. It might be from the conditioning of the milieu in which we live but this is no excuse. When events of significance are

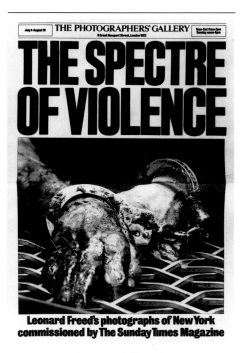

Leonard Freed

Nineteen-sixty-eight was also the year of one of Magnum's more successful group projects, published as the book *America in Crisis*. Charles Harbutt, then Magnum's president, working with bureau chief Lee Jones, asked every photographer to spend time reporting on the United States throughout the year. Harbutt also devised a unique mode of presentation for the work when it was exhibited: the viewer pulled a lever attached to three projectors, each showing different pictures from the project so that, like a slot machine, different images would line up in different sequences each time, demonstrating their multiple meanings. The machine was set up so that the only time three images could match was if they were all the same photograph: a mask of President Richard Nixon, with a dollar sign drawn across his forehead.

But there was also a significant movement away from the public and newsworthy to the more personal and intimate as subject matter, often to the fringes of one's own society. Whereas early Magnum photographers were intrigued by a newly opened world after the war, and interested in breaking through new Cold War barriers with pioneering work such as that done in the Soviet Union and China (since Cartier-Bresson's first trip, some dozen Magnum photographers have gone to work in China), photographers in the 1960s began investigating nooks much closer to home. David Hurn worked in England on strippers and the little-known gay community. In the United States Burk Uzzle was exploring the world of motorcyclists, and Bruce Davidson was hanging out with teenage gang members in Brooklyn. Leonard Freed published his book, *Black in White America*, Sergio Larrain was in his native Chile documenting the lives of street children and prostitutes, Costa Manos went to uncover his heritage in his *Greek Portfolio*, and long-time associate member Danny Lyon was photographing prisoners in Texas.

Their interest in the fringes was accompanied by a desire to decrease the photographer's estrangement from the nominally exotic, to begin to become more implicated in the lives of others, and to alleviate the problem expressed by an African proverb, "The foreigner sees only what he knows" (quoted by Claude Roy in his introduction to a recent book by Riboud). Charles Harbutt, in his 1973 book, *Travelog*, asserts

his urgent sense that he "had to regain some control over the making of my photographs so that they would integrate better with my life."

A classic example of an attempt to enter the lives of others without simply observing them, which also highlights the problems of such a stance, is Bruce Davidson's *East 100th Street*, in which he photographed "what people called the worst block in the city." Working with a large-format camera on a tripod and with a black cloth over his head, he asked to photograph residents wherever they wanted, distributed pictures to everyone, and documented "leaks, cracks and unheated buildings" for a neighborhood citizens' committee. Davidson would return frequently over a nearly two-year period. "Sometimes I had to force myself to go to the block because I was afraid to break the painful barrier of their poverty," he wrote. "But once I was there and made contact with someone, I never wanted to leave. Like the TV repairman or organ grinder, I appeared and became part of the street life."

Davidson had previously reported on the civil rights movement, and his pictures often were printed in the popular press. This time, journalistic publications are said not to have been interested in publishing his essay (many of the large American picture magazines were also going out of business during this period, capped by *Life* in 1972). The photographs were shown in 1970 at New York's Museum of Modern Art and appeared in a book published by Harvard University Press, after publication in the European arts magazine, *Du*. They are beautiful images, quiet, often serene, almost elegant. In David-

The Paper Negative

Danny Lyon

Danny Lyon

Cover of Paper Negative, *c. 1980.*
(© 1980 by Danny Lyon)

Danny Lyon

Colombia, 1972. (© 1980 by Danny Lyon)

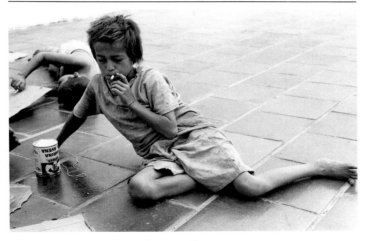

Danny Lyon

Josélyn, Santa Marta, Colombia, 1972. (© 1980 by Danny Lyon)

435

Eugene Richards

Cover of Exploding Into Life, *c. 1986.*

son's staged approach, the day-to-day vicissitudes of life, its bubbling warmth and frenzied despair, are temporarily quieted.

The *New York Times* uncharacteristically published multiple reviews. They included a highly favorable review by art critic Hilton Kramer, who viewed the posed, large-format approach as having given the people of East Harlem the photographic respect usually accorded the upper classes; a mixed review by photography critic A. D. Coleman; and a highly critical review by Philip Dante, who asserts that he grew up in a similar environment. He harshly condemned Davidson for exploitation and deception, for creating a "dark journey into purgatory" in pursuit of his own "symbol-minded" vision, one that does not, however well-intentioned, acknowledge the reality of those who live there. "It is one thing to

respond artistically to the visual provocativeness of a crumbling tenement; another to have to live within its oppressive walls," Dante wrote.

For many, *East 100th Street* remains a classic essay and an inspiration, a major achievement in the history of documentary photography. But the problem this type of work may be seen as alluding to, whatever its resolution in this particular case, remains. It is linked both to the perceived insufficiency of the documenting of a social ill as a stimulus for social change in a world increasingly submerged by and knowledgeable of a complexity of problems, and the danger as well of disconnected, soaring metaphor as even the most socially concerned photographers tire of articulating the obvious. Critic Alan Sekula, in an essay "On the Invention of Photographic Meaning," referred to this transition as "The passage of the

photograph from report to metaphor (and of photographer from reporter to genius). . . ."

Charles Harbutt, in his book *Travelog*, which appeared three years after Davidson's volume, suggests an increase of this tension as a form of resolution. "The good photographer skates as close to the brink of total realism, while still honoring the otherness of the image," he wrote in the book's epilogue, "or he skates as close to otherness—the sheer, unique, two-dimensional object—while never leaving the direct realism of which the medium is capable. But the great photographer skates close to both brinks simultaneously and, in the process, frequently states new ways the problem can be perceived if not solved, new ways the rules can be broken if not observed. The result is a two-dimensional image that is a separate experience in itself while totally authentic to the real continuum which gave it birth." Like Davidson's essay, Harbutt's book would be influential, an experiment in the experiential fusion of form and content. The problem is in the

Eugene Richards

Photograph of Dorothea Lynch from Exploding Into Life.

riskiness of the endeavor he suggests, which is dependent on intuition as never before, destroying the traditional landmarks of the journalist. No longer does one attempt only to sense the event in its repercussions, but to reinvent it.

While a number of photographers were scrutinizing domestic issues in more in-

timate, personalized ways, Philip Jones Griffiths, a Welshman trained originally as a pharmacist, was photographing the war in Vietnam. The resulting 1971 book, *Vietnam Inc.*, proclaims yet another photographic approach that is explicit in its abandonment of traditional, "liberal" empathy for everyone involved in war as its inevitable victim. Instead it becomes a searing, sarcastic indictment of American involvement.

Responsible for photographs, text, and layout, Griffiths combined them to powerful effect. Many of the photographs are tense, but in the context of war appear almost matter-of-fact, while the captions make them ferocious. For example, two images of uniformed Vietnamese children in a ward full of the American wounded are captioned: "Orphans visit a United States Army hospital to sing and dance for the wounded men whose predecessors were responsible for these children's parentless status." Even a photograph of American soldiers at rest (one sprawls, bare-chested, while reading a 1970 Plymouth catalogue), is captioned to emphasize a sense of the surrounding war's many-leveled insanity. "Salesmen used to follow GI's into the field to make a 'sale' so that the boys will have a real reason for wanting to get home in one piece. Today they find it safer to have the GI choose his car's trim and upholstery by mail order."

There are also large and dramatic images of horrid suffering, but the horror is never allowed to become heroic or sentimental. There are other images that contextualize them and assign

Sebastião Salgado
Cover of Other Americas, *c. 1986.*

blame where it has not often been assigned photographically, such as in a photograph of soldiers surrounding a printout from the "the computer that 'proves' the war is being won." Or, quite simply, the helmeted face of an American pilot is put opposite a photograph of a civilian burned by napalm. In Vietnam, where many observers could not agree with the policies of the government whose troops they were covering, the role of society's reliable witness was becoming that of revulsed critic, and the photoreporter, the team player, was becoming an author in his or her own right.

Magnum photographers are still pursuing ambitious reportages, perhaps more than ever, throughout the world. Foreign reportages include Peress's long-term project in Northern Ireland, which he has been working on during various trips over the last two decades, Salgado's international "Archaeology of Industrialism," Steele-Perkins' look at the effects of modernization on Africa, Abbas's worldwide investigation into the Islamic world and Zachmann's on the Chinese diaspora; domestic reportages include Paris-based Franck on

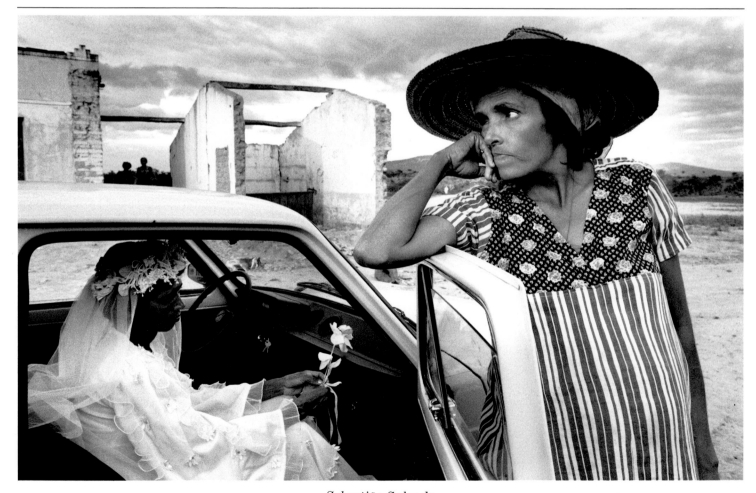

Sebastião Salgado
Brazil, c. 1981.

437

old age as well as portraits of artists, London-based Marlow on Thatcher's Britain, Reed on black America, Fusco on the homeless, and Richards on the American poor and drug addiction.

But the problems in photographic

point of view penetrate both the mainstream media and the consciousness of the reader. ". . . when I started magazines it was to try to tell people everything you do know so that they would learn something," asserts Glinn. "And

societal disbelief in the facility of significant change. Furthermore, as photographs of disaster proliferate and liberalism is maligned through much of the world, images that appeal to a sense of empathy and social concern

Josef Koudelka

Cover of Gypsies. *c. 1975.*

Josef Koudelka
Bratislava, 1965.

communication recognized in the work of Davidson, Harbutt, and Griffiths, among others, have intensified. It is an even greater distance from *Picture Post*'s enthusiastic embrace of Capa's imagery fifty years ago, "This Is War!", to a perception related by Capa award-winner Susan Meiselas that the photographer is mute before the devastation of another war. ". . . it's difficult now to feel that I can't make an image to bring the devastation of the war with the contras home, even though I feel a tremendous urgency all the time to do so," she stated in 1987, nine years after beginning her intensive and ongoing coverage of Nicaragua during the Sandinista revolution. "It's not that there haven't been images made, but the larger sense of an 'image' has been defined elsewhere—in Washington, and in the press, by the powers that be. I can't, we can't, somehow reframe it. . . ."

There is a shared uncertainty among Magnum's younger photographers, as well as some of the older generations, about their continued ability to influence the course of events, to have their

now I think the attitude of . . . most glossy magazines is to be obscure and keep something from view and to imply the best way to learn how to eat well in Berlin is to sit down with two nude ladies across the table . . ." Discovering what is going on in the world is also often harder, both because of the manipulative attitudes of governments (the photo opportunity is the bane of photojournalists almost everywhere) and the rising costs of travel. Riboud points out that traveling abroad is now about four times more expensive than when he joined Magnum in 1951, making an independent, exploratory vision that much more difficult to sustain.

It is for these reasons as well that the ethos of "concerned photography," a term Cornell Capa used to represent the work of his brother Robert and of Bischof and Chim, is being vigorously reinterpreted. Close-up empathy misses the newer, more ironic perception of both the events themselves and of the media that represents them, the absence of clear-cut distinctions between good and evil, as well as the general

may be shunned by editors and even readers as too sentimental, even naive.

The result is that one no longer has to come from the world of art, as Cartier-Bresson did, to question the journalistic photographer's implicit social contract as reliable, clearly legible witness. The increasing frustration and complexity of that role has led many, at the very least, to rethink the nature of the act of witnessing, so that the strength of the image begins to reside less in the proffered experience of direct seeing and more in the paradox of appearance, less an easy identification by the reader with what the photograph depicts and more a rethinking of relationships—among reader, subject, and photographer.

There are those who have begun to overtly implicate the reader in their own situation as reporter-observer, attempting to warp if not shatter the easy sense of the photograph as a window onto the world that can be quickly accessed. "These photographs, made during a five-week period . . . do not represent a complete picture of Iran or a final record of that time," writes Gilles Peress at the beginning of his book, *Telex Iran*, which mixes telexes to and from Magnum's offices (often concerning at-

tempts to find him assignments) with photographs taken throughout the country. Coincident with the period when Americans were being held hostage, motivated in large measure by hysterical media coverage ("Mideast Madness," "100,000 Shriek Hatred") Peress's photographs are the puzzled, chaotic articulations of a self-avowed outsider looking for explanations in areas where other journalists, confined for months to their on-the-spot positions in front of the American Embassy, were unable to go.

In this context, the photographs are asserted as questions rather than answers, a strategy in keeping with a growing disbelief that it is possible to present conclusions without involving the reader in the photographer's attempt to understand. The revelation of the image is located in the telling, not just in the evidence of what has been told. *The New York Times Magazine*, which published Peress's work, entitled it "A Vision of Iran," rather than giving it a more definitive headline, for a rare instance recognizing its own inability to authoritatively decipher world events.

Likewise, Raymond Depardon, an experienced and respected photoreporter who came to Magnum ten years after founding, with Gilles Caron, the photographic agency Gamma, began to insert himself into his own reportage. His work in Beirut and Afghanistan, two areas embroiled in violent conflict, was compiled in a small book called *Notes*, combining diary-like texts with a reporter's captions and photographs. "November 26. This is war. This house was destroyed by the regular Afghan army only five days ago . . .", reads one of his notations. At another point in the book, he writes: "I would like to be solitary—a loner, a bachelor, a wanderer. When I travel I am like a child. Not to attempt to seduce. In Paris they did not understand."

Three years later, while at Magnum, he did a similar one-month project with the French daily newspaper *Liberation*, sending back from New York a single photograph and short text every day, which were published in the foreign affairs section. Then, for *Le Monde*, he used a comparable technique to cover the French presidential campaign. No longer, in these instances, are the "objective" realities of the witnessing photographer allowed to diverge from the reactions, thoughts, and feelings of the witness who, it is made clear, is a highly subjective being. Some, like Danny Lyon who went on to publish *Paper Negative*, go even farther, in his case to the extent of fictionalizing the photographer, himself, who is treated like a character in a novel.

Particularly in recent years, Magnum has also had a number of photographers who, neither content to remain within the confines of photojournalism nor interested in reinventing its language, yet who want to deliver highly personal messages, have turned to the broader, less temporal pathways of documentary photography. There they have been able to articulate more intimate, highly individuated, and often poetic approaches to photographic speech, to the events of their lives.

Eugene Richards is one photographer whose images are at times rendered as direct, raw exclamations that delineate a terrain of agony and grief. In the book *Exploding Into Life*, Richards and coauthor Dorothea Lynch, his longtime companion, examine a world permeated by cancer in which they were also submerged. Written by Lynch, the book concentrates on

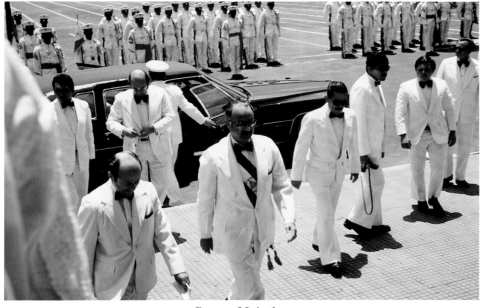

Susan Meiselas

Cover of Nicaragua, *c. 1981.*

Susan Meiselas

Gen. Anastazio Somoza, Managua, Nicaragua, c. 1977–78.

439

the predicament of others in the hospital and details the impact of breast cancer on her own life. Richards' searing, intensely painful images depict Lynch's suffering and fleeting joys, and implicitly his own, before she succumbs to the disease. The book serves both as an indictment of a medical system and a personal diary, a testament.

Sebastião Salgado, a Brazilian living in Paris, has also turned to testament, but in a form that is more elegiac, less an open wound. He worked during a seven-year period on a project—a return to his native region—which became an extended meditation on the profoundly mythic, redemptive dimensions he saw encompassed within the

lives of Latin America's peasants. Similarly, his work in the Sahel region of Africa, which also served a timely journalistic function, becomes in its entirety a paean to the dignity of masses of people dying from famine, refusing to let them be caricatured simply as victims, affirming their more generous humanity.

Also living in Paris and separated from his homeland, Josef Koudelka, a Czech refugee, has created disciplined images of other exiles and gypsies that resonate deeply with a highly personalized and refined lyric of captured identity. Koudelka travels (with a sleeping bag) much of the year pursuing his own personal odysseys, and

often camps out at Magnum's Paris office. A methodical worker who rarely accepts an assignment, he says that he still manages to average about one thousand rolls of exposed film every year.

In another nonjournalistic, on-the-road mode, Magnum boasts a small group of photographers, particularly Elliott Erwitt, Richard Kalvar, and Guy Le Querrec, whose images contain a rare component in photography, humor, albeit of an often ironic, distressing nature. For decades Erwitt, for example, has been noted for coming back from assignments with a few pictures for personal consumption of the odd dog and of the bizarre gesture from

Alex Webb

Cover of Under a Grudging Sun: Photographs from Haiti Libéré: 1986–1988, *c. 1989.*

Alex Webb

Port au Prince, Haiti, July 1987.

Alex Webb

Memorial for victims of army violence, Port au Prince, Haiti, July 1987.

the beaches, streets, and catacombs of the world.

As color photography has become the norm in magazines, almost every Magnum photographer has taken to it. While earlier this decade both Mary Ellen Mark's color photographs of prostitutes in Bombay, *Falkland Road*, and Susan Meiselas' color work in Nicaragua were at first criticized for "prettifying" subjects that should have been, some critics felt, treated in the more austere black-and-white tradition, some photographers now cover the world almost exclusively in color: for example, James Nachtwey, who has won the Capa award twice for his virtually continuous coverage of war and other upheavals, and editorial photographers Steve McCurry and Nick Nichols. But there are also a number of photographers who, in certain of their best work, have used color without at-

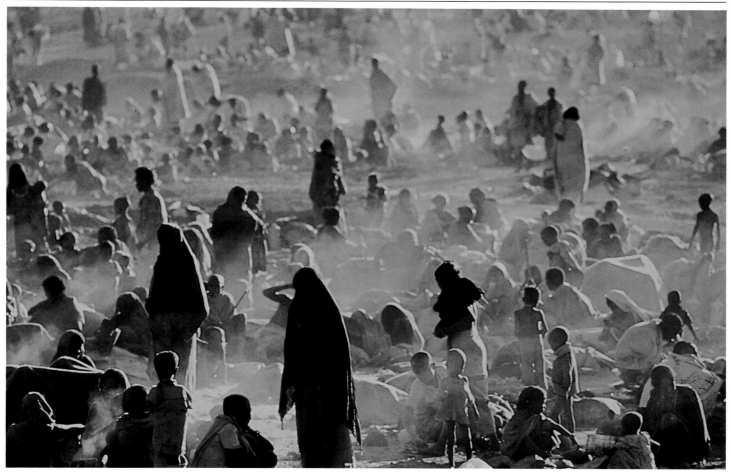

Ferdinando Scianna

A refugee camp, Tigre province, Ethiopia, November 1984.

tempting to fill the role of realistic witness but to demonstrate a sense of atmosphere and place. At times this work becomes highly personalized tone poems of spirit and mood, linked less vigorously to temporal, individuated realities. Examples range from Barbey or Gruyaert's moody color from North Africa, to Hartmann's meditation on the beauty and power of technology's artifacts, Manos's quirky views of Americans at leisure, Stock's studies of landscapes and flowers, and Webb's *Hot Light/Half-Made Worlds*, a kaleidoscopic reflection on tropical societies. (Webb's most recent color effort, on Haiti, has considerably thicker roots in that country's current events.)

As many of Magnum's photographers have chosen to emphasize their own personal vision, working at greater length and complexity, they have had to not only look for forms of presentation other than the magazine, but to develop and refine skills that go beyond the traditional parameters of the photojournalist as producer of images. In order to assert more individual control over the presentation of their photographs, circumventing a traditional dependency on others in the editorial process, they have had to work to understand the relationship of photographs to each other, of the effect of layout and of text, of visual syntax, in order to implement their own points of view. Many have become, to a considerably larger extent, the authors of their own work, able themselves to direct the meanings of their photographs, to preserve ambiguities when wanted, to place the images in contexts which amplify, rather than redirect or constrict, their meanings. In this sense they continue to extend the Magnum tradition of independence.

While almost everyone seems to be working on a personal project, usually a book or exhibition, there are a number of photographers who have chosen to use their editing skills with other photographers' work. René Burri and Mark Godfrey, for example, also work as magazine picture editors. Others edit books of images, such as *About 70 Photographs*, a critical investigation edited by Chris Steele-Perkins in London, and *El Salvador*, which utilized the work of thirty photographers to make an alternative presentation to the conflict there, coedited by Susan Meiselas. René Burri and Bruno Barbey also orchestrated the compiling of a recent book of Magnum images on the Middle East, *Terre de Guerre* ("Land of War"). Filmmaking, which Magnum photographers have always done, continues to be popular and some, like Depardon, Erwitt, and Gaumy, do it almost full-time (for a short period in the 1960s there was a Magnum film department).

Cornell Capa founded the International Center of Photography, a museum with a large educational component, in New York in 1974, the same year that David Hurn founded a forty-student school of documentary photography in Wales. Teaching is particularly popular, with many members working part-time on the international workshop and lecture circuits. Guy Le Querrec's pedagogic methods include the use of a videotape; he asks students to press a button to freeze a frame as if they were taking a picture. He has also organized an unusual event at the annual Rencontres Internationales de la Photographie at Arles, in which jazz musicians improvise in response to photographs projected onto a screen.

Much has changed—in the world as well as in photography—since Magnum was founded in 1947. Yet, while there

441

are more and better photographers and agencies throughout the world, Magnum continues to produce a considerable portion of the most interesting photographic work. As an organization, it is largely faithful to its own peculiarities as well. It still has frequent financial crises and other problems that have plagued the cooperative since its inception. According to Lee Jones, who was with Magnum for twenty-three

Magnum Group Project

Cover of Terre de Guerre; *photograph by David Seymour.*

years, "It's a citadel of contradictions and will always be. The day that it stops, it won't be Magnum, it'll just be a well-run organization." Leonard Freed, who says that he's attracted to Magnum because of the state of constant conflict within, states, "There are others who have died, spiritually, and have no energy left. But we have more spirit at Magnum than in most other places."

But there is also a feeling that, as an organization, Magnum is now a much more difficult place to be. It is certainly a much larger group. Older and younger photographers often do not know each other personally, and sometimes do not sympathize with each other's aims. The annual budget for the New York office alone is $1 million, making it even more necessary to rely on big-money work, such as annual-report photography or more aggressive editorial marketing, as is currently being attempted by better coordination among the three offices. The market for the publication of lengthy picture sto-

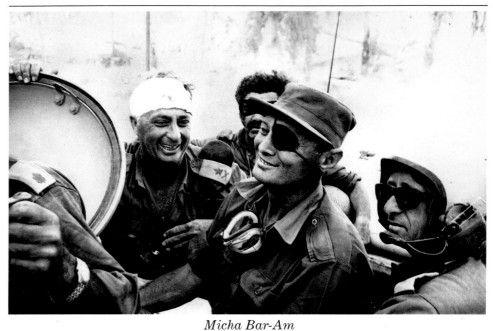

Micha Bar-Am

General Ariel Sharon and Moshe Dyan on the west bank of the Suez, 1973.

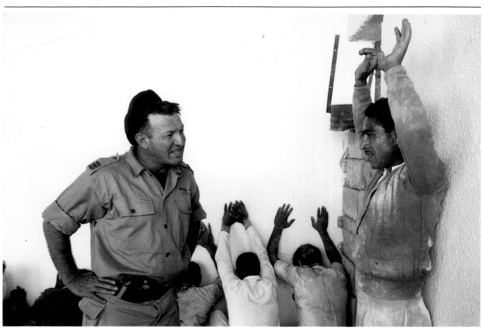

Burt Glinn

Interrogation of Arab prisoners by an Israeli soldier, Gaza, 1956.

ries, Magnum's trademark, has diminished to the point that, according to Paris editor Jimmy Fox, only 18 percent of such stories distributed throughout twenty-two countries are sold immediately, and just half after five years.

It is also a group that, without clear leadership, has great troubles making decisions without often savage internecine warfare. "Each person had a string tied to the mammoth's leg" when attempting group projects, says Fox. There is a candor among photographers that in its directness can be refreshing, or in its vitriol brutal. Glinn points to the inherent problem of how "to be

competitive with one another, and yet not show too much hostility." Or, Fox asserts more bluntly, "Magnum tends to breed paranoia."

Some photographers are accepted into Magnum and seem to stultify, unable or unwilling to take the photographic risks that brought them into the agency, perhaps too convinced of their own worth because of their connection to Magnum. For a variety of reasons, other talented photographers have not been accepted into Magnum (prominent among them Robert Frank, whose 1958 book, *The Americans,* would emerge as a singular influence on photographers ever since, many of

them from Magnum). Some, unable or unwilling to work within the organization, have left, such as the traumatic move in the early 1980s by four members, including Godfrey, Mark, and former presidents Harbutt and Uzzle, along with other colleagues, to form another agency, Archive, which deprived Magnum of much of its middle generation.

But what then is Magnum? Why does it still exist if it is so loosely conceived and problematic? I asked several photographers and staff members for their answers. They came up with a melange of ideas, ranging from "ego" to "compassion," from "curiosity" to "the same point of view." But the answer that rings the truest is *mefiance*, a French word with no English equivalent, but which can be loosely translated to mean a kind of skeptical or suspicious defiance.

Ferdinando Scianna, an associate from Sicily, mentioned *mefiance* in connection with Cartier-Bresson's method of sensing and photographing an event though its reverberations, not feeling compelled to focus on its center. This, as articulated by Scianna, becomes a metaphor for the tendency of Magnum photographers to occupy the periphery, not constrained by the centers of power, the conventional points of concern. It is a sense of *mefiance* that is true not only to their coverage of the world, but to their experimentation with the traditions of photography, and, as stated by Eve Arnold, who asserted the necessity of a strong ego, to their relationship with publications.

A sense of *mefiance* is what led Capa to envision and then, with his colleagues, found Magnum. Rodger had it when he reacted to the problem of framing the dead at a concentration camp, gave up his *Life* career, and traveled in a Land-Rover throughout Africa; he still has it now, in his retirement, refusing to ever consider himself an artist, despite descriptions of him as such. (Cartier-Bresson, on the other hand, now considers himself only to have been an artist.) Chim's sense of *mefiance* included his ability to find transcendent human values amongst the devaluation of war. It also explains some of the irascibility within the organization.

But most of all an attitude of *mefiance* links much of Magnum's past with its present, and it is an approach that will surely be even more necessary in the years to come. Not only is the world changing rapidly, increasing in complexity as it decreases in understanding, but so is photography. Earlier models do not suffice as people no longer see far-away places first through photographs, as was true when Magnum began, but are accustomed to

Erich Lessing

Isaac Newton's manuscript on the aberration of light and the prism he used for these experiments.

viewing the world through a thick veil of imagery, much of it distorting. Nor is the "decisive moment," the finding of visual coherence in the random activities of the everyday, a strategy that is easily applicable to the forceful splintering of contemporary societies.

Instead, between the vision of the artist and the testimony of the witness, Magnum's traditional field of endeavor, there still exists an area to be exploited, but one that seems now to gravitate towards an appeal to the intellect as well as the emotions, and one that combines the authority of the eyewitness with the humility of one. The mythic world-traveling photographer must, in the current information age, pick and choose carefully what is said and how it is being said. Otherwise, he or she risks becoming simply another interesting personality, absorbed and nullified, an applauded player repeating elegant maxims to a numbed audience from an increasingly crowded media stage.

Perhaps the greatest change overtaking still photography is the recent introduction of computer technology, which allows photographs to be recorded on reusable disks and photographs to be composited or otherwise physically retouched in a manner that is quick, efficient, and virtually impossible to detect. In the first case there may no longer be a negative with which to verify an image. The result of the second technique, which has been used occasionally in the last few years by newspapers and magazines, par-

ticularly on covers, is that one is deprived of the automatic sense that the photograph is a transcription of the basic visual facts framed within its rectangle, let alone the essence of a situation. Furthermore, programmers are working to mathematically generate imagery that appears to be as realistic as a photograph, without using a camera.

It is evident that as electronic photography systems are more widely distributed, both to professionals and amateurs, the traditional perception of the photograph as a mechanical recording from reality may be seriously compromised. If so, it may become necessary to label photographs as fiction or nonfiction, as is done with words. The photograph will no longer be automatically authoritative, and arguments like the one about the veracity of the image of the Falling Soldier will seem nostalgic.

Paradoxically, as the mechanical fidelity of the photograph is questioned, it may be generally recognized for linguistic subtlety, like writing, opening up the potential for creating and appreciating a richer photographic literature. The media, which in recent years seems even more omnipresent and single-voiced, may take advantage of the new technology to further modify images, viewing photographs as raw material to be altered in order to more vigorously project its own vision of the world. Publications may, one hopes, also search for independent visions that utilize photography's inherent richness. The experimentation of Magnum pho-

tographers, their self-reliance and *mefiance*, may become increasingly important as much of the heart of their own medium changes.

A growing concern in this increasingly postmodern culture, particularly in the visual one, is that there be people left to say things authentically who can reach the public, not losing interest in exploring the increasingly volatile, variegated complexities of the day. Perhaps the photographer committed to such exploration faces an ever-increasing loneliness as other photographers take and immediately transmit images to far-away offices or, without moving from their computer systems, make photographs to depict the world. Certainly, these future challenges are not only up to Magnum to meet, and there are many others capable of meeting them. But it is by now, more than forty years later, a well-developed Magnum tradition to attempt to meet challenges, to navigate the shifting distances between fact and fiction, between loyalty to the world and their own egos, between public and private concerns.

Ernst Haas, in a 1960 letter to the membership, complained that "Our missiles have not reached the moon." It is increasingly clear that not only must they be launched, and launched continuously, but that Magnum, to its credit, with all its various tensions and explosions, has been one of a very few organizations able to survive while continuing to act as a launching pad. The moon will always be there.

Biographical Notes and Selected Bibliographies

Stuart Alexander

Magnum has not only survived but grown because it has continually evolved. Membership in the cooperative was loosely defined before 1955, when the first formal definitions, still in use today, were created by John G. Morris, international executive editor from 1953 to 1961. To become a member, a photographer normally must go through distinct stages. At anytime before full membership a photographer may be discontinued. Many photographers have been associated with Magnum since its beginnings but never became full members. It is for this reason that only photographers who are currently or formerly have been members of Magnum or who eventually became full members are included.

A Magnum photographer usually is first a nominee, then an associate member, and finally a full member. A nominee is elected to work "under the guidance of a member photographer during an initial test period." After that period, which generally lasts one or more years, the nominee may be elected an associate member. An associate member works full-time through Magnum but does not hold stock. After a year or more as an associate, the photographer may be elected to full member status. Contributors are generally older photographers who may have been full members and who occasionally work through Magnum. Correspondents are essentially stringers because of geographical distance: they may do an occasional project through Magnum but they do not necessarily work full-time through the group.

The bibliographies have been drastically shortened due to space limitations. More complete bibliographies are available in the archives of the Center for Creative Photography, Tucson, Arizona.

Abbas

Born in Iran in 1944. Began photographing for a newspaper in Algeria in 1962. Studied mass communications in England (1964–68). During 1968 and 1969 photographed for the Olympic committee. Worked as a free-lance photographer for *Jeune Afrique* (1970–71). Then, until 1973, worked for the agency Sipa, traveling to Biafra, Bangladesh, Northern Ireland, and South Vietnam. In 1974 joined the Gamma agency and continued photographing throughout the Third World. Photographed in South Africa and the revolution in Iran from 1978 to 1980. Left Gamma and became a Magnum nominee in 1981. Became an associate member of Magnum in 1983; also returned to Mexico to photograph that year. Became a full member of Magnum and made first fashion photographs in 1985. Traveled to Mexico again (1986) and in 1987 began a large project photographing the resurgence of Islam throughout the world. Abbas's books include the following:

Zaire Today. Diallo, Siradiou. Paris: Éditions Jeune Afrique, 1977. *Iran: La Révolution Confisquée.* Paris: Éditions Clétrat, 1980. *Retornos a Oapan.* Colección Río de Luz. Mexico City: Fondo de Cultura Económica, 1986.

Eve Arnold

Born in Philadelphia to Russian immigrant parents. Began photographing, and managed photo-finishing plant, in 1946. Studied photography with Alexey Brodovitch at New York City's New School for Social Research in 1948. First associated with Magnum in 1951; became an associate member in 1955; a full member in 1957. Made first of five trips to Soviet Union in 1965. Photographed in China and in 1980, the Brooklyn Museum opened a large traveling exhibition of these photos. Received the National Book Award for *In China* in 1980. Awarded the Lifetime Achievement Award from the American Society of Magazine Photographers. Arnold's major publications include the following books and exhibition catalogues:

The Unretouched Woman. New York: Alfred A. Knopf, 1976. (Also published in London: Jonathan Cape, 1976.) *Flashback!: The 50's.* New York: Alfred A. Knopf, 1978. *In China.* New York: Alfred A. Knopf, 1980. (British edition: London: Hutchinson; German edition: Kiepenheuer and Witsch; Japanese edition: Tokyo: Shogakukan; French edition: *En Chine.* Paris: Nathan, 1981.) *In America.* New York: Alfred A. Knopf, 1983. (British edition: London: Martin, Secker & Warburg.) *Marilyn Monroe: An Appreciation.* New York: Alfred A. Knopf, 1987. (British edition: Hamish Hamilton; Canadian edition: Random House; German edition: Busse; French edition: *Marilyn for Ever.* Paris: Albin Michel; Spanish edition: Mondadori; Italian edition: *Omaggio a Marilyn.* Milan: Arnoldo Mondadori.) *Private View: Mikhail Baryshnikov's American Ballet Theatre.* New York: Bantam Books, 1988.

Bruno Barbey

Born February 13, 1941, in Berrechid, Morocco. Studied at l'École des Arts et Métiers in Vevey, Switzerland (1959–60). Photographed in Italy (1961–64). From 1962 to 1966 photographed *Atlas des Voyages.* Began association with Magnum in 1964; became an associate member in 1966; a full member in 1968. From 1966 to 1979 worked extensively in regions of political unrest and in the third world. Served as Magnum's European vice-president 1978 and 1979. Worked in Poland in 1980 and 1981. Co-curated with René Burri "Terre de Guerre" exhibition at the Galerie Magnum, Paris. First one-man exhibition held in Paris, 1967. Continues to photograph throughout the world, returning most frequently to North Africa and the Far East. Current European vice-president. Awarded, among others, the French National Order of Merit, 1985. Barbey's major publications include the following books and exhibition catalogues:

From 1964 to 1968 Barbey made all of the photographs for several books in the series l'Atlas des Voyages, published in Lausanne by Editions Rencontre. Some of the titles that Barbey photographed are *Naples, Portugal, Koweit, Kenya, Ecosse,* and *Camargue.*
Ceylan: Sri Lanka. Texts by J. Milley, E. Geais, and A. Barret. "Rêves et Réalités" series. Paris: André Barret, 1974. *L'Iran: Pérennité et renaissance d'un empire.* Text by René Maheu and Jean

Boissel. Paris: Editions Jeune Afrique, 1976. (Also in an English edition as *Iran: Rebirth of a Timeless Empire.*) *Nigeria.* Text by Balogoun. Paris: Editions Jeune Afrique, 1978. *Bombay.* Moraes, Dom. The Great Cities series. Amsterdam: Time-Life Books, 1979. *Pologne.* Text by Bernard Guetta. Paris: Editions Arthaud, 1982. (German edition: *Polen.* Text by Karl Dedecius. Hamburg: Hoffmann und Campe, 1982. English edition: *Poland.* Text by Czeslaw Milosz. London: Thames & Hudson, 1982.) *Le Gabon.* Paris: Editions du Chêne, 1984. *Portugal.* Text by Stefan Reisner. Hamburg: Hoffmann und Campe, 1988.

Ian Berry

Born April 4, 1934, at Preston, Lancashire, England. Moved to South Africa in 1952. Worked for the *Rand Daily Mail* and later the magazine *Drum* until 1960. Moved to Paris in 1962, where he became an associate member of Magnum. Moved to London in 1966 and worked there on contract for *The Observer Magazine.* Became a full member of Magnum in 1967. Awards Berry has received include: the first major photographic bursary from the Arts Council of Great Britain, 1974; Nikon's Photographer of the Year Award, 1977. Elected European vice-president of Magnum in 1976 and 1977. Berry's publications include the following:

The English. London: Allen Lane, 1978. "Black and Whites: l'Afrique du Sud par Ian Berry." *Camera International* [Paris], no. 18 (Winter 1988): 7, 9, 13–20, 23–82. [Includes texts by Claude Nori, François Mitterand, Pierre Haski, and Gabriel Bauret.]

Werner Bischof

Born April 26, 1916, in Zurich, Switzerland. Studied photography with Hans Finsler at Zurich's Kunstgewerbeschule from 1932 to 1936. Opened a photography and advertising studio in Zurich in 1936. Designed installations for the Swiss National Exhibition (1939). Served in Swiss military, beginning in 1939. Began contributing regularly to the Swiss magazine *Du* in 1941. Traveled throughout Europe to photograph the war's devastation in 1945. Became a full member of Magnum in 1949. From 1951 to 1952 traveled to India, South Korea, Japan, and Indochina; in 1953 photographed in Europe and the United States. Traveled through Mexico to South America in 1954. He was found dead May 16, 1954, after his jeep accidentally went over a cliff in the Peruvian Andes. Bischof's archives are maintained by Magnum and by his sons in Zurich. Bischof's books and exhibition catalogues include the following:

Werner Bischof: 24 Photos. Einleitung von Manuel Gasser. Bern: L. M. Kohler, 1946. *Die Schweizer Spende: Tätigkeitsbericht.* Oligiati, R. Zurich: Conzett & Huber, 1948. *Das leidgenössische Gestüt in Avenches.* Baumann, J. Zurich: Conzett & Huber, 1954. *Japan.* Text by Robert Guillain. Paris: Robert Delpire, 1954. (Also published in the following identical foreign editions: Zurich: Manesse, 1954; New York: Simon & Schuster, 1954; London: Sylvan Press, 1954.) *Werner Bischof 1916–1954: A Memorial Portfolio.* Basel: Basler Druck und Verlagsanstalt, 1954. *Indiens pas morts.* Photographs by Werner Bischof, Robert Frank, and Pierre Verger. Text by Georges Arnaud. Paris: Robert Delpire, 1956. (Also published as *Indios.* Zurich: Manesse, 1956; *From Incas to Indios.* New York: Universe Books, 1956; *Incas to Indians.* London: Photography Magazine, 1956; *Dagli Incas agli Indios.*) *Werner Bischof: Carnet de route.* Texts by Manuel Gasser. Paris: Robert Del-

pire, 1957. (Also published as *Unterwegs.* Zurich: Manesse, 1957; *The World of Werner Bischof: A Photographer's Odyssey.* New York: E. P. Dutton, 1959; *Fran Färdevägar.* Stockholm: International Publishing Corp., 1960.) *Werner Bischof, 1916–1954.* Fárová, Anna. Prague: S.N.K.L.H.U., 1960. New York: Paragraphics/Grassman, 1966. *Werner Bischof: Querschnitt.* Bischof, Rosellina, and Peter Schifferli. Texts by Manuel Gasser, Henri Cartier-Bresson, John G. Morris, Claude Roy, and Charles Rosner. Zurich: Arche-Verlag, 1961. *Japan.* Text by Robert Guillain. New York: Gallery Edition/Bantam Books, 1961. *Werner Bischof.* Flüeler, Niklaus. Bibliothek der Photographie. Lucerne, Switzerland: C. J. Bucher, 1973. (Published in the series, Photography: Men and Movements. Garden City, N.Y.: Amphoto, 1976.) *Werner Bischof, 1916–1954.* Texts by Bhupendra Karia and Manuel Gasser, ICP Library of Photographers series. New York: Grossman Publishers, 1974. (Includes texts by many people about Bischof and excerpts from letters by Bischof.) *Werner Bischof.* Texts by Hugo Loetscher and Giorgio Soavi. I Grandi Fotografi series. Milan: Gruppo Editoriale Fabbri, 1983. *Werner Bischof.* Dieuzaide, Jean. Toulouse, France: Galerie Municipale du Chateau d'Eau, 1984. (Exhibition catalogue.) *Werner Bischof.* Introduction by Claude Roy. Collection Photo Poche. Paris: Centre National de la Photographie, 1986.

Brian Brake

Born June 27, 1927, in Wellington, New Zealand. Began photographing in the late 1930s. Apprenticed with portrait photographer Spencer Digby in 1945. Became an associate of the Royal Photographic Society of Great Britain in 1947 and joined the New Zealand Film Unit as a cameraman. In 1950 received a British Council Bursary to study color cinematography in Great Britain. Moved to London in 1953 and met Magnum figures Ernst Haas, John Morris, and Henri Cartier-Bresson in 1954. Became a Magnum associate member in 1955 and a full member in 1957; in 1958 elected Magnum's European vice-president. In 1960 photographed the acclaimed monsoon essay, established a base in Hong Kong (1961–62), and in 1962 began working almost exclusively for *Life* magazine. Resigned from Magnum and joined the Rapho agency in 1967. Formed film production company, Zodiac Films, in 1970. Returned to settle in New Zealand in 1976. In 1985 co-organized the three-week photographer's tour, Focus on New Zealand, and in 1986 became a Fellow of the New Zealand Academy of Fine Arts, Governor General Art Award. Brake died of a heart attack in August 1988, in Auckland, New Zealand. Awards Brake received include: the Egyptian Order of Merit (1969); New Zealand Professional Photographers' Association Honorary Fellowship (1978); Order of the British Empire, (1981); Honorary Master of Science in Photography, Brooks Institute of Photography, Santa Barbara, Calif. (1983); and Photographic Society of New Zealand Honorary Fellowship (1984). Brake's books and exhibition catalogues include the following:

The Chinese Smile. Text by Nigel Cameron. London: Hutchinson, 1958. *New Zealand: Gift of the Sea.* Text by Maurice Shadbolt. Christchurch, New Zealand: Whitcombe and Tombs, 1963. *Peking: A Tale of Three Cities.* Text by Nigel Cameron, New York: Harper & Row, 1965. *House on the Klong.* Text William Warren. Bangkok: Published privately by James Thompson, 1968. *The Sculpture of Thailand.* New York: The Asia Society, 1972. (Also published by

445

the Australia Council, 1976.) *Form und Farbe*. Cologne: Museum für Ostasiatische Kunst, 1972. *Brake Brake: 40 Photographs*. Introduction by David P. Millar. Wellington, New Zealand: Dowse Art Gallery/Queen Elizabeth II, Arts Council of New Zealand, 1976. *New Zealand Potters: Their Work and Words*. Text by Doreen Blumhardt. Wellington, New Zealand: A.H. & A.W. Reed, 1976. *Legend and Reality: Early Ceramics of South East Asia*. Texts by Roxanna M. Brown, Prof. Dr. Otto Karow, Prof. Dr. Peter W. Meister, and Hans W. Siegel. Kuala Lumpur: Oxford University Press and Museum für Ostasiatische Kunst, Cologne, 1977. *Hong Kong*. Text by Robert Elegant. Great Cities Series. Amsterdam: Time-Life International, 1977. *A Look at Brian Brake and His Work with Kodachrome Film*. Rochester, New York: Kodak, [c. 1977]. *Rome and Her Empire*. Text by Barry Cunliffe. New York: McGraw-Hill, 1978. *Art of the Pacific*. Text by James McNeish and David Simmons. London and New York: Oxford University Press and Abrams, 1979. *The Sacred Image*. Text by Dr. Piriya Krairiksh. Cologne: Museum für Ostasiatische Kunst, 1979. *Sydney*. Text by Peter Porter. Great Cities Series. Alexandria, Virginia: Time-Life Books, 1980. *Craft New Zealand*. Text by Doreen Blumhardt. Wellington, New Zealand: Reed, 1981. *Batik: Fabled Cloth of Java*. Text by Inge McCabe Elliott. New York: Clarkson N. Potter, 1984. *"Kahurangi" Treasures from New Zealand*. Los Angeles: Pacific Asia Museum and the Los Angeles Olympic Organising Committee, 1984. *Te Aho Tapu: The Sacred Thread*. Text by Mick Pendergrast. Auckland, New Zealand: Reed Methuen, 1987. *Guide to New Zealand*. Text by Maurice Shadbolt. Sydney: Reader's Digest, 1988.

René Burri

Born April 9, 1933, in Zurich, Switzerland. Studied at Zurich's Kunstgewerbeschule with Johannes Itten, Hans Finsler, and Alfred Willimann from 1949 to 1953. Worked as an assistant operator for Ernest A. Heiniger on Walt Disney's Cinemascope production *Switzerland*. Received a grant to make a film about the Kunstgewerbeschule and began association with Magnum through Werner Bischof in 1953. Became an associate member of Magnum in 1955 and began traveling around the world; in 1959, made a full member of Magnum. Instrumental in creating Magnum Films in 1965. Received the International Film and Television Festival Award in New York in 1967. Elected European vice-president of Magnum in 1982 and inaugurated the Galerie Magnum in Paris with the exhibition "Terre de Guerre," co-curated with Bruno Barbey. A major retrospective exhibition, "René Burri One World," presented at the Kunsthaus Zurich and the Palais de Tokyo, Paris, in 1984. Worked as art director of *Schweizer Illustrierte* in 1988. Burri's major books and exhibition catalogues include the following:

Die Deutschen. Texts selected by Hans Bender. Zurich: Fretz & Wasmuth, 1962. French edition: *Les Allemands*. Texts selected by Jean Baudrillard. Paris: Robert Delpire, 1963.) *El Gaucho*. Texts by Jose Luis Lanuza. Foreword by Jorge Luis Borges. Buenos Aires: Muchnik Editores, 1968. (American edition: *The Gaucho*. New York: Crown Publishers; British edition: *The Gaucho*. London: Macdonald.) *La Grèce*. Texts by Jacques Van Den Bossche. Paris: S.N.E.P., 1974. *Lost Pony*. Mendoza, George. San Francisco: San Francisco Book Co., 1976. *The Architecture of Luis Barragan*. Ambasz, Emilio. New York: The Museum of Modern Art, 1976. *In Search of the Holy Land*. Morton, H.V. Introduction by Raymond Flower. New York: Dodd, Mead, and Co., 1979. *René Burri: Die Deutschen: Eine Austellung von Photographien aus den sechziger Jahren*. Introduction by P. Katalog 5. Cologne: Galerie Rudolf Kicken, 1981. (Exhibition catalogue.) *Terre de guerre*. Text by Charles-Henri Favrod. Edited by René Burri and Bruno Barbey. Paris: Magnum Photos, 1982. (Exhibition catalogue.) *René Burri*. Texts by René Burri and Hans Koning. I Grandi Fotografi Serie Argento. Milan: Gruppo Editoriale Fabbri, 1983. *René Burri One World: Fotografien und Collagen 1950–1983*. Texts by Guido Magnaguagno, Hans Puttnies, Hans Koning, Willy Rotzler, René Burri, and Charles-Henri Favrod. Schweizer Photographie Series, no. 3. Berne: Benteli Verlag, 1984. *Die Deutschen: Photographien 1957–1964*. Texts by Hans Magnus Enzensberger. Munich: Schirmer/Mosel, 1986. *Ein Amerikanischer Traum: Photographien aus der Welt der NASA und des Pentagon*. Nördlingen: Delphi 1042, Greno, 1986. *René Burri, One World: An Edit*. Introduction by Corinne Diserens. Essay by Carole Naggar. New York: Burden Gallery and the Swiss Institute, 1988. (Exhibition catalogue.)

Cornell Capa

Born Cornell Friedmann, April 10, 1918, in Budapest. Moved to Paris in 1936 and began working as a photographic printer for his brother Robert. Emigrated to New York in 1937 and began working for the photo agency Pix, adopting the name Cornell Capa. From 1937 to 1941 worked as a printer for *Life* magazine. Became an American citizen in 1943, served in the Photo Intelligence unit of the U.S.A.F. from 1941–45; was staff photographer for *Life* magazine (1946–54). Made the first of several Latin American trips in 1953. Became full member of Magnum in 1954; also served as vice-president of American Society of Magazine Photographers (1953–55); Contributing photographer of *Life* magazine (1955–57); elected president of Magnum in 1956, holding office through 1959. Founded the Robert Capa/David Seymour Photographic Foundation in Israel in 1958 (which existed until 1966). Then founded and directed the International Fund for Concerned Photography in New York in memory of Werner Bischof, Robert Capa, and David Seymour; in 1967, organized the first "Concerned Photographer" exhibition. Ceased activities as a photographer in 1974 to found and direct the International Center of Photography (ICP) in New York. In 1975, received the Honor Award from the American Society of Magazine Photographers; and in 1978, the Award of Honor from the Mayor of the City of New York. In 1983, became contributing member of Magnum. Cornell Capa's books include the following:

Retarded Children Can Be Helped. Capa, Cornell, and Maya Pines. Great Neck, New York: Channel Press, Inc., 1957. *Through Gates of Splendor*. Elliot, Elisabeth. Pictures edited by Cornell Capa. New York: Harper & Brothers, 1957, *The Savage My Kinsman*. Pictures edited by Cornell Capa. New York: Harper and Brothers, 1961. (Also published in London by Hodder & Stoughton, 1961.) *Let Us Begin: The First 100 Days of the Kennedy Administration*. Edited by Cornell Capa and Richard L. Grossman. New York: Simon and Schuster, 1961. *Who Brought the Word*. Text edited by Marianna Slocum and Sam Holmes. Santa Ana, Calif.: Wycliffe Bible Translators, Inc., in cooperation with The Summer Institute of Linguistics, 1963. *Farewell to Eden*. Huxley, Matthew, and Cornell Capa. New York: Harper and Row, 1964, *Adieu au paradis*. Paris: Horizons de France, 1965. *The Emergent Decade: Latin American Painters and Painting in the 1960s*. Text by Thomas M. Messer. Texts and photographs by Cornell Capa. New York: Solomon R. Guggenheim Museum and Cornell University Latin American Year, 1966. *Adlai Stevenson's Public Years*. Text from his speeches and writings. Photographs by Cornell Capa, John Fell Stevenson, and Inge Morath. Preface by Walter Lippmann. New York: Grossman, 1966. *The Andean Republics*. Life World Library series. New York: Time-Life Books, 1966. *The Concerned Photographer*. Edited and with an introduction by Cornell Capa. Texts by Robert Sagalyn and Judith Friedberg. New York: Grossman, 1968. *New Breed on Wall Street*. Mayer, Martin. The Macmillan Company, London: Collier—Macmillan Limited, 1969. *Israel/The Reality: People, Places, Events in Memorable Photographs*. Edited by Cornell Capa. Preface by Nelson Glueck. Introduction by Moshe Shamir. New York: World Publishing, in association with The Jewish Museum, 1969. *The Concerned Photographer 2*. Edited by Cornell Capa. New York: Grossman, in cooperation with the International Fund for Concerned Photography, 1972. *Language and Faith*. Edited by Cornell Capa and Dale Kietzman. Santa Ana, Calif.: Wycliffe Bible Translators, Inc., 1972. *Behind the Great Wall of China: Photographs from 1870 to the Present*. Edited by Cornell Capa. Introduction by Weston J. Naef. New York: The Metropolitan Museum of Art, 1972. *Jerusalem: City of Mankind*. Edited by Cornell Capa. Introduction by Teddy Kollek with J. Robert Moskin. New York: Grossman Publishers, Viking Press, 1974. *Margin of Life: Population and Poverty in the Americas*. Text by J. Mayone Stycos, New York: Grossman Publishers, 1974. ICP Library of Photographers series. (Editor.) New York: Grossman, 1974–79. *Robert Capa, Werner Bischof, David Seymour—Chim, Lewis W. Hine, Dan Weiner, Roman Vishniac, and Lucien Aigner*. *Cornell Capa*. Texts by Cornell Capa and Harvey V. Fondiller. I Grandi Fotografi Serie Argento. Milan: Gruppo Editoriale Fabbri, 1983.

Robert Capa

Born André Friedmann on October 22, 1913, in Budapest. Began photographing in 1930. Worked as a photographer in Berlin for the agency Dephot in 1931 and studied political science at the Deutsche Hochschule für Politik until 1933, then moved to Paris. Met Henri Cartier-Bresson, David Seymour (Chim), and Gerda Taro; made contacts important to the creation of Magnum. Participated in forming the agency Alliance Photo. Began collaborating with Gerda Taro in 1935 and adopted the name Robert Capa. Beginning in 1936 his coverage of the Spanish Civil War appeared regularly in *Vu, Regards, Ce Soir, Weekly Illustrated* [London] and *Life*. Also shot newsreel footage for the March of Time during this period. Gerda Taro killed in Spain in 1937. In 1938 traveled to China. Emigrated to New York in 1939. From 1941–45 worked as a correspondent for *Life* magazine in Europe, photographing World War II. Throughout the war photographs appeared in *Illustrated* [London] and *Collier's*. Wrote *Slightly Out of Focus* in 1947, and the same year cofounded Magnum with Henri Cartier-Bresson, Maria Eisner, George Rodger, David Seymour (Chim), and William and Rita Vandivert. Also traveled to Russia with John Steinbeck and received the Medal of Freedom from the U.S. Army. Photographed in Israel (1948–50), and completed the first of a number of stories for *Holiday* (1949), which became a steady Magnum client. In 1951 became president of Magnum and was naturalized as an American citizen in 1954. Died on May 25, 1954, in Thai-Binh, Indochina (Vietnam) after stepping on a land mine while photographing troop patrols for *Life*. Posthumously awarded the Croix de guerre avec palme by the French army. In 1955 the annual Robert Capa Gold Medal Award was established by *Life* and the Overseas Press Club. Archives are with Magnum and the International Center of Photography, New York. Capa's books include the following:

Death in the Making. Photographs by Robert Capa and Gerda Taro. Captions by Gerda Taro. Preface by Jay Allen. Arrangement by André Kertész. New York: Covici-Friede, 1938. *The Battle of Waterloo Road*. Forbes-Robertson, Diana, and Robert Capa. New York: Random House, 1941. *Invasion!* Wertenbaker, Charles Christian. New York and London: D. Appleton—Century Co., 1944. *Slightly Out of Focus*. New York: Henry Holt and Co., 1947. (Also published in Tokyo in a Japanese translation in 1956.) *A Russian Journal*. Steinbeck, John. New York: The Viking Press, 1948. *Report on Israel*. Shaw, Irwin, and Robert Capa. New York: Simon & Schuster, Inc., 1950. *Robert Capa: War Photographs*. Stuart, Jozefa. Introduction by John Steinbeck. Washington, D.C.: Smithsonian Institution Traveling Exhibition Service, 1960. *Images of War*. New York: Grossman, 1964. French edition: *Images de guerre*. Paris: Hachette, 1965; Italian edition: *Immagini della guerra*. Milan: Mursia, 1965; German edition: *Das Gesicht des Krieges*. Düsseldorf: 1965. *Robert Capa*. Edited by Anna Fárová. Texts by various authors. New York: Paragraphic Books/Grossman, 1969. *Robert Capa, 1913–1954*. Introduction by Cornell Capa. ICP Library of Photographers. New York: Grossman, 1974. *Front populaire*. Capa, Robert and David Seymour. Text by Georgette Elgey. Paris: Chêne/Magnum, 1976. *Capa: emlèkkiállitás*. Introduction by Ivan Boldizsár. Budapest: Budapest Mücsarnok, 1976. *Robert Capa*. Martinez, Romeo. Maestri della fotografia series. Milan: Arnoldo Mondadori Editore, 1979. *Les grandes photos de la guerre d'espagne*. Text by Georges Soria. Photographs by Robert Capa and David Seymour. Paris: Editions Jannink, 1980. *Robert Capa*. Tokyo: Pacific Press Services and International Center of Photography, New York, 1980. *Robert Capa*. Texts by Anna Winand. I Grandi Fotografi Serie Argento. Milan: Gruppo Editoriale Fabbri, 1983. *Robert Capa: War and Peace*. Tokyo: Pacific Press Services and the International Center of Photography, New York, 1984. (Exhibition catalogue.) *Robert Capa: Photographs*. Edited by Richard Whelan and Cornell Capa. New York: Alfred A. Knopf, 1985. (French edition: *Robert Capa: Photographe*. Paris: Sylvie Messinger, 1985; Italian edition: *Capa: Robert Capa, Fotografo 1932.1954*. Texts by Cornell Capa, Richard Whelan, and Italo Zannier. Udine: Art &, 1987.) *Robert Capa: A Biography*. Whelan, Richard. New York: Alfred A. Knopf, 1985. (French edition: Paris: Mazarine, 1985.) *Robert Capa*. Barcelona: Fundacio Caixa de Pensions, 1986. *Robert Capa: Sommertage, Friedenstage: Berlin 1945*. Photographs by Robert Capa. Edited by Diethart Kerbs. Edition Photothek series, no. 16. Berlin: Dirk Nishen/Verlag in Kreuzberg, 1986. *Robert Capa: cuadernos de guerra en España (1936–1939)*. Collecion Imagen No. 9. Selection and presentation by Carlos Serrano. Valencia: Salla Parpallo/IVEI, 1987. *Robert Capa*. Introduction by Jean Lacouture. Collection Photo Poche.

Paris: Centre National de la Photographie, 1988. *Robert Capa: Photographs from Israel, 1948–1950.* Edited by Micha Bar-Am. Tel Aviv: The Tel Aviv Museum of Art, 1988.

Henri Cartier-Bresson

Born August 22, 1908, in Chanteloup, France. Studied painting with André Lhote (1927–28), then studied at Cambridge University (1928–29). Went to the Ivory Coast for a year in 1931. Upon return to France, made first photographs and met Tériade, and in 1932 some of these photographs were published and exhibited. Spent a year in Mexico in 1934 with an ethnographic expedition; in 1935 became involved with film with Paul Strand in the United States. Worked on documentary film production (1936–39) with Jean Renoir and independently. Held prisoner of war in Germany from 1940 to 1943. Following that, made the documentary film *Le Retour.* Photographed in the United States (1946–47) primarily for *Harper's Bazaar.* In 1947 a "posthumous" retrospective exhibition was presented at the Museum of Modern Art, New York (Cartier-Bresson was believed to have been killed during the war). That same year was a cofounder of Magnum. Lived and worked in the Far East from 1948 to 1950. In 1952 published *The Decisive Moment,* which made an enormous impression on photographers throughout the world. In 1954 photographed in Russia, and in 1955 a retrospective exhibition, which traveled world-wide, opened at the Musée des Arts Décoratifs in Paris. Spent three months in China (1958–59). In 1965 a retrospective exhibition opened in Tokyo and traveled throughout the world until 1969. Became a contributing member of Magnum in 1966. From 1969 to 1970 made documentary films for American television. Devoted more time to drawing and painting in the mid-70s and in 1975 the first of several exhibitions of drawings was held. Received an honorary Doctor of Letters from Oxford University (1975). In 1979 another retrospective exhibition (which traveled internationally) opened at the International Center of Photography, New York. In 1987, the Museum of Modern Art, New York, devoted an exhibition to his early photographic work. The Grand Prix International de Photographie Henri Cartier-Bresson was created by the Centre National de la Photographie, Paris, in 1988. Cartier-Bresson's major books and exhibition catalogues include the following:

The Photographs of Henri Cartier-Bresson. Texts by Lincoln Kirstein and Beaumont Newhall. New York: Museum of Modern Art, 1947. *Beautiful Jaipur.* Text by Max J. Olivier. Jaipur: Information Bureau, Government of Jaipur, 1948. *Images à la sauvette.* Paris: Editions Verve, 1952. (American edition: *The Decisive Moment.* New York: Simon and Schuster, 1952). *Les danses á Bali.* Text by Antonin Artaud. Commentary by Béryl de Zoete. Collection 'huit.' Paris: Robert Delpire, 1954. (German edition: *Bali: Tanz und Theater.* Olten: Roven Verlag, 1954.) *D'une Chine à l'autre.* Preface by Jean-Paul Sartre. Paris: Robert Delpire, 1954. (German edition: *China gestern und heute,* 1955; American edition: *From One China to Another.* Text by Han Suyin. New York: Universe Books, 1956; British edition: *China in Transition.* Text by Han Suyin. London: Thames & Hudson, 1956.) *Les Européens.* Paris: Editions Verve, 1955. (American edition: *The Europeans.* New York: Simon and Schuster, 1955.) *Moscou, vu par Henri Cartier-Bresson.* Collection Neuf. Paris: Robert Delpire,

1955. (German edition: *Menschen in Moskau.* Düsseldorf: Karl Rauch Verlag; American edition: *People of Moscow.* New York: Simon & Schuster; British edition: *People of Moscow.* London: Thames & Hudson; Italian edition: *Mosca.* Milan: Artimport.) *Henri Cartier-Bresson: Fotografie.* Fárová, Anna. Prague: Státní nakladatelství krásné literatury, hudby a umění, 1958. (Slovak edition: Bratislava: Slovenské Vydavateľstvo Krásnej Literatury, 1959.) *Photographies de Henri Cartier-Bresson.* Paris: Delpire, 1963. (American edition: *Photographs by Cartier-Bresson.* Introductions by Lincoln Kristein and Beaumont Newhall. New York: Grossman; British edition: *Photographs by Cartier-Bresson.* London: Jonathan Cape; Japanese edition: Tokyo: Asahi; Swiss edition: *Henri Cartier-Bresson: Meisteraufnahmen.* Zurich: Fretz and Wasmuth Verlag, 1964.) *China.* Afterword by Barbara Brakeley Miller. New York: Bantam Books, 1964. *Henri Cartier-Bresson: Exhibition of Photographs After the Decisive Moment.* Tokyo: Asahi Shimbun, c. 1966. *Photographs by Cartier-Bresson.* Introduction by Claude Roy and Ryoichi Kojima. Tokyo: Asahi Shimbun, 1966. *Henri Cartier-Bresson.* Texts by Henri Cartier-Bresson, Claude Roy, and Helmut May. Cologne: Kunsthalle Köln, 1967. *Henri Cartier-Bresson.* Texts by Claude Roy and Ryoichi Kojima. Milan: French Embassy/Centro Francese de Studi di Milano/Popular Photography Italiana, 1967. (Reprinted from *Popular Photography Italiana* [October 1967].) *Flagrants délits.* Paris: Delpire, 1968. (American edition: *The World of Henri Cartier-Bresson.* New York: Viking Press, 1968; Swiss and German editions: *Meine Welt von Henri Cartier-Bresson.* Lucerne and Frankfurt: Bucher Verlag, 1968.) *L'Homme et la machine.* Introduction by Etiemble. Paris: IBM World Trade Corp., 1969. American edition: *Man and Machine.* New York: IBM World Trade Corp., 1969; British edition: *Man and Machine.* London: IBM World Trade Corp., 1969.) *Vive la France.* Cartier-Bresson, Henri, and François Nourissier. Paris: Robert Laffont, Selection du Reader's Digest, 1970. American edition: *Cartier-Bresson's France.* New York: Viking Press; British edition: *Cartier-Bresson's France.* London: Thames & Hudson; Swiss and German editions: *Frankreich.* Lucerne and Frankfurt: Bucher Verlag.) *The Face of Asia.* Introduction by Robert Shaplen. New York: John Weatherhill and Orientations Ltd., Hong Kong, 1972. (French edition: *Visage d'Asie.* Paris: Chêne, 1972.) *A propos de l'U.R.S.S.* Paris: Chêne, 1973. (American edition: *About Russia.* New York: Viking Press; British edition: *About Russia.* London: Thames & Hudson; Swiss and German editions: *Sowjetunion, photographische Notizen von Henri Cartier-Bresson.* Lucerne and Frankfurt: Bucher Verlag.) *Henri Cartier-Bresson: Drawings.* Introduction by Julian Levy. New York: Carlton Gallery, 1975. *Henri Cartier-Bresson.* History of Photography series. Millerton, N.Y. Aperture, 1976. (Includes a text by Cartier-Bresson. French edition: Paris: Delpire/ Nouvel Observateur, 1976; Japanese edition: Tokyo: Quick Fox, 1976; German edition: Munich: Rogner and Bernhard, Photo-Galerie, 1978. Published in a revised edition later: *Henri Cartier-Bresson.* Aperture Masters of Photography series. New York: Aperture, 1987; Italian edition: Udine: Art &, 1988.) *Henri Cartier-Bresson.* Essay by Sir Ernst Gombrich. London: Victoria and Albert Museum, 1978. *Henri Cartier-Bresson.* [Tokyo]: Pacific Press Service, 1979. *Henri Cartier-Bresson: Photographe.* Foreword by Yves Bonnefoy. Paris: Robert Delpire, 1979. (American editions: *Henri Cartier-Bresson: Photographer.* Boston: New York Graphic

Society, 1979; *Henri Cartier-Bresson: Photographer.* Paris: Robert Delpire for the International Center of Photography, 1979.) *Henri Cartier-Bresson: Dessins, 1973–1981.* Preface by Bernadette Contensou. Texts by James Lord and André Berne Joffroy. Paris: Musée d'Art Moderne de la Ville de Paris, 1981. *L'Imaginaire d'après nature.* Paris: Michel Chandeigne, 1982. (Limited letterpress edition of 30. Text reprinted from *Henri Cartier-Bresson.* Paris: Delpire/Nouvel Observateur, 1976.) *Henri Cartier-Bresson.* Introduction by Jean Clair. Collection Photo Poche. Paris: Fondation Nationale de la Photographie, 1982. (Later French edition published by Centre National de la Photographie, Paris. American edition: *Henri Cartier-Bresson.* Introduction by Michael Brenson. Pantheon Photo Library. New York: Pantheon Books, 1985.) *Henri Cartier-Bresson: Ritratti: 1928–1982.* Texts by André Pieyre de Mandiargues and Ferdinando Scianna. I Grandi Fotografi series. Milano: Gruppo Editoriale Fabbri, 1983. (British edition: *Henri Cartier-Bresson: Portraits.* The Great Photographers series. London: William Collins Son, 1984.) *L'Immaginario d'après nature: Disegni, dipinti, fotografie, documentari Henri Cartier-Bresson.* Introduction by Giuliana Scimé. Texts by Henri Cartier-Bresson, Lamberto Vitali, and James Lord. Milan: Padiglione d'Arte Contemporanea, 1983. *Henri Cartier-Bresson.* Toulouse: Galerie Municipale du Château d'Eau, 1984. *Henri Cartier-Bresson: Carnet de notes sur le Mexique.* Introduction by Juan Rulfo. Paris: Centre Culturel du Mexique, 1984. *Henri Cartier-Bresson: Drawings and Paintings.* Preface by David Elliott. Texts by Julian Levy and André Berne Joffroy. Oxford: Museum of Modern Art, 1984. *Henri Cartier-Bresson: Paris à vue d'oeil.* Introductions by André Pieyre de Mandiargues and Vera Feyder. Paris: Paris Audiovisuel and Association des Amis du Musée Carnavalet, 1984. *Henri Cartier-Bresson.* [Seoul]: KBS, 1985. *Henri Cartier-Bresson en Inde.* Introduction by Satyajit Ray. Text by Yves Véquaud. Collection Photo Copies. Paris: Centre National de la Photographie, 1985. *Henri Cartier-Bresson: Photoportraits.* Introduction by André Pieyre de Mandiargues. Paris: Gallimard, 1985. (American and British editions: New York and London: Thames & Hudson, 1985; German edition: Munich: Schirmer & Mosel, 1985.) *Henri Cartier-Bresson: Zeichnungen.* Introduction by Dieter Schrage. Salzburg: Rupertinum and Museum moderner Kunst Wien, Vienna, 1985. Galassi, Peter. *Henri Cartier-Bresson: The Early Work.* New York: The Museum of Modern Art, 1987. *Henri Cartier-Bresson in India.* Foreword by Satyajit Ray. Introduction by Yves Véquaud. London: Thames & Hudson, 1987. *Trait pour trait: Les dessins d'Henri Cartier-Bresson.* Introduction by Jean Clair. Avant-propos by John Russell. Paris: Arthaud, 1989. (English edition: *Line by Line.* London: Thames & Hudson, 1989.)

Bruce Davidson

Born September 5, 1933, in Oak Park, Illinois. Began working after school for a professional photographer in 1946. In 1951, received a prize for his photographs in the Kodak-Scholastic National Photography Competition. From 1951 to 1954 studied photography at the Rochester Institute of Technology. Studied with Josef Albers at Yale University (1954–55). Served in the military (1955–57). In 1957 worked as a free-lance photographer for *Life* magazine. Became an associate member of Magnum in 1958 and a full member in 1959. Awarded a John Simon Guggenheim Fellowship in 1962. Had one-man exhibition at the Mu-

seum of Modern Art, New York, in 1966. The following year received the first grant given for photography from the National Endowment for the Arts and began photographing for East 100th Street project. East 100th Street photographs exhibited at the Museum of Modern Art, New York, in 1970; also received a grant from the American Film Institute and made the film *Living Off the Land* the same year. Served as American vice-president of Magnum in 1972. Retrospective exhibition at the International Center of Photography, New York, in 1979. Began photographing the New York subway in color (1980); exhibition of these images at the International Center of Photography, New York, in 1982. Served again as American vice-president of Magnum in 1983. In 1988 the Smithsonian Institution exhibited *East 100th Street,* *The Cafeteria,* and *Subway* photographs. Davidson's books and exhibition catalogues include the following:

The Bridge. Talese, Gay. New York: Harper & Row, 1964. *The Negro American.* Edited and with introductions by Talcott Parsons and Kenneth B. Clark. Foreword by Lyndon B. Johnson. Boston: Houghton Mifflin Company, 1966. *East 100th Street.* Cambridge, Mass.: Harvard University Press, 1970. *Subsistence U.S.A.* Text by Carol Hill. New York: A Subsistence Press Book, Holt, Rinehart & Winston, 1973. *Bruce Davidson, Photographs.* Preface by Henry Geldzahler. New York: An Agrinde/Summit Book, 1978. *Bruce Davidson, photographies.* Paris: Chêne, 1978. *Views from Pentagram, 212 5th Avenue, New York.* London: Pentagram Design, 1979. *Bruce Davidson.* Introduction by Jean Dieuzaide. Toulouse, France: Galerie Municipale du Château d'Eau, 1983. *Bruce Davidson.* Collection Photo Poche. Paris: Centre National de la Photographie, 1984. (Published in New York by Pantheon in 1985 in the Pantheon Photo Library.) *Subway.* Afterword by Henry Geldzahler. New York: Aperture, 1986.

Raymond Depardon

Born July 6, 1942, in Villefranche-sur-Saône, France. Made first photographs of parents' farm in 1954. Worked for six months assisting the local photographer-optician in 1956. Moved to Paris in 1958 to work as assistant to photographer Louis Foucherand. Worked as a paparazzi photographer for Dalmas agency, covered the Algerian War, and fulfilled military service (1960–62). Met Gilles Caron and in 1967 founded the agency Gamma with Caron, Hubert Henrotte, and Hugues Vassal. Made first film, *Jan Pallach,* in 1969, and has since directed sixteen films. Imprisoned one month in Chad (1970) with photographers Caron, Michael Honorin, and Robert Pledge. Following Caron's disappearance in Vietnam, turned away from photojournalism to shoot nudes for *Playboy* and *Lui.* In 1971 returned to covering world events. Became director of Gamma in 1973 after a faction left to form the agency Sygma; that same year shared the Robert Capa Gold Medal with David Burnett and Chas Gerretsen for their book *Chili.* From 1975 to 1977 traveled frequently to Chad. Left Gamma to become an associate member of Magnum in 1978 and became a full member in 1979; also that year, the film *Numéro Zéro* received the Georges Sadoul Prize. European vice-president of Magnum in 1980. Shot the documentary *Reporters* (1981) about Gamma. Nominated for an Academy Award for *Reporters* (1982); received the César Award for best documentary. During 1983 and 1984, made first fiction film, *Empty Quarter (une*

447

femme en afrique), included in the official selection at the Cannes Film Festival in 1985. Participated in national project D.A.T.A.R. to document urban and rural landscape in France (1984). Depardon's major books and exhibition catalogues include the following:

Chili: Special Reporter-Objectif. Photographs by three photographers, including Depardon. Paris: Gamma, 1973 or 1974. *Tchad.* Paris: Raymond Depardon, 1978. *Gilles Caron—Reporter, 1967–1970.* Paris: Chêne, 1978. *Notes.* Malaucène, France: Arfuyen, 1979. *Raymond Depardon. Correspondance new-yorkaise. Alain Bergala. Les absences du photographe.* Depardon, Raymond, and Alain Bergala. Avant-propos de Christian Caujolle. Ecrit sur l'image series. Paris: Libération/Editions de l'Etoile, 1981. (Originally published as a feature in *Libération.*) *Le désert américain.* Avant-propos: La route de nuit par Serge Toubiana. Ecrit sur l'image series. Paris: Editions de l'étoile, 1983. *San Clemente.* Text by Bernard Cuau. Collection Photo Copies. Paris: Centre National de la Photographie, 1984. *Les Fiancées de Saigon.* Paris: Cahiers du Cinéma, 1986. *Raymond Depardon: Correspondence.* Introduction by Nan Richardson. New York: Aperture/Burden Gallery, 1986. *Hivers.* Paris: Arfuyen/Magnum Photos, 1987. *Recherche métaphysiciens, désespérément.* Text by Bernard-Henri Levy. Paris: Magnum for Ministère de la Poste et des Télécommunications, [1987]. *Les vues de Raymond Depardon.* Preface by Bernard Frank. Paris: Le Monde, 1988. *Riminicinema—Raymond Depardon.* Edited by Katrine Le Gallou and Sabino Martiradonna. Rimini, Italy: Riminicinema, 1988.

Elliott Erwitt

Born July 26, 1928, in Paris to Russian immigrant parents. Raised in Milan and moved to Paris in 1938. Immigrated to New York in 1939 and moved to Los Angeles with family in 1941. Studied at Los Angeles City College (1942–44) and began working in a commercial darkroom in 1944. Moved to New York in 1948 and studied film at the New School for Social Research; that same year met Edward Steichen and Robert Capa. Traveled to France and Italy in 1949, worked with Roy Stryker at Standard Oil in New York in 1950 and later in Pittsburgh. First associated with Magnum in 1953 and became a full member in 1954. Elected president of Magnum in 1966; held the office for three consecutive terms until mid-1969. Made first of several films in 1970, received an American Film Institute grant in 1973, and a National Endowment for the Arts grant in 1976. Served as American vice-president of Magnum in 1974 and 1980. A major international exhibition, "Personal Exposures," opened in Paris in 1988. Erwitt's major books include the following:

Eastern Europe. New York: Time-Life Books, 1965. *Photographs and Anti-Photographs.* Text by Sam Holmes. Introduction by John Szarkowski. Greenwich, Conn.: New York Graphic Society, 1972. *Observations on American Architecture.* Chermayeff, Ivan. New York: Viking Press, 1972. *Elliot Erwitt: The Private Experience.* Masters of Contemporary Photography Series. Text by Sean Callahan. New York: T. Y. Crowell, Inc., An Alskog Book, Los Angeles, 1974. *Son of Bitch.* Introduction by P. G. Wodehouse. New York: Grossman Publishers, 1974. (French edition: *Chien de ma chienne.* Paris: Chêne, 1974.) *Recent Developments.* Introduction by Wilfrid Sheed. New York: Simon & Schuster, 1978. (French edition: *Récents dévelop-*

pements. Introduction by Robert Doisneau. Paris: Denoël-Filipacchi, 1978.) *The Angel Tree.* Howard, Linn, and Mary Jane Pool. New York: Alfred A. Knopf, 1984. *Hundstage.* Photographs by Elliott Erwitt. Text by Volker Bartsch. Hamburg: Ellert & Richter, 1988. *Personal Exposures.* New York: W. W. Norton, 1988. (French edition: Paris: Editions Nathan, 1988.) *Elliott Erwitt.* Introduction by Elliott Erwitt, adapted by Claude Helft. Collection Photo Poche. Paris: Centre National de la Photographie, 1988.

Martine Franck

Born April 2, 1938, in Antwerp, Belgium. Raised in the United States and England from 1942 to 1954. Studied at the University of Madrid (1956–57) and at l'École du Louvre (1958–62) in Paris. Began working as a photographer in Far East in 1963. Worked in the Time-Life laboratory (1964) in Paris and as assistant to Eliot Elisofon and Gjon Mili. In 1965 began to free-lance and joined the agency Vu in 1970. With Alain Dagbert, Hervé Gloaguen, François Hers, Richard Kalvar, Jean Lattès, Guy Le Querrec, and Claude Raymond-Dityvon founded the agency Viva in 1972. Became an associate member of Magnum in 1980 and a full member in 1983. Franck's books include the following:

Etienne-Martin. Text by Michel Ragon. Brussels: La Connaissance, 1970. *Cárdenas.* Text by José Pierre. Brussels: La Connaissance, 1971. *Le Théâtre du Soleil: 1789.* Paris: Théâtre Ouvert/Stock, 1971. *Le Théâtre du Soleil: 1793.* Paris: Théâtre Ouvert/Stock, 1972. *Martine Franck.* Preface by Ariane Mnouchkine. Paris: Contrejour, 1976. *Les Lubérons.* Text by Yves Berger. Paris: Chêne, 1978. *Martine Franck: Le temps de vieillir.* Collection Journal d'un voyage. Introduction by Robert Doisneau. Paris: Editions Denoël-Filipacchi, 1980. *Martine Franck.* Introduction by Jean Dieuzaide. Toulouse, France: Galerie Municipale du Chateau d'Eau, 1982. *Martine Franck.* Texts by Vera Feyder and Attilio Colombo. I Grandi Fotografi Series. Milano: Gruppo Editoriale Fabbri, 1982. *Martine Franck: Des Femmes et la création (photographies).* Introduction by Vera Feyder. Le Havre: Maison de la Culture du Havre, 1983. *La BPI en toute liberté.* Paris: Editions du Centre Pompidou/BPI, 1986. *Martine Franck.* Introduction by Giuliana Scimé. Agrigento, Italy: Centro Culturale Editoriale Pier Paolo Pasolini, 1987. *De Temps en temps.* Preface by Claude Roy. Paris: Les Petits Frères des Pauvres, 1988. *Portraits.* Text by Yves Bonnefoy. Amiens, France: Editions Trois Cailloux, 1988.

Leonard Freed

Born in Brooklyn, New York, October 23, 1929. Bought a camera and traveled to Europe and North Africa in 1950; returned to New York in 1952. Learned darkroom technique while in Holland in 1953. Studied with Alexey Brodovitch in New York in 1955; returned to Europe the same year. First associated with Magnum in 1956. Settled in Amsterdam in 1958 and photographed for the Dutch Salvation Army magazine. Began traveling and free-lance photographing in 1961. Made first motion picture using animated still photographs (1962–63). Photographed blacks in America (1964–65), covered the Six-Day War and its aftermath in Israel (1967), and returned to Israel in 1968 to work as a staff photographer for *Israel* magazine. Resettled in New York in 1969. Became a full member of Magnum in 1972. Photographed the Yom Kippur War in 1973. Taught photography at the New School for Social Re-

search in New York (1980). Freed's books and exhibition catalogues include the following:

Joden van Amsterdam. Amsterdam: Bezige Bij, 1959. *Deutsche Juden heute.* Edited by Hans Hermann Köper. Texts by Robert Neumann. Alphons Silbermann, Ludwig Marcuse, Hermann Kesten. Munich: Rütten & Loening, 1965. (Republished by Bertelsmann-Lesering in Guttersloh, Germany, 1966.) *Zwart in blank america.* Amsterdam: Bezige Bij, 1968. *Black in White America.* New York: Grossman Publishers, 1969. German editions: *Schwarz in weiss America.* Tübingen: Rainer Wunderlich Verlag, 1969 and Frankfurt-am-Main: Büchergilde Gutenberg, 1969; Dutch edition: *Zwart in blank amerika.* Amsterdam: Nederlandse Boekenclub, 1969; Italian edition: *Nero in Blanco America.* Milan: Il Diaframma, 1969.) *Off Limits.* Frankfurt-am-Main: Heinrich Heine Verlag, 1969. *Made in Germany.* New York: Grossman Publishers, 1970. (British edition: *Leonard Freed's Germany.* London: Thames & Hudson, 1971.) *Seltsame Spiele.* Frankfurt-am-Main, Germany: Verlag Bärmeier & Nikel, 1970. *The Spectre of Violence.* Texts by Magnus Linklater and Sue Davies. London: The Photographers' Gallery, 1973. Grunfeld, Frederic V. *Berlin.* The Great Cities series. Amsterdam: Time-Life Books, 1977. *Police Work.* Foreword by Studs Terkel. New York: Simon & Schuster, 1980. *La danse des fidèles.* Paris: Chêne, 1984. *Leonard Freed.* Introduction by Jean Dieuzaide. Toulouse: Galerie Municipale du Chateau d'Eau, 1987.

Paul Fusco

Born August 2, 1930, in Leominster, Massachusetts. Became interested in photography in the mid-1940s. Served as a photographer in the United States Signal Corps in Korea (1951–53). Received a B.F.A. in photojournalism at Ohio University in Athens, Ohio, in 1957. From 1957 to 1971 worked as a staff photographer for *Look* magazine. Became an associate member of Magnum in 1973 and a full member in 1974. Fusco's books and exhibition catalogues include the following:

Sense Relaxation: Below the Mind. Fusco, Paul, and Bernard Gunther. New York: Collier Books/Macmillan, 1968. *La Causa: The California Grape Strike.* Fusco, Paul, and George D. Horwitz. New York: Collier Books, 1970. *What to Do Until the Messiah Comes.* Fusco, Paul, and Bernard Gunther. New York: Collier Books/Macmillan, 1971. *The Photo Essay: Paul Fusco & Will McBride.* Text by Tom Moran. Los Angeles: Alskog, T. Y. Crowell, New York, 1974. *Marina & Ruby: Training a Filly with Love.* Fusco, Paul, Patricia Sayer Fusco, and Marina Fusco. New York: William Morrow & Co., 1977.

Jean Gaumy

Born August 28, 1948, in Royan, France. Worked as editor and photographer for a provincial newspaper in Rouen while completing university education (1969–73). In 1972 the agency Viva distributed his photographs; in 1973 joined the agency Gamma. First photographer allowed to document French prison life. Became a Magnum nominee in 1977 and an associate member in 1980. Made first film, *La Boucane*, in 1984. Became a full member of Magnum in 1986. Produced and directed second film, *Jean-Jacques*, in 1987. Has traveled extensively in Central America and Iran. Gaumy's major books include the following:

Jean Gaumy: L'Hôpital. Paris: Contrejour, 1976. *Jean Gaumy. Les incarcérés.*

Yann Lardeau. L'utopie pénitentiaire. Gaumy, Jean, and Yann Lardeau. Précédés des carnets de Jean Gaumy. Ecrit sur l'image series. Paris: Editions de l'Étoile, 1983.

Burt Glinn

Born July 23, 1925, in Pittsburgh, Pennsylvania. Served in the U.S. Army in the United States and Germany (1943–46). Studied at Harvard College (1946–49); was photographer and picture editor for *The Harvard Crimson.* Worked for *Life* magazine (1949–50) and began free-lancing in 1950. First associated with Magnum in 1951. Based in Seattle from 1952 to 1955. In 1954 became a full member of Magnum, and in 1956 began to travel and photograph throughout the world. Awarded the Mathew Brady Trophy in 1960. Elected president of Magnum in 1972 and held the office for three terms until 1975. Contributing editor of *New York* magazine from 1974 to 1977. Served as president of the American Society of Magazine Photographers (1980–81). Re-elected president of Magnum in 1987 and is the current president. Served as American vice-president of Magnum in 1963–64, 1966, 1968–71, and 1981–82. Glinn's books include the following:

A Portrait of All the Russias. Van der Post, Laurens. London: The Hogarth Press, 1967. *A Portrait of Japan.* Text by Laurens Van der Post. New York: William Morrow & Co., 1968.

Mark Godfrey

Born June 23, 1944, in Wauwatosa, Wisconsin. Began working for local newspapers in Tucson, Arizona, in 1963 after graduating from high school. Worked for daily newspapers in Houston, Texas, and Topeka, Kansas, before traveling to Vietnam in the summer of 1969. From September 1969 to September 1970 photographed in Vietnam for the Associated Press and in late 1970 joined *Life* magazine on contract. Became an associate member of Magnum in 1973 and a full member in 1974. Elected American vice-president of Magnum in 1977 and held the office through 1978. Settled in Washington, D.C., in 1976. Resigned from Magnum in 1981. Godfrey's books include the following:

Unconventional Photography: The Unofficial Program for the 1976 Democratic National Convention. New York: Magnum, 1976. Photographs included in National Geographic books (published from 1979 to 1982) on the Aztec civilization, the frontiers of science, America's back country, and valley regions of the United States.

Philip Jones Griffiths

Born February 18, 1936, in Rhuddlan, Wales. Began photographing in the 1950s, studied pharmacy in Liverpool University, and worked as a pharmacist, and worked part-time as a photographer for the *Manchester Guardian.* Became a full-time free-lance photographer in 1961. From 1966 to 1968 photographed in Vietnam; became an associate member of Magnum in 1967. Returned to photograph in Vietnam in 1970. Became a full member of Magnum in 1971. Began making documentary films in 1974. Based in Thailand in 1977. Moved to New York City in 1980; elected president of Magnum and held the office for five terms (1980–85). Returned to photograph in Southeast Asia in 1985. Griffiths' books include the following:

Vietnam Inc. New York: Collier Books, 1971. *Bangkok.* Blofeld, John. The Great Cities series. Amsterdam: Time-Life Books, 1979.

Harry Gruyaert

Born August 25, 1941, in Antwerp, Belgium. Received a camera in 1955 from his father, a photography professor at the Gevaert factory, who taught him darkroom technique. Studied at l'École du Cinéma et de la Télévision in Brussels (1960–63). After receiving diploma began free-lance fashion and advertising work in Paris while working as director of photography for several films for Flemish television. In 1965 made first of many trips to Morocco to photograph. Lived in London from 1968 to 1971; settled in Paris in 1972, returning regularly to photograph Belgium. In 1976 received the Prix Kodak de la Critique Photographique. Became a Magnum nominee in 1981 and an associate member in 1983. Became a full member of Magnum in 1986, the same year an exhibition was presented at the Palais de Tokyo, Paris. Gruyaert's books and exhibition catalogues include the following:

Harry Gruyaert. Antwerp: International Cultureel Centrum, 1979. *Harry Gruyaert: Le Maroc.* Stockholm: Franska Institutet, 1980. *Harry Gruyaert: TV Shots.* Text by Yves Bourde. Paris: FNAC Galeries, [1984]. *Maroc: Extrême Maghreb du soleil couchant.* Text by Michel Jobert. Photographs by Harry Gruyaert and Jean-Paul Jaouen. Collections Grands Livres. Paris: Editions Jeune Afrique, 1984. *Lumières blanches: Photographies de Harry Gruyaert.* Introduction by Alain Macaire. Text by Richard Nonas. Photo Copies Series. Paris: Centre National de la Photographie avec le concours du Ministère de la Culture, 1986.

Ernst Haas

Born March 2, 1921, in Vienna. Briefly studied medicine and then studied photography for a year at the Graphischen Lehr-und Versuchs-Anstalt. In 1947 the American Red Cross headquarters in Vienna exhibited his photos of the homecoming of POWs, which were published in *Heute* magazine in 1949; *Life* subsequently ran the story. Was invited by Robert Capa to join Magnum. Became a full member of Magnum in 1950. "Images of a Magic City" (New York)—first major color essay—was published in two issues of *Life* magazine in 1953. Elected vice-president of Magnum in 1958. Elected president of Magnum in 1960. First one-person exhibition, "Ernst Haas Color Photography," opened at the Museum of Modern Art, New York, in 1962. Did four-part series "The Art of Seeing" for National Educational Television in 1964, followed in 1965 by a Kodak-sponsored traveling exhibition of dye-transfer prints of this project. Became a contributing member of Magnum in 1966. Began teaching photographic workshops in the early 1970s; spent majority of time photographing in Japan for a book project (1980–85). Awarded the Kulturpreis from the Deutsche Gesellschaft für die Photographie (1972); and the Hasselblad award and the Leitz Master of Photography Award (1986). Died of a stroke, September 12, 1986, in New York City. The Haas archive is with Magnum Photos and the Haas Studio in New York. Haas's books include the following:

The Creation. New York: Viking Press, 1971. (French edition: *La création.* Paris: Denoël, 1972; British edition: *The Creation.*) *In America.* New York: A Studio Book/Viking Press, 1975. *Ende und Anfang.* Haas, Ernst, and Hellmut Andics. Düsseldorf and Vienna: Paul Zsolnay/Econ, 1975. *In Germany.* New York: Viking Press, 1976. (Includes an interview with Haas conducted by Thilo Koch. French edition: *En Allemagne.* Paris: Chêne.) *Himalayan Pilgrimage.* Text by Gisela Minke. London: Thames & Hudson, 1978. *Ernst Haas.* Text by Bryn Campbell. I Grandi Fotografi series. Milan: Gruppo Editoriale Fabbri, 1982.

Charles Harbutt

Born July 29, 1935, in Camden, New Jersey. Studied at Marquette University (1952–56), Milwaukee, receiving a degree in journalism. Worked as associate editor and photographer for *Jubilee* magazine (1956–59). Became a free-lance photographer in 1959. Became an associate member of Magnum in 1963 and a full member in 1964. From 1968 to 1970 was consultant to the New York City Planning Commission; during 1968 and 1969 directed the *America in Crisis* book and exhibition project. Received the Gold Medal from the Atlanta International Film Festival for *America* in 1970. Elected president of Magnum in 1970 and held the office until 1972. Vice-president of the American Society of Magazine Photographers (1970–71). Received Best Photographic Book of the Year Award in 1974 from Rencontres Internationales de la Photographie in Arles, France, for *Travelog.* Was visiting artist at the Art Institute of Chicago, Rhode Island School of Design, and Massachusetts Institute of Technology. Elected president of Magnum again in 1976 and held the office for two terms. Left Magnum in 1981 and cofounded the photographers' cooperative agency, Archive Pictures, the same year. Harbutt's books and exhibition catalogues include the following:

America in Crisis. Pictures edited by Charles Harbutt and Lee Jones. Text by Mitchel Levitas. New York: Ridge Press/Holt, Rinehart and Winston, 1969. *The Plan for the City of New York.* Edited by the New York City Planning Commission. Photographs edited by Charles Harbutt. Cambridge, Mass.: M.I.T. Press, 1970, 1971. 6 vols. *Travelog.* Cambridge, Mass.: M.I.T. Press, 1973. *Kertesz and Harbutt: Sympathetic Explorations.* Essay by Andy Grundberg. Moorhead, Minn.: Plains Art Museum, 1978. *Charles Harbutt.* Interview by Joe Cuomo. Text by Attilio Colombo. I Grandi Fotografi series. Milan: Gruppo Editoriale Fabbri, 1982. *Progreso.* Paris: Navarin Editeur/Paris Audiovisuel/Fondation Kodak-Pathé, 1986. (American edition: New York: Archive Pictures, 1987.) *Charles Harbutt.* Introduction by Jean Claude Lemagny. Paris: Galerie de Photographie de la Bibliothèque Nationale, 1986.

Erich Hartmann

Born July 29, 1922, in Munich, Germany. Made first photographs in 1930. Immigrated with family to the United States in 1938; worked in the office of a textile mill, attended evening high school, and took night classes at Siena College. Volunteered for the U.S. Army in 1943 and served in Europe. Moved to New York in 1946 and learned photography as assistant to a portrait photographer. From 1948 to 1950 studied photography at the New School for Social Research with Charles Leirens, Berenice Abbott, and Alexey Brodovitch. First associated with Magnum in 1951 and became a full member in 1954. The exhibition "Sunday Under the Bridge" opened at the Museum of the City of New York in 1956. The exhibition and book project "Our Daily Bread," sponsored by the Pillsbury Company, opened in New York in 1962 and later traveled throughout the United States. From 1969 through 1973 lectured and taught workshops for Syracuse University and the International Fund for Concerned Photography. Served as the American vice-president of Magnum in 1975 and 1979; elected president of Magnum for one term in 1985. Hartmann's books and exhibition catalogues include the following:

Our Daily Bread. Minneapolis: Pillsbury Company, 1962. *Space: Focus Earth.* Text by Georges Bardawil. Paris: European Space Research Organization, 1972. (French edition: *Au clair de la terre.* Paris: Organization Européene de Recherches Spatiales, 1972; Belgian edition: *Au clair de la terre.* Brussels: Editions Arcade, 1972.) *Europe in Space: Satellites.* Neuilly-sur-Seine, France: European Space Research Organization, 1973.

David Hurn

Born July 21, 1934, in Redhill, Surrey, England. Attended the Royal Military Academy (1952–54) in Sandhurst, England. Began photographing in 1955. From 1955 to 1957 served as assistant photographer to Michael Peto and George Vargas at Reflex Agency, London, and then worked as a free-lance photographer based in London. Became an associate member of Magnum in 1965 and a full member in 1967. Moved to Wales in 1971. Was editorial advisor for the photography magazine *Album.* Member of the photographic committee and the arts panel of the Arts Council of Great Britain (1972–77). Became the head of the School of Documentary Photography and Film at Gwent College of Higher Education, Newport, Gwent, Wales, in 1973. Received the Kodak Photographic Bursary in 1975 and from 1978 to 1987 served as a member of the Photographic Committee of the Council for National Academic Awards for the United Kingdom. Spent 1979–80 as Distinguished Visiting Artist and Adjunct Professor at Arizona State University in Tempe. Received the Imperial War Museum Artistic Records Award in 1987. Hurn's books and exhibition catalogues include the following:

Wales/Black & White: Photographs by David Hurn. [Cardiff]: Welsh Arts Council, 1974. *David Hurn.* Introduction by Jean Dieuzaide. Toulouse, France: Galerie Municipale du Chateau d'Eau, 1977. *David Hurn: Photographs 1956–1976.* Introduction by Tom Hopkinson. London: Arts Council of Great Britain, 1979. *David Hurn: Arizona Trip.* Interview by Bill Jay. [London]: Olympus Cameras Centre, 1982. *Up to Date: David Hurn.* Introduction by Susan Beardmore. Interview and Essay by Ian Walker. Cardiff: The Ffotogallery 1984.

Richard Kalvar

Born November 14, 1944, in New York and raised in Brooklyn. Attended Cornell University (1961–65). Worked in New York City as an assistant to fashion photographer Jerome Ducrot, then traveled throughout Europe until 1967. Returned to Cornell to complete Bachelor of Arts degree in English (1968). Began working as a free-lance photographer in New York. In 1970 Antoine Bourseiller, director of the National Theater of Marseille, invited him to be in a play. In 1971, moved to Paris and joined the photo agency Vu. The following year was a cofounder of the agency Viva. Became an associate of Magnum in 1975 and two years later was elected a full member. From 1984 to mid-1988 served as European vice-president of Magnum. Kalvar's books and exhibition catalogues include the following:

Familles en France. Paris: Viva, 1973. *British Journal of Photography Annual 1976. Unconventional Photography: The Unofficial Program for the 1976 Democratic National Convention.* [New York: Magnum, 1976.] "Richard Kalvar," in *Album Photographique 1.* Edited by Pierre de Fenoyl. Paris: Centre Georges Pompidou, 1979. *L'Usine.* Preface by François Nourissier. Texts by Djan Seylan and Christian Caujolle. Paris: Colgate-Palmolive, 1987.

Josef Koudelka

Born January 10, 1938, in Boskovice, Moravia (Czechoslovakia). Began photographing family and friends around 1952. Studied engineering at the Technical University in Prague (1956–61). Made first trip abroad to Italy in 1961, and began photographing gypsies in Czechoslovakia. At the same time contributed photographs to *Divadlo (Theater* magazine). Worked as an aeronautical engineer (1961–67) and left in 1967 to photograph full time. In 1968 photographed the invasion of Prague; in 1969 anonymously awarded the Overseas Press Club's Robert Capa Gold Medal for these photographs. In 1970 was granted asylum in England. In 1971 became an associate member of Magnum and a full member in 1974. *Josef Koudelka,* a one-person exhibition, opened at the Museum of Modern Art, New York, in 1975. Koudelka has been the recipient of major grants and awards and has had two major exhibitions, a retrospective exhibition in 1984 at the Hayward Gallery, London, and a major retrospective in 1988 which opened in Paris at the Centre National de la Photographie and in New York at the International Center of Photography. Awards include: the Prix Nadar, Paris, for his book *Gitans: La Fin du Voyage* (1978); the Bourse de sejour et de recherche a l'etranger, an invitation from the Mission Photographique de la D.A.T.A.R. to participate in a national project to document urban and rural landscape in France (1986); and the Grand Prix National de la Photographie from the Ministère de la Culture et de la Communication (1989). Became a naturalized citizen of France in 1987. Koudelka's books include the following:

Diskutujeme o morálce dneška. Prague: Svoboda, 1965. Jarry, Alfred. *Král Ubu: Rozbor inscenace Divadla Na zábradlí v Praze.* Prague: Divadelní Ústav, 1966. *Josef Koudelka: Cikáni: Výběr z fotografii—1961–1966.* Text by Anna Fárová. Prague: Divadlo za branou, 1967. *Josef Koudelka.* Text by Anna Fárová. Prague: Divadlo za branou, 1968. *Gypsies.* Texts by John Szarkowski and Anna Fárová. Afterword by Willy Guy. Millerton, New York: Aperture, 1975. *Gitans: La fin du voyage.* Introduction by Robert Delpire. Afterword by Willy Guy. Paris: Delpire, 1975. *Josef Koudelka.* Text by Romeo Martinez. I Grandi Fotografi Series. Milan: Gruppo Editoriale Fabbri, 1982. *Josef Koudelka.* Introduction by Bernard Cuau. Collection Photo Poche. Paris: Centre National de la Photographie, 1984. *Exils.* Photographs by Josef Koudelka. Texts by Robert Delpire, Alain Finkielkraut, and Danièle Sallenave. Collection Photo Copies. Paris: Centre National de la Photographie, 1988. (American edition: *Exiles.* Essay by Czeslaw Milosz. New York: Aperture, 1988.)

Sergio Larrain

Born November 5, 1931, in Santiago, Chile. Began taking photographs in 1949. Studied forestry at the University of California, Berkeley (1949–53). Studied at the University of Michigan, Ann Arbor, and traveled throughout Europe and the Middle East. Returned to Chile in 1954 and began to work as a free-lance photographer. In 1956 became a staff

photographer of the Brazilian magazine *O Cruzeiro*. Lived in London in 1958 and moved to Paris in 1959 and became associated with Magnum. Became a full member of Magnum, based in Chile, in 1961. Trained in yoga (1968–70) under Oscar Ichazo. Resigned from Magnum in 1970 and changed status to contributing photographer. Larrain's books include the following:

El Rectangulo en la mano. [Santiago, Chile: Cadernos Brasileiros, c. 1963.] *La Casa en la Arena.* Neruda, Pablo, and Sergio Larrain. Barcelona: Lumen, 1966. *Chili.* L'Atlas des Voyages series. Lausanne: Editions Rencontre, c. 1968.

Guy Le Querrec

Born May 12, 1941, in Paris. Began taking pictures at age twelve. From 1960 to 1968 worked for insurance companies. In 1962 made first photographs of jazz musicians. Served in the military from 1962 to 1964. Became a photographer in 1968. Became staff photographer and picture editor for *Jeune Afrique* in 1969. Joined the agency Vu in 1971 and a cofounder of the agency Viva. In 1976 became an associate member of Magnum and taught his first photographic workshop in Arles, France. Elected a full member of Magnum in 1977. Directed the first Atelier de la Ville de Paris at the Lycée Henri IV in 1980 and in 1983, coordinated the "Jazz and Photo" exhibition and presentation at the Rencontres Internationales de la Photographie in Arles. Le Querrec's books include the following:

Quelque part. Texts by Arnaud Claass and Roméo Martinez. Paris: Contrejour, 1977. *G. Le Querrec.* Introduction by Jean Dieuzaide. Toulouse: Galerie Municipale du Chateau d'Eau, 1978. *Portugal 1974/1975: Regards sur une tentative de pouvoir populaire.* Présentées par Jean-Paul Miroglio and Guy Le Querrec. Texts by Jean-Pierre Faye. Paris: Hier & Demain, 1979. *Java présente jazz sous les platanes 1984.* Vitrolles, France: L'Association Java, 1984. *Tête à tête: Daniel Druet, un sculpteur et ses modèles, 1981.* Paris: Carrere, 1988.

Erich Lessing

Born in Vienna July 23, 1923. Immigrated to British-mandated Palestine (now Israel) in 1939. Studied at the Technical College of Haifa (1939–45) while raising fish on a kibbutz and working as a driver and photographer. Served as an aviator and photographer in the Sixth Airborne Division of the British Army. Upon returning to Vienna in 1947 began to work as a reporter and photographer for the Associated Press. Became associated with Magnum in 1950; elected a full member in 1955. Photographed political events in Europe and North Africa, including the Hungarian Revolution of 1956. By 1960 turned to pictorial evocations of historical events and personalities and art books. Awarded the Prix Nadar for the book *L'Odyssée* in 1966; was named professor by the Austrian government in 1974; and in 1976 began teaching at the Academy of Decorative Arts in Vienna. Became a contributing photographer in 1979. The following year named honorary member of the Society of Artists (Künstlerhaus) in Vienna and in 1984, honorary member of the Österreichisches Museum der Photographie in Vienna. Elected member of International Committee of Museums—UNESCO in 1985. Technical expert for United Nations Development Agency in India to create a department of photography at the Institute of Design in Ahmedabad (1986–87). Taught art documentation and photography at the Salzburg Summer Academy (1988–89). Lessing's books include the following:

Szene: ein Bildwerk über die Staatsoper und das Burgtheater. Vienna: Staatsdruckerei, 1954. *Imago Austriae.* Edited by Otto Schulmeister. Photographs by Erich Lessing and others. Vienna: Herder, 1963. *Kleinodien aus der Wiener Schatzkammer.* Walter, Anton Julius and Erich Lessing. Bern: Halwag, 1964. *Die Odyssee.* Freiburg: Herder, 1965. *Discoverers of Space: A Pictorial Narration.* Preface by Archibald MacLeish. Introduction by Sir Bernard Lovell. Freiburg: Herder, 1967, 1969. *The Story of Noah Told in Photographs.* New York: Time-Life Books, [1968]. *Roma.* Text by Norbert van Kaan. Freiburg: Herder, 1968. *Roma Remembered.* Text by Werner Bergengruen. Introduction by Clare Booth Luce. Freiburg: Herder, 1968, 1969. *Vérité et poésie de la Bible.* Text by several authors. Fribourg: Hatier, 1969. *Die Abenteuer des Odysseus.* Verse by Bertus Aafjes. Freiburg: Herder, 1969. Bergengruen, Werner. *Deutsche Reise.* Freiburg: Herder, 1969. *Ravenna-Steine Reden.* Text by Wolfgang Stadler. Freiburg: Herder, 1970. *Jesus: History and Culture of the New Testament: A Pictorial Narration.* New York: Herder and Herder, 1971. (Originally in German as: *Der Mann aus Galiläa.* Freiburg: Herder, 1971.) *The Spanish Riding School of Vienna.* Handler, Hans. New York: McGraw-Hill, 1972. (Originally in German as *Die Spanische Hofreitschule zu Wien.* Vienna: Verlag Fritz Molden, 1972.) *Traumstrassen durch Deutschland.* Lessing, Erich, and Janko Musulin. Vienna: Verlag Fritz Molden, 1973. *Great People of the Bible and How They Lived.* Pleasantville, New York: Reader's Digest, 1974. *Die K.(u.)K.-Armee, 1848–1914.* Allmayer-Beck, Johann Christoph and Erich Lessing. Munich: C. Bertelsmann, 1974. *L'Opera de Paris.* Text by Olivier Merlin. Fribourg: Hatier, 1975. *Brauer Bunte Mauer.* Munich: Verlag F. Bruckmann KG, 1975. *Traumstrasse Donau.* Lessing, Erich, and Ernst Trost. Vienna: Verlag Fritz Molden, 1975. *Deutsche Ritter, Deutsche Burgen.* Meyer, Werner, and Erich Lessing. Munich: C. Bertelsmann, 1976. *Le message de l'espérance.* Text by Claus Westermann. Fribourg: Hatier, 1976. *Die Griechischen Sagen.* Texts by Ernest Borneman, Wolfgang Oberleitner, and Egidius Schmalzriedt. Munich: C. Bertelsmann, 1977. *Die kaiserlichen Kriegsvölker: von Maximilian I. bis Prinz Eugen, 1479–1718.* Allmayer-Beck, Johann Christoph, and Erich Lessing. Munich: C. Bertelsmann, 1978. *Traumstrassen durch Frankreich.* Gascar, Pierre, and Erich Lessing. Vienna: Verlag Fritz Molden, 1978. *Les Celtes.* Texts by Venceslas Kruta and Miklós Szabó. Fribourg: Hatier, 1978. *Ephesos: Weltstadt der Antike.* Lessing, Erich, and Wolfgang Oberleitner. Vienna: Verlag Carl Ueberreuter, 1978. *Ludwig van Beethoven.* Essay by Kurt Dieman. Freiburg: Herder, 1979. *Judaica: Die Sammlung Berger: Kult und Kultur des europäischen Judentums.* Text by Wolfgang Häusler. Vienna: Jugend und Volk, 1979. *Deutsche Schlosser, Deutsche Fürsten.* Hüttl, Ludwig, and Erich Lessing. Munich: C. Bertelsmann, 1980. *Paulus.* Texts by Pierre Geoltrain, David Flusser, and Edward Schillebeeckx. Freiburg: Herder, 1980. *Hallstatt: Bilder aus der Frühzeit Europas.* Vienna: Jugend und Volk, 1980. *Wolfgang Amadeus Mozart.* Essay by Géza Rech. Freiburg: Herder, 1980. *Joseph Haydn.* Essay by Rudolf Klein. Freiburg: Herder, 1981. *Das Heer unter dem Doppeladler: Habsburgs Armeen, 1718–1848.* Allmayer-Beck, Johann Christoph, and Erich Lessing. Munich: C. Bertelsmann, 1981. *Die Italienische Renaissance: In Bildern erzählt.* Texts by Karl Otmar von Aretin and Friedrich Piel. Munich: C. Bertelsmann, 1983. *Die Niederlande: Die Geschichte in den Bildern ihrer Maler erzählt.* Texts by

Karl Schütz and Georg Kugler. Munich: C. Bertelsmann, 1985. *La Grece.* Texts by A. Lemaitre. Paris: Payot, 1987. *Der Wiener Musikverein.* Edited by Franz Endler. Vienna: J & V Edition Wien, 1987. *Die Bibel: Das Alte Testament in Bildern erzählt.* Texts by several authors. Munich: C. Bertelsmann, 1987. *European Porcelain.* Frankfurt: Falken, 1989. *History of France.* Munich: Bertelsmann, 1989. *Egypt.* Paris: Nathan, 1989.

Constantine Manos

Born of Greek immigrant parents October 12, 1934, in Columbia, South Carolina. By age fourteen was photographing for local newspapers. Graduated from the University of South Carolina in 1955 with a degree in English literature. In 1953 became official photographer for the summer music festival at Tanglewood. Worked as staff photographer for the *Stars and Stripes* in Europe while in the military (1956–58). Settled in New York to work as a free-lance photographer. Lived in Greece (1961–64), photographing life in isolated villages. Settled in Boston upon return to the United States. Became an associate member of Magnum in 1963 and a full member in 1965. The book *A Greek Portfolio* (1972) won awards at Arles and at the Leipzig Book Fair. Has had one-person shows at the Art Institute of Chicago, the Bibliothèque Nationale in Paris, and at galleries in New York, London, Milan, Boston, and Toulouse. His bicentennial project, *The Bostonians*, resulted in a multimedia presentation and a book. In 1984 Manos began a major color project on American culture. The first public exhibition of these photographs was held in Athens in April 1987, as part of the International Month of Photography. Manos's books and exhibition catalogues include the following:

Portrait of a Symphony. Foreword by Aaron Copland. New York: Basic Books, [1961]. *A Greek Portfolio.* New York: A Studio Book/Viking Press, 1972. (British edition: London: Secker & Warburg, 1972; Swiss edition: *Griechische Impressionen.* Lucerne: Bucher Verlag, 1972; French edition: *Suite Crecque.* Paris: Chêne, 1972.) *Bostonians.* Cambridge, Mass.: Cambridge Seven Associates, 1975. *Constantine Manos.* Introduction by Jean Dieuzaide. Toulouse, France; Galerie Municipale du Chateau d'Eau, 1986.

Mary Ellen Mark

Born March 20, 1940, in Philadelphia. Studied art and art history at the University of Pennsylvania (1958–62). Began photographing in 1963. Earned a M.A. in photojournalism at the Annenberg School of Communications, University of Pennsylvania, in 1964. Photographed in Turkey on a Fulbright Scholarship (1965–66). Photographed India in 1968. Taught first photographic workshop in 1974. Received a United States Information Agency grant to lecture and exhibit in Yugoslavia in 1975. Became an associate member of Magnum in 1976 and a full member in 1977. Awards include: Leica Medal for Excellence for the book *Falkland Road* (1982); Philippe Halsman Award for Photojournalism from the American Society of Magazine Photographers (1986); named Photographer of the Year by the Friends of Photography, Carmel, California (1987); and the World Press Award for Outstanding Body of Work Throughout the Years (1988). Resigned from Magnum in 1981 and became one of the cofounders of the photographers' cooperative agency Archive Pictures. Mark's books include the following:

Passport. New York: Lustrum Press, 1974. *The Photojournalist: Mary Ellen Mark & Annie Leibovitz.* Text by Adrianne Marcus. Los Angeles: Alskog/ T. Y. Crowell, 1974. *Ward 81.* Text by Karen Folger Jacobs. Introduction by Milos Forman. New York: A Fireside Book/Simon & Schuster, 1979. *Falkland Road: Prostitutes of Bombay.* New York: Alfred A. Knopf, 1981. *Mary Ellen Mark: Photographs of Mother Teresa's Missions of Charity in Calcutta, India.* Carmel, Calif.: The Friends of Photography, 1985. *Streetwise.* Philadelphia: University of Pennsylvania Press, 1988.

Peter Marlow

Born January 19, 1952, in Kenilworth, Warwickshire, England. Earned a Bachelor of Science with honors in psychology at Manchester University, England. Traveled throughout Latin America (1975–76). In 1977 began to photograph for Sygma, working on international news and feature stories. Left Sygma in 1980 when he became a Magnum nominee. Awarded an Arts Council of Great Britain grant in 1983, the same year the photo project "London by Night" was completed. Became an associate member of Magnum in 1982 and a full member in 1986. Awarded a grant in 1988 from the Photographers' Gallery, London, to continue with a book project on Liverpool, England. Marlow's publications include the following:

"Lewisham—What Are You Taking Pictures For?" *Camerwork* no. 8 (September 1977): 11–12. "Les decharges de l'espair." *Emois* no. 6 (November 1987): 62–67.

Susan Meiselas

Born June 21, 1948, in Baltimore, Maryland. Graduated from Sarah Lawrence College in 1970. Worked as assistant editor for Frederick Wiseman's film *Basic Training* in 1971 and earned a Master of Education degree at Harvard University. Worked as a photography advisor for the Community Resources Institute of the New York City Public Schools; Artist-in-Residence for schools in South Carolina and Mississippi; consultant to the Polaroid Foundation in Cambridge, Mass.; and as a free-lance photographer. Became a Magnum nominee in 1976 and an associate in 1977. Photographed in Nicaragua from 1978 to 1979, returns regularly to Central America. In 1980 became a full member of Magnum. After sharing the American vice-presidency of Magnum with Eugene Richards and Alex Webb in 1986, elected sole American vice-president of Magnum in 1987. Awards and distinctions include: the Robert Capa Gold Medal from the Overseas Press Club, New York (1979); the Leica Award for Excellence and Photojournalist of the Year by the American Society of Magazine Photographers (1982); the Engelhard Award from the Institute of Contemporary Art, Boston (1985). Meiselas' books include the following:

Learn to See. Edited by Susan Meiselas. Cambridge, Mass.: Polaroid Corp., 1975. *Carnival Strippers.* New York: Farrar, Straus Giroux, 1975. (Canadian edition: Toronto: McGraw-Hill Ryerson, 1976; French edition: *Strip-tease forain.* Paris: Chêne, 1977.) *Nicaragua: June 1978–July 1979.* Edited with Claire Rosenberg. New York: Pantheon Books, 1981. (French edition: Paris: Editions Herscher, 1981.) *El Salvador: Work of Thirty Photographers.* Text by Carolyn Forché. Chronology by Cynthia Arnson. Edited by Harry Mattison, Susan Meiselas, and Fae Rubenstein. New York: Writers and Readers, 1983.

Wayne Miller

Born September 19, 1918, in Chicago, Illinois. Studied banking at the University of Illinois, Urbana (1938–40), while working part-time as a photographer for the university yearbook and local newspaper. Served in U.S. Navy from 1942 to 1946, attaining rank of lieutenant. Assigned to Edward Steichen's Naval Aviation Unit. In 1946 began working as freelance photographer in Chicago. Photographed blacks in the northern states on two consecutive Guggenheim fellowships (1946–48). Also taught photography at the Institute of Design, Chicago. In 1949 moved to Orinda, California, and worked for *Life* magazine until 1953. Was Edward Steichen's assistant on the "The Family of Man" exhibition at the Museum of Modern Art, New York (1953–55), and was elected chairman of the American Society of Magazine Photographers. Returned to Orinda and was first associated with Magnum. Became a member of Magnum in 1958 and served as president from 1962 to 1966. Worked as special assistant to the director of the National Park Service in environmental affairs (1967–70), and received the Department of Interior's Meritorious Service Award. Became executive director of the Public Broadcasting Environmental Center for the Corporation for Public Broadcasting in 1970. In 1975 retired from professional photography and was named California Tree Farmer of the Year. From 1975 through 1979 served as president of Forest Landowners of California. Became a contributing photographer in 1980. The following year began operating a vineyard in California. In 1985 was elected a member of Society of American Foresters. Most recently (1987) was elected president of the Redwood Region Conservation Council. Miller's books include the following:

A Baby's First Year. Spock, Benjamin, M.D., and John Reinhart, M.D. New York: Pocket Books, 1956. (First published by Duell, Sloan and Pierce, 1955.) *The World is Young.* New York: The Ridge Press, 1958.

Inge Morath

Born May 27, 1923, in Graz, Austria. Educated in France and Germany. Earned a B.A. in romance languages at Berlin University in 1944. Worked as an editor, translator, and interpreter for the United States Information Service in Austria (1946–49). Also wrote for the Red-White-Red Radio Network, collaborated with the literary magazine *Der Optimist*, and worked as the Austrian editor for *Heute* magazine. Began collaboration with Ernst Haas. From 1949 to 1950, first associated with Magnum as a writer and researcher. Moved to London and began to photograph in 1951. Apprenticed as a photojournalist with Simon Guttman (1952). First associated with Magnum as a photographer in 1953. From 1953 to 1954, assistant to, and researcher for, Henri Cartier-Bresson. Made first trip to Spain to photograph in 1954. Became a full member of Magnum in 1955. During the late 1950s, traveled to Iran and Tunisia. Made first of several trips to the Soviet Union in 1965. Became a naturalized U.S. citizen in 1966. Lectured at Cooper Union in New York City (1971–72). As of 1972, became competent in Mandarin. Made first of many trips to photograph in the People's Republic of China in 1978. In 1984, Morath was awarded a Doctor of Fine Arts *Honoris Causa* by the University of Connecticut, Hartford. The following museums have held exhibitions of her work: Art Institute of Chicago (1964); Grand Rapids Art Museum, Grand Rapids,

Michigan (1979); Museum of Modern Art, Vienna (1980); Kunsthaus Zurich, Siftung für Photographie (1980); Burden Gallery, Aperture Foundation, New York City (1987). Retrospective exhibitions were held in 1988 at the Exhibition Hall of the Union of Photojournalists, Moscow, and the Sala de Exposiciones del Canal de Isabel II, Madrid. Morath's books and exhibition catalogues include the following:

Guerre à la tristesse. Text by Dominique Aubier. Photography by Inge Morath and others. Collection Neuf. Paris: Robert Delpire, 1955. (British edition: *Fiesta in Pamplona.* London: Photography Magazine, 1956. American edition: *Fiesta in Pamplona.* New York: Universe Books, 1956.) *Venice Observed.* McCarthy, Mary. Photographs by Inge Morath and others. New York: Reynal & Co., 1956. (Swiss edition: *Venice: connue et inconnue.* Lausanne: Editions de L'Oeil, 1956.) *Bring Forth the Children: A Journey to the Forgotten People of Europe and the Middle East.* Brynner, Yul. Photographs by Inge Morath and Yul Brynner. New York: McGraw-Hill, 1960. *De la Perse à l'Iran.* Texts by Edouard Sablier. Paris: Robert Delpire, 1958. (American edition: *From Persia to Iran.* New York: Viking Press, 1960; Swiss edition: *Persien.* Zurich: Manesse Verlag/Conzett & Huber, 1960. Also reissued in paperback: Paris: Nouvel Observateur/Delpire, 1980.) *Tunisie.* Texts by Claude Roy and Paul Sebag. Photographs by Inge Morath, André Martin, and Marc Riboud. Paris: Delpire, 1961. (American edition: *Tunisia.* New York: Orion Press, 1961.) *Le masque.* Drawings by Saul Steinberg. Paris: Maeght Editeur, 1967. *In Russia.* Morath, Inge, and Arthur Miller. New York: A Studio Book, Viking Press, 1969; (Norwegian edition: *I Russland.* Oslo: Grøndahl & Son, 1970; British edition: *In Russia.* Swiss Edition: *En Russie.* Lucerne: Bucher Verlag, 1974.) *East West Exercises.* Text by Ruth Bluestone. New York: Simon, Walker & Co., 1973. *Inge Morath: An Exhibition of Her Photographs.* Ann Arbor: The University of Michigan Theatre Programs, 1974. *Grosse Photographen unserer Zeit: Inge Morath.* Carlisle, Olga. Bibliothek der Photographie series. Lucerne: C. J. Bucher, 1975. (Also published in a French version.) *Meine Schwester, das Leben.* Pasternak, Boris. Edited and with texts by Olga Andreyev Carlisle. Lucerne: Reich Verlag, 1975. (American edition: *My Sister, Life and Other Poems.* New York: Harcourt Brace Javanovich, 1976. *In the Country.* Morath, Inge, and Arthur Miller. New York: Viking Press, 1977. (Swiss edition: *Country Life.* Lucerne: Reich Verlag; British edition: *Country Life.*) *Inge Morath: Photographs of China.* Introduction by Robert M. Murdock. Grand Rapids, Mich: Grand Rapids Art Museum, 1979. *Chinese Encounters.* Morath, Inge, and Arthur Miller. New York: Farrar, Straus & Giroux, 1979. (British edition: Middlesex, England: Penguin Books; Swiss edition: Lucerne: Reich Verlag.) *Bilder aus Wien: Der liebe Augustin.* Contributions by Inge Morath, André Heller, Barbara Frischmuth, Pavel Kohout, and Arthur Miller. Lucerne: Reich Verlag, 1981. *Salesman in Beijing.* Morath, Inge, and Arthur Miller. New York: Viking Press, 1984. (British edition: London: Methuen, 1984. Also published in paperback by Penguin, London.) *Portraits.* Photographs and Afterword by Inge Morath. Introduction by Arthur Miller. New York: Aperture, 1986. *Inge Morath: Saul Steinbergs Masken und andere Fotobilder.* Introduction by Otto Breicha. Salzburg, Austria: Rupertinum Museum, 1988. *Inge Morath: Retratos de hombres y paisajes.* Madrid: Sala de Exposiciones de Canal de Isabel II/Consejeria de Cultura, 1988.

Michael Nichols

Born September 4, 1952, in Alabama. Studied fine arts in Montevallo, Ala., before taking up photography (c. 1971). Subsequently drafted into the army, working as a staff photographer during his tour of duty (1971–75). Upon discharge attended the University of North Alabama (1975–78). Apprenticed with Charles Moore, a photographer with the Black Star agency (1978–80). Began experimenting with flash techniques, producing photographs which led to first professional assignment (1979), for *Geo* Magazine. Photographed for *Geo* for six years, covering every continent except the Antarctic. Nichols became a Magnum nominee in 1983, an associate member in 1985, and a full member in 1988. Nichols has published the following:

Gorilla: Struggle for Survival in the Virungas. Essay by George B. Schaller. Edited by Nan Richardson. New York: Aperture, 1989.

Gilles Peress

Born December 29, 1946, at Neuilly-sur-Seine, France. Studied at the Institut d'Etudes Politiques in Paris (1966–68), and at the Université de Vincennes (1968–71). First associated with Magnum in 1970 and made first of many trips to photograph in Northern Ireland that year. Became an associate member of Magnum in 1972 and a full member in 1974. Moved to New York the following year. Served as Artist-in-Residence at Apeiron Photographic Workshop in New York State (1977–78). Photographed in Iran (1979 and 1980); in 1981 received the Kodak-sponsored Prix de la critique photographique for color work on Guatemala, and for *Telex Persan,* awarded the Prix du premier livre by the City of Paris and the Foundation Kodak-Pathé. Also received the Robert Capa Gold Medal Overseas Press Club Award. Received the W. Eugene Smith Award for Humanistic Photography in 1984 and elected American vice-president of Magnum. Taught at Harvard University (1986) and from 1986 to 1987 served as Magnum president. Peress's books include the following:

Telex: Iran. Text by Gholam-Hossein Sa'edi. Millerton, New York: Aperture, 1984. (French edition: *Telex Persan.* Texts by Claude Nori and Gholam-Hossein Sa'edi. Paris: Contrejour, 1984.) *A Double Diary of the Twin Cities.* Peress, Gilles, and Nan Richardson. Minneapolis: First Banks, 1986.

Eli Reed

Born August 4, 1946, in Linden, New Jersey. In 1969 graduated from the Newark School of Fine and Industrial Arts where he studied pictorial illustration. Began photographing in 1970. Worked at the *Middletown Times Herald Record* in New York State in 1977. Joined the *Detroit News* in 1978. Moved to the *San Francisco Examiner* (1980). Runner-up for the Pulitzer Prize (1981). Awarded an Overseas Press Club Award for "Best Photoreporting for Newspapers and Wire Services" (1982), and received a Neiman Fellowship at Harvard University (1982). Other awards include the Nikon World Understanding Award in 1983 for work in Central America. Received a 1988 World Press Award. During 1983–84 spent four months in Beirut, Lebanon, and returned in May 1987. Became a Magnum nominee in 1983, an associate member in 1985, and a full member in 1988. Reed's books include the following:

Beirut: City of Regrets. Text by Fouad Ajami. New York: W. W. Norton, 1988.

Marc Riboud

Born June 24, 1923, in Lyons, France. Made first photographs in 1937. Participated in the French Resistance from 1943 to 1945, then studied engineering at the École Centrale in Lyons (1945–48). Until 1951 worked as an engineer in factories in Lyon, then became a free-lance photographer. In 1952 moved to Paris and began association with Magnum. Lived in London during 1954. In 1955 became a full member of Magnum and made first of many trips to the Far East. Made first photographs of China in 1957. Served as European vice-president of Magnum from 1959 through 1973 (except for 1965). Served as president from 1975 to 1976. Resigned in 1980; later his status was changed to contributing photographer. Major awards include: Overseas Press Club Award for *The Three Banners of China* (1966); Overseas Press Club Award for *The Face of North Vietnam* (1970). Had a retrospective exhibition at the Musée d'Art Moderne de la Ville de Paris (1985), and the 1988 exhibition, "Marc Riboud: Lasting Moments, 1953–1988," which opened at the International Center of Photography, New York City. Riboud's books and exhibition catalogues include the following:

Vrouwen van Japan. Arnothy, Christine. Utrecht: Bruna & Zoon, 1959. (Also published in English: *Women of Japan.* London: A Bruna Book/André Deutsch, 1959.) *Le bon usage du monde.* Roy, Claude. L'Atlas des voyages series. Lausanne: Editions Rencontre, 1964. *Ghana.* Rouch, Jane. L'Atlas des voyages series. Lausanne: Editions Rencontre, 1964. *Les Trois bannières de la Chine.* Preface by Han Suyin. Paris: Robert Laffont, 1966. Also published in English: *The Three Banners of China.* New York: Macmillan, 1966. *Vivir en China.* Parise, Goffredo. Barcelona: Editorial Kairós, 1967. *Face of North Vietnam.* Text by Philippe Devillers. New York: Holt, Rinehart and Winston, 1970. *Bangkok.* Text by William Warren. New York: Weatherhill/Serasia, 1972. *Marc Riboud.* Afterword by Jean Dieuzaide. Toulouse: Galerie Municipale du Chateau d'Eau, 1977. *Chine: instantanés de voyage.* Paris: Arthaud, 1980. (Swiss edition: *Bericht aus China.* Zurich: Atlantis, 1981; American edition: *Visions of China: Photographs by Marc Riboud 1957–1980.* Introduction by Orville Schell. New York: Pantheon, 1981.) *Marc Riboud.* Text by Anna Farova. I Grandi Fotografi series. Milan: Gruppo Editoriale Fabbri, 1982. *Gares et trains.* Text by Jacques Reda. Paris: A.C.E. Editions, 1983. *Marc Riboud: photos choisies, 1953–1985.* Paris: Musée d'Art Moderne de la Ville de Paris/Paris Audiovisuel, 1985. *Marc Riboud: photographes photographiés.* Chalon-sur-Saône: Musée Nicéphore Niepce, 1985. *Marc Riboud: Images de Villeurbanne.* Introduction by Christian Caujolle. Lyon: Fondation Nationale de la Photographie, 1985. American edition: *Marc Riboud. Journal.* Présenté par Claude Roy. Paris: Editions Denoël, 1986. *Marc Riboud: Photographs at Home and Abroad.* Introduction by Claude Roy. New York: Harry N. Abrams, 1988. *Marc Riboud: l'embarras du choix.* Paris: Marc Riboud and Société Wild-Leitz France, distributed by Centre National de la Photographie, 1988. *Marc Riboud.* Introduction by Marc Riboud. Collection Photo Poche. Paris: Centre National de la Photographie, 1989. *Le Grand Louvre: du donjon à la pyramide.* Prefaces by François Mitterand and I. M. Pei. Texts by Catherine Chaine and Jean-Pierre Verdet. Paris: Hatier, 1989.

Eugene Richards

Born April 25, 1944, in Boston, Massachusetts. During the 1960s earned a de-

gree in English from Northeastern University. Attended photographer Minor White's graduate courses at Massachusetts Institute of Technology. Served as a volunteer health advocate for VISTA in rural southeastern Arkansas (1968–69) and photographed the area. In 1970 cofounded RESPECT, a private social-action program that provided paralegal services; published a newspaper, *Many Voices*; and distributed food and clothing in West Memphis, Arkansas. Returned to Boston area in 1972. Created Many Voices Press in 1978 to publish his book, *Dorchester Days*. That same year became a Magnum nominee. Also discovered that companion and collaborator of more than ten years, Dorothea Lynch, had breast cancer, and at her request, began to document the course of her illness. Started photographing in emergency ward at Denver General Hospital in 1980 and became an associate member of Magnum. Received a Guggenheim fellowship and the W. Eugene Smith Award for Humanistic Photography in 1981. Became full member of Magnum in 1982. Dorothea died in 1983 after writing texts for two more of Richards' books, *50 Hours* and *Exploding Into Life. Exploding Into Life* received the Nikon award for best photographic book (1986) and he received the International Center of Photography Photographic Journalism Award for *Below the Line* (1987). In 1986 shared the American vice-presidency of Magnum with Susan Meiselas and Alex Webb. Richards' books include the following:

Few Comforts or Surprises: The Arkansas Delta. Cambridge, Mass.: M.I.T. Press, 1973. *Dorchester Days.* Postscript by Dorothea Lynch. Wollaston, Mass.: Many Voices Press, 1978. *50 Hours.* Lynch, Dorothea, and Eugene Richards. [Wollaston, Mass.]: Many Voices Press, 1983. *Exploding Into Life.* Lynch, Dorothea, and Eugene Richards. New York: Aperture, in Association with Many Voices Press, 1986. *Below the Line: Living Poor in America.* Photographs and interviews by Eugene Richards. Mount Vernon, N.Y.: Consumer's Union, 1987.

George Rodger

Born March 19, 1908, at Hale, Cheshire, England. Attended St. Bees College in Cumbria, England (1921–25), then joined the British Merchant Navy in 1927 and sailed twice around the world. Made first photographs during this period. Lived in the United States from 1929 to 1936 working various jobs. Worked as a still photographer for B.B.C. Television in London for two years and began freelance photographing through the Black Star agency in London in 1939. Covered World War I for *Life* magazine (1939–45), met Robert Capa in 1943, and became a *Life* staff photographer in 1945. Remained with *Life* until 1947, then was a cofounder of Magnum. In 1948 he traveled the entire length of Africa and returned frequently throughout his career to photograph that continent. Settled in Smarden, Kent, England, in 1959 and continued to travel and photograph on assignment. Became a contributing photographer in 1970. A retrospective exhibition was held at The Photographers' Gallery, London (1987). Rodger's books and exhibition catalogues include the following:

Red Moon Rising. London: Cresset Press, 1943. *Far on the Ringing Plains.* New York: Macmillan, 1943. *Desert Journey.* London: Cresset Press, 1944. *Le village des Noubas.* Collection "huit." Paris: Delpire, 1955. *Le Sahara.* Collection du Musée de l'Homme. Paris: Centre de diffusion Française, 1957. *George Rodger:*

Photographer for Life Magazine. Essay by Inge Bondi. London: Arts Council of Great Britain, 1974. *George Rodger.* Bondi, Inge. London: Gordon Fraser, in association with the Arts Council of Great Britain, 1975. *The World of the Horse.* Campbell, Judith. Special photography by George Rodger. New York: A Ridge Press Book, T. Y. Crowell, 1975. *George Rodger en Afrique, 1941–1980.* Texts by Carole Naggar and George Rodger. Grenoble: Galerie de Prêt, 1982. *George Rodger en Afrique.* Naggar, Carole. Paris: Editions Herscher, 1984. *George Rodger: Magnum Opus: Fifty Years in Photojournalism.* Edited by Colin Osman. Introduction by Martin Caiger-Smith. London: Dirk Nishen, 1987.

Sabastião Salgado

Born February 8, 1944, in Aimores, Brazil. After studying law for one year in Vitoria, Brazil, completed economics studies in Brazil (1967). In 1968 earned a master's degree in economics from São Paulo University, Brazil, and Vanderbilt University in the United States, and then worked for one year for the Brazilian Ministry of Finance. Studied to obtain doctorate in agricultural economics at the Université de Paris (1969–71) and in 1970 made first photographs. While working for London-based International Coffee Organization (1971–73), made several trips to Africa. Moved to Paris in 1973. Began to work as a free-lance photographer and joined the agency Sygma. Worked through the Gamma Agency in Paris (1975–79). In 1977 began to photograph frequently in South America. In 1979 became a Magnum nominee and in 1981 became an associate member. Became a full member of Magnum in 1984. Major awards include: W. Eugene Smith Award for Humanistic Photography (1982); Prix du Premier Livre Photographiqe from the City of Paris and Kodak for the book *Autres Ameriques* (1984); Oskar Barnack Prize (1985); named Photographic Journalist of the Year (1986) in New York by the International Center of Photography. Received the Victor Hasselblad Award (1989). In 1987 began a project to document the disappearance of traditional manual industries throughout the world. Salgado's books and exhibition catalogues include the following:

Sebastião Salgado: fotografias. Introduction by Pedro Vasquez. Rio de Janeiro: Ministério da Educação e cultura/ Edição Funarte/Nucleo de Fotografia, 1982. *Sahel: l'homme en détresse.* Introduction by Jean Lacouture. Text by Xavier Emmanuelli. Paris: Prisma Presse, réalisé par le Centre National de la Photographie, au profit de Médecins sans Frontières, 1986. *Autres Amériques.* Paris: Contrejour, 1986. Spanish edition: *Otras Americas.* Introduction by Gonzalo Torrente Ballester. Madrid: Ediciones ELR, 1986. American edition: *Other Americas.* Introduction by Alan Riding. New York: Pantheon Books, 1986. *Sebastião Salgado.* Introduction by Jean Dieuzaide. Toulouse, France: Galerie Municipale du Château d'Eau, 1986. *Sebastião Salgado: Sahel-el fin del camino.* Prologue by Rosa Montero. Text by Josep Vargas. Madrid: Communidad de Madrid/Para Médicos Sin Fronteras, 1988.

David Seymour (Chim)

Born David Szymin, November 20, 1911, in Warsaw. Moved to Russia with family in 1914 and returned to Warsaw in 1919. Graduated from the Leipzig Akademie für Graphische Künste in 1931. Studied printing-ink chemistry at the Sorbonne (1931–33) and adopted the nickname "Chim." Began working as a free-lance

photographer in Paris and met Henri Cartier-Bresson and Robert Capa. In 1934 his photographs began to appear regularly in *Regards* magazine. Photographed the Spanish Civil War and other events in Europe (1936–38), traveled to Mexico (1939), and moved to New York City (fall, 1939), where he adopted the name David Seymour. From 1942 to 1945 served in photo reconnaissance and interpretation in the U.S. Army. Was a cofounder of Magnum in 1947. Assumed presidency of Magnum upon Robert Capa's death in 1954. Chim was killed November 10, 1956, by Egyptian machine-gun fire while driving near the Suez Canal with French photographer Jean Roy to cover an exchange of prisoners. His archives are with Magnum Photos and the International Center of Photography, New York. Seymour's books include the following:

Children of Europe. Paris: UNESCO, 1949. *The Vatican: Behind the Scenes in the Holy City.* Carnahan, Ann. New York: Farrar, Straus and Co., 1949. *Little Ones.* [Tokyo]: Heibonsha, 1957. *Chim—David Seymour, 1911–1956.* Introduction by Henri Cartier-Bresson. Paris: Editions Michel Brient, 1966. *David Seymour—"Chim".* Introduction by Judith Friedberg. New York: Paragraphic Books/Grossman Publishers, 1966. (Series edited by Anna Farova. Also published with a text by Anna Farova in Prague by S.N.K.L.H.U.) *David Seymour—"Chim," 1911–1956.* Texts by Henri Cartier-Bresson, Judith Friedberg, Eileen Shneiderman, and others. ICP Library of Photographers. New York: Grossman Publishers, 1974. *Front populaire.* Capa, Robert, and David Seymour "Chim." Text by Georgette Elgey. Paris: Chêne/Magnum, 1976. *Les grandes photos de la guerre d'espagne.* Text by Georges Soria. Photographs by Robert Capa and David Seymour—Chim. Paris: Editions Jannink, 1980.

Marilyn Silverstone

Born March 9, 1929, in London. After graduating from Wellesley College in Massachusetts, worked during the 1950s as an associate editor for *Art News, Industrial Design,* and *Interiors.* Also served as associate producer and historical researcher for an Academy Award-winning series of films on painters. Began to work as a free-lance photographer in 1955 and moved to New Delhi, India (1959–73). Became an associate member of Magnum in 1964 and a full member in 1967. The film, *Kashmir in Winter,* made from her photographs, won an award at the London Film Festival in 1971. Became an ordained Buddhist nun in 1973. In 1978 became a contributing photographer. Currently living in Kathmandu, Nepal, where she practices Buddhism and researches the vanishing customs of Rajasthan and the Himalayan kingdoms. Silverstone's books include the following:

Bala: Child of India. Story by Marilyn Silverstone and Luree Miller. London: Methuen & Co., 1962. Miller, Luree. *Gurkhas and Ghosts: The Story of a Boy in Nepal.* London: Methuen & Co., 1964. *Ocean of Life: Visions of India and the Himalayan Kingdoms.* Preface by Haven O'More. Afterword by the Ven. Khanpo Thupten. New York: Aperture, A Sadev Book, 1985.

W. Eugene Smith

Born December 30, 1918, in Wichita, Kansas. Made first photographs in 1933 and shortly after began to sell them to newspapers. Attended one semester at the University of Notre Dame, studied with Helene Sanders at the New York

Institute of Photography, and by 1937 began to work for *Newsweek* magazine. Left *Newsweek* in 1938 and worked through Black Star agency. Worked for *Life* magazine (1939–42). At *Parade* magazine for one year. Photographed World War II in the South Pacific for *Flying* magazine (1943–44); the next year rejoined *Life* and photographed in the South Pacific. Suffered severe injuries from shellfire while photographing there. For two years thereafter (1945–47) underwent medical operations and recuperated. Following recuperation worked for *Life* (1947–55). Resigned to join Magnum as an associate. With the support of two consecutive Guggenheim fellowships, began a project in 1956 to photograph Pittsburgh, and made color architectural photographs for the American Institute of Architects Centennial Exhibition at the National Gallery of Art in Washington, D.C. In 1957 became a full member of Magnum. In 1958 began a photographic essay on a mental health clinic in Haiti. Resigned from Magnum in 1959, changing status to contributing photographer. For one year (1961–62) photographed the Japanese industrial firm Hitachi Limited. Worked with Carole Thomas to develop a magazine that was never published (1964–65). In 1970 a retrospective exhibition, "Let Truth Be the Prejudice," opened at the Jewish Museum, New York. Moved to Minamata, Japan, in 1971 to document with Aileen Mioko Smith the aftermath of industrial pollution. Moved to Tucson, Arizona (1977), to teach at the University of Arizona. Died from a stroke on October 15, 1978, in Tucson. Smith's archives are at the Center for Creative Photography in Tucson, Arizona. Magnum Photos, Paris, offers distribution in Europe. Smith's books and exhibition catalogues include the following:

Eugene Smith: Photography. Minneapolis: University of Minnesota, 1954. *Hitachi Reminder.* Statement by W. Eugene Smith. Introductory comment by Jun Miki. Tokyo: Hitachi, Ltd., 1961. *Japan—A Chapter of Images: A Photographic Essay.* Smith, W. Eugene, with Carole Thomas. Tokyo: Hitachi, Ltd., 1963. *W. Eugene Smith: His Photographs and Notes.* Afterword by Lincoln Kirstein. New York: Aperture, 1969. *Minamata.* Words and photographs by W. Eugene Smith and Aileen M. Smith. An Alskog-Sensorium Book. New York: Holt, Rinehart & Winston, 1975. *W. Eugene Smith: A Chronological Bibliography, 1934–1980.* Johnson, William S. Tucson, Ariz.: Center for Creative Photography, University of Arizona, 1980, 1981. *W. Eugene Smith: Master of the Photographic Essay.* Edited, with commentary by William S. Johnson. Foreword by James L. Enyeart. New York: Aperture, 1981. *W. Eugene Smith.* Texts by John G. Morris and William S. Johnson. Tokyo: Pacific Press Service, 1982. *W. Eugene Smith.* Introduction by William S. Johnson. Collection Photo Poche. Paris: Centre National de la Photographie, 1983. Published in English in the Pantheon Photo Library. New York: Pantheon, 1986. *W. Eugene Smith.* Introduction by William S. Johnson. I Grandi Fotografi series. Milan: Gruppo Editoriale Fabbri, 1983. (Also published in Barcelona by Ediciones Orbis in 1984.) *W. Eugene Smith Papers.* Compiled by Charles Lamb and Amy Stark. Guide Series No. 9. Tucson: Center for Creative Photography, 1983. *W. Eugene Smith: A Chronological Bibliography: Addendum.* Johnson, William. Tucson: Center for Creative Photography, University of Arizona, 1984. *W. Eugene Smith: Let Truth Be the Prejudice: His Life and Photographs.* Maddow, Ben. Afterword by John G. Morris. New

York: Aperture, 1985. *Myth and Vision: On the Walk to Paradise Garden and the Photography of W. Eugene Smith.* Hansen, Henning. Lund, Sweden: Aris, University of Lund, 1987.

Chris Steele-Perkins

Born July 28, 1947, in Rangoon, Burma. Moved to England in 1949. Began studying chemistry at the University of York, England, in 1966; traveled and worked in Canada in 1967; studied psychology at the University of Newcastle-upon-Tyne, England (1967–70). Obtained an honors degree in psychology and worked as photographer and picture editor for the student newspaper. In 1971 lectured in psychology and photographed theater productions. Moved to London (1971), working full-time as a free-lance photographer. Traveled to Bangladesh to photograph for various relief organizations in 1973. Taught photography at Stanhope Institute and at North East London Polytechnic (1973–74). In 1975 joined EXIT Group, which dealt with problems of human behavior in major British cities. Co-curator, with Mark Edwards, of the exhibition "Young British Photographers" at the Photographers' Gallery, London (1975). In 1976 was associated with the Paris-based agency Viva and taught photography at the Polytechnic of Central London. Served on the Photographic Committee of the Arts Council of Great Britain (1976–79). With Mark Edwards co-curated the exhibition "Film Ends" (1977) at The Photographers' Gallery, London. In 1979 left Viva to become a Magnum nominee. Began working extensively in the third world in 1980. Made associate member of Magnum in 1981 and a full member in 1982. For story on thalidomide victims received the Oscar Barnack Award from World Press Photo in 1988. Also in 1988, won the Tom Hopkinson award for British Photojournalism from the Photographers' Gallery, London. Steele-Perkins' books include the following:

The Teds. Steele-Perkins, Chris, and Richard Smith. London: Travelling Light/Exit, 1979. *About 70 Photographs.* Edited by Chris Steele-Perkins. Commentaries by Chris Steele-Perkins and William Messer. London: Arts Council of Great Britain, 1980. *La Grèce au présent.* Paris: Bibliothèque publique d'information, Centre Georges Pompidou, 1981. *Survival Programmes: In Britain's Inner Cities,* by Exit Photography Group: (Nicholas Battye/Chris Steele-Perkins/ Paul Trevor). London: The Open University Press, Milton Keynes, 1982. *Beirut: Frontline Story.* Nassib, Selim, and Caroline Tisdall. London: Pluto Press, 1983.

Dennis Stock

Born July 24, 1928, in New York City. Served in the U.S. military for one year (1946) before working as an apprentice to photographer Gjon Mili from 1947 to 1951. In 1951 won first prize in *Life* magazine's Young Photographers Contest. Also in 1951 began association with Magnum, becoming a full member in 1954. Met James Dean in Hollywood in 1955 and photographed him there, in New York, and in his native Indiana. From 1957 to 1960 photographed jazz musicians and in 1962 received first prize in the In-

ternational Photography Competition in Poland. Took a leave of absence from Magnum in 1968 to create a film production company, Visual Objectives, Inc. Also began teaching first of many photographic workshops. Served as vice-president of Magnum's film and new media division from 1969 to 1970: Photographed in Japan in 1974. Was the subject of a retrospective exhibition at the International Center of Photography, New York, in 1977. Stock's books include the following:

Portrait of a Young Man: James Dean. Tokyo: Kadokawa Shoten, 1956. *Jazzwelt.* Text by Nat Hentoff. Stuttgart: Gerd Hatje, 1959. *Jazz Street.* Text by Nat Hentoff. Garden City, New York: Doubleday, 1960. *The Happy Year.* Self, Margaret Cabell. Manhasset, N.Y.: Channel Press, Inc., 1963. *California Trip.* New York: Grossman Publishers, 1970. *The Alternative: Communal Life in New America.* Hedgepeth, William, and Dennis Stock. New York: Macmillan, 1970. *Gelebte Zukunft: Franz von Assisi.* Von Galli, Mario. Lucerne: O. J. Bucher, 1970. (English edition: *Living our Future: Francis of Assisi.* London: Franciscan Herald, 1972.) *The National Parks Centennial Portfolio.* San Francisco: Sierra Club, 1972. *Edge of Life: The World of the Estuary.* Wayburn, Peggy. Introduction by Paul Brooks. San Francisco: Sierra Club, 1972. *Brother Sun: A Photographic Appreciation.* Introduction by J. G. Mitchell. San Francisco: Sierra Club, 1974. *The Circle of Seasons.* Text by Josephine W. Johnson. New York: A Studio Book, Viking Press, 1974. *California: The Golden Coast.* Text by Philip L. Fradkin. New York: A Studio Book, Viking Press, 1974. *A Haiku Journey.* Stock, Dennis, and Dorothy Britton. Tokyo: Kodansha International, 1974. *This Land of Europe.* Tokyo: Kodansha International, 1976. *Voyage poétique à travers le japon d'autrefois.* Paris: Bibliothèque des Arts, 1976. *James Dean Revisited.* New York: Viking Press/Penguin Books, 1978. *Alaska.* Essays by Claus M. Naske, William Hunt, and Lael Morgan. New York: Harry N. Abrams, 1979. *America Seen.* Paris: Contrejour, 1980. *Franziskus: Der Mann aus Assisi.* Schnieper, Xavier, and Dennis Stock. Lucerne, Switzerland: Reich Verlag, 1981. *Saint Francis of Assisi.* Text by Xavier Schnieper. Photographs by Dennis Stock. London: Frederick Muller Ltd., 1981. *Dennis Stock.* Text by Monica Cossardt. I Grandi Fotografi series. Milan: Gruppo Editoriale Fabbri, 1982. *Impression, Fleurs.* Preface by Gérald van der Kemp. Text by Monica Cossardt. Paris: Mengès, 1986. *Flower Show.* New York: Rizzoli, 1986. *James Dean Revisited.* Munich: Schirmer & Mosel, 1986. *Provence Memories.* Introduction by Phillip Conisbee. Boston: New York Graphic Society/Magnus, 1988. *Hawaii.* New York: Harry N. Abrams, 1988.

Kryn Taconis

Born May 7, 1918, in Rotterdam, Holland. Made first home movies on a trip to the United States in 1936. Around 1940 learned basic photography skills from Paul Guermonprez and worked as a darkroom technician in Amsterdam in 1941. Worked as a free-lance photographer with Carel Blazer (1942–45). Spent

three months as a prisoner of war in 1943. Beginning in 1944 worked with *Ondergedoken* (Hidden) *Camera,* a group of the Dutch Resistance movement. First met Robert Capa circa 1944–45. In 1946–47 traveled to the United States to visit *Life* magazine's editors. Worked as the Benelux correspondent for Time-Life, Inc. (1948–49). Established a working base in Paris in 1949. First associated with Magnum in 1950. Became a full member of Magnum, 1954. Moved to Geneva in 1955. In 1957 produced a photographic essay about the Front de Libération Nationale (Algerian Revolutionary Army), which Magnum suppressed from fear of disapproval by the French government. Moved to Brussels in 1958 and to Canada in 1959. Resigned from Magnum in 1960, continuing to work as a free-lance photographer. Worked at the National Film Board of Canada from 1965 to 1967. Awarded a silver plaque at La Plata for his film *A Celebration* in 1967. Taught photography in Kitchener, Ontario, throughout the 1970s. From 1975 to 1977 worked on a never-completed photographic essay, "La Meuse." Died on July 12, 1979, in Toronto, Ontario. Archives are at the National Archives of Canada in Ottawa, where Brian Carey and Louise Guay co-organized a retrospective exhibition, "Kryn Taconis, Photojournalist," which opened in June 1989. Taconis's books include the following:

Amsterdam tijdens de hongerwinter. Introduction by Max Nord. Amsterdam: Uitgeverij Contact in collaboration with Bezige Bij, 1947. *Amsterdam 1950–1959: 20 fotografen/photographers.* Amsterdam: Fragment Uitgeverij in collaboration with Gemeentearchief Amsterdam, 1985. *Kryn Taconis: Photojournalist/Photojournaliste.* Edited by Brian Carey and Louise Guay. Ottawa: Canada Supply and Services/National Archives of Canada, 1989.

Burk Uzzle

Born August 4, 1938, in Raleigh, North Carolina. From 1955 to 1956 worked as a staff photographer for the Raleigh newspaper the *News and Observer.* From 1957 to 1962 worked as a free-lance photographer in Atlanta, Houston, and Chicago for the New York-based agency Black Star. In 1962 began photographing for *Life* magazine. Left *Life* in 1967 to become a full member of Magnum. In 1970 received the Page One Award from the Newspaper Guild of New York. Served as president of Magnum from 1978 until mid-1980. Resigned from Magnum in 1982 and continues to work as a free-lance photographer. Uzzle's books include the following:

Landscapes. Introduction by Ronald Bailey. New York: Magnum, 1973. *All American.* Introduction by Martha Chahroudi. St. Davids, Penn.: St. David's Books, in association with Aperture, Millerton, New York, 1984. (French edition: *Mon Amérique.* Introduction by Gilles Mora. Paris: Contrejour, 1985.)

William Vandivert

Born August 16, 1912, in Evanston, Illinois. Studied chemistry at Beloit College (1928–30) and at the Art Institute of Chi-

cago (1930–35). In 1935 made first photographs and began to photograph for the *Herald-Examiner* in Chicago. Worked as a midwestern-based staff photographer for *Life* magazine (1936–38) and moved to London in December 1938 to work for *Life* in Europe. Covered World War II in Europe for *Life* until 1945. Met Robert Capa in 1941. Traveled around the world for *Life* for one year (1945–46) and left *Life* in 1946. William and Rita, his wife, were cofounders of Magnum (1947). Both Vandiverts withdrew from Magnum the following year. William continued his career as an independent free-lance photographer. The Vandiverts collaborated on first of several wildlife books in 1957; Rita researched and wrote the texts and William supplied the photographs. In 1959 they traveled to the Soviet Union. Served as president of the American Society of Magazine Photographers (1965–66). During the 1980s he suffered two major strokes that prevented him from continuing to work. The Vandiverts collaborated on each of the following titles: Rita contributed the text; William the photographs.

Common Wild Animals and Their Young. New York: Dell Paperback, 1957. *The Porcupine Known as J. R.* New York: Dodd, Mead, 1959. (British edition: *Gregory.* London: Hamish Hamilton, 1959.) *Young Russia: Children of the U.S.S.R. at Work and at Play.* New York: Dodd, Mead, 1960. (British edition: London: Dodd, Mead by arrangement with Wheaton, Exeter.) *Barnaby.* New York: Dodd, Mead, 1963. (British edition: London: Hamish Hamilton.) *Favorite Wild Animals.* New York: Scholastic, 1973. *Favorite Pets.* New York: Scholastic, 1975. *Understanding Animals as Pets.* New York: Frederick Warne, 1975. *To the Rescue: Seven Heroes of Conservation.* New York: Frederick Warne, 1982.

Alex Webb

Born May 5, 1952, in San Francisco, California. Taught photography as a child by father; began to photograph seriously in 1968. Studied history and literature at Harvard University (1970–74) and attended courses at Harvard's Carpenter Center for the Visual Arts. In 1972 studied photography with Bruce Davidson and Charles Harbutt at the Apeiron photographic workshop in Millerton, New York. In 1974 began working as a free-lance photographer as a Magnum nominee; in 1976 became an associate member of Magnum. Photographed extensively in the American South (1976–77). Began photographing in color in the Caribbean, Mexico, and Africa in 1978. The following year became a full member of Magnum (1979). Received the Overseas Press Club Award for photographs of the U.S.-Mexico border in 1980; shared American vice-presidency of Magnum with Susan Meiselas and Eugene Richards in 1986 and received a grant from the New York State Council on the Arts in 1986. Received the Leopold Godowsky, Jr., Color Photography Award in 1988. Webb's books include the following:

Hot Light/Half-Made Worlds: Photographs from the Tropics. New York and London: Thames & Hudson, 1986. *Under a Grudging Sun: Photographs from Haiti Libéré, 1986–1989.* New York and London: Thames & Hudson, 1989.

Selected Bibliography

Stuart Alexander

The group books listed below do not always include work by all members active at the time of their publication. Indeed, some members were opposed to some of the books.

Books and Exhibition Catalogues

Magnum's Global Photo Exhibition 1960. Tokyo: The Mainichi Newspapers/ Camera Mainichi, 1960. *Let Us Begin: The First 100 Days of the Kennedy Administration.* Edited by Cornell Capa and Richard L. Grossman. New York: Simon & Schuster, 1961. *Creative America.* Texts by several authors. New York: Ridge Press for the National Cultural Center, 1962. *WIJ: foto's van magnum.* Amsterdam: Stedelijk Museum/Magnum Photos, 1963. *Peace on Earth: Photographs by Magnum.* Text by Pope John XXIII. New York: Ridge Press/Odyssey Press, 1964. *America in Crisis.* Pictures edited by Charles Harbutt and Lee Jones. Text by Mitchel Levitas. New York: Ridge Press/Holt, Rinehart and Winston, 1969. *This is Magnum.* Tokyo: Magnum/Pacific Press Service, 1979. *Magnum Photos.* Introduction by Hugo Loetscher. Saint-Ursanne, Switzerland: Saint-Ursanne, 1980. *Paris/Magnum: Photographs 1935–1981.* Introduction by Inge Morath. Text by Irwin Shaw. Millerton, N.Y.: Aperture, 1981. *Terre de Guerre.* Text by Charles-Henri Favrod. Edited by René Burri and Bruno Barbey. Paris: Magnum Photos, 1982. *Magnum Concert.* Introduction by Roger Marcel Mayou. Fribourg: Triennale internationale de la photographie au musée d'art et d'histoire de Fribourg, 1985. *After the War Was Over.* Introduction by Mary Blume. New York and London: Thames & Hudson, 1985. (French edition: *Après la Guerre . . .*). Paris: Chêne, 1985. German edition: *Eine neue Zeit . . . 1944–1960.* Cologne: DuMont Buchverlag, 1985.) *The Fifties: Photographs of America.* Introduction by John Chancellor. New York: Pantheon Books, 1985. *Israel: The First Forty Years.* Edited and texts by William Frankel. Introduction by Abba Eban. New York and London: Thames & Hudson, 1987. (French edition: *Terre Promise?: quarante ans d'histoire en Israel.* Paris: Nathan Image, 1988.) *Bons baisers.* Magnum. Collection Cahier d'Images. Paris: Contrejour, 1987. *China: A Photohistory 1937–1987.* Introduction by Jonathan D. Spence. Edited with commentaries by W. F. Jenner. London: Thames & Hudson, 1988.

Includes Magnum

The Family of Man. Steichen, Edward. Prologue by Carl Sandburg. New York: Museum of Modern Art, 1955.

General Articles About Magnum

Note: A German photography periodical called *Magnum* was published in the fifties and early sixties. It had no connection with Magnum Photos.

Morris, John. "Magnum Photos: An International Cooperative," in *U.S. Camera 1954.* New York: U.S. Camera Publishing Corp., 1953 (pp. 110–60).

Dobell, Byron. "Magnum: The First Ten Years . . . ". *Popular Photography* 41:3 (September 1957).

"Magnum." *Creative Camera* no. 57 (March 1969): 93–115.

Tardy, Hervé. "Magnum." *Reporter-Objectif* [Paris] no. 10 (December 1972/January 1973): 32–78.

Hall, James Baker. "The Last Happy Band of Brothers." *Esquire* 81:4 (April 1974): 117–25, 232–33, 235–37.

"Les origines de Magnum," in *Arles 76: 7ᵉ rencontres internationales de la photographie.* Introduction by Lucien Clergue. Arles, France: Rencontres Internationales de la Photographie, 1976 (pp. 13–49, 84–95).

"Magnum photos, una appassionante avventura." *Progresso Fotografico* 83:9 (September 1976): 17–89.

Fondiller, Harvey V. "Magnum: Image and Reality." *35 mm Photography* (Winter 1976): 58–103, 114–18.

"Magnum." *Photo Technique* [London] 5:10 (November 1977): 27–66.

Rovers, Paolo. "Magnum." *Valokuva* [Helsinki] (November 1977): 3, 6–36, 38, 40.

Naggar, Carole. "Magnum raconte Paris: Rodger raconte Magnum." *Photo Cinéma Magazine* no. 24 (November 1981): 36–51.

Morris, John G. "John G. Morris: A Photographic Memoir." *Exposure* 20:2 (1982): 1–33.

"Photographer's Space: Magnum Photos." *Photo Japan* [Tokyo] no. 009 (July 1984): 158–59.

Stern, Marilyn. "Magnum: The Legend Lives On." *Photo District News* 6:6 (June 1986): 34–36, 38, 40.

Group Portfolios in Periodicals

Scheidegger, Ernst. "Magnum Photos Inc.: sechs weltbekannte photoreporter." *Camera* 32:10 (October 1953): 408–36.

"Sacred Feasts—Public Rejoicings: Excerpts of Topical Photographs from: George Rodger, Erich Lessing, Ernst Haas, Henri Cartier-Bresson." *Camera* 33:12 (December 1954): 534–61.

"L'Humain dans l'homme." *Camera* 42:3 (March 1963): 44–53.

Edelson, Michael. "The New Magnum Photographers." *Camera 35* (August/September 1968): 28–35, 64.

Harbutt, Charles. "America in Crisis: Pictures from a New Book." *Photography Annual 1970.* New York: Ziff-Davis, 1969 (pp. 56–63, 188, 190).

"L'Amérique en crise." *Photo* [Paris] no. 39 (December 1970): 34–45, 102.

"Vietnam: le choc et l'insolite," and other titles. *Grand Angle* [Lyon] no. 1 (November/December 1976): 2, 14–52, 60–61, 65, 67.

Orlando, Ruggero. "America." Supplement to *Il Fotografo* [Milan] no. 39 (May 1980): 1–80.

"Marilyn: Ses photographies interdites: Négatifs et contacts perforés de sa main . . . retrouvés." *Photo* [Paris] no. 153 (June 1980): 38–47, 114.

"OM stellt vor: 8 Magnum-fotografen." *OM: Olympus-Magazine,* no. 3 (1981): 28–35.

"Les Premières images." *Libération* [Paris] Supplément au no. 8 (12 May 1981): A–H.

"Terre de guerre: Trente-cinq années d'images par les grands de Magnum." *Photo* [Paris] no. 182 (November 1982): 90–101, 150.

"Pologne: Album Magnum." *Photo* [Paris] no. 187 (April 1983): 46–53, 107.

"20 ans déjà: Kennedy vu par les grands de Magnum." *Photo* [Paris] no. 195 (December 1983): 30–37, 108.

"Magnum: 40 ans d'Amerique Latine." *Photo* [Paris] no. 230 (November 1986): 76–79.

"L'Oeil de Bodard sur la grande cimaise de Chine: Arles/Magnum." *Photomagazine* [Paris] no. 94 (July/August 1988): 80–87.

Chronology of Magnum

Stuart Alexander

Numerous photographers have been associated with Magnum over the years. Included below are only photographers who eventually became full members and photographers who are currently associated with Magnum.

1947

First meeting in April at the penthouse restaurant of the Museum of Modern Art, New York. Founding members were Robert Capa, Henri Cartier-Bresson, George Rodger, David Seymour (Chim) and William Vandivert. Maria Eisner was named secretary/treasurer. Rita Vandivert was made president.

The first New York office was at 21 E. 10th Street and the first office in Paris was Maria Eisner's apartment at 22 rue de Pontoise where Maria Eisner was living. Later the office moved to 125 rue du Faubourg St. Honoré.

22 May. Magnum Photos, Inc., filed a certificate of incorporation in New York County, New York. The New York office is established at the Vandivert's, at 55 W. 8th Street.

The first group project, working with John G. Morris, picture editor of the *Ladies' Home Journal,* covered the daily lives of farm families around the world in a series of articles called "People Are People the World Over," which ran for one year.

1948

William and Rita Vandivert resign. Maria Eisner becomes president. Werner Bischof and Ernst Haas are first associated. Inge Morath begins as a writer and researcher.

The New York office moves to 4 W. 64th Street.

1949

Werner Bischof becomes a member.

Maria Eisner Lehfeldt moves to New York with her husband and directs the office there. Her former apartment at 125 rue du Faubourg St. Honoré becomes the Paris office.

The New York office moves to 55 W. 45th Street.

1950

Ernst Haas becomes a member. Kryn Taconis is first associated.

Georges Ninaud becomes the *gerant* of the Paris office. Inge Bondi begins working in the New York office.

1951

Eve Arnold, Burt Glinn, Erich Hartmann, Erich Lessing, and Dennis Stock begin their association.

Maria Eisner Lehfeldt resigns. Robert Capa takes over as president.

Margot Shore begins working in the Paris office and later becomes Paris bureau chief.

The New York office moves to the Fawcett Building on W. 44th Street.

1952

Henri Cartier-Bresson's book, *The Decisive Moment,* is published.

Marc Riboud begins his association.

The second major group project, "Generation X," begins (stories on young men and women just turning twenty).

1953

John G. Morris becomes international executive editor.

Elliott Erwitt is first associated. Inge Morath begins her association with Magnum as a photographer.

The New York office moves to 17 E. 64th Street.

"Generation X" series, "Youth and the World," appears in *Holiday.*

1954

16 May. Werner Bischof dies in the Peruvian Andes.

25 May. Robert Capa dies near Thai Binh, Indochina (now Vietnam).

Elliott Erwitt, Burt Glinn, Erich Hartmann, and Kryn Taconis become members. Cornell Capa becomes a member after his brother's death. Brian Brake begins his association.

David Seymour succeeds Robert Capa as president. During his tenure Seymour drafts Magnum's by-laws.

Trudy Felieu succeeds Margot Shore as the Paris bureau chief.

1955

The first formal definitions of membership are put into effect.

Erich Lessing, Inge Morath, and Marc Riboud become members. Eve Arnold, Brian Brake, René Burri, and W. Eugene Smith become associates. Wayne Miller begins his association.

"The Family of Man" exhibition, including many works by Magnum, opens at the Museum of Modern Art in New York.

At year's end the New York office moves to 15 W. 47th Street.

1956

Ansel Adams, Philippe Halsman, Dorothea Lange, Russell Lee, Herbert List, and Wayne Miller are named the first group of contributing photographers, even though some had contributed as early as 1948. Contributors were defined as "independent photographers who have been close friends of Magnum" who appointed Magnum as their "exclusive agents—even though they deal directly with some clients."

10 November. David Seymour dies while photographing in the Suez.

Leonard Freed is first associated.

Cornell Capa succeeds Seymour as president.

A Magnum group exhibition opens at the Photokina exposition in Cologne, West Germany.

1957

Eve Arnold, Brian Brake, W. Eugene Smith, and Dennis Stock become members.

Michel Chevalier becomes European editor in the Paris office.

A Magnum group exhibition is included in the Premiere Exposition Internationale Biennale de la Photographie in Venice.

1958

Wayne Miller becomes a member. Bruce Davidson becomes an associate.

First year to have two vice-presidents: Brian Brake in Europe and Ernst Haas in the United States.

Lee Jones begins as associate editor in the New York office; later becomes New York bureau chief. Trudy Felieu resigns.

1959

René Burri and Bruce Davidson become members. W. Eugene Smith resigns, continuing as a contributing photographer. Sergio Larrain is first associated.

Kate Lewin becomes the librarian to organize the archives.

1960

Kryn Taconis resigns.

Ernst Haas succeeds Cornell Capa as president.

Magnum members photograph the making of John Huston's film, *The Misfits*.

Ernst Haas designs the exhibition "The World as Seen by Magnum Photographers." Shown in Japan and at the Library of Congress in Washington, D.C., and in other nations.

1961

Sergio Larrain becomes a member. Hiroshi Hamaya becomes a contributor.

John G. Morris resigns as executive editor; continues to edit the monthly *Magnum News Service*.

Michel Chevalier of the Paris office dies in a car accident. Gedeon de Margitay becomes the New York bureau chief. William de Bazelaire becomes the Paris bureau chief.

1962

Ian Berry becomes an associate.

Wayne Miller succeeds Ernst Haas as president.

The New York office moves to 72 W. 45th Street.

A group exhibition, "L'humain dans l'homme," is shown at the Photokina exposition in Cologne, West Germany.

1963

Charles Harbutt and Constantine Manos become associates.

Marc Riboud is European vice-president and Burt Glinn is American vice-president. *Magnum News Service* completes term of publication and John G. Morris leaves Magnum.

1964

Charles Harbutt becomes a member. Marilyn Silverstone becomes an associate. Bruno Barbey is first associated.

William de Bazelaire resigns from the Paris office. Joseph Morhaim succeeds him as Paris bureau chief.

Magnum Films, with Philip Gittelman as executive producer, is created as a special unit for the creation and distribution of motion picture films.

1965

Constantine Manos becomes a member. David Hurn becomes an associate. Thomas Höpker first associated.

Inge Morath succeeds Riboud as European vice-president. Charles Harbutt succeeds Burt Glinn as American vice-president. Georges Ninaud resigns. Marc Riboud succeeds him as *gerant* of the Paris office.

1966

Bruno Barbey and Burk Uzzle become associates. Henri Cartier-Bresson and Ernst Haas become contributing photographers. Brian Brake resigns. Elliott Erwitt is elected to succeed Wayne Miller as president. Glinn and Riboud resume their vice-presidencies.

Russell Melcher succeeds Joseph Morhaim as Paris bureau chief.

1967

Ian Berry, David Hurn, Marilyn Silverstone, and Burk Uzzle become members. Philip Jones Griffiths, Danny Lyon, and Donald McCullin become associates.

Charles Harbutt becomes American vice-president.

1968

Bruno Barbey becomes a member. Danny Lyon and Don McCullin are invited to become members. Micha Bar-Am is first associated.

Burt Glinn resumes American vice-presidency.

Paul Gauci becomes controller in the New York office.

1969

Donald McCullin resigns. Danny Lyon continues his association with Magnum, although he does not become a member.

Charles Harbutt succeeds Elliott Erwitt as president.

Anna Obolensky succeeds Russell Melcher as Paris bureau chief.

1970

Sergio Larrain resigns and later becomes a contributing photographer. George Rodger becomes a contributing photographer. Hiroji Kubota and Gilles Peress first associated.

Inge Bondi resigns.

The New York office moves to 15 W. 46th Street.

Magnum Films disbanded.

1971

Philip Jones Griffiths becomes a member. Josef Koudelka becomes an associate.

1972

Leonard Freed becomes a member. Gilles Peress becomes an associate.

Burt Glinn succeeds Charles Harbutt as president. Bruce Davidson succeeds Burt Glinn as American vice-president.

1973

Paul Fusco and Mark Godfrey become associates.

Charles Harbutt is elected American vice-president.

1974

Paul Fusco, Mark Godfrey, Josef Koudelka, and Gilles Peress become members. Alex Webb becomes a nominee.

Erich Lessing becomes European vice-president and Elliott Erwitt becomes American vice-president.

The Paris office moves to 2 rue Christine.

1975

Richard Kalvar becomes an associate.

Marc Riboud succeeds Burt Glinn as president. Erich Hartmann is elected American vice-president.

1976

Guy Le Querrec, Mary Ellen Mark, and Alex Webb become associates. Micha Bar-Am becomes a correspondent. Susan Meiselas becomes a nominee. Miguel Rio Branco becomes a contributor.

Charles Harbutt succeeds Marc Riboud as president. Ian Berry is elected European vice-president and Mark Godfrey is elected American vice-president.

James Fox becomes editor-in-chief in Paris, after working in the New York office as special projects editor from 1966–71.

A Magnum group exhibition is included at the Rencontres Internationales de la Photographie in Arles, France.

1977

Richard Kalvar, Guy Le Querrec, and Mary Ellen Mark become members. Susan Meiselas becomes an associate. Jean Gaumy becomes a nominee. Raghu Rai becomes a correspondent.

1978

Raymond Depardon becomes an associate. Marilyn Silverstone becomes a contributing photographer. Eugene Richards becomes a nominee.

Burk Uzzle is elected to succeed Charles Harbutt as president. Bruno Barbey becomes the European vice-president.

1979

Raymond Depardon and Alex Webb become members. Erich Lessing becomes a contributing photographer. Sabastião Salgado and Chris Steele-Perkins become nominees.

Erich Hartmann becomes American vice-president.

Natasha Chassagne succeeds Anna Obolensky as Paris bureau chief.

"This is Magnum" exhibition, organized by Robert Kirschenbaum of Pacific Press Services, opens in Tokyo and Osaka.

1980

Susan Meiselas becomes a member. Martine Franck, Jean Gaumy, and Eugene Richards become associates. Marc Riboud resigns and later becomes a contributing photographer. Peter Marlow becomes a nominee.

Philip Jones Griffiths succeeds Burk Uzzle as president. Raymond Depardon becomes European vice-president and Elliott Erwitt becomes American vice-president.

The New York office moves to 251 Park Avenue South.

The group exhibition "Magnum Photos" opens at Saint-Ursanne, Switzerland.

1981

Charles Harbutt, Mark Godfrey, and Mary Ellen Mark resign.

Sebastião Salgado and Chris Steele-Perkins become associates. Abbas and Harry Gruyaert become nominees.

Burt Glinn is elected American vice-president.

The exhibition "Paris/Magnum" opens at the Musée du Luxembourg, Paris, and travels to the International Center of Photography in New York.

1982

Burk Uzzle resigns. Eugene Richards becomes a member. Peter Marlow becomes an associate. Ferdinando Scianna becomes a nominee.

René Burri becomes European vice-president.

The Paris office moves to 20 rue des Grands Augustins.

The exhibition "Terre de Guerre" inaugurates the Galerie Magnum in Paris.

1983

Martine Franck and Chris Steele-Perkins become members. Abbas and Harry Gruyaert become associates. Michael Nichols and Eli Reed become nominees.

Bruce Davidson becomes American vice-president.

1984

Sabastião Salgado becomes a member.

Richard Kalvar becomes European vice-president and Gilles Peress becomes American vice-president.

1985

Abbas becomes a member. Cornell Capa becomes a contributing photographer. Michael Nichols and Eli Reed become associates. Stuart Franklin, Steve McCurry, Alberto Venzago, and Patrick Zachmann become nominees.

Erich Hartmann succeeds Philip Jones Griffiths as president. Alex Webb becomes American vice-president.

"Magnum Concert" exhibition opens at the Musée d'art et d'histoire in Fribourg, Switzerland.

The "Focus on Magnum Photographic Workshops" are held in June at the New School in New York.

The exhibition "Magnum Photographs 1932–1967" is held in the fall at Pace/MacGill Gallery in New York.

1986

Jean Gaumy, Harry Gruyaert, and Peter Marlow become members. James Nachtwey becomes a nominee.

Ernst Haas dies September 12.

Gilles Peress succeeds Erich Hartmann as president. Susan Meiselas, Eugene Richards, and Alex Webb share the American vice-presidency.

Natasha Chassagne resigns.

A London office opens on Gray's Inn Road, with Neil Burgess as bureau chief.

1987

Stuart Franklin, Ferdinando Scianna, and Patrick Zachmann become associates.

Burt Glinn succeeds Gilles Peress as president. Susan Meiselas assumes the American vice-presidency.

François Hebel becomes director of administration of the Paris office.

The New York office moves to 72 Spring Street.

The Galerie Magnum in Paris closes.

1988

Eli Reed and Michael Nichols become members. James Nachtwey becomes an associate. Gideon Mendel, Martin Parr, Gueorgui Pinkhassov, and Franco Zecchin become nominees.

Bruno Barbey becomes European vice-president.

The London office moves to 23-25 Old Street.

"Magnum en Chine" is exhibited at the Commanderie de Ste. Lucie in Arles, as part of the Rencontres Internationales de la Photographie.

1989

Thomas Höpker, Hiroji Kubota, James Nachtwey, and Ferdinando Scianna become members. Misha Erwitt becomes a nominee.

Burt Glinn is named chairman of the board. Gilles Peress succeeds Glinn as president. Susan Meiselas reelected American vice-president. Guy Le Querrec elected vice-president, Paris. Peter Marlow elected vice-president, London (a newly created position).

Magnum International formed to handle all business outside of the three major bureaus. Bruno Barbey named Magnum International vice-president.

Note on the Printing of the Photographs

Prints in the gallery of the publication were made by the following printers and labs:

Pictorial Services, Paris

Bruno Barbey
Ian Berry
Werner Bischof
René Burri
Henri Cartier-Bresson
Martine Franck
David Hurn
Richard Kalvar
Josef Koudelka
Sergio Larrain
Erich Lessing
W. Eugene Smith

Publimod Photo, Paris

Guy Le Querrec
Marc Riboud

Imaginoir, Paris

(with names of the printers)

Raymond Depardon	Patrick Toussaint
Jean Gaumy	Patrick Toussaint
Sebastião Salgado	Jean-Yves Brégand
Ferdinando Scianna	Didier Léger

Goossens, Paris

Abbas	Félix Rieder

Yvon Le Marlec, Paris

Patrick Zachmann

Igor Bakht, New York

Cornell Capa
Robert Capa
Leonard Freed
Paul Fusco
Ernst Haas
Erich Hartmann
Constantine Manos
Wayne Miller
Inge Morath
David Seymour
Marilyn Silverstone
Dennis Stock

Schneider/Erdmann, New York

Bruce Davidson
Burt Glinn
Danny Lyon
Mary Ellen Mark
Gilles Peress

Glen Brent, London

Eve Arnold
George Rodger
Chris Steele-Perkins

Other

Photographer:	Printer:
Micha Bar-Am	Micha Bar-Am
Elliott Erwitt	Doug Rice
Stuart Franklin	Stuart Franklin
Mark Godfrey	Mark Godfrey
Hiroshi Hamaya	Hiroshi Hamaya
Charles Harbutt	Charles Harbutt
Hiroji Kubota	Hiroji Kubota
Peter Marlow	Peter Marlow
Susan Meiselas	James Nubile
Eli Reed	James Nubile
Eugene Richards	Brian Young
Kryn Taconis	José Byloos and Marcel Lemay
Burk Uzzle	Burk Uzzle